Merry Christmas 1986

For Connie 'Doc' Angelondous,

Thought this might inspire you, or at least bring
you pleasure. Sculpture is cheap to initiate, too!
Wood, clay, metal... I can assist with technique, etc.

"Just call me 'Proffessor'"

Chris A. "cdf" Frazier

German Expressionist Sculpture

This exhibition and its catalogue are funded in part by grants from the National Endowment for the Arts and the National Endowment for the Humanities and by an indemnity from the Federal Council on the Arts and Humanities.

German Expressionist Sculpture

Organized by **Stephanie Barron**

Los Angeles County Museum of Art

Exhibition Itinerary:

Los Angeles County Museum of Art
October 30, 1983–January 22, 1984

Hirshhorn Museum and Sculpture Garden
Smithsonian Institution, Washington, D.C.
April 4–June 17, 1984

Josef-Haubrich Kunsthalle Köln
July 7–August 26, 1984

90 89 88 87 86 85 84 83 54321

Edited by Barbara Einzig, Lynne Dean, and Andrea P. A. Belloli

Designed by Jeffrey Mueller

Typeset in Walbaum by Continental Typographics Inc, Woodland Hills, California

Printed in an edition of 13,100 softcover and 1,500 hardcover on Espel papers, by Nissha Printing Co., Ltd., Japan

Front cover:
Kirchner
*Head of a Woman, Head of Erna
(Frauenkopf, Kopf Erna),* 1913 [1912]
(cat. no. 67)

Back cover:
Barlach
The Avenger (Der Rächer), 1914
(cat. no. 9)

Published by the
Los Angeles County Museum of Art,
5905 Wilshire Boulevard,
Los Angeles, California 90036.

A hardcover edition of this catalogue has been published by The University of Chicago Press, 5801 South Ellis Avenue, Chicago, Illinois 60637, and The University of Chicago Press, Ltd., London, in association with the Los Angeles County Museum of Art.

A German edition of this catalogue has been published by Prestel Verlag, Mandlstrasse 26, 8000 Munich 40, West Germany.

Catalogue essays by Wolfgang Henze, Joachim Heusinger von Waldegg, Dietrich Schubert, Martin Urban, and Gerhard Wietek, and Documentary Section essays by Theodor Däubler, L. de Marsalle, Carl Georg Heise, P. R. Henning, Max Osborn, and Max Sauerlandt were translated by Dr. Hans Wagener, Professor of German, Department of Germanic Languages, UCLA.

Library of Congress Cataloging in Publication Data
Main entry under title:

GERMAN EXPRESSIONIST SCULPTURE.

 Catalog of an exhibit organized by the Los Angeles County Museum of Art and also held at the Hirshhorn Museum and Sculpture Garden and at Kunsthalle Köln.
 Bibliography: p.
 Includes index.
 1. Sculpture, German—Exhibitions. 2. Expressionism (Art)—Germany—Exhibitions. 3. Sculpture, Modern—20th century—Germany—Exhibitions. I. Barron, Stephanie. II. Los Angeles County Museum of Art. III. Hirshhorn Museum and Sculpture Garden. IV. Kunsthalle Köln.
NB568.5.E9G47 1983 730'.943'074 83-13552

LACMA: ISBN 0-87587-115-1 (paper)
The University of Chicago Press:
ISBN 0-226-03820-3 (cloth)

Contents

Foreword

In 1931, Alfred H. Barr, Jr., then director of The Museum of Modern Art, wrote in the catalogue of the *Modern German Painting and Sculpture* exhibition: "Many believe that German painting is second only to the School of Paris, and that German sculpture is at least equal to that of any other nation." The present exhibition and catalogue, devoted exclusively to Expressionist sculpture, allow us to recognize its excellence and vitality. Never before, either in Germany or America, has there been such an exhibition. With few exceptions, sculpture has been omitted from surveys of the Expressionist movement as a whole and from general presentations of twentieth-century art. Yet the fact that a significant body of such work has survived, and that an even greater one was created, cannot be overlooked.

This exhibition was conceived and organized by Stephanie Barron, Curator of Twentieth-Century Art at the Los Angeles County Museum of Art, over the last three years. It includes representative examples of German Expressionist sculpture from European and American collections and examines plastic works produced by German artists and by their contemporaries elsewhere in Europe who were affected by the movement and its spirit. Much of the information presented in the exhibition and catalogue was acquired through research in books, catalogues, and periodicals from the early part of this century that were made accessible by The Robert Gore Rifkind Foundation and Library of German Expressionism in Beverly Hills.

It is a special pleasure for the Los Angeles County Museum of Art to collaborate, as it did in 1980 on *The Avant-Garde in Russia, 1910–1930: New Perspectives,* with the Hirshhorn Museum and Sculpture Garden, Washington, D.C. We are very pleased that the present exhibition will also travel to the Josef-Haubrich-Hof Kunsthalle Köln where we anticipate that it will be as much of a revelation to viewers as it will be to their counterparts in the United States.

The lenders to the exhibition, who are listed separately in this catalogue and who have agreed to part with works from their collections for display in Los Angeles, Washington, D.C., and Cologne, have our sincere thanks; without them this exhibition would not have been possible. The early support of several of them was extremely important to the project: Dr. Wolf-Dieter Dube, now Director-General, Staatliche Museen Preussischer Kulturbesitz, Berlin; Dr. Leopold Reidemeister, Director, Brücke-Museum, Berlin; Dr. Eberhard Roters, Director, Berlinische Galerie, Berlin; Dr. Siegfried Salzmann, Director, Wilhelm-Lehmbruck-Museum der Stadt Duisburg; Dr. Martin Urban, Director, Nolde-Stiftung Seebüll; and European and American collectors Hans Geissler, Karl-Heinz Scherer, Titus Felixmüller, and Robert Gore Rifkind.

This catalogue was copublished in English in association with The University of Chicago Press and in German by Prestel Verlag. Thus the history of a movement largely ignored by scholars and the general public will now be accessible to a wide audience.

German Expressionist Sculpture has received major funding from the National Endowment for the Arts and the National Endowment for the Humanities; many foreign loans have been indemnified by the Federal Council on the Arts and Humanities. We are also grateful for support from the Goethe Institute for related events. Without this support, an exhibition and publication of this magnitude would not have been possible.

Earl A. Powell III
Director
Los Angeles County Museum of Art

Abram Lerner
Director
Hirshhorn Museum and Sculpture Garden

Siegfried Gohr
Director
Josef-Haubrich Kunsthalle Köln

Acknowledgments

The organization of *German Expressionist Sculpture* has taken over three years and involved the cooperation of many institutions and individuals. Initial support for the project came from Earl A. Powell III, Director, Los Angeles County Museum of Art, and from the Board of Trustees. The early and confident commitment of Abram Lerner, Director, Hirshhorn Museum and Sculpture Garden, Washington, D.C., as well as a generous grant from the National Endowment for the Arts provided critical support to the success of this venture. In 1981, I was awarded a McCloy Fellowship by the American Council on Germany that enabled me to travel throughout that country for one month to do research. Finally, the Museum's Modern and Contemporary Art Council has provided continued support for the exhibition since its inception. This interest and enthusiasm has been much appreciated.

To gather more than one hundred and twenty sculptures in a variety of media from over seventy lenders in Europe and North America has been an arduous adventure involving assistance from several individuals. In 1981, Dr. Wolf-Dieter Dube, now Director-General, Staatliche Museen Preussischer Kulturbesitz, Berlin, was a Scholar-in-Residence at The Robert Gore Rifkind Foundation in Beverly Hills. During those six weeks, and in the intervening two years, Dr. Dube was unfailingly helpful and encouraging, providing expertise and guidance to this project. Professor Peter W. Guenther, University of Houston, in addition to being a contributor to the catalogue, has been an exceptional colleague; he has reviewed manuscripts and translations and made many valuable conceptual suggestions. Karin Breuer, my able research assistant, smoothly coordinated the graphic works in the show and collaborated on the checklist. The staff of The Rifkind Foundation over the past three years – Ms. Breuer, Gabrielle Oulette, Tjimkje Singerman, Katherine Jones Isaacson, and Susan Trauger – has been extremely helpful.

In Germany, Dr. Joachim Heusinger von Waldegg, Kunsthalle Mannheim, has been particularly helpful in locating sculptures by lesser-known artists of the twenties and has made many valuable suggestions about the organization of the project, as well as contributing to the catalogue. I also thank Dr. Wolfgang Henze, Campione d'Italia (Lugano), for his assistance in securing works by Kirchner for the exhibition, for opening his Kirchner archives to me for catalogue research, and for his essay on Kirchner's sculpture. Karlheinz Gabler, Frankfurt, generously made available his rich archives on the Brücke artists. Dr. Gerhard Wietek, Director, Schleswig-Holsteinisches Landesmuseum, contributed several essays to the catalogue and made many cogent suggestions concerning the entire project. Dr. Eberhard Roters, Director, Berlinische Galerie, Berlin, has been unfailingly enthusiastic about and supportive of this project. Dr. Siegfried Gohr, Director, Josef-Haubrich Kunsthalle Köln, and our German collaborator on the exhibition, was especially helpful in negotiating with lenders and locating photographs. (Unfortunately, because of their fragile nature, a few important wood and plaster sculptures [by Barlach, Belling, Heckel, Kirchner, Kokoschka, and Emy Roeder] could not be included in this exhibition.)

This presentation has been enriched by conversations and correspondence with each of the contributors to the catalogue and with other individuals, including Thomas Borgmann (Cologne); Dr. Lucius Grisebach (Berlin); France Roussillon (Montargis); Dr. Martin Schwander (Basel); Dr. Heinz Spielmann (Hamburg); and Dr. Beat Stutzer (Chur). Research on the sculpture of Barlach and Kollwitz and the problems of casting took me to Hamburg, Güstrow, and to the H. Noack Foundry, Berlin. For their efforts on my behalf at these various locales, I am indebted to: Hans Barlach, Dr. Hartmut Dietrich, and Dr. Isa Lohmann-Siems (Hamburg); Dr. Ull Eisel (Güstrow); and Dr. Arne Kollwitz, Joachim Segeth, and Bernd Schultz (Berlin). In North America, Louis Danziger (Los Angeles); Professor Albert Elsen (Berkeley); Dr. Naomi Jackson-Groves (Ottawa); and Professor Peter Selz (Berkeley) have willingly shared with me their ideas about the exhibition. Ernst Schurmann (San Francisco) and Richard Schneider (Los Angeles), both of the Goethe Institute, have enthusiastically supported this project.

I would like to thank my colleagues in the Museum who have been of great help over the past three years. Myrna Smoot, Assistant Director of Museum Programs, has been instrumental in coordinating travel arrangements and resolving numerous problems in conjunction with the exhibition and catalogue. Editor Lynne Dean and former Editor Barbara Einzig, under the direction of Coordinator of Publications and Graphic Design Letitia Burns O'Connor and Head Publications Editor Andrea P. A. Belloli, have worked tirelessly with mountains of texts in English and German to produce a unified publication. Jeffrey Mueller responded creatively to the challenge of designing the catalogue. Museum Photographer Larry Reynolds took many of the photographs used in the catalogue, including those on the front and back covers. Colleagues Peter Fusco, Curator of Decorative Arts and European Sculpture, and Scott Schaefer, Curator of European Paintings, have both shared with me their ideas about this exhibition. For the installation, I was fortunate to be able to work with architects Frank Gehry and Greg Walsh; their conception was realized by Jim Kenion, Head of Technical Services, and his able staff. Our Museum Registrar, Renée Montgomery, and her assistant John Passi worked for over a year, often in consultation with conservators William Leisher and Billie Milam, to assure the safe transport of all the works in the exhibition. William Lillys and Lori Starr of the Museum's Education Department have both responded warmly and creatively to this project. My thanks also go to the several individuals who have provided capable translation assistance, including Dr. Hans Wagener, Professor of German, Department of

Germanic Languages, UCLA; Joachim Neugroschel, who provided the excellent translation of the important and difficult excerpt from Einstein's *Negerplastik;* Dr. Alla Hall; and Museum Service Council Assistant Grete Wolf.

In the Department of Twentieth-Century Art, I am grateful for the encouragement of my colleague Senior Curator Maurice Tuchman and to Stella Paul, Curatorial Assistant, who has assisted on the exhibition and catalogue in numerous areas. Ms. Paul also was instrumental in locating the Kirchner sculpture *Female Dancer with Necklace* (cat. no. 60), previously assumed lost. Our former department secretary Cathy Bloome enthusiastically and skillfully managed correspondence with over seventy lenders and a dozen contributors, as well as texts in two languages, with grace and aplomb. It was a special pleasure to work with her. Museum Service Council Volunteer Grace Spencer has also been of great assistance on this project.

The keen interest maintained by colleagues, collectors, and artists in the exhibition has been a source of constant inspiration. I thank all of them for helping to make this assessment of the forgotten sculpture of German Expressionism a reality.

Stephanie Barron
Curator of Twentieth-Century Art

Lenders to the Exhibition

Allen Memorial Art Museum, Oberlin College, Oberlin, Ohio
Arnhold Collection
The Baltimore Museum of Art
Bayerische Staatsgemäldesammlungen, Munich
Berlinische Galerie, Berlin
Brücke-Museum, Berlin
Bündner Kunstmuseum Chur, Switzerland
Conrad Felixmüller Estate, Hamburg
Deutsches Brotmuseum, Ulm, Federal Republic of Germany
Erich Heckel Estate
Ernst Barlach Haus, Stiftung Hermann F. Reemtsma, Hamburg
Titus Felixmüller, Hamburg
Janet and Marvin Fishman
Galleria Henze, Campione d'Italia
Georg Kolbe Museum, Berlin
Gerhard Marcks Stiftung, Bremen
Germanisches Nationalmuseum, Nuremberg
Hamburger Kunsthalle
Paul Rudolph Henning, Berlin
Hessisches Landesmuseum, Darmstadt
Hirshhorn Museum and Sculpture Garden, Smithsonian Institution, Washington, D.C.
Kunsthalle Bielefeld
Kunsthaus Zürich
Kunstmuseum Hannover mit Sammlung Sprengel
Lehmbruck Estate
Reinhard and Selma Lesser
Los Angeles County Museum of Art
The Minneapolis Institute of Arts
Kaspar Müller, Basel
Musée de Peinture et de Sculpture, Grenoble
Museum Folkwang, Essen
Museum für Kunst und Gewerbe, Hamburg
Museum Ludwig, Cologne
Museum of Fine Arts, Boston
The Museum of Modern Art, New York
Nolde-Stiftung Seebüll
Öffentliche Kunstsammlung, Basel, Kunstmuseum and Kupferstichkabinett
The Robert Gore Rifkind Collection, Beverly Hills, California
The Robert Gore Rifkind Foundation, Beverly Hills, California
Gary and Brenda Ruttenberg
The St. Louis Art Museum, Missouri
Collection Scherer, Efringen-Kirchen
Schleswig-Holsteinisches Landesmuseum, Schloss Gottorf in Schleswig
Kamiel and Nancy Schreiner, Amsterdam, The Netherlands
Mr. and Mrs. Henry Sieger
Mr. and Mrs. Nathan Smooke
Staatliche Kunstsammlungen, Kassel, Neue Galerie
Staatliche Museen Preussischer Kulturbesitz, Berlin, Nationalgalerie
Staatsgalerie Stuttgart, Graphische Sammlung
Städtische Galerie im Städelschen Kunstinstitut, Frankfurt am Main
Städtische Museen Heilbronn
Stedelijk Museum, Amsterdam
Tabachnick Collection, Toronto
University of California at Los Angeles, Grunwald Center for the Graphic Arts
Karen Voll
Von der Heydt-Museum, Wuppertal
Wilhelm-Lehmbruck-Museum der Stadt Duisburg
Several anonymous lenders

Contributors to the Catalogue

S.B. **Stephanie Barron**
Curator, Twentieth-Century Art
Los Angeles County Museum of Art

K.B. **Karin Breuer**
Research Assistant, Twentieth-Century Art
Los Angeles County Museum of Art
Curator
The Robert Gore Rifkind Foundation, Beverly Hills

P.W.G. **Professor Peter W. Guenther**
University of Houston

W.H. **Wolfgang Henze**

J.H.v.W. **Joachim Heusinger von Waldegg**

S.L. **Stephan Lackner**

S.P. **Stella Paul**
Curatorial Assistant, Twentieth-Century Art
Los Angeles County Museum of Art

D.S. **Dr. Dietrich Schubert**
Professor of Art History
University of Heidelberg

M.U. **Professor Dr. Martin Urban**
Director
Nolde-Stiftung Seebüll

G.W. **Professor Dr. Gerhard Wietek**
Schleswig-Holsteinisches Landesmuseum, Schleswig

Notes to the Reader

For each object in this exhibition, the following information has been supplied when available or appropriate: title in English and German, date of execution, casting date, medium, edition number, dimensions, lender, catalogue raisonné reference, inscriptions, and foundry marks. Subtitles of works are indicated following a colon, and alternative titles are indicated following a slash. Dimensions are given with height preceding width preceding depth, unless otherwise indicated; abbreviations have been used as follows:

b.	- back	l.b.	- lower back
b.l.	- back left	l.l.	- lower left
b.r.	- back right	l.r.	- lower right
f.	- front	r.	- right
l.	- left		

The catalogue entries are arranged chronologically.

A general Bibliography appears at the end of the book, followed by individual Bibliographies for each of the artists featured in the exhibition. In selecting works for inclusion, emphasis was placed on oeuvre catalogues and on books which themselves contain extensive bibliographies. Citations appear in short form in the footnotes, using the author's last name (or the institution's name in the case of exhibition catalogues produced by museums or galleries) and the date of publication. For complete information, the reader should consult the Bibliography for the artist in question; the general Bibliography (if a single asterisk follows a work cited in short form); or the extensive Kirchner Bibliography (if a short citation is followed by two asterisks).

A gray background is used throughout the catalogue to distinguish articles and photographs originally published during the Expressionist period. Comparative photographs of objects not included in the exhibition are also set against a gray background. Photographs appearing in the Documentary Section of the catalogue are not necessarily those that were used to illustrate the essays or texts as they were originally published.

Frontispiece:
Heckel
The Wood-Carver: Portrait of E.
L. Kirchner (Der Holzschnitzer:
Bildnis E. L. Kirchner), 1948
Lithograph
30 x 30 cm.
(11¾ x 11¾ in.)
The Robert Gore Rifkind
Foundation, Beverly Hills,
California
Dube, 331

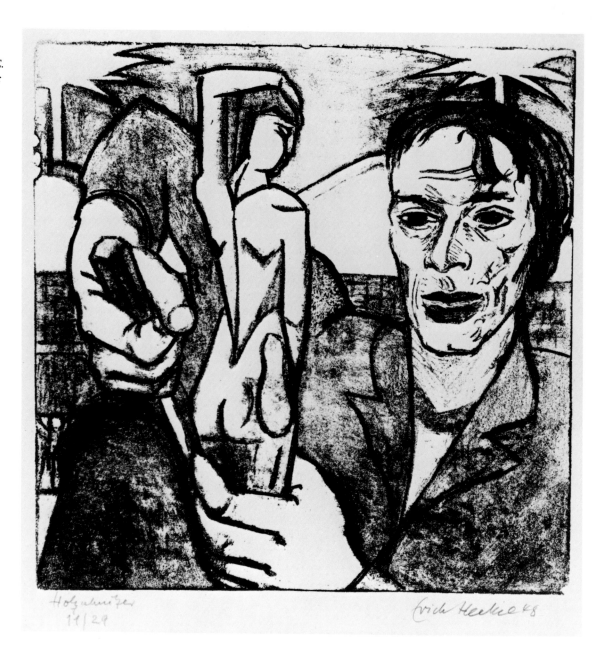

German Expressionist Sculpture: An Introduction

Stephanie Barron

German Expressionist sculpture occupies a distinguished place in the history of modern art. However, except for the work of two well-known German sculptors–Wilhelm Lehmbruck and Ernst Barlach–the significance, and in fact the very existence, of this body of work created in the first third of the twentieth century are largely unrecognized. It is the aim of the current exhibition and catalogue to begin to rectify this art historical oversight. More than one hundred and twenty examples of German Expressionist sculpture by thirty-three artists are presented, together with thirty related works of art on paper. Included are sculptures by artists recognized for their work in this medium–Ernst Barlach, Wilhelm Lehmbruck, Georg Kolbe, Renée Sintenis, Gerhard Marcks–as well as sculpture by such figures as Käthe Kollwitz, Ernst Ludwig Kirchner, Erich Heckel, Karl Schmidt-Rottluff, Emil Nolde, Max Beckmann, Egon Schiele, and Otto Freundlich, whose reputations are based on their painting and graphic oeuvres. A significant number of works by lesser-known artists, who belonged to the second generation of Expressionism in the twenties– among them Herbert Garbe, Conrad Felixmüller, Paul Rudolf Henning, William Wauer, and Christoph Voll– are also examined. Included in the catalogue are examples of the artists' rich and varied writings as well as evaluations by contemporary critics, scholars, writers, and poets. Seven essays and excerpts from contemporary texts, published in translation for the first time, highlight the German Expressionists' concern with particular materials and their attraction to African and Oceanic art. They also indicate the seriousness and passion with which the artists and writers of this movement addressed issues of importance to themselves and their art in the teens, twenties, and thirties.

THE GERMAN EXPRESSIONIST MOVEMENT IN EUROPE

The coming of age of modern art can be traced to the second decade of this century, when Cubism, Futurism, the Russian avant-garde, Dada, Surrealism–and German Expressionism–emerged simultaneously in France, Italy, Russia, Switzerland, and Germany. The German Expressionist, Russian avant-garde, and Surrealist movements were not limited to individual styles or media. Rather, they encompassed breakthroughs in painting, sculpture, printmaking, film, theater, design, architecture, and especially in literature. Frequently artists collaborated or experimented in different areas; painters and sculptors wrote plays and designed for the film or theater. German Expressionism was therefore more than a style. Emerging at a time of great cultural, economic, social, and political flux, it reached maturity by the years of the First World War, attaining its height in the teens and during the Weimar Republic before coming to an end as a movement by the mid-twenties.

The Expressionist era was one of great experimentation, excitement, and energy involving participants in major German cities such as Berlin, Dresden, Munich, Hamburg, and Cologne, as well as in isolated towns–Worpswede, Güstrow, Lübeck, and Seebüll. The movement encompassed the work of many non-German artists, including the Austrians Oskar Kokoschka and Schiele and the Swiss Hermann Scherer and Albert Müller. It transcended national borders and spread across Europe, finding short- as well as long-term adherents in Belgium, Austria, Switzerland, France, Russia, and Czechoslovakia. Many artists of the period whose work is identified with other stylistic tendencies, such as Cubism or Futurism, or with other centers of artistic activity, created works which would be unimaginable without the model of German Expressionism. Some of these artists, like the Ukranian Alexander Archipenko or the Czechoslovakian Oto Gutfreund, lived briefly in Germany and exhibited there. By including them in this exhibition, we wish to focus attention on those of their sculptures that are infused with an Expressionist attitude.

The development of the German Expressionist movement is not easy to trace in a linear fashion. However, as has been suggested elsewhere,[1] the movement manifested itself in four phases. It began with two artists' groups: Die Brücke (The Bridge) in Dresden in 1905, and Der Blaue Reiter (The Blue Rider) in Munich in 1911. The Brücke was founded by four young architecture students, Ernst Ludwig Kirchner, Karl Schmidt-Rottluff, Erich Heckel, and Fritz Bleyl, whose interests had turned to art. Influenced by Edvard Munch, Paul Gauguin, and Vincent van Gogh, they sought in their own work a new freedom of expression. A manifesto they wrote proclaimed their intense passion for art and their burning desire to free themselves from the conventions of established society; these artists sought to establish a "bridge" to the future. They were extremely prolific, both in painting and in the graphic arts–most especially, in the making of woodcuts. The four original Brücke artists invited others to join them; Nolde, Otto Mueller, and Max Pechstein were affiliated with the group for intermittent periods.

Although most of the Brücke artists experimented with sculpture, only Kirchner and Heckel executed any three-dimensional work while the group was together. The studios of Brücke members, first in Dresden and then in Berlin, where they lived from 1911 until their formal dissolution in 1913, were decorated extensively with carved furniture, exotic wall paintings, and many hand-colored and painted objects. These objects, called *Kunsthandwerk*, were made for personal or family use (fig. 1, p. 14). Much Brücke carving was initially intended for private use and generally was not exhibited during the artists' lifetimes. Perhaps for this reason, Brücke sculpture is, for the most part, an aspect of its members' oeuvres unknown in the United States.

Der Blaue Reiter, the other artists' group linked to the first phase of German Expressionism, was founded in Munich in 1911 by Franz Marc and Wassily Kandinsky, both of whose work was in the process of

||
1. Peter Guenther in Sarah Campbell Blaffer Gallery, 1977, p. 7ff.*

Fig. 1
Kirchner, *Mirror of the Four Times of Day* (cat. no. 70), c. 1923.

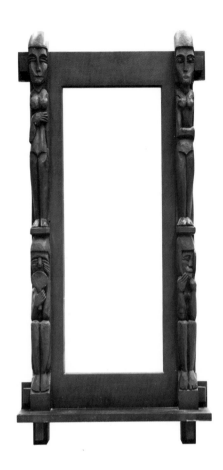

Fig. 2
Photograph by Kirchner, autumn 1924, showing a group of sculptures by Scherer: from left to right, *Lovers* (cat. no. 114); *Mother Nursing Child* (cat. no. 117); *Mother and Child (Mutter und Kind)*, c. 1924, wood, Kunstkredit Basel. At center right is Kirchner's *Two Friends (Die Zwei Freunde)*, c. 1924–25, wood, Kunstmuseum Basel.

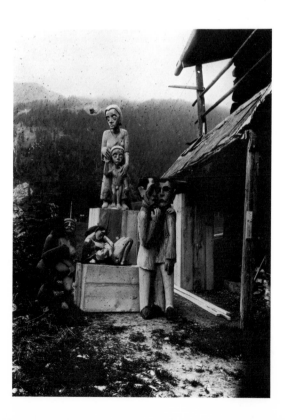

evolving toward nonobjectivity. In 1912, they coauthored an almanac, *Der Blaue Reiter*, one of the most important publications of modern art. This anthology included articles on art, music, and theater and was illustrated with images of contemporary, Romanesque, Gothic, and Renaissance art, as well as non-Western and folk objects. While the Brücke artists were greatly impressed by the non-Western art they saw in museums in Dresden and Berlin and created their own environments to evoke it, Der Blaue Reiter responded differently. An article in the almanac discussed masks, and the publication also included photographs of many examples of African, Oceanic, and Pre-Columbian art. However, none of the Blauer Reiter artists created a significant body of sculpture. Marc and August Macke each created a few modest three-dimensional pieces, and many of the members of Der Blaue Reiter carved *Kunsthandwerk* for private use. Therefore, Der Blaue Reiter falls outside the perimeters of this exhibition.

The second phase of German Expressionism was marked by the artists' anticipation of, involvement in, and response to the First World War. These artists approached the War with great zeal at first and with tremendous confidence in Germany's cause; the War was welcomed as a way to bring about a new social order. There was shock, frustration, and outrage as events unfolded, however, and the German Expressionist artists in particular mounted fervent calls for peace, both in their art and in the journals they sponsored. Some found the hostilities unbearable and ultimately fled Germany. For example, following a nervous breakdown in Berlin, Kirchner moved to Switzerland in 1918 and settled in Frauenkirch, near Davos. In 1923, when the Kunsthalle Basel mounted a large exhibit of Kirchner's work, a group of young local artists responded enthusiastically. Several of them, including Albert Müller and Hermann Scherer, decided to devote themselves to the ideals of the Brücke. With the latter as their model, they formed a group called Rot-Blau (Red-Blue). Beginning in 1923, Müller and Scherer visited Kirchner in the mountains and started to experiment with wood carving (fig. 2, p. 14).

The impact of the War and its aftermath on artists in Germany was enormous and brought about the third phase of German Expressionism. At the end of the hostilities, the Expressionists were united in their struggle against the official regime. A period of exuberant experimentation and interaction among media ensued. Participants in the movement felt strongly that only art could humanize a brutal world situation. On the heels of the revolutions in Russia and Germany, a number of Expressionists joined one of several of the short-lived radical artists' groups in Berlin—the Novembergruppe (November Group) and the Arbeitsrat für Kunst (Workers' Council for Art)—or in Dresden—the Dresden Sezession: Gruppe 1919 (Dresden Secession: Group 1919). These associations sponsored a number of political and artistic activities and exhibitions. The Novembergruppe, founded by former Brücke member Pechstein in 1918, declared itself a

group of radical artists and had as its motto "Liberty, Equality, Fraternity." Its members strove for harmony among the Expressionists, Cubists, and Futurists in Berlin.

Many second-generation German Expressionists who were members of these groups, including Oswald Herzog, Rudolf Belling, Freundlich, Garbe, Gela Forster, and Emy Roeder, flirted with abstraction during this period, seeking to integrate it with the expressiveness in their own work, thus providing their three-dimensional pieces with a new-found tension. The motivating influence on the work of the November-gruppe and the Arbeitsrat für Kunst was the sculpture of Archipenko. As early as 1910, Archipenko's work had been based on a rhythmic handling of positive and negative space, light and shadow, and a dissolution of the human figure in Cubist-like faceted planes. Archipenko subordinated the evocative figure to the principle of rhythmic, dynamic form (fig. 3, p. 15, and cat. no. 2).

In 1918, the influential Berlin dealer and publisher Herwarth Walden mounted an exhibition of Archipenko's work at his Galerie Der Sturm. It greatly impressed a number of sculptors who had begun to emphasize reductive qualities in their work, which tended toward abstraction. In the same year, Walden published a small pamphlet, *Der Sturm: Eine Einführung (Der Sturm: An Introduction)*, in which he attempted to divide the achievements of German Expressionism into separate sections – painting, sculpture, poetry, and music. In his discussion of sculpture, he described the expressive yet abstract style which would become characteristic of work of the twenties:

> Expressionist sculpture...attempts no longer to imitate forms in nature, but instead to create abstract images. Just as painting uses the surface as material for artistic representation, sculpture has the body shape as prerequisite. This shape, however, lies not in the imitation of nature, but in the relationship between the individual sculptural forms.[2]

The sculpture of some members of the November-gruppe (Garbe, Belling, and Herzog) was clearly an extension of Archipenko's principles and translated his constructed forms into "Expressionist abstractions." In Garbe's *Sleep/Lovers* (fig. 4, p. 15, and cat. no. 40), for example, the recognizable form of a man in repose was transformed into essential abstract and rhythmical shapes. An emphasis on voids as integrating elements in sculpture and on the expressive gesture combined with a Futuristic dynamic of form is apparent in work by Belling and Freundlich, both extant and destroyed.[3]

After the War, Dresden, which a decade earlier had been the home of the Brücke artists, saw the birth of

||

2. Walden, [1918], unpaginated.*

3. This new trend was particularly suited to interpretations of another new art form – modern dance. The expressive movements of Mary Wigman, Isadora Duncan, Loie Fuller, and Martha Graham inspired many sculptors during the twenties.

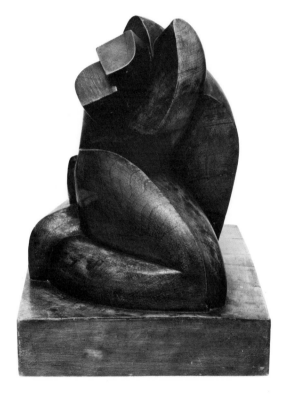

Fig. 3
Archipenko, *Kneeling Couple in Embrace* (cat. no. 2), 1911–14.

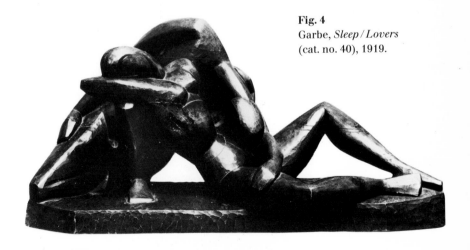

Fig. 4
Garbe, *Sleep/Lovers* (cat. no. 40), 1919.

Fig. 5
Voll, *Nude, Ecce Homo*
(cat. no. 146), 1924–25.

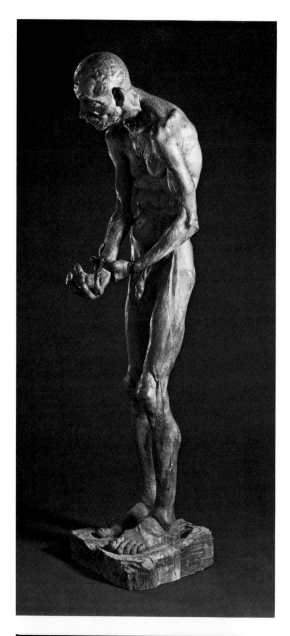

Fig. 6
Gela Forster (German,
1892–1957)
Conception (Empfängnis)
Stone
Lost

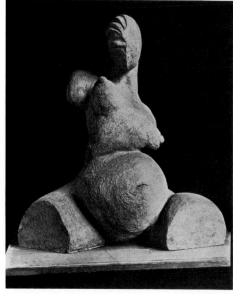

the short-lived Sezession: Gruppe 1919, which included among its ranks two important sculptors, Christoph Voll and Gela Forster, and the painter and graphic artist Conrad Felixmüller, who created a small sculptural oeuvre. Voll, a prolific sculptor, was attracted by the inherent power of wood. His rough, unrestrained, striking human figures convey strong emotion. At the beginning of his career, Voll worked with wood by hacking away at the surface, thus imparting a characteristic brutality to his pieces. A few large works, including the life-size *Nude, Ecce Homo* (fig. 5, p. 16, and cat. no. 146), attest to Voll's technical mastery. The old man depicted in this latter sculpture – a universal figure accusing the society he confronts – directly and emotionally affects the viewer. This remains one of the most memorable works of German Expressionism. Many years later, Gerhard Marcks remembered: "He [Voll] died very young and was certainly one of our best sculptors."[4]

Gela Forster married Archipenko in 1922, and worked in Dresden and Berlin before emigrating to America a year later. Unfortunately, her entire sculptural oeuvre from the early twenties has disappeared; it is known today only through photographs of three sculptures and contemporary accounts.[5] In 1919, Forster exhibited *Man* (figs. 4 and 5, p. 33), *Conception* (fig. 6, p. 16), and *Awakening* (figs. 2 and 3, p. 32) with the Sezession: Gruppe 1919. At the time, well-known critic Theodor Däubler wrote of *Man:* "The entire sculpture climaxes in a cry."[6] Forster's *Conception*, a monumental work in stone, recalls the Venus of Willendorf, a type of figure that recurs in German Expressionist works, conveying without excessive detail the feeling of a swollen, full, fecund body. Forster's sculpture, like much of the postwar work discussed above, combined diverse elements into a kind of abstract emotionalism.

By the mid-twenties, German Expressionism had ceased to be a viable movement, although individual artists continued to work in an Expressionist mode. A number of other styles had begun to achieve widespread recognition, including Dadaism, Constructivism, and Neue Sachlichkeit (New Objectivity), which made its appearance in the famous exhibit of 1925 in Mannheim. By this time, the Bauhaus, the most influential modern art school, was actively pursuing a direction which emphasized architecture and technology and showed little tolerance for the Expressionistic impulse. By the time the National Socialists came to power in 1933, German Expressionism as a movement was already over. Due to the Nazis' systematic proscription, harassment, and defamation of modern art and their ultimate destruction of numerous objects, artists who previously had been popular and lauded

4. Letter from Gerhard Marcks to Peter Guenther dated March 27, 1979.

5. See translation of Däubler's article "Gela Forster" in this catalogue, pp. 30–33; and Alfred Günther, "Vor Bildwerken von Gela Forster," *Menschen: Buch-Folge Neuer Kunst*, vol. 2, no. 37, May 4, 1919, p. 1.

6. Däubler, op. cit., p. 30 of this catalogue.

were suddenly prohibited from exhibiting and working and found their art removed from public display. Thus, during Expressionism's fourth phase, the Nazis confiscated hundreds of paintings, sculptures, and prints from public collections. In 1937 in Munich, for example, over seven hundred works of art by Nolde, Kirchner, Heckel, Kokoschka, Beckmann, Schmidt-Rottluff, Kandinsky, and dozens more were collected in the infamous *Entartete Kunst (Degenerate Art)* exhibition and documented in the accompanying catalogue (figs. 7 and 8, p. 17). Any discussion of German Expressionism therefore must rely heavily on contemporary documentation of the many important works of art which were destroyed by the Nazis or lost in the Second World War.

CHARACTERISTICS OF EXPRESSIONIST SCULPTURE

Although German Expressionist sculptures were created during several decades by many artists in a wide variety of circumstances, some general characteristics may be established. Expressionism, it has been suggested by Ivan Goll, was "a belief, a conviction."[7] These sculptures seek to make visible the inner experience of humanity. They focus on the human image and on human psychology, evoking a specific political and social context, projecting a bitter reaction against existing conditions and expressing utopian ideals. Frequently such sculptures possess bold colors and rough outlines; the forms are elongated and stretched to their limits or hewn from found wood. German Expressionist sculpture conveys an emotionally charged handling of subject matter. It demands an empathetic response from the viewer. Gesture is emphasized over restraint, resulting in unconventional forms which convey an excess of feeling.

Like many other artists of the early twentieth century, the German Expressionists maintained a keen interest in the inherent properties of materials and strove to interrelate subject matter with the most evocative and appropriate media. They shared with other modernists a respect for the power of non-Western art, seen in growing museum collections or while travelling. Much of their sculpture is imbued with the direct, evocative strength they admired in such objects. For the most part, German Expressionist sculpture was carved or cast rather than modeled and polished. The image is either blocklike—its formal definition integral with the shape of the original material—or it is distorted, as if trying to escape the confines of the medium. Much of this sculpture is monumental, if not in scale then in the feeling it imparts.

The fact that the German Expressionist era was closely tied to the nationalistic hopes and final anguish of the First World War is clear from the use of titles like *Fear, Hunger, Anger, Despair,* and *Mourning,* or *The*

||

7. In an article written on the "death" of Expressionism for the Yugoslavian journal *Zenit,* vol. 1, no. 8, 1921, p. 9, Goll stated: "Expressionism was not the name of an artistic form, but that of a belief, a conviction. It was much more a sense of a worldview than the object of an artistic endeavor."

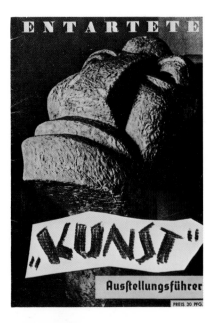

Fig. 7
Cover of *Entartete Kunst (Degenerate Art)* exhibition catalogue, 1937, with Freundlich's *New Man (Die neue Mensch),* 1912, plaster *(Gips)*; destroyed.

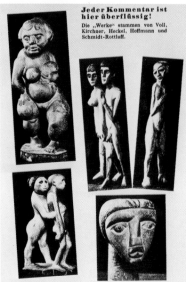

Fig. 8
Page 19 of *Entartete Kunst* exhibition catalogue, showing (clockwise from left) works by Voll, Kirchner, Heckel, Schmidt-Rottluff, and Eugen Hoffmann.

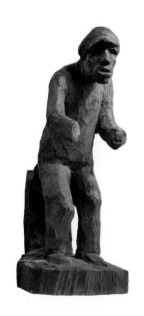

Fig. 9
Voll, *The Beggar* (cat. no. 143), c. 1923.

Fig. 10
Pablo Picasso (Spanish, 1881–1973)
Head of a Woman, 1909
Bronze
41 × 23.5 × 25.1 cm.
(16⅛ × 9¼ × 9⅞ in.)
Los Angeles County Museum of Art, Gift of Mr. and Mrs. Nathan Smooke in Memory of Joseph and Sarah Smooke and Museum Purchase with Funds Provided by Mr. and Mrs. Jo Swerling, Mrs. Harold M. English in Memory of Harold M. English, and Mr. James Francis McHugh
78.6

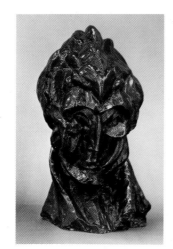

Fig. 11
Auguste Rodin (French, 1840–1917)
The Walking Man, 1877
Bronze
84.5 × 42.5 × 55.5 cm.
(33¼ × 16¾ × 21⅜ in.)
National Gallery of Art, Washington, D.C., Gift of Mrs. John W. Simpson, 1942

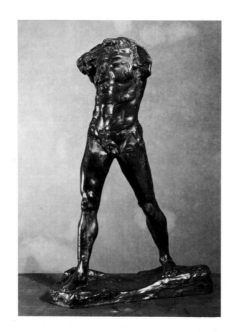

Fig. 12
Lehmbruck
Standing Female Figure, 1910
Bronze
191.2 × 54 × 40 cm.
(75¼ × 21¼ × 15¾ in.)
National Gallery of Art, Washington, D.C., Ailsa Mellon Bruce Fund, 1965

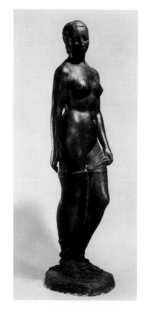

Avenger, The Ecstatic One, and *The Beggar* (fig. 9, p. 17, and cat. no. 143). The artists' reaction to and interest in probing the psyches of their subjects also led many of them to create piercing portraits and self-portraits. Frequently these were larger than life, with attention fixed on the face as the greatest signifier of human expression. Spiritual themes—the inner turmoil of man, the expression of external chaos, or even specifically religious content—were extremely important. Some of the most moving German Expressionist works are modern interpretations of traditional themes—the Crucifixion, Pietà, *Ecce Homo,* or representations of figures such as Job or St. Sebastian. The introduction of Medieval and Renaissance iconography into a contemporary context lent such sculpture a compelling intensity and rooted it firmly in traditions of Northern European art.

GERMAN EXPRESSIONIST SCULPTURE AND MODERN ART

Masterpieces in sculpture were produced in all the major modernist styles—Cubism, Futurism, Constructivism, Dada, and Surrealism. However, none of these styles engendered a large body of work in three dimensions. The Cubists, for example, searched for a new pictorial fusion of mass and void in the representation of objects in space. A "cool," cerebral style of lines and shapes rendered in a monochromatic palette, Cubism is essentially an art of two dimensions. Only a few significant examples in sculpture exist, such as Picasso's *Head of a Woman,* 1909 (fig. 10, p. 18). The tangible quality of sculptural materials actually denies the ambiguous nature of Cubist images.[8] By contrast, the German Expressionist idiom could be rendered successfully in plastic terms: the love of raw materials, the exaggerated gestures, the concentration on psychological and spiritual themes, and the pure, unbridled energy characteristic of German Expressionist painting and graphics lent themselves well to sculpture.

Although it is commonly held that modernism in sculpture began with Rodin in Paris at the end of the nineteenth century, it is significant that one of the two earliest—and most important—German Expressionist sculptors, Ernst Barlach, studied in Paris around the turn of the century but was unmoved by Rodin. Instead, he was attracted to French artists of an earlier period—Jean François Millet, Constantin Meunier, and Theophile Steinlen—whose images of workers and peasants appealed to his sensibility. On the other hand, for Wilhelm Lehmbruck, the other early German Expressionist sculptor, Rodin was a nemesis. Lehmbruck was aware of the French artist's *Thinker* and *Walking Man* (fig. 11, p. 18) as antecedents for the twentieth-century sculptor's exploration of modern man as his spiritual mirror image. It was not until

8. Douglas Cooper, *The Cubist Epoch,* New York: Phaidon Books, 1970, pp. 231–62; Fred Licht, *Sculpture – 19th and 20th Centuries,* New York: New York Graphic Society, 1967, pp. 40–42; Robert Rosenblum, *Cubism and Twentieth Century Art,* New York: Harry N. Abrams, Inc., 1961, pp. 262–68.

Lehmbruck actually confronted Rodin's work that he was able to free himself from the French sculptor's influence and to create his own wholly original sculptures. In breaking free from the Academic tradition, Lehmbruck began, around 1910, to create a new kind of sculpture, as seen in the *Standing Female Figure* (fig. 12, p. 18),[9] which he exhibited in the 1910 *Salon d'Automne*. He experimented with subjecting the human body to a recombination of individual parts to provide an evocative silhouette. At the 1912 *Berlin Secession* exhibition (and in the *Armory Show* in New York the following year), Lehmbruck exhibited *Kneeling Woman* (fig. 13, p. 19) in which the full, round forms of earlier sculpture were replaced by elongated, mannerist lines. Lehmbruck rejected the traditional modulated, articulated surface in favor of essential forms and simple, attenuated gestures to convey meaning.

EXPRESSIONIST THEMES: THE WAR

As we have seen, the First World War initially was greeted with anticipation and pride. Many German artists served in the military, some on the front lines, others in the medical corps; some, including Franz Marc and August Macke, were killed. At the end of the War, Lehmbruck committed suicide. In the first few months of fighting, the Expressionist Barlach felt burning patriotism. His supreme war image is *The Avenger* (originally called *Berserker*) (fig. 14, p. 19, and cat. nos. 9 and 10), which represents a German patriot surging forward in his attack on the Allies, his movement checked only by the sword he holds over his head and back. By comparing the lithograph of the figure in *The Avenger*—entitled *The Holy War* and published in the periodical *Kriegszeit (Wartime)* (fig. 15, p. 19, and cat. no. 11)—with the sculpture, we can understand how Barlach himself saw this figure—a looming, powerful, larger-than-life-size hero. As he wrote:

> I have been at work on my storming *Berserker [The Avenger]* and it begins to be important to me. Could it be possible that a war is being waged and I forget it over a hundred-pound image of clay? To me this *Berserker* is the crystallized essence of War, the assault of each and every obstacle, rendered credible. I began it once before but cast it aside because the composition seemed to burst apart. Now the unbearable is necessary to me.[10]

Barlach's figures of this period are highly compact and emotionally charged with extraordinary purpose.

If young German artists approached battle with the zeal and fervor of Barlach's *Avenger,* they returned, if

9. National Gallery of Art, Washington, D.C., *The Art of Wilhelm Lehmbruck,* exh. cat., New York: The MacMillan Company, 1972, p. 20.

10. Naomi Jackson Groves, *Ernst Barlach: Life in Work: Sculpture, Drawings, and Graphics; Dramas, Prose Works, and Letters in Translation,* Königstein im Taunus: Karl Robert Langewiesche, [1972], p. 69. See entry of September 5, 1914.

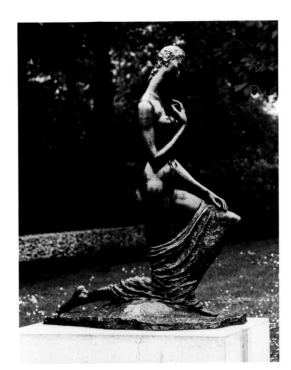

Fig. 13
Lehmbruck
Kneeling Woman, 1911
Bronze
175 × 68.5 × 138.5 cm.
(68⅞ × 30 × 54½ in.)
Wilhelm-Lehmbruck-Museum der Stadt Duisburg

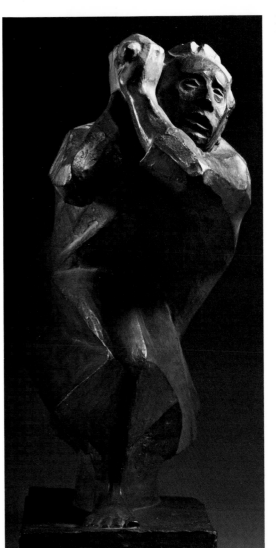

Fig. 14
Barlach, *The Avenger*
(cat. no. 9), 1914.

Fig. 15
Barlach, *The Holy War*
(cat. no. 11), 1914.

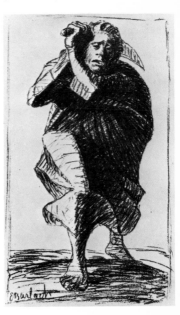

Fig. 16
Lehmbruck, *The Fallen Man*
(cat. no. 91), c. 1915–16.

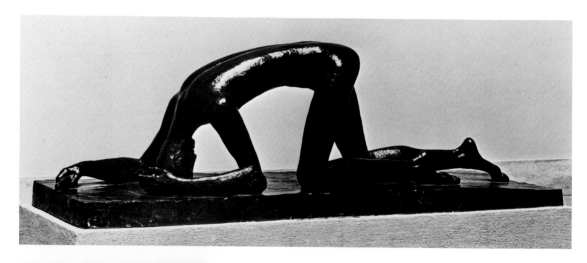

Fig. 17
Lehmbruck
*Seated Youth (Sitzender
Jüngling)*, c. 1916–17
Cast cement
Städelsches Kunstinstitut,
Frankfurt

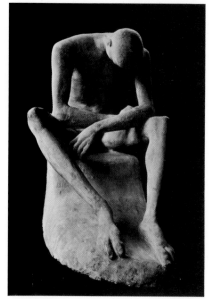

Fig. 18
Kollwitz
*Memorial: The Parents
(The Mother) (Denkmal: Die
Eltern [Die Mutter])*, 1924–32
Stone
h: 122 cm. (48 in.)
Eessen near Diksmuide,
Belgium

Versions of both *The Mother*
and its pendant, *The Father,*
executed in the workshop of
Ewald Mataré in 1954, are in
the Church of St. Alban,
Cologne.

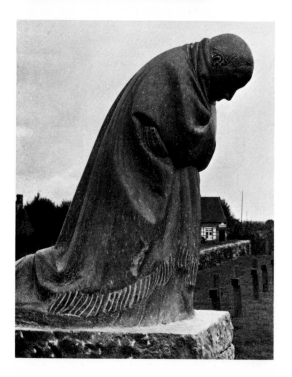

at all, desolate, lonely, and defeated; if Barlach's fig-
ures signal the high point of early hope and nationalis-
tic pride in the War, Lehmbruck's *Fallen Man* (fig. 16,
p. 20, and cat. no. 91) and *Seated Youth* (fig. 17, p. 20;
cf. cat. no. 92) represent the spiritual and moral col-
lapse felt by the War's end. When art historian Paul
Westheim, who was also Lehmbruck's first biog-
rapher, returned home from the front on leave in 1916,
he saw *The Fallen Man* for the first time:

> A fallen youth is depicted, cramped in his collapsed
> position....What we see is a young warrior who
> somehow in the force of the charge...received that
> little piece of lead which has torn him down. But this
> is a death which the body is resisting. The body
> reacts and accuses, and screams, and refuses to
> accept the fact of its end. The head, beating down
> between the shoulderblades like fire slung from the
> cannon, bores into the ground in despairing help-
> lessness, as if protection could be found from the
> death being spewed forth that day....A weapon, a tool
> of death now becomes useless, drops from his hand.
> For once again the world has collapsed, a world
> filled with love, filled with activity, filled with happi-
> ness, a world whose focal point had been this hero.
> There are no soft lines, no melting surfaces in this
> body. Even in the form there is groaning and grating
> and oppression.[11]

By 1917 many of Lehmbruck's friends—both Ger-
man and French—had not returned from the War; he
himself had moved to Switzerland, overcome by the
catastrophe. The *Seated Youth,* perhaps a self-portrait
or a generalized portrait of his artist friends, mourns
for an entire generation. It and *The Fallen Man,* so
totally unlike traditional sentimental or triumphant
memorial sculpture, depict suffering, despair, and the
mourning, rather than the celebration, of victory.

Like Lehmbruck, Käthe Kollwitz also created a
significant war memorial: the large stone sculpture of
a kneeling mother and father for the cemetery in

‖‖
11. National Gallery of Art, Washington, D.C., 1972, op. cit.,
pp. 29–30.

Eessen near Diksmuide in Belgium (fig. 18, p. 20). Kollwitz was an intense pacifist who felt strongly about the human predicament and who experienced great anguish at the death of her son in the War. Several of her most powerful graphic and sculptural works, including *Tower of Mothers* (fig. 19, p. 21, and cat. no. 86) and the related cycle of seven woodcuts, *The War* (fig. 20, p. 21, and cat. no. 82), are eloquent arguments for peace. In the former she decries the conscription of young children into the army; the mothers militantly surround and defend their young. In formal terms this composition owes much to Barlach, whose sculpture and woodcuts influenced Kollwitz from 1917 on. *Tower of Mothers* shares with Barlach's sculptures a dependence on the blocklike form as a basis for its overall definition. Although sculpted in the round, the figures barely project from the confines of the solid mass, seeming instead to merge with one another.

EXPRESSIONIST THEMES: RELIGION AND SPIRITUALITY

Sculptures such as Barlach's *War Memorial for the Güstrow Cathedral* (cat. no. 21), Joachim Karsch's *Job and His Friends* (fig. 24, p. 22; cf. cat. no. 59), Kollwitz's *Pietà* (cat. no. 85), Ludwig Gies' *Crucifixion* (fig. 21, p. 21), Karl Albiker's *St. Sebastian* (fig. 22, p. 22), Voll's *Nude, Ecce Homo* (fig. 5, p. 16, and cat. no. 146), and Ossip Zadkine's *Prophet* (cat. no. 150) all invoke familiar imagery to convey the artists' convictions with respect to contemporary events. The spirituality which these sculptors felt compelled to express was caused by the stress of the period in which they lived but was well within the confines of German tradition. The expressive wooden carvings, especially of religious subjects, produced by Northern Gothic artists of the fourteenth and fifteenth centuries were viewed with renewed interest by the German Expressionists. In adopting wood carving as a technique, they hoped to imbue their own works with a similar spirituality. Barlach, the preeminent and most prolific "modern Gothic," found in this Northern tradition a way to convey many of his most passionate concerns, among which was man's striving towards the spiritual; he believed the human figure to be the "expression of God, insofar as he broods, haunts, and burrows in and behind man."[12]

Several of Kollwitz's sculptures also convey a deep spirituality. Her *Pietà,* permeated with the sorrow of a mother mourning her son, a victim of the War, recalls Renaissance antecedents. Lehmbruck's *Fallen Man* can be seen as a fallen St. Sebastian, one of the most popular figural types of the era. Albiker's disturbing depiction of that saint (fig. 22, p. 22) is an uncanny juxtaposition of Medieval form and modern content. These symbolic martyr figures convey the pathos and intense feelings experienced by the artists during the turbulent War years. Similarly, the Old Testament theme of "Job and His Friends" inspired both Karsch and Zadkine to create full-scale, multi-figure sculptures whose traditional symbolic significance may be

12. Dube, 1972, p. 176.*

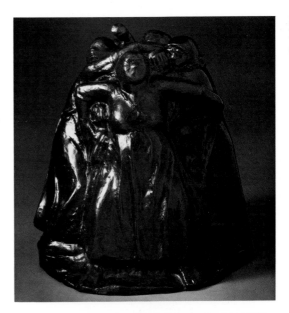

Fig. 19
Kollwitz, *Tower of Mothers*
(cat. no. 86), 1937–38.

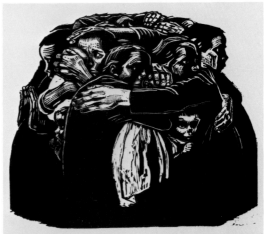

Fig. 20
Kollwitz, *The Mothers: The War*
(cat. no. 82), 1922–23.

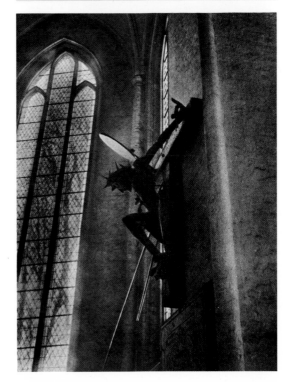

Fig. 21
Ludwig Gies (German, b. 1887)
The Crucifixion
Formerly St. Marienkirche,
Lübeck; destroyed
See also figs. 1–3, pp. 37–39.

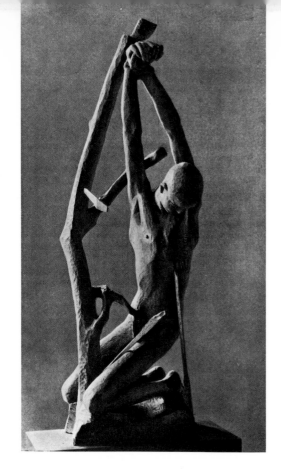

Fig. 22
Karl Albiker (German,
1878–1961)
*St. Sebastian (Der Heilige
Sebastian),* 1920–26
Wood
h: 145 cm. (57⅛ in.)
Staatliche Kunstsammlungen
Dresden, D.D.R.

Fig. 22
Karl Albiker (German,
1878–1961)
*St. Sebastian (Der Heilige
Sebastian),* 1920–26
Wood
h: 145 cm. (57⅛ in.)
Staatliche Kunstsammlungen
Dresden, D.D.R.

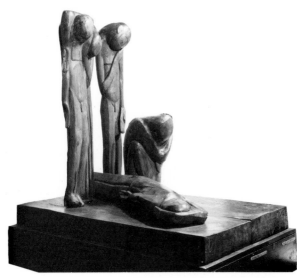

Fig. 23
Zadkine
*Job and His Friends (Hiob und
seine Freunde),* 1914
Wood
h: 123 cm. (48½ in.)
Koninklijk Museum voor
Schone Kunsten, Antwerp

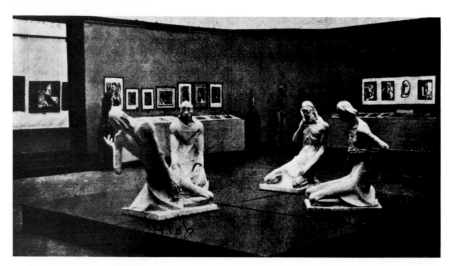

Fig. 24
Installation view of Karsch's *Job
and His Friends (Hiob und seine
Freunde),* 1919, plaster *(Gips),*
published in *Beilage zur
Vossischen Zeitung* (Berlin), no.
16, April 25, 1920, on the occa-
sion of the *Freie Sezession* exhi-
bition. This sculptural group
won the Staatspreis der
Preussischen Akademie der
Künste (State Prize of the
Prussian Academy of Arts).

seen as an extension of the specific anguish and dis-
appointment of the postwar era (figs. 23 and 24, p. 22,
and cat. no. 59). In the Karsch group, the figures
gesticulate and rend their clothes; in the Zadkine they
turn inward, seemingly overwhelmed by their grief.

Perhaps the most moving of all German Expression-
ist religious sculptures was the life-size wood crucifix
created by Ludwig Gies and hung in St. Marienkirche
in the northern city of Lübeck (fig. 21, p. 21).[13] This
sculpture was so disturbingly Expressionistic—with
explicit detailing of wounds and bodily contortion—
that it was immediately vandalized by the townspeople
when it was installed. Subsequently the sculpture was
destroyed entirely. It may seem astonishing that a
contemporary religious work hung in a northern Ger-
man Gothic church in the 1920s could have aroused
people's passions to such an extent. At the time, it was
observed that "it would [have] be[en] hard to find a
symbol that would impress posterity more powerfully
and deeply with the meaning of the World War and its
fallen heroes."[14] By all accounts, the Gies *Crucifixion*
was a masterpiece of carving, which created an
acutely emotional impact.

THE USE OF WOOD AND THE ATTRACTION OF THE "PRIMITIVE"

As previously mentioned, one of the great innovations
of art in this century is to be found in the respect with
which artists have considered the inherent properties
of their materials. The Cubists and Constructivists in-

13. See translation of Heise's "Der Kruzifixus von Gies" in this
catalogue, pp. 37–40.

14. Ibid., p. 39 of this catalogue.

troduced man-made and found objects into their work, thus challenging illusionism, the very basis of earlier representational art. The German Expressionists exploited the natural properties of their materials and regarded their qualities as essential components of a complete aesthetic statement. Stone, clay, and—most importantly—wood particularly suited this aim. Unlike Medieval polychromed and gilded sculpture, in which the variegations of the wood were smoothed over or disguised, its natural form and density are significant aspects of German Expressionist sculpture.

Although many of the sculptures in this exhibition are bronze, it is important to realize that very few of these were cast during the artists' lifetimes. Although Kollwitz and Lehmbruck, for example, obviously intended that their plasters be cast, it is not clear whether, in all cases, artists like Barlach and Karsch wished to have this done. Often due to financial constraints and lack of patronage during their lives, work could only be cast posthumously. Barlach, however, was clearly a wood sculptor first and foremost. When one sees his *Avenger* in bronze, one must keep in mind that the work was done first in clay and plaster (1914), then in wood (1922), and not until after 1930 in a bronze edition, cast at the urging of his dealer, Alfred Flechtheim.

The German Expressionists' particular attraction to wood coincided, in great measure, with their enthusiasm for African and Oceanic art. This interest, characteristic of most modern movements, has been ascribed to the widespread influence of Paul Gauguin and his work and to the attraction for artists of the collections in European ethnographic museums, which had opened at the end of the nineteenth century in many European cities—among them the Völkerkunde-Museum (Ethnographic Museum) in Dresden. A keen public interest existed in this art, fueled by the Völkerkunde-Museum's elaborately illustrated portfolios and catalogues and by several popular publications dealing with African, Oceanic, and Eskimo art. On a formal level, the German Expressionists responded to such objects as inspiration for a great number of their experiments in wood. The formal characteristics of African works that attracted these artists are reflected in the frontal, iconic quality of their wood carvings as well as in the simplified forms of their paintings or the stark definition of their woodcuts.

Among the German Expressionists, it was the Brücke group which had the most intense interest in "primitive" objects. As Leopold Ettlinger has pointed out, these artists were probably most familiar with Oceanic art, since in 1907 the Asian, American, and African collections of the Völkerkunde-Museum were in storage so that the extensive holdings from the South Seas could be shown.[15] The decoration of the Brücke artists' studios was inspired in part by wall paintings from the Palau Islands and other objects that they saw in the museum.

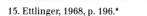

15. Ettlinger, 1968, p. 196.*

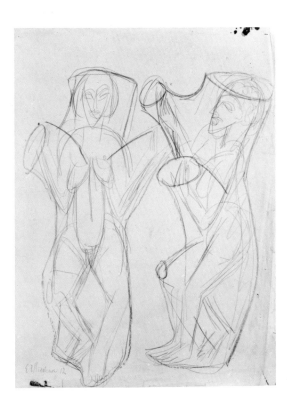

Fig. 25
Kirchner
Sketch for Sculpture (Skizze zu Skulptur), 1912
Pencil and chalk on paper
48.5 × 38 cm.
(19⅛ × 15 in.)
Bündner Kunstmuseum Chur

In spite of the fact that Kirchner wrote in 1913 in his *Chronik der K[ünstler] G[emeinschaft] Brücke (Chronicle of the Brücke Artists' Group)* that he had "discovered primitive art in 1903," he does not seem to have created sculptural works before 1909.[16] Although only he and Heckel made sculpture during the time that the Brücke was together, and plastic work by other artists dates from the later teens, the Brücke members clearly shared an interest in wood, in ethnographic art, and in the rough, unpolished, or uncamouflaged surface.

Kirchner was particularly articulate about the nature of wood carving and the creative process. As early as 1911 he wrote to the Hamburg collector Gustav Schiefler: "It is so good for painting and drawing, this making of figures, it lends wholeness to drawing and is such a sensual pleasure when blow by blow the figure grows more and more from the trunk. There is a figure in every trunk, one must only peel it out" (fig. 25, p. 23).[17] In 1925, Kirchner wrote under the pseudonym Louis de Marsalle in the journal *Der Cicerone* about the importance of working in wood, arguing passionately in favor of direct carving as opposed to bronze or plaster casting.[18] He also was keenly aware of the properties of various woods. In 1911 he wrote to

16. E. L. Kirchner, 1913, translated in Chipp, 1973, p. 174–78.**

17. June 27, 1911, letter to Schiefler; see essay by Henze in this catalogue, p. 114.

18. See translation of Kirchner's [de Marsalle's] "Über die plastischen Arbeiten E. L. Kirchners" in this catalogue, pp. 43–46.

Fig. 26
Schmidt-Rottluff, *Red-Brown Head* (cat. no. 124), 1916–17.

Fig. 27
Schmidt-Rottluff
Mother (Mutter), 1916
Woodcut
41.3 × 32.4 cm.
(16¼ × 12¾ in.)
The Robert Gore Rifkind Collection, Beverly Hills, California

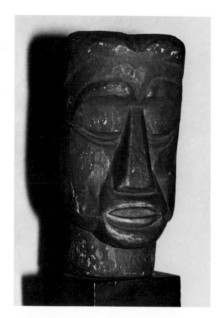

Fig. 28
Head
Benin (Nigeria)
Terracotta
14.2 × 9.3 × 12.1 cm.
(5½ × 3½ × 4¾ in.)
Seattle Art Museum, Katherine White Collection
81.17.497

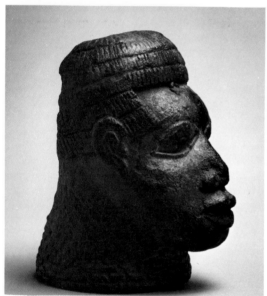

Fig. 29
Pechstein
Moon (Mond), 1919
Wood
h: 105 cm. (41⅜ in.)
Destroyed

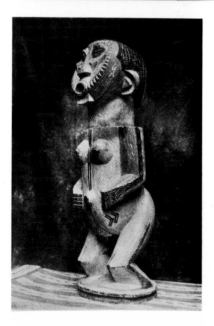

Schiefler: "The maple wood that you sent us lends itself well to being worked; it has such short fibers and is, as a whole, completely homogenous. One is tempted to polish it."[19]

Heckel, cofounder of the Brücke in Dresden, carved most of his sculptures from soft, easily manageable wood, such as linden, birch, poplar, and acacia. His sculptures appear to have been inspired either by ethnographic works or by the Gothic. They range from contorted, crudely carved nudes to softly modeled, taut female figures. All physiognomic articulation of these modern madonnas relates to the single, vertical tree trunk, the origin of the sculpture. Like fifteenth-century church figures, they are often covered in opaque colors. Although Heckel stopped carving by 1920, he remained fascinated by ethnographic sculpture, collected it, and used it as a motif in his later paintings and prints. His enthusiasm for carved figures (if only for slightly over a decade) seems to have encouraged other artists to explore the medium.[20]

Brücke member Schmidt-Rottluff's carvings were largely executed around 1917, several years after the group disbanded. Most are blocklike, swiftly hewn, and more frontal and masklike than sculptures by Kirchner or Heckel (fig. 26, p. 24). These carvings and related woodcuts (fig. 27, p. 24) drew their subjects entirely from the artist's imagination, but they reflect strong inspiration from Benin and other African art (fig. 28, p. 24). Brücke member Emil Nolde actually traveled to the South Seas in 1913 and carved a small number of figures from the firewood he found on board ship. These figures possess strong resonances of the original shapes of the wood fragments. Although his predecessors or contemporaries had begun to make wood carvings inspired by what they saw on their artistic explorations, Nolde did no such sculp-

||

19. See essay by Henze in this catalogue, p. 114.

20. See essay by Wietek on Heckel in this catalogue, pp. 92–93.

tural work while on the Islands, although he did create a great number of paintings, prints, and watercolors which vividly reflect his South Sea observations.

Of the Brücke artists with a significant sculptural oeuvre, Pechstein stands somewhat apart from the others. His output must have numbered over twenty works, although all but a few have been lost. In 1914, perhaps under the influence of Gauguin and of his fellow Brücke artists' attraction to non-Western cultures, Pechstein and his wife set off for the Palau Islands. The group of wood carvings (fig. 29, p. 24) that resulted from this trip is directly related to non-Western prototypes. They bear the mark of direct observation of Oceanic peoples and their ritual carvings; in fact, Pechstein used local carving tools, and many of his works share titles with the works which inspired them.[21]

THE PORTRAIT

One of the favored subjects of the German Expressionist sculptor was the portrait head, which could communicate in a highly condensed way all the expressive and psychological attitudes he wished to convey. Even artists who did no other plastic work, such as Otto Dix (fig. 30, p. 25), Kokoschka, and Schiele, were intrigued with portrait sculpture. Kokoschka's *Self-Portrait as a Warrior* (fig. 31, p. 25), done early in his life, remains one of the strongest statements of German Expressionist self-portraiture in sculpture.[22] It reflects Schmidt-Rottluff's belief in "...the head...[as] the gathering point of the whole psyche, of all expression."[23] The Expressionists' approach to the portrait differed from that used by earlier artists; instead of concentrating on commissioned or commemorative likenesses, they chose themselves and their friends – artists, writers, critics, dealers – as subjects, or selected literary figures (Hamlet, Don Quixote) whose troubles and concerns mirrored the chaotic feelings and problems of their own era. In these portraits, most of which were cast in bronze, individual characteristics were emphasized. The most compelling of these heads – mostly rendered in a frontal attitude – are those which are over-life-size and in which the impact and significance of the subject and its expressive interpretation are enhanced by the scale. Such sculptures were done by a variety of artists from the teens through the thirties. Beckmann's *Self-Portrait* (fig. 32, p. 26, and cat. no. 29), for example, created on the eve of the artist's persecution and forced exile from his native land, conveys audacity and power.

Even in portraits of specific individuals, the German Expressionists were not bound by traditionally accepted notions of artistic likeness or beauty. Rather, they were more interested in capturing the ethos of

21. See translation of excerpt from Osborn's *Max Pechstein* in this catalogue, pp. 47–50.

22. Unfortunately, this extremely fragile work could not be borrowed for the present exhibition.

23. See essay by Wietek on Schmidt-Rottluff in this catalogue, p. 183.

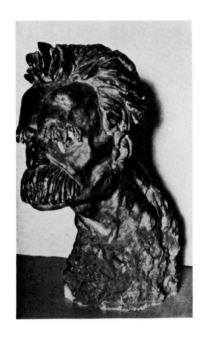

Fig. 30
Otto Dix (German, 1891–1969)
Portrait of Nietzsche, 1912
Plaster *(Gips),* painted green
58 × 48 cm.
(23 × 19 in.)

Formerly Stadt-Museum, Dresden. Sold by the Nazis at the Galerie Fischer auction, Lucerne, 1939, lot 35; present location unknown.

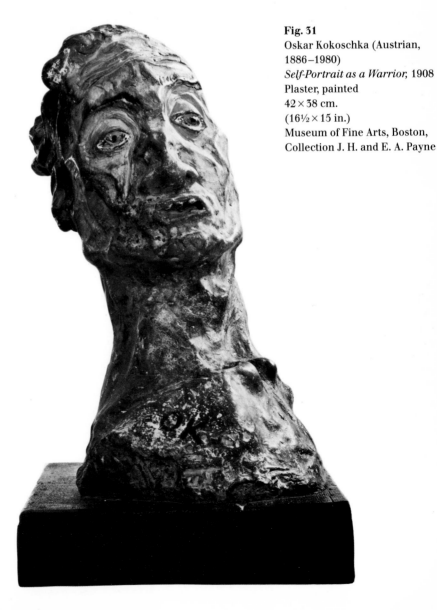

Fig. 31
Oskar Kokoschka (Austrian, 1886–1980)
Self-Portrait as a Warrior, 1908
Plaster, painted
42 × 38 cm.
(16½ × 15 in.)
Museum of Fine Arts, Boston, Collection J. H. and E. A. Payne

their subject, be it the acute intelligence of gallery owner Herwarth Walden as depicted by William Wauer (fig. 33, p. 26, and cat. no. 147), or the evocative spirituality of Käthe Kollwitz rendered by her close friend Barlach as part of his *War Memorial for the Güstrow Cathedral,* 1927 (cat. no. 21).

SCULPTURE AND ARCHITECTURE

Many of the German Expressionists were involved with architectural sculpture, factory and urban design, and monumental sculpture, in addition to their work on a smaller scale. Barlach's *War Memorial* and *The Crucifixion* by Gies have already been mentioned. Another important project, which can be seen today in the form of a re-creation, was Hoetger's 1927 commission executed to adorn the facade of the Gewerkschaftshaus-Volkshaus, Bremen, the *Memorial to Labor* (fig. 34, p. 27, and cat. nos. 53–58). These eight nonheroic figures represent the exploitation of laborers in capitalist society in the form of weary workers and a worker with a child. One can hardly help but recall Michelangelo's *Slave* cycle; both artists used a series of evocative, gesturing figures to express their sympathy for the downtrodden. These works also share formal characteristics: a strong reliance on the original blocky form and a contrasting of open gestures with the initial shape of the block. Just as Lehmbruck's *Fallen Man* depicted the soldier as the victim of war, and not as a triumphant victor, so, too, did Hoetger focus on the victimized laborer rather than the idealized worker championed in the nineteenth century by Meunier, Jules Dalou, and Rodin. In this sense the *Memorial to Labor* is a typical German Expressionist work.

A few years later, in 1930, Ernst Barlach received a large-scale commission for what certainly would have been his crowning achievement: *The Community of Saints,* sixteen over-life-size figures intended for the facade of St. Katherinenkirche in Lübeck (fig. 35, p. 27, and cat. no. 22). According to Carl Georg Heise, then director of the Museum für Kunst und Kulturge-

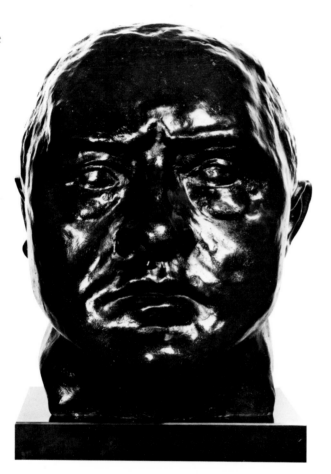

Fig. 32
Beckmann, *Self-Portrait*
(cat. no. 29), 1936.

Fig. 33
Photograph of Herwarth Walden with his portrait by Wauer
(cat. no. 147).

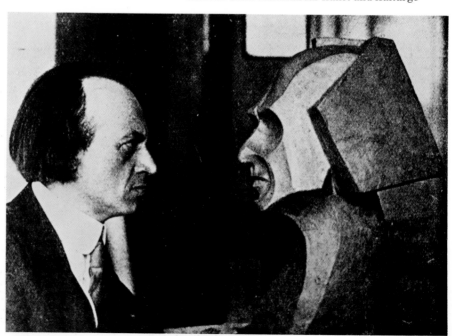

schichte, Lübeck, Barlach's figures were not meant to represent the community of church saints, but rather the struggle and suffering of people trying to find a link between their lives of hardship and the redeeming powers of a higher world. Although this link could not always be found, humanity was always endeavoring to find it.[24] Despite the fact that only three of the figures were completed before the Nazis came to power, we know from Barlach's sketches that this cycle would have been a monument to humanity's striving for spirituality.

The Expressionist Rudolf Belling derived his reputation in the 1920s in great measure from his architecturally related works. His "tectonic rooms" (now lost), a kind of *Gesamtkunstwerk,* or total work of art, created together with architects, resembled scenes from Expressionist films. These collaborations are indicative of the spirit of the twenties, during which the traditional boundaries between fine and applied art and among various disciplines were abandoned. The notion of *Gesamtkunstwerk* became a popular one and found adherents among artists throughout Europe—for example, Kurt Schwitters and Rudolph Steiner—who all created total art environments of which sculpture was an integral part.

* * * *

The Expressionism which flourished in painting in the twenties was characterized by often grotesque, sometimes brutal subject matter, bold coloration, and a dense picture plane. It possessed a greater intensity than that of the teens, as can be seen in Felixmüller's *Death of the Poet Walter Rheiner,* 1925 (fig. 37, p. 28). Yet the sculpture from this same period, whether by Felixmüller himself (fig. 36, p. 28, and cat. no. 37) or by his fellow artists, rarely achieved a similar intensity.

24. See article by Isa Lohmann-Siems in *Ernst Barlach 1870– 1970,* Bonn-Bad Godesberg: Inter Nationes, 1971, p. 41, note 95.

Fig. 34
Hoetger
Weary Worker with Crossed Arms (cat. no. 55), 1928.

Fig. 35
Barlach
The Community of Saints (Die Gemeinschaft der Heiligen),
1929–30
Charcoal on paper
50 × 73.6 cm.
(19½ × 29 in.)
Museum für Kunst und Kulturgeschichte, Lübeck.

This drawing shows the general plan for the niche figures on the west facade of St. Katherinenkirche, Lübeck.

Unlike the earlier Brücke period, when the painting, sculpture, and printmaking of Kirchner, Heckel, and others were so strongly interrelated, an interconnection between two- and three-dimensional representation was not as evident in the twenties. Most of the later Expressionist sculptors were more concerned with examining and reconciling connections between the expressive gestures explored by their predecessors and a formal language borrowed from other stylistic arenas at this time.

Although several artists represented in this exhibition continued – or began – to execute sculpture in the thirties, this was more the exception than the rule. Essentially, by the late twenties, German Expressionist sculpture had begun to give way to the sculpture of Neue Sachlichkeit, to work which returned to classical themes and proportions, or to adaptations of Constructivist assemblages of materials. For twenty years the German Expressionists had maintained a total involvement with the human figure. While sculptors in other areas had moved away from figuration, the Expressionists examined the human form closely, frequently interpreted it through intense color and bold outlines, hacked it out of raw wood, and stretched it to its limits. In so doing, they orchestrated a resonant cry against the Academic tradition in sculpture. It is this legacy which we are only now beginning to recognize and understand.

Fig. 36
Felixmüller, *Woman with Flowing Hair* (cat. no. 37), 1923.

Fig. 37
Felixmüller
Death of the Poet Walter Rheiner (Der Tod des Dichters Walter Rheiner), 1925
Oil on canvas
185.5 × 129.5 cm.
(73 × 51 in.)
Private Collection, U.S.A.

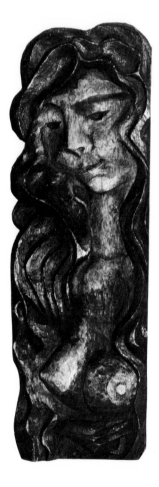

Documentary Section

THEODOR DÄUBLER:
"GELA FORSTER" (1919)

Gela Forster, née Angelica Bruno-Schmitz (1892–1957), was a sculptor and founding member of the short-lived Dresden Sezession: Gruppe 1919. In 1922, she married Alexander Archipenko and, after a year spent working in Dresden and Berlin, they emigrated to the United States. All of Forster's sculptural work from this period has disappeared, and we know it only from photographs and laudatory contemporary accounts. Among these favorable appraisals was the following article by Theodor Däubler (originally published in the journal *Neue Blätter für Kunst und Dichtung (New Newspaper for Art and Poetry)* in June of 1919 and reprinted in Theodor Däubler, *Dichtungen und Schriften,* Munich: Kösel-Verlag, 1956).

Däubler (1876–1934), a poet and author of the cosmogonic epic *Das Nordlicht (Northern Lights)* (1910), wrote numerous essays on modern art and became a champion of Expressionism. He was close to Barlach and served as the subject for one of that artist's sculptures in 1929. Däubler's art criticism exhibits a spirituality and intensity of language characteristic of literary Expressionism, and it shares with all poetry and writing the fate that such qualities can never be conveyed completely in translation. In a collection of essays entitled *Der neue Standpunkt (The New Standpoint),* published in 1916, Däubler praised modern artists ranging from Van Gogh and Cézanne to Picasso and Marc. The first line of his essay on Marc confirms an essentially Expressionist view of his age: "Our times have a great purpose: a new eruption of the soul." The images reproduced here were included in the original article. Permission to translate it is courtesy of Kösel-Verlag, Munich. – P.W.G.

When Chagall allows heads to float about freely or when he sets them backwards on bodies, the sole reason for this is that the artist, in addition to having a vehement sense of color, must also perceive violent actions and give them form. When Delaunay places houses askance, this represents a discovery that has finally been made: space confined by a frame knows only the logic which governs the boundlessness of nature. Houses which incline toward the central core of a picture, or which in a given plane take both their own and a corresponding form of crystallization – these are not artistic nonsense! On the contrary: the frame should exert its influence. We are now learning to perceive as pedantic an approach that adheres to the laws of nature. This of course does not mean that from now on one cannot create in a traditional manner. Cubism already provides the basis for a tremendous (nonviolent) organization of the spiritual. Nevertheless: modern art is revolution, not only in an artistic sense, but even more in a political one! Beginning with Van Gogh the most sensitive minds began to foresee, in an uncanny way, the upheavals that we have been experiencing for the past five years. Everything is the prelude to something unprecedented, even if that something has been expected for a long time! Now man does not want to adapt to any conditions: he is crying out. At first always against something. Against everything that exists. Suddenly he also cries out for what he already holds to be attainable. Undergoing severe convulsions!

No modern artist has perceived the rictus of this development in as cold-blooded and controlled a manner as Gela Forster in her [sculpture] *Man* [figs. 4 and 5, p. 33]. This is revolution! Those who are passionate, eager for life, dare to engage in it. Prophets are often ascetics; revolutionary human beings often have contempt for the sensual. But this is not the case with those who most fundamentally undermine rotten conditions – particularly not with revolutionary artists. They aim for a stimulating effect: they yearn for the arrival of more free and beautiful generations! They are animated by an absolute, a magnificent eros. Love, a sensuous intoxication, shall be victorious over the conventional, the reasonable. When his voice becomes that of a man, the young boy cries out in passion: he demands his woman. If he is a complete human being, he is possessed by a desire for erotic ideals, for a more glorious life for his children and his children's children. The rebel is always erotic: when he is an artist, he is often sensuous in the extreme. Something of this kind already stands before us in the work of Gela Forster.[1] The entire sculpture climaxes in a cry. The sculptor has reduced the head to its most primitive, the egglike shape of the skull: it has become the bearer, we can even say the revealer, of a tragic mouth. Eyes, nose have been incorporated into the mouth. The sexual agitation and, in the behavior of the limbs, the spiritually expressed agitation of this symbolic man are pressing toward only one goal: to declare a head with such a mouth to be artistically possible now, yes, self-evident, proven by logic. Actually, a bronze! In spite of the missing legs and feet. Rodin's headless *Walking Man* [fig. 11, p. 18] was also cast. In this magnificent work the head is missing, so that the observer is shaken by a realization: the idea proceeds, though the head has been struck off. (Originally the sculpture represented John the Baptist.) In Gela Forster's intense sculpture the sensation rises powerfully: away with the feet; the cry (once sounded) resounds through the entire world.

Rottluff Picasso *[sic]* has gained a deep understanding of African sculpture; Schmidt-Rottluff has also seen it. Gela Forster was able to perceive it fervently. The naiveté in the sculptures of wild or semiwild peoples (I am not speaking of the Benin) has had a much stronger effect on modern artists than have the statues of those races who disappeared long ago. But for none of these artists can we establish a dependence on the creations of distant but surviving tribal cultures.

Gela Forster's female statues *Conception* [fig. 1, p. 31] and *Awakening* [figs. 2 and 3, p. 32] express

||
1. For an equally enthusiastic contemporary appraisal of Forster's sculpture, see Alfred Günther, "Vor Bildwerken von Gela Forster," *Menschen: Buch-Folge Neuer Kunst,* vol. 2, no. 37, May 4, 1919, p. 1. – Ed.

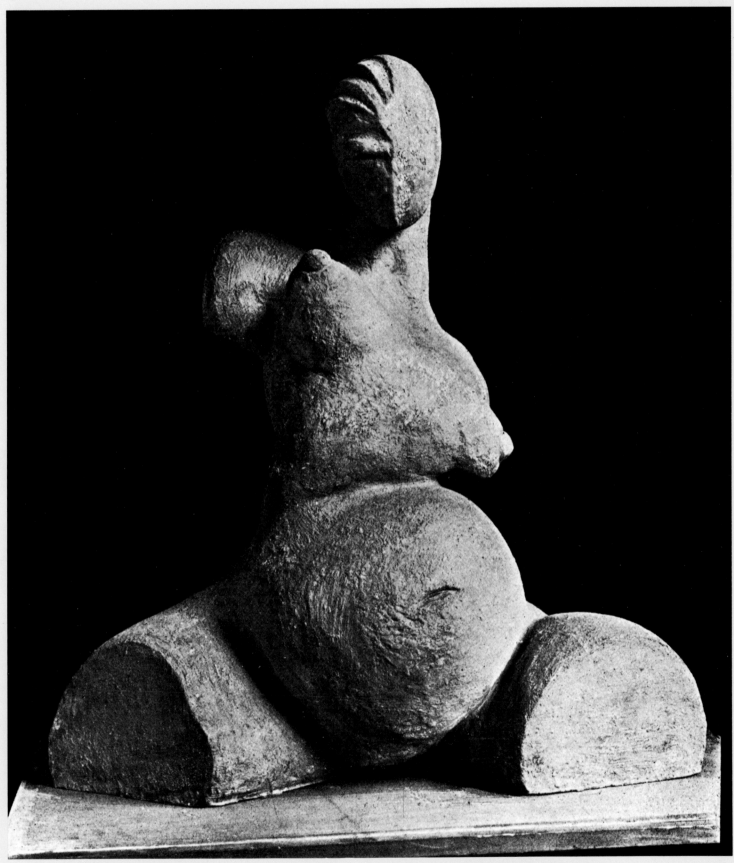

Fig. 1
Conception (Empfängnis),
stone, lost.

Fig. 2
Awakening (Erwachen), stone, lost; side view.

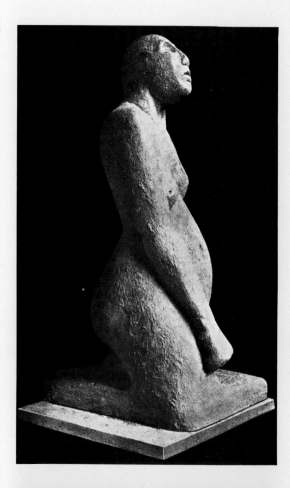

Fig. 3
Awakening (Erwachen), stone, lost; front.

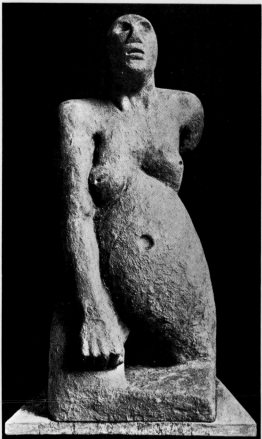

experiences with which we are quite familiar. As a consequence these sculptures appear barbaric to us, yet vigorously and spontaneously perceived – not constructed, heaped together, oppressive. The technique employed in these female forms is highly interesting: it provides a definite contrast to that seen in the aforementioned sculpture, *Man.* In the latter we find an almost elegant and simultaneously strong rhythm, in the geometrical sense. The clearly delineated head corresponds, in nearly measured fashion, to the two halves of the buttocks. In the case of female figures, particularly in *Awakening,* a greater compression is noticeable. The sense of style is less strained. The treatment of the skin is rough in all sculptures, but pronouncedly so with the female ones. Yet Gela Forster in no way imitates Rodin's impressionistic technique. Neither are we dealing principally with a treatment of the skin in her work, as in the work of Medardo Rosso.[2] This artist wanted to sculpt sunlight: he was less concerned with "human beings"; for him they were at best carriers and bearers of light. Rodin had an excellent command of the interplay of shadows. He created his own mode of presenting "skin." He too began with the sculpture of Rosso and Carpeaux.[3] Gela Forster again confronts us with the problem of "skin" in her three sculptures. She has already solved it for herself in an exciting and very independent way.

||

2. Medardo Rosso (1858–1928): Leading Italian sculptor of the late nineteenth century. Rosso's strong Impressionist tendencies appear in his concern for representing the effects of light in his sculpture. – Ed.

3. Jean Baptiste Carpeaux (1827–1875): Major nineteenth-century French sculptor, best known for his *Dance* (1896, facade of the Paris Opera). – Ed.

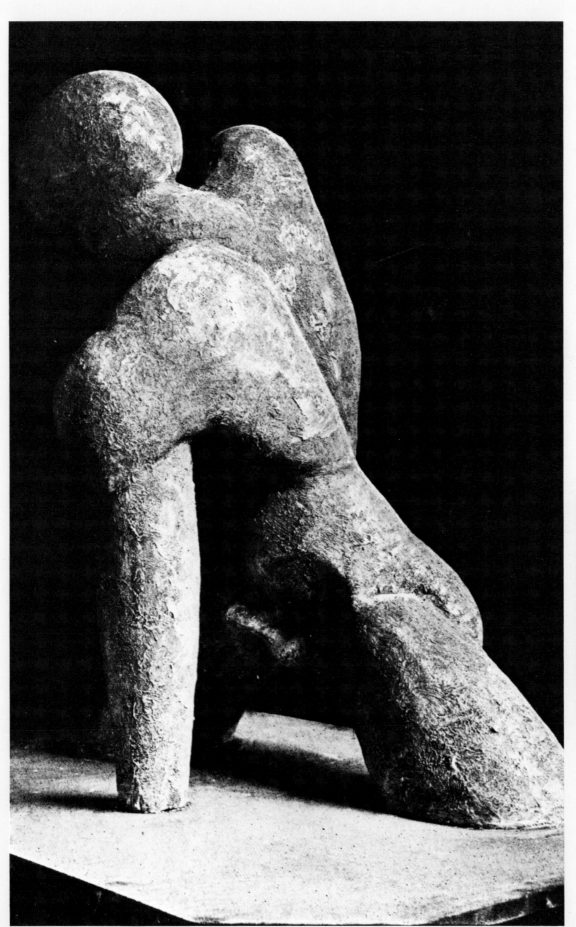

Fig. 4
Man (Der Mann), stone, lost;
rear left.

Fig. 5
Man (Der Mann), stone, lost;
rear right.

CARL EINSTEIN:
EXCERPT FROM *AFRICAN SCULPTURE* (1915)

Carl Einstein (1885–1940) was one of the most important writers and critics associated with German Expressionism. He established his reputation in 1907 with his novel *Bebuquin*, which was initially serialized in the periodical *Opale* and published in book form by Verlag Der Sturm in 1912. In addition, he translated Van Gogh's letters into German in 1914; copublished the bitter and satirical magazine *Der blutige Ernst (Bloody Seriousness)* with George Grosz; coedited the *Europa-Almanach* in 1925 with Paul Westheim; and in 1926 wrote his famous volume *Kunst des 20. Jahrhunderts (Art of the Twentieth Century)* as part of the *Propyläen Kunstgeschichte (Propyläen History of Art)*, a highly important multi-volume reference work. In 1929, Einstein moved to France where he continued to be active as an editor, writer, and critic, and in 1936 he joined the Republican forces in Spain to fight against Franco. After twice being interned in France, he committed suicide in 1940 at the French-Spanish border as German troops approached.

The excerpts translated here are taken from Einstein's *Negerplastik (African Sculpture)* (originally published in 1915 by Kurt Wolff Verlag, Munich), the first book to deal exclusively with the subject of African sculpture. Although in light of our present state of ethnological awareness many of the premises in Einstein's text necessarily appear unfounded and extremely romantic, it was nonetheless significant for its extremely positive endorsement of such work. Amplification, as opposed to a strictly logical argument, serves as the primary persuasive strategy in Einstein's text and suggests the impassioned stance he maintained toward his subject. The intensity and immediacy of emotional impact and the powerful simplicity which he ascribes to African sculpture are among the qualities which attracted the Expressionist artists – especially the members of the Brücke – to the works of African and Oceanic peoples. – P.W.G.

Religion and African Art. African art is, above all, religious. The Africans, like any ancient people, worship their sculptures. The African sculptor treats his work as a deity or as the deity's custodian. So, from the very beginning, the sculptor maintains a distance from his work, because the work either is or contains a god. The sculptor's labor is adoration from a distance. And thus the work is, a priori, independent. It is more powerful than its maker, who devotes his full intensity to the sculpture and thus, as the weaker being, sacrifices himself to it. His labor must be described as religious worship. The resulting work, as a deity, is free and independent of everything else.... The work will never be involved in human events, except as something powerful and distanced. The transcendence of the work is both determined by and presumed in religion.... The effect lies not in the artwork, but in its presumed and undisputed godliness. The artist will not dare to vie with the god by striving for an effect; the effect is certainly given and predetermined. It makes no sense to regard such an artwork as striving for an effect, especially since the idols are often worshiped in darkness.

The artist produces a work that is autonomous, transcendent, and not interwoven with anything else. This transcendence is manifested in a spatial perception that excludes any act by the viewer; a completely drained, total, and unfragmentary space must be given and guaranteed. Spatial self-containment does not signify abstraction here; it is an immediate sensation. Wholeness is guaranteed only if the cubic [i.e., solid, three-dimensional] is achieved totally, that is, if nothing can be added to it. The activity of the viewer is entirely omitted....

A characteristic feature of African sculptures is the strong autonomy of their parts. This too is determined by religion. The sculptures are oriented not toward the viewer but in terms of themselves; the parts are perceived in terms of the compact mass, not at a weakening distance. Hence, they and their limits are reinforced.

We also notice that most of these works have no pedestal or similar support. This lack might come as a surprise, since the statues are, by our standards, extremely decorative. However, the god is never pictured as anything but a self-sufficient being, requiring no aid of any kind. He has no lack of pious, venerating hands when he is carried about by the worshiper.

Such an art will seldom reify the metaphysical, since the metaphysical is taken for granted here. The metaphysical will have to be manifested entirely in the complete form, concentrated in it with amazing intensity. That is to say, the form is treated in terms of extreme self-containment. The result is a great formal realism.... Formal realism, which is not construed as imitative naturalism, has a given transcendence; for imitation is impossible: whom could a god imitate, to whom could he subjugate himself? The result is a consistent realism of transcendental form. The artwork is viewed not as an arbitrary and artificial creation, but rather as a mythical reality, more powerful than natural reality. The artwork is real because of its closed form; since it is self-contained and extremely powerful, the sense of distance will necessarily produce an art of enormous intensity.

While the European artwork is subject to emotional and even formal interpretation, in that the viewer is required to perform an active visual function, the African artwork has a clear-cut aim, for religious reasons beyond the formal ones. The African artwork signifies nothing, it symbolizes nothing. It *is* the god, and he maintains his closed mythical reality, taking in the worshiper, transforming him into a mythical being, annulling his human existence....

For the artwork to have a delimited existence, every time-function must be omitted; that is, one cannot move around or touch the artwork. The god has no ge-

netic evolution; this would contradict his valid existence. Hence, the African has to find a depiction that, without the use of surface relief, shows a pious and nonindividual hand and instantly expresses it in solid material. The spatial viewing in such an artwork must totally absorb the cubic space and express it as something unified; perspective or normal frontality is out of the question here, they would be impious. The artwork must offer the full spatial equivalent. For it is timeless only if it excludes any time-interpretation based on ideas of movement. The artwork absorbs time by integrating into its form that which we experience as motion.

Viewing Cubic Space... African sculpture presents a clear-cut establishment of pure sculptural vision. Sculpture that is meant to render the three-dimensional will be taken for granted by the naive viewer, since it operates with a mass that is determined as mass in three dimensions. This task appears to be difficult, indeed almost impossible at first, when we realize that not just any spatiality, but rather the three-dimensional, must be expressed as a *form*. When we think about it, we are overwhelmed with almost indescribable excitement; this three-dimensionality, which is not taken in at one glance, is to be formed not as a vague optical suggestion, but rather as a closed, actual expression. European solutions, which seem makeshift when tested against African sculpture, are familiar to the eye, they convince us mechanically, we are accustomed to them. Frontality, multiple views, overall relief, and sculptural silhouette are the most usual devices.

Frontality almost cheats us of the third dimension and intensifies all power on one side. The front parts are arranged in terms of one point of view and are given a certain plasticity. The simplest naturalistic view is chosen: the side closest to the viewer, orienting him, with the aid of habit, in terms of both the object and the psychological dynamics. The other views, the subordinate ones, with their disrupted rhythms, suggest the sensation that corresponds to the idea of three-dimensional motion. The abrupt movements, tied together mainly by the object, produce a conception of spatial coherence, which is not formally justified.

The same holds true for the silhouette, which, perhaps supported by perspective tricks, hints at the cubic. At closer inspection, we see that the silhouette comes from drawing, which is never a sculptural element.

In all these cases, we find the technique of painting or drawing; depth is suggested, but it is seldom given immediate form. These approaches are based on the prejudice that the cubic is more or less guaranteed by the material mass and that an inner excitement circumscribing the material mass or a unilateral indication of form would suffice to produce the cubic as a form. These methods aim at suggesting and signifying the sculptural, rather than going all the way. Yet this is not possible along these lines, since the cubic is pre-

Fig. 1
Carl Einstein and Dr. Eichhorn, director of the Ethnographic Museum of Berlin, inspecting the Flechtheim Collection.

sented as a mass here and not immediately as a form. Mass, however, is not identical with form; for mass cannot be perceived as a unity; these approaches always involve psychological acts of motion, which dissolve form into something genetically evolved and entirely destroy it. Hence, the difficulty of fixing the third dimension in a single act of optical presentation and viewing it as a totality; it has to be grasped in a single integration. But what is form in the cubic?

Clearly, form must be grasped at one glance, but not as a suggestion of the objective; anything that is an act of motion must be fixed as absolute. The parts situated in three dimensions must be depicted as simultaneous; that is, the dispersed space must be integrated in the field of vision. The three-dimensional can neither be interpreted nor simply given as a mass. Instead, it has to be concentrated as specific existence; this is achieved when that which produces a view of the three-dimensional and is felt normally and naturalistically to be movement is shaped as a formally fixed expression.

Every three-dimensional point of a mass is open to infinite interpretation. This alone makes it almost impossible to achieve an unequivocal goal, and any totality seems out of the question....

The African seems to have found a pure and valid solution to this problem. He has hit upon something that may initially strike us as paradoxical: a formal dimension.

The concept of the cubic as a form (only with this concept should sculpture be created, not with a material mass) leads directly to determining just what that form is. It is the parts that are not simultaneously visible; they have to be gathered with the visible parts into

a total form, which determines the viewer in a visual act and corresponds to a fixed three-dimensional viewing, producing the normally irrational cubic as something visibly formed. The optical naturalism of Western art is not an imitation of external nature. Nature, passively copied here, is the standpoint of the viewer. This is how we understand the genetic evolution, the unusually relative quality of most of our art. European art was adjusted to the viewer (frontality, perspective); and the creation of the final optical form was left more and more to the actively participating viewer....

The task of sculpture is to form an equivalent absorbing the naturalistic sensations of movement, and thus the mass, in their entirety and transforming successive differences into a formal order. This equivalent has to be total, so that the artwork may be felt, not as an equivalent of human tendencies directed elsewhere, but rather as something unconditionally self-contained and self-sufficient....

We have stressed that sculpture is a matter not of naturalistic mass, but only of formal clarification. Hence, the invisible parts, in their formal function, have to be depicted as a form; the cubic, the depth quotient (as I would like to call it), has to be depicted on the visible parts as form; to be sure, only as form, never blending with the objective, the mass. Hence, the depiction of the parts cannot be material or painterly; instead, they must be presented in such a way as to become plastic, a way that is naturalistically rooted in the act of motion, fixed as a unity and visible simultaneously. That is to say: every part must become sculpturally independent and be deformed in such a way that it absorbs depth, because the conception, appearing from the opposite side, is worked into the front, which, however, functions in three dimensions. Thus every part is a result of the formal presentation, which creates space as a totality and as a complete identity of individual optics and viewing, and also rejects a makeshift surrogate that weakens space, turning it into mass.

Such a sculpture is strongly centered on one side, since this side manifestly offers the cubic as a totality, as a result, while frontality sums up only the front plane. This integration of the sculptural is bound to create functional centers, in terms of which it is arranged. These cubic *points centraux* [central points] instantly produce a necessary and powerful subdivision, which may be called a strong autonomy of the parts. This is understandable. For the naturalistic mass plays no part, the famous, unbroken, compact mass of earlier artworks is meaningless; moreover, the shape is grasped not as an effect, but in its immediate spatiality. The body of the god, as dominant, eludes the restrictive hands of the worker; the body is functionally grasped in its own terms. Europeans frequently criticize African sculpture for alleged mistakes in proportion. We must realize that the optical discontinuity of the space is translated into clarification of form, into an order of the parts, which, since the goal is plasticity, are evaluated differently, according to their plastic expression. Their size is not crucial; the decisive feature is the cubic expression assigned to them and which they must present no matter what.

However, there is one thing that the African eschews, but to which the European is led by his compromise: the modeling interpolated in the elementary; for there is one thing this purely sculptural procedure requires: definite subdivisions. The parts are virtually subordinate functions, since the form has to be concentratedly and intensely elicited in order to be form; for the cubic, as a result and as an expression, is independent of the mass. And only that is permissible. For art as a qualitative phenomenon is a matter of intensity; the cubic, in the subordination of views, must be presented as tectonic intensity....

I would like to add something about the group. The group visually confirms the previously stated opinion that the cubic is expressed not in mass but in form. Otherwise, [the group], like any broken sculpture, would be a paradox and monstrosity. The group constitutes the extreme case of what I would like to call the remote sculptural effect: at closer inspection, two parts of a group relate no differently to one another than two remote parts of a figure. Their coherence is expressed in [their] subordination to sculptural integration, assuming that we are not dealing simply with a contrasting or additive repetition of the formal theme. Contrasting repetition has the advantage of reversing directional values and thus also the meaning of sculptural orientation. On the other hand, juxtaposition shows the variation of a sculptural system within a visual field. Both are grasped totally, since the given system is unified.

CARL GEORG HEISE:
"THE CRUCIFIX BY GIES" (1921)

Carl Georg Heise (1890–1979) was cofounder with Hans Mardersteig of the important Expressionist art journal *Genius* (1919–21), which was published in Munich by Kurt Wolff Verlag. In 1920, he assumed the directorship of the Museum für Kunst und Kulturgeschichte, Lübeck, and soon established himself as one of the outstanding museum directors of the period. In 1930, he commissioned Barlach to sculpt a series of sixteen larger-than-life-size figures for the facade of the Gothic brick St. Katherinenkirche in Lübeck (see cat. no. 22). He also was responsible for commissioning Sintenis' *Daphne* (cat. no. 135), which was installed in the sculpture garden of the Behn-Haus, Lübeck. Heise's support of the Expressionists and of Edvard Munch occasioned many attacks from the local press, and in 1930 he found it necessary to defend himself and his acquisition policies in a special publication.

When the Nazis gained control in 1933, Heise was dismissed from his museum directorship and placed in "retirement." He then became an art critic for the *Frankfurter Zeitung* until the Nazis removed him from this post. From 1939 to 1945, he worked as a reader for Gebr. Mann Verlag in Berlin, and in 1945, following the War, he was appointed director of the Hamburger Kunsthalle and became a professor at the Universität Hamburg – positions which he held until 1955.

Heise's "Der Kruzifixus von Gies" ("The Crucifix by Gies") was originally published in *Genius,* vol.3, no. 2, 1921, pp. 198 – 202. The creator of the crucifix, Ludwig Gies (b. 1887), was well known for his small sculptures and medals. He was a professor at the Berliner Hochschule für freie und angewandte Kunst from 1917 until 1937, when he was dismissed by the Nazis. In 1950, he accepted a professorship at the Werkschule in Cologne. – P.W.G.

Ludwig Gies' crucifix was created as an entry for the war-memorial competition of St. Marienkirche in Lübeck. As was to be expected, the jury and the church board did not give the work serious consideration. For a moment it seemed as if the upper hand would be gained by the artistically educated members of the congregation's progressive governing body; they stood up for Gies' work with great warmth and energy. The crucifix temporarily found an ideal place in the ambulatory of the cathedral. At the same time, however, a controversy about art ensued that excited people to the boiling point; its conclusion was made memorable by the wanton mutilation of the work. The head was knocked off and dumped into the millpond.

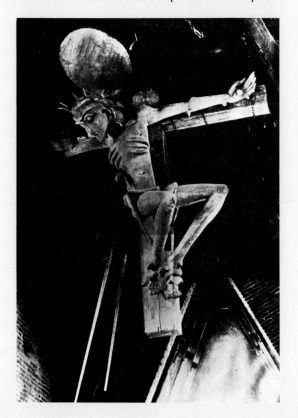

Thank God, it was found and successfully restored. Then the crucifix adorned the hall of the Bauhaus at the *Deutsche Gewerbeschau* in Munich. Taken from its very dignified location, where it stood in the midst of life as the practical fulfillment of an artistic task of an important kind; uprooted by a referendum and returned to the art trade of the day as a wandering exhibition piece. It is hard to determine what is more significant: the work itself or its fate. Its existence is a testament to the infiltration of Expressionist form by a strong and particular religious emotion, and to the competent craftsmanship of a modern sculptor in the service of a noble and timeless purpose. Its destruction, however, testifies to the increasing discrepancy between popular feeling and artistic culture in our time – to the dangerously increasing gravity of the situation we are in. Both aspects merit serious consideration.

The work was created for a spacious church nave of the north German Gothic brick style. It respects this fact in structure, rhythm, and mood. The specificity of this task has dictated the fundamentals of form and craft. The austere artistic language of the energetically drawn contours and violent *contrapposto* is not fashionable deviousness; rather it adapts to the pictorial adornment of the Gothic period in conscious, voluntary affinity. The exacting simplification of all motifs is never stammering primitivity, but is intentionally directed toward achieving particular aesthetic effects. The acute triangular form of the pulled-up knees, the pointed chin, the straight, upward-pointing fingers of the right hand are all new elements of an expressive feeling for beauty which is very much personally determined. And the spiritual values are also of such deep and individual quality – particularly striking in such a frequently treated subject – that they alone would make the work one of the most valuable documents of contemporary religious experience. The artist did not shy away from rendering the agonies of death in a moving, drastic manner. Everything seems to show pain and torment. Yet in the compassionate

Fig. 1
The Crucifixion, installation at the *Deutsche Gewerbeschau*, Munich; destroyed.

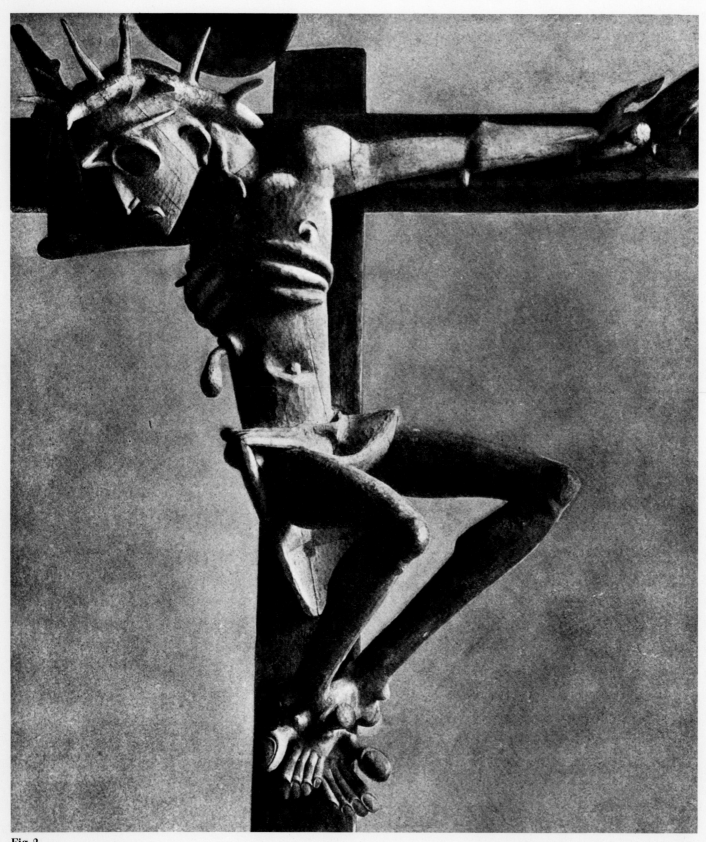

Fig. 2
The Crucifixion (detail)
Formerly St. Marienkirche,
Lübeck; destroyed.

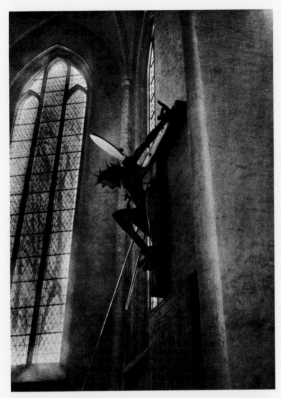

Fig. 3
The Crucifixion,
Formerly St. Marienkirche,
Lübeck; destroyed.

bowed head, in the right arm's subdued gesture of blessing, the idea of sacrifice has gained such an urgent form in so touching and conciliatory a manner that sorrow and the conquest of sorrow are united in a majestic image of redemption. It would be hard to find a symbol that would impress posterity more powerfully and deeply with the meaning of the World War and its fallen heroes.

The material, too, adapts to its surroundings; it is wood, which we have long been unaccustomed to using for works of such monumental dimensions. Thus the crucifix of 1921 becomes closely akin to the fifteenth-century cross of triumph. In collaboration with the sculptor Hitzberger,[1] the forms have been hewn out of a few huge oak planks, and in each individual form one feels the spirit of the material. The coloring is reserved, nowhere has the character of the wood been destroyed: the body has been stained a green-blue, the planks of the cross and the drops of blood, red; only the rays and the nimbus have been gilded. Ghostlike, the polished plate of the nimbus reflects the green coloration of the head. This excellence in craftsmanship has symptomatic meaning: the more readily it is accepted that the time of the individual creator, the great master, is over, the more we welcome a renewal of the principles of craftsmanship. They alone can slowly prepare the ground for a new blossoming of the highest personal achievement.

The work was hung in the ambulatory of the Lübeck cathedral – against a plain white wall, the right hand's blessing a phantasmal silhouette before the tall church window. The effect was astonishing. An

||
1. Otto Hitzberger (b. 1878): Expressionist sculptor of primarily religious subjects. – Ed.

amazing phenomenon – a work of modern craftsmanship and spirit proved to be equal to the architectural power of the Middle Ages. For in comparison, the work did not disappoint; it formed a harmonious sound with window, pillar, and cross vault. The seeming arbitrariness of intensely personal creativity derived [its] laws and proportions from the surrounding architecture. Anyone familiar with the tasks of practical art administration knows what this placement means. It marks the moment in which desire and effort turn into fulfillment and mastery. In this seems to lie the ultimate significance of Gies' crucifix, which extends far beyond its artistic value as such. He has made visible his long-desired, finally achieved stage of development.

Yet visible for whom? Can we speak of fulfillment and of having achieved a goal when only a few people share in it; when the masses not only remain blind, but reject, condemn, rage, stone? The newspapers started the controversy; the defenders remained in the minority; the adversaries spoke of blasphemy, of folly, of a public disgrace that demanded expiation. They are the ones who are responsible for the mutilation. Not the fanaticism of an individual, but the indignation of the crowd passed sentence. As when in the case of political murder, the perpetrator is the instrument of blind mass hatred, in this instance the head of the Christ figure fell as the blatant expression of the people's rage. The masses revolt against art. The long-suppressed indignation reached its height at the moment when, in the opinion of art lovers, a truly popular, practical task had been completed in a surprisingly satisfying manner. It is easy and customary to shrug off this hate-filled discord between art and life by compassionately referring to the artistic narrow-mindedness of the masses. But this attitude only betrays a narrow-minded view of the world itself. To feel no urge to change this fatal condition is to lose every right to intervene as a supporter of art in the relationship between art and people.

Many a mitigating argument will be advanced against anyone who emphasizes this conflict which, increasing from decade to decade, reduces the fundamental effectiveness of the best of our new generation of artists. It will be argued that good new art has never been popular at the time of its origination; that the master has always been ahead of the crowd; that prophets have always been stoned. That is certainly true. But is art prophecy? Certainly the Greek art of the Periclean age did not find such resounding resonance in every contemporary as in our textbooks today, two thousand years later; but a wait-and-see attitude is far from hate and the rage of destruction. And who could possibly believe that an Athenian of the Golden Age might have desecrated the image of a god out of artistic fanaticism? A Raphael or a Rubens created in the limelight of his fame, during his own lifetime – not in great popularity, but enthusiastically supported by the most powerful on earth. A Michelangelo, a Rembrandt became lonelier the higher he rose, but the favor of the people followed closely behind him. The people did not always understand in depth, but

their understanding nevertheless was so fertile that the unmatched achievement of individual artists was able to define popular artistic conceptions of future epochs. This is no longer the case. After the slow decline of the Biedermeier spirit,[2] no uniform style could affirm the existence of a common culture. Culture and art have declined to such an extent that even in the nineteenth century the illusion of a congenial taste only served to maintain the pretense of a uniform popular culture. The renaissance of the arts that then ensued took place for masters and connoisseurs only, in isolation from decisive world events. Since that time, the gap between people and art has widened. Considering conflict of the belligerence that was displayed in the Gies affair, this gap appears to have become unbridgeable. For a long time it was thought that what might be interpreted as necessary martyrdom would prove in the course of time to be an unavoidable absence of broad influence. Today such false pride in suffering must appear untimely to every intelligent person. However, the fact that Manet's and Cézanne's, Leibl's and even Liebermann's[3] art is beginning to be canonized on the art market and by the critics, should not mislead us into assuming that this art has ever been truly popular – or that it ever will be. It remains the concern of a small group of initiated connoisseurs. The separation of art and people is becoming greater, rather than diminishing.

A second argument, however, appears to be almost more convincing. The art of our time supposedly has not reached its full zenith – so say the obliging intermediaries – it is a transitional product with all its weaknesses, but also with all the fascination of being ahead of its time. The artwork of the future, existing within it in embryo, should be venerated. For what could be more blissful than the first days? Archaic works of art of all styles and all cultures are being rediscovered as relatives, proving a point – only the coming decades of posterity will disclose the deepest meaning of the present. This may be true. But prophecy and desire are poor consolation for insufficient visible evidence. And does the enthusiasm of the artists and their chorus not all too often exhaust itself, even in relation to historic art, in admiration of something that is not mature, something that is not the goal, but only a groping toward the goal? Do not misunderstand me: this argument, which the best succumb to and which has become the teacher of us all, can bring

||

2. Biedermeier: Term for a brief artistic period occurring around the middle of the nineteenth century, primarily in Germany and Austria, which might be characterized as diminished Classicism. The term derives from two benevolent but provincial types created by Victor von Scheffel in the caricature journal *Fliegende Blätter* in 1848. While in general works on art history, the Rococo is considered to be the last true European style, in Central European art histories, the Biedermeier plays the same role. – Ed.

3. Wilhelm Leibl (1844–1900): A leading late nineteenth-century German Realist painter, intimately associated with the Munich School. Max Liebermann (1847–1935): German Impressionist painter who founded the Berlin Secession and was its president from 1898 to 1911. – Ed.

about the blood transfusion necessary to an aging culture. But would it not be wrong to demand that during this severe crisis the untrained person who enjoys not with his intellect, but with his pure instinct, be raised to lofty heights and deeply moved by such works of art? There exists no intellectual excuse sufficient to obscure the distance of the arts from the living participation of the people.

It would certainly be wrong if, frightened by this insight, one attempted to change art by force. On the one hand, a thoughtful feeling of responsibility prevents us from joining in the praises of present conditions, which open up ever more grotesquely the conflict between art and the judgment of the layman. On the other hand, a deeper insight into the developmental context prevents us from engaging in a foolish fight against symptoms which are not the cause but the effect. It keeps us from condemning the artists who, in greatest personal honesty, are under the spell of their declining century. They are not the guilty ones, but we are; not their art is responsible, but our world view. To be more precise, our lack of ideological creativity. Only our changed heart can change art. No sculptor will be able to creatively bring about a new vision of the world; to demand this would be to place too high a value on the importance of the fine arts. The artist's obligation of leadership does not extend beyond making visible the best and deepest aspects of the dominating spirit. This makes us fully aware of how little we are served today by the increasing participation of the general public in artistic problems; it shows us to how small an extent the overrating of art can initiate a transformation of the spirit. The determination of the existence of errors that does not point to any means for their correction may appear to be useless arrogance. But reflection on art should not lead to philosophical dilettantism. That has caused us enough harm. Our task can only be to define the value and the place of a work of art to the best of our knowledge. In the case of Gies' crucifix an attempt of this kind necessarily leads to evidence of a great achievement and its necessity, as conditioned by its time. Nobody will be able to overstep with impunity this stage of artistic development. Every advancement has to take this road. Communities cannot be too strongly impressed with the fact that their active support of such attempts is essential to progress beyond the banal and imitative religious art of the past decades. When understood correctly, the attainment of such progress may be seen to be in the church's own best interest. But it is ultimately important for us totally to accept the fact that so far no goal has been reached. The heart blood of the noblest is flowing, but up to now it has been shed without guilt, and in vain.

P.R. HENNING:
"CLAY – A MANIFESTO" (1917)

While living in Switzerland, Paul Rudolf Henning (b. 1886) wrote "Ton – Ein Aufruf" ("Clay – A Manifesto") as part of a larger work on modern art published by the Kunsthaus Zürich in 1917. It was reprinted both as the second pamphlet produced by the Arbeitsrat für Kunst in 1919 and in the journal *Mitteilungen des Deutschen Werkbundes*, no. 5, 1919–20. In 1980, it was again reprinted by the Akademie der Künste, Berlin, in the catalogue for its exhibition entitled *Arbeitsrat für Kunst 1918–1921*.

The overwhelming majority of sculptures produced in the period prior to the emergence of the Expressionist movement had been executed in stone, especially marble, or in bronze. Only with the Expressionists did wood again come into widespread use as a sculptural medium. In this article, Henning argues forcefully for a wider use of clay in sculpture – especially in the form of terracotta. He himself made terracotta sculptures (see cat. no. 51), as well as a number of very large reliefs for various buildings in Aachen, Cologne, and Berlin, but his advocacy of clay as a sculptural medium had only a slight effect beyond his own endeavors. This article is typical of the fervor and the vision of the future which dominated artists' writings of the period. For additional information on Henning, see this catalogue pp. 98–99. Permission to translate this essay is courtesy of Paul Rudolf Henning and the Akademie der Künste, Berlin. – P.W.G.

Earth that can be molded and fired presents inexhaustible possibilities for creating plastic values of the strongest effect. In spite of this, "works of clay" are extremely rare, in fact almost nonexistent, among modern sculptures. Stone, bronze, or wood – the "nobler" materials – are given preference, although clay is likely to be found in the workshop of every sculptor. The reason for the rarity of ceramic sculpture is neither the unavailability of the material nor the technical difficulty of the firing process, but rather the fact that today's artists, in spite of their daily handling of clay, are completely removed from actually working with its specific qualities. They have lost all feeling for modeling clay according to its nature; they have become blind to clay. Its greatest advantage – namely its plastic possibilities – has forced it into subordination in relation to other materials. Taken out of the clay box, molded on a skeleton of wood, iron, or wire, treated with all kinds of tools, it becomes the shape, the model, for an "original" work of art. This model, though made from clay, is anything but earthen, having been knowingly used by the artist as a model for another material, as a means of experiencing a different kind of material altogether – stone, bronze, or wood. In other words, the clay model's only purpose is to create and facilitate flexibility of creative composition within a different medium. After the plaster cast, the negative, has been taken from the clay model, it is worthless. It is cut to pieces, destroyed to the point of unrecognizability, thrown back into the clay box to be later resurrected in another model for another "original." The plaster mold is the only durable bearer of the work – from it the real original arises directly or indirectly. Even the few sculptors who present us with figures or other ceramic works make use of the plaster cast without much ado.[1] It is therefore no wonder that in the course of time sculptors have lost all understanding of clay's inherent properties and, no longer able to disclose its possibilities of artistic expression, do not use clay anymore. Although no technical arguments can be advanced against the use of negatives

||
1. The mindless adoption of the convenient and amiable plaster form is the cause of the decline, of the low level of today's art of sculpture. – P. R. H.

in the making of ceramic works, as long as the end result possesses the absolute quality of clay, such use provides no basis for creating or even promoting the understanding of clay's specific qualities. But as soon as we remember that clay, directly shaped by hand, formed into hollow bodies of a thousandfold variety, can be fired as a true original, then the greatness of its specific qualities will stimulate us to take advantage of the unprecedented freedom that the use of clay gives us – a freedom that can be increased to reach incredible proportions. The experience of this freedom overwhelms anyone who has been in a position to witness the emergence of such original works of art, and we need not be materialists to want to free a kind of material from its worst servitude and to lead it back to its original wealth of creative possibilities. Only then will the sculptor speak a powerful, free, and above all immediate language of form; he will experience, as in a new dimension, things he never dreamt of.

If we want to create compositions that stand independently, that is, in a more or less upright position, then we have to begin from the base, molding the pliable, shapable clay into hollow or solid forms from the bottom upward. We thus literally realize the idea of the construction and experience *static* forces with our senses. By considering the weight of clay itself and how it can be built up or extended in individual or combined forms, forms originate which correspond to the laws of static forces and which are specific to the nature of clay – works of art are born, communicating the rhythm of their inner construction. Herein lies the main element of the "completely formed" terracotta.

Another aspect is the *plastic* interpretation of clay. This quality is increased many times as soon as we abandon our idea of pure statics, as soon as we completely neglect the laws of gravity, beginning with any kind of form and developing the creation of this form in all directions, adding on in the process. Because as long as one maintains the connections between the inner hollow spaces, one is able to "pot together" any plastic idea. An entire network of pipes or discs of clay, or whatever one may call them, may appear before our eyes. Yes, even separately shaped, individually fired pieces may be connected by seams – a language of

sculpture which has no equal! And in addition, there is our basic ability to enliven the physical surface of the clay original by way of contrast, the subtractive function, the cutting out of the clay wall: this piercing, this true clay-quality, this making "the hollow" visible, the shard audible! The expression of a work of art can be increased to vehement heights by means of this rhythmic piercing and by the inclusion of something so far unmentioned: *color*. The fired piece of clay will have different colors depending on the kind of earth used, on the mixture of different kinds of earth, on the admixture of chemicals, etc. Apart from this color of its own, terracotta can be given color in a number of different ways. In addition to the simple technique of painting the work with color, there are, of course, transparent and opaque, shiny and dull glazes that may be applied – glazes that in the firing process combine with the clay and become permanent. The spectrum of color has been steadily extended through the untiring efforts of chemistry and now affords our artists a choice of countless combinations. In addition to the painted terracotta, monochrome glazed sculpture has been preferred by the past era of artistic imitation.

Finally, let us realize how much our means of expression is enriched as soon as we break the bonds of the merely "imitative." For then we may take up a linear, spatial, or multicolored approach to ceramics, either emphasizing or denying the plastic form itself. Thus clay, in boundless freedom, opens the road to the abstract, the purely spiritual. Manifestations which are yearning for life find in clay incomparably fertile ground for form, color, and architectonic structure. The immediate *unification of tectonics and color with the plastic* cannot be valued too highly when we speak of clay. Our ability to produce weatherproof ceramics has suddenly made architectural applications possible. In addition to glass as a colorful building material (see Taut's glass house),[2] clay will bring joy to those architects who want to redeem mankind from the deadly gray-on-gray of our cities.

||

2. Bruno Taut (1880–1938): One of the few Expressionist architects. For the *Ausstellung des Deutschen Werkbundes* of 1914 in Cologne, Taut built a "glass house" for the Luxfer-Prismen-Syndikat that influenced many younger architects. It was built of steel, cement, and colored glass and had glass mosaics as floors. Taut attributed his love for glass partly to the poems of Paul Scheerbarth, which were published under the title of *Glasarchitektur (Glass Architecture)* in 1914. Scheerbarth believed that glass walls would improve humanity since people would be visible to one another most of the time. – Ed.

L. DE MARSALLE:
"CONCERNING THE SCULPTURE OF E. L. KIRCHNER" (1925)

Louis de Marsalle was the pseudonym adopted by Ernst Ludwig Kirchner for several essays and articles he wrote on the subject of his own work. In 1920, the highly sensitive Kirchner first employed this nom de plume in an article entitled "Zeichnungen von E. L. Kirchner" ("The Drawings of E. L. Kirchner"), which appeared in the important art journal *Genius*. This article was illustrated with twenty-one of Kirchner's drawings. Other "de Marsalle" publications included: "Über Kirchners Graphik" ("Concerning Kirchner's Graphic Work"), *Genius*, 1921; "Über die Schweizer Arbeiten von E. L. Kirchner" ("Concerning E. L. Kirchner's Swiss Period"), the foreword to the catalogue of an exhibition of his works held at the Galerie Ludwig Schames in Frankfurt in 1922 (reprinted in *Europa-Almanach* in 1925); and "Über die plastischen Arbeiten E. L. Kirchners" ("Concerning the Sculpture of E. L. Kirchner"), *Der Cicerone*, vol. 17, no. 14, 1925, pp. 695–701, which is translated here. The images reproduced as figures 1 – 3 and 5 – 7 were included in the original article. Kirchner wrote two additional catalogue introductions under this pseudonym, one for an exhibition of his work held at the Galerie Aktuaryus, Zurich, in 1927 and one for an exhibition held at the Kunsthalle Bern in 1933 – at the time, the largest exhibition of Kirchner's work ever held.

In choosing his pseudonym, Kirchner created a French critic who openly admired his German style. Although he never revealed his reasons for adopting this disguise, it is generally agreed by scholars that the choice was made as a conscious attempt on Kirchner's part to counter the widely held opinion that modern art both originated and experienced its zenith in France. Permission to translate this essay is courtesy of Dr. Wolfgang Henze, Campione d'Italia. – P.W.G.

When one frequents the workshops of creative artists, one often experiences surprises. When I visited the studio of E. L. Kirchner one day, I found there a number of sculptures of all sizes and of different kinds of material – sculptures Kirchner was using to explain his idea of sculptural form to a young artist.

Although some museums and private collectors own a few of his pieces, Kirchner's plastic work is almost unknown, and I believe it is finally time to publish something in relation to it. Kirchner's sculpture is not only of great importance in regard to his own work but during the past years has also had a stimulating effect on a number of young artists. Thus it seems to be in a position to initiate a new movement in the very backward sculpture of our time. As far as I know, Kirchner is in our day the only sculptor whose forms cannot be traced back to classical antiquity. Just as in his paintings, he gives his experiences direct form in characters taken from contemporary life. His sculpting began simultaneously with his painting, thus going back to the year 1900.[1] Both modes of artistic expression ran so closely parallel to one another and so completed each other that, in many cases, the same problem is addressed in the paintings as in the sculptures. Kirchner's still lifes and interiors often contain figures that he has sculpted earlier. Thus he transposed a form from one mode of artistic expression to another, until he found the solution offering the strongest expression. In this manner, Kirchner gained the insight that the intensive study of nature and the assistance of the imagination could create a new form far stronger and of more intense effect than a naturalistic rendition. He discovered the hieroglyph and enriched our modern period with an important means of expression, just as in their own time Seurat invented the *touche*, the breaking up of color, and Cézanne the system of the cylinder, cone, and sphere.

Kirchner's sculptural efforts, which extend over a period of twenty-five years, very clearly show his

development in this respect. Already the early, wooden *Crouching Woman*, taken as a total composition, is an absolute hieroglyph of the term *Crouching*. The composition of the body, which has been condensed into the cube, could not have been rendered more intensely or unequivocally. At the same time the figure possesses great liveliness. However, these works of Kirchner have hardly anything in common with what one nowadays refers to as sculpture. They are as far removed from the Greek as from the African, for they are born from the immediate perception of today's life. Certainly, it is a long way from this early *Crouching Woman* to the *Friends* [fig. 5, p. 46] or the *Lovers* [fig. 3, p. 53]. But the thread of development is nowhere interrupted.

It is most significant that from the very beginning Kirchner rejected as inartistic a working method generally practiced by sculptors today: namely, proceeding from a clay model by way of a plaster impression to the actual material. He creates his figures directly out of the material. One has to realize that in the case of the old working method, only the clay model is actually created by the artist, whereas the end result and all work toward it is done by other hands. In light of this, the dismal uniformity of our sculpture exhibitions becomes readily comprehensible, and in viewing the sculptures one often asks oneself what in these works of art the artist is actually still responsible for. In the case of sculpture the material is far more decisive than in painting; and the sculptor leaves it to other hands to fashion this material. How different that sculpture appears when the artist himself has formed it with his hands out of the genuine material, each curvature and cavity formed by the sensitivity of the creator's hand, each sharp blow or tender carving expressing the immediate feelings of the artist. One must keep this in mind when viewing the *Female Dancer with Extended Leg* which he carved out of oak [fig. 1, p. 43, and cat. no. 66], or the *Head of Erna* [fig. 3, p. 44, and cat. no. 67], or the *Friends*.

What would one have to say concerning paintings for which the painter provided only outlines, specify-

Fig. 1
Female Dancer with Extended Leg (cat. no. 66), 1913.

||
1. For a discussion of the difficulties encountered in dating Kirchner's work, see essay by Henze, p. 114. – Ed.

ing which colors were to be applied within them, but leaving the execution to an assistant? For in painting, this would be analogous to what is today standard practice in sculpture.

In sculpture Kirchner discovered very important laws: above all, the overriding importance of the large, total form and its creation from the proportions of the individual forms. He sculpts the wood block according to its nature, forming the small form out of the large. He finds a method by which the changed proportions may remain subservient to the overall composition. So the *Friends* give the impression of being as big as giants, although they are only 175 centimeters high, because they have larger-than-life heads. Kirchner's striving for monumental simplicity induces him to press the human body into ever simpler form. For example, in the *Lovers* he reduces the female nude to a pointed oval shape and thereby strongly and intensely expresses the soft sensuality of the female body.

He finds new solutions for the equilibrium of moving bodies. Kirchner's *Rearing Horseman* maintains his equilibrium because the horse's legs have been made stronger. In a much more primitive manner, the Baroque sculptor balanced the equestrian statue of Augustus the Strong in Dresden-Neustadt by making the tail larger.

In my essay on Kirchner's graphic art which appeared in *Genius,* I attempted to demonstrate, using the *Melancholy Woman* as an example, that Kirchner has found a novel way to solve the problem of rendering the expression of the soul in sculpture. There, in order to create this expression, he shaped the eye into a speaking hieroglyph. In *Woman and Girl* [fig. 6, p. 46], illustrated here, Kirchner put the expression of maternal concern into the shaping of the mouth. All these things have been rendered in a purely sculptural

manner. No matter what Kirchner creates, he will never become unsculptural.

He also places color in the service of his sculpture. With complete freedom and nonobjectivity, it is employed to heighten and accentuate the sculptural idea. There are figures from earlier times, such as the *Crouching Woman,* in which coloring creates form directly. There are heads on which the eyes and mouth have been painted in order not to interrupt the larger form. Often this results in very special effects. The richness of color of Medieval sculptures seems about to rise again, except that the modern period applies color very differently than did the old masters.

Kirchner's sculpture works mainly with simple basic shapes: cylinder, cone, egg-shape, and sphere. Cube and oblong occur more indirectly as forms of composition. These simple forms do not originate from mathematical speculation, but rather from a drive toward monumentality. Kirchner desires and forms men and beings, not soulless artistic shapes. This alone distinguishes his works from the rest of modern sculpture which, with a few exceptions, is oriented more or less toward arts and crafts.

Kirchner is one of the very few contemporary artists who is gifted enough to create new forms and a new style. But his works also have a spiritual message. That is their specifically German quality. They mean something, one may think of something when viewing them, yet they are not literary. A work such as *Friends* would be wonderful in a modern meeting room of modern men, because of its external shape as well as its spiritual meaning. The material that Kirchner most prefers is wood. He also likes to work in stone, and a few figures from his hand are cast as well. The works reproduced in this article constitute a selection from his entire sculptural oeuvre between 1900 and 1924–25.

Fig. 2
Crouching Woman (Hockende),
1909–10
Cast tin
h: approx. 20 cm. (7¾ in.)
Photograph by Kirchner

Fig. 3
Head of a Woman, Head of Erna
(cat. no. 67), 1913; photograph
by Kirchner.

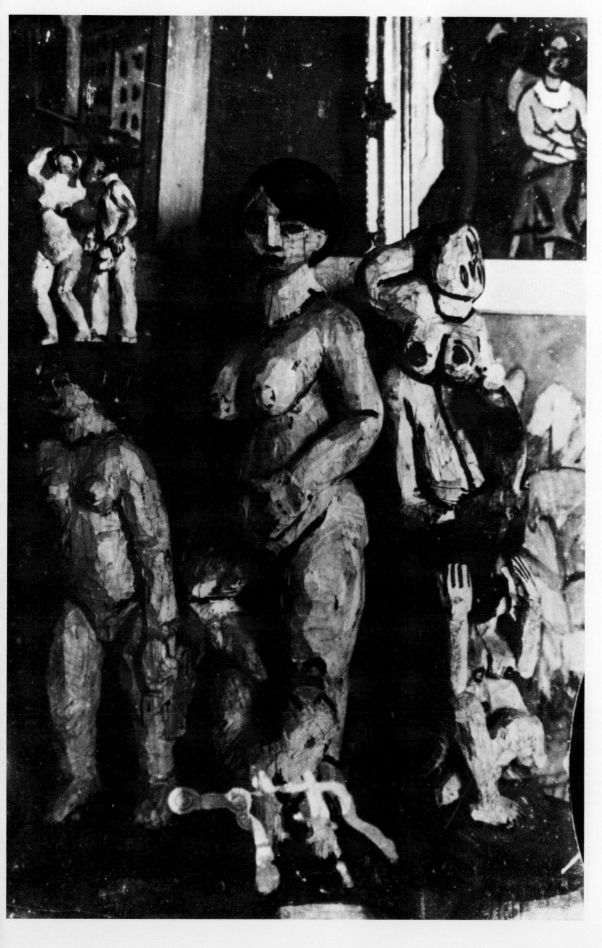

Fig. 4
Group of paintings, together with six sculptures from the years 1910–11, photographed by Kirchner. The painting *The Bosquet; Square in Dresden* (1911; Gordon, 198) may be seen at lower right. Since Josef Feinhals acquired this painting in May 1912 at the Cologne *Sonderbund* exhibition, the photograph must originate no later than that date. Lower left: *Nude with a Bath Towel/Bathing Woman (Akt mit Tuch/Badende)* [1905], wood, formerly in the collection of the Museum für Kunst und Gewerbe, Hamburg, See fig. 1, p. 52.

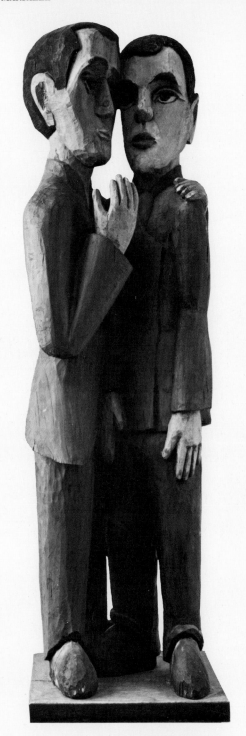

Fig. 5
The Two Friends (Die Zwei Freunde), 1924–25
Wood, painted
h: 175 cm. (68⅞ in.)
Kunstmuseum Basel

See woodcut (cat. no. 72) and
painting of the same name and
date (Gordon, 763). Subjects are
Hermann Scherer (right) and
Albert Müller (left). Also see
photo of the artists, fig. 12,
p. 128.

Fig. 6
*Mother and Child/Woman and
Girl (Mutter und Kind/Frau
und Mädchen)*, 1923
Wood, painted
h: 90 cm. (35⅜ in.)
Private Collection
Photograph by Kirchner

Fig. 7
Cow (Kuh), 1920–23
Swiss stone-pine, painted
Private Collection

Photographed by Kirchner in
1925 in front of the Wildboden
House in Davos.

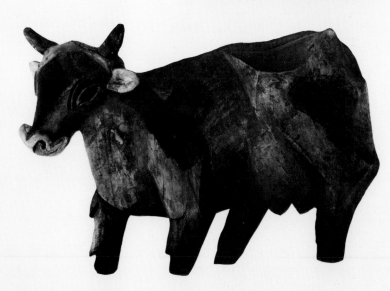

MAX OSBORN:
EXCERPT FROM *MAX PECHSTEIN* (1922)

Max Osborn (1890–1946) was the editor of the *Vossische Zeitung,* one of the oldest and most widely circulated Berlin newspapers. In addition to being an influential journalist and sensitive observer, he was one of the best-known theater and art critics of his day. His 1922 monograph *Max Pechstein* – originally published by Propyläen Verlag and excerpted here – was the first comprehensive work on the famous Brücke artist. Other works by Osborn include *Der Holzschnitt (The Woodcut),* published in Bielefeld in 1905, and his memoirs, *Der bunte Spiegel: Erinnerungen aus dem Kunst-, Kultur- und Geistesleben der Jahre 1890 bis 1933 (The Colored Mirror: Memoirs of the Artistic, Cultural, and Intellectual Life of the Years 1890 to 1933),* which were published in New York in 1905 and contain important observations on the Expressionist period. The images reproduced here as figures were included in the original text. For additional information on Max Pechstein, see this catalogue, pp. 168–69. – P.W.G.

The strong sense of form which led the painter Pechstein to the graphic arts also initiated his experiments with sculpture. Impressionism had rarely sent its disciples to the neighboring country. Yet the movement of those who aspired to a decorative-monumental style of painting – that movement which had once accompanied the triumphal procession of the plein-air painters – was characterized by its development of a secret love of sculpture. The German-Romans heeded this call until the time of Klinger.[1] Expressionism, separated from them by oceans but nevertheless connected by the secret channels of a subterranean stream – Marées[2] – in accord with its nature had to feel itself drawn back to sculpture.

Looking at Pechstein's paintings, at Pechstein's head and body, one would think that he would have worked even more as a sculptor on the side. But time and again it becomes obvious that by nature his sensual world view is so specifically focused with such intensity on the enjoyment of color that he could never be lured too far away by the abstraction of pure form. At any rate, his delight in craft at times moved him to also be active in the latter arena.

Here, too, one can trace a logical and clear stylistic development running parallel to that of his painting.... In 1909, Pechstein carved several sculptures that did not deny their origin in the final phase of Impressionism. Rodin's art seems to have acted as godfather. Pechstein created a male bust that he himself cast, using a plaster model. He utilized the tin of discarded paint tubes. The bust is completely oriented toward capturing the momentary impression, toward movement. Just as Rodin had before, Pechstein made an attempt to capture the liveliness of natural appearances, to grasp the elements of a motion, the transition of a motion, detached as autonomous parts from the picture of reality. This manner is represented even more pronouncedly in a bronze, the subject of which is a mother breast-feeding her child. The movement is tremendously bold. The mother's body is bent forward beyond all natural posture, coiled, almost distorted. Obviously, Pechstein's intention is not simply to model the two figures, but rather the mystery of motherly

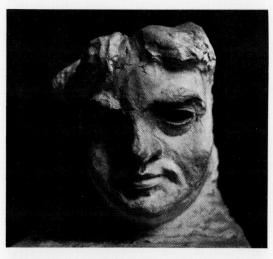

nurturing. He wanted to express the essence of motherhood. The exaggeration was intended to serve this purpose. But within these parameters his presentation is completely in the manner of Rodin or of the younger Belgians who followed the French master. As in the tin bust, muscles and tendons, particularities of bone structure and skin, continue to speak. Later on such works can no longer be found. For in Pechstein's later sculptures, even when he allows his imagination to roam freely, he now seeks to concentrate the message of form; he is attempting a definite structure of authoritative planes, which are defined by clear, unambiguous contours. Once in a while he found a piece of marl on the North Sea island of Helgoland, and was unable to resist the temptation to carve a few small figures with his knife out of the soft and artistic material – mermaids [figs. 4 and 5, p. 49], small squatting figures, half-animal, half-human, as if a wave had washed ashore a few petrified creatures from the bottom of the sea. They are odd sisters of the round, nude women who crouch on the beach in Pechstein's coastal paintings. They are miniature versions of the massive women with whom we are familiar, whose animalistic physicality is here turned, in a funny and secretive way, into that of fairy-tale creatures.

But the true joy of sculpting took full possession of Pechstein only when he discovered the material that perfectly corresponded to his character: wood. A carved bust of 1913 reveals the complete transformation. The material was problematic; it offered stronger resistance; therefore the depiction of nature was reduced to what constitutes its critical surface com-

||

1. Max Klinger (1857–1920): Nineteenth-century sculptor, graphic artist, and painter of complex allegories. – Ed.

2. Hans von Marées (1837–1887): Important nineteenth-century German Romantic painter, who resided in Italy from 1873 until his death. – Ed.

Fig. 2
Head (Kopf), 1913
Wood
Lost

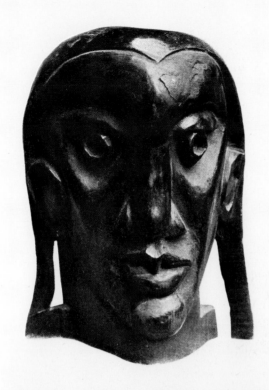

Fig. 3
Vase Carrier (cat. no. 112), 1909.

plexes. The stricter style of Pechstein the painter is mirrored here. And just as the South Sea journey brings this style to fruition in Pechstein's painting, here too, Pechstein's sculptural activity culminates in the decorative simplification of his carved figures of 1919. This simplification constitutes a stripping away, consciously and fundamentally, of everything that might be considered imitative of nature. *The Nun* [fig. 8, p. 50], the *Moon* [fig. 9, p. 50], the *Quarter Moon* [fig. 6, p. 49] – these are carvings which to a large extent reflect the primitive artistry with which Pechstein had become familiar on the Palau Islands: small idols, freed from the tree trunk, whose shapes shimmer through the enchantment; dreamlike appearances, the head and limbs of which are beginning to move in what seems to be the twilight of half-consciousness. They have a motionless, strictly bound posture, with extreme concentration on the structure of form. Just as in Pechstein's woodcuts, color is often added to these woodcarvings as an enlivening element. The figures are painted in dark, full, and expressive colors, the strong contrasts of which adapt to the crude spatial cuts of the knife. The tones correspond to the material and become one with it. Thus these fruits of leisure hours filled with rich imagination have become impressive and enigmatic symbols of Pechstein's idea of art.

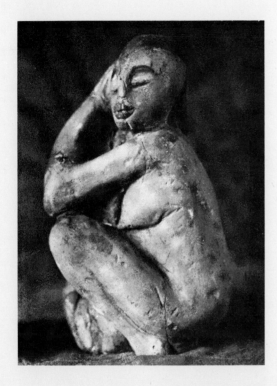

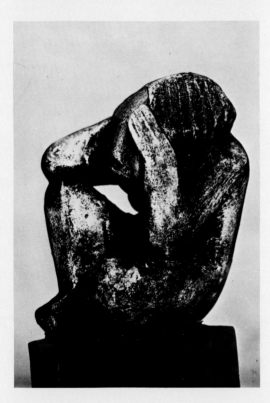

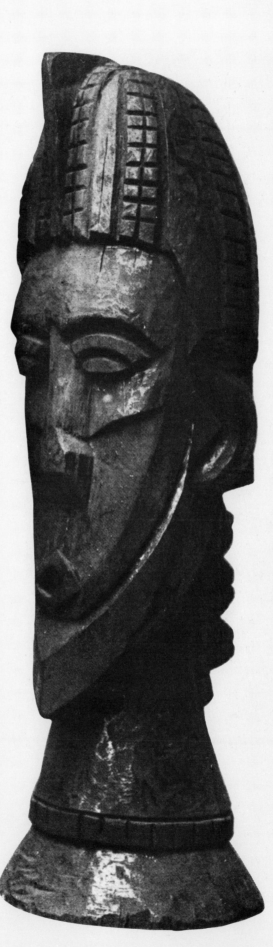

Fig. 4
Mermaid (Meerweibchen), 1913
Marl
Lost

Fig. 5
Young Mermaid (Meerjunges),
1917
Marl
Lost
Photograph by Pechstein

In Osborn's publication, the
date given for this sculpture
was 1918. This has been
changed here to follow Wietek
(see p. 169).

Fig. 6
Quarter Moon (Viertelmond),
1919
Wood
Destroyed 1945 in Pechstein's
Berlin studio.

Fig. 7
Wood Sculpture (Holzskulptur),
1919; lost.

Fig. 8
The Nun (Die Nonne), 1919
Wood
Lost

Fig. 9
Moon (Mond), 1919
Wood
h: 105 cm. (41⅜ in.)
Destroyed 1945 in Pechstein's
Berlin studio.

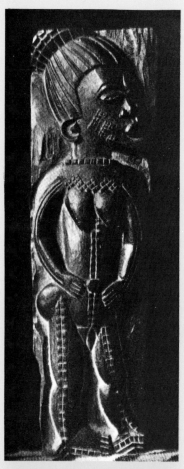

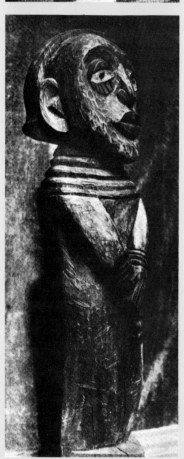

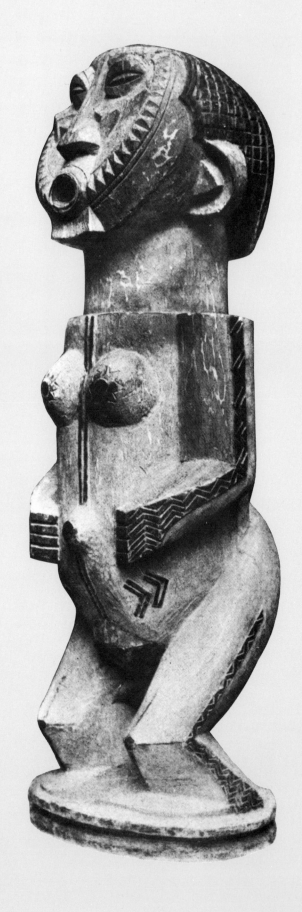

MAX SAUERLANDT:
"WOOD SCULPTURES BY KIRCHNER, HECKEL, AND SCHMIDT-ROTTLUFF IN THE MUSEUM FÜR KUNST UND GEWERBE, HAMBURG" (1930–31)

In 1919, [Friedrich August] Max Sauerlandt (1880–1934) was appointed director of the Museum für Kunst und Gewerbe, Hamburg. In this position, he became the first German museum director to acquire and exhibit Brücke sculpture systematically in a public museum. As early as 1926, he began planning an exhibition of Brücke sculpture and crafts, and the 1929 reinstallation of the modern collection enabled him to exhibit Brücke works throughout the Museum für Kunst und Gewerbe. Sauerlandt also served as the acting director of the Landeskunstschule Hamburg starting in 1930 and was a professor at the Universität Hamburg, where in 1933 he taught a course – remarkable in its time – entitled "German Art of the Last Thirty Years."

Several of Sauerlandt's many publications were devoted to the introduction and defense of the German Expressionists. In 1932, aware of the political threat posed by the Right, he wrote to a Danish friend describing the Expressionists as "the pillars of the bridge…which is built across the abyss threatening us." Sauerlandt was frequently criticized for his acquisition of Expressionist art and was removed from his university and museum positions by the Nazis shortly before his death in 1934. The essay translated here was originally published as "Holzbildwerke von Kirchner, Heckel und Schmidt-Rottluff im Hamburgischen Museum für Kunst und Gewerbe" in the journal *Museum der Gegenwart: Zeitschrift der Deutschen Museen für Neuere Kunst,* no. 1, 1930–31. The images reproduced here as figures 1 and 3 – 7 were included in the original essay. Permission to translate this essay is courtesy of the Museum für Kunst und Gewerbe, Hamburg, and Frau Charlotte Specht, Hamburg. – P.W.G.

These fictions, these hieroglyphs that every art needs, are understood so poorly by those who want all truths to be natural, and who thereby tear art out of its sphere. – Goethe, *Plato as a Companion of Christian Revelation,* 1826

In 1910, the decisive year for the contemporary period of German art, Max Liebermann, in his last term as president of the Berlin Secession, declared the following before Manet's *Execution of the Emperor Maximilian:* "In the face of this painting we find the confirmation of the truth that yesterday's revolutionaries have become today's classics."

Since then the wheel has continued to turn, and the revolutionaries of 1910, who had been rejected by that exhibition, have become the recognized leaders of 1930.[1] We are indebted to them for the most beautiful gift that a work of art can provide: a powerful heightening and expanding of our perspective on life, a complete renewal of our world view.

Perhaps it is possible to find within a period's final style, with all its apparent contradictions, the beginnings of the new – transitional forms that are, as they say, latent. Yet the common opinion of current historians – who would like to believe in an even flow of development and who hold that a violent break with tradition is impossible – is wrong. Even in the stream of artistic events there are cataracts – revolutions that bring forth an entirely new picture.

We have witnessed such a spiritual revolution. It took place during the fertile five years prior to the year 1910. With infallible instinctual certainty the artists who at that time created the foundations of a new form

sensed that the ring of the developmental chain was closing. In their own time they sensed what Philipp Otto Runge[2] felt a hundred years earlier when he wrote: "Today once again something is coming to an end." Now what was coming to an end was the period of Impressionism, the last sigh of relief of a long life of art, which in its best representatives had certainly shown greatness.

It was a rich time for painting, which was then experiencing its first blossoming. Never before had so many great names and works appeared – and yet it was only the beginning.

The works of art created during that period have made us aware of needs that we never experienced before, and in this awareness lies the path of our rejuvenation: a need for form and color that are neither a rendition of reality nor an intensification of the forms and colors of reality but on the contrary, something entirely different that must autonomously stand in opposition to the appearance of reality, for the work of art bears within itself the law of its own form.

Will the art of our times have far-reaching effect? One cannot measure with a yardstick effects upon the soul. Not breadth, but *intensity* of effect is decisive. And this intensity of the immediate effect is there. It guarantees a breadth of effect as well. Spiritual change has always come about in this way: from the few to the many – but only if the few are conscious of their obligation. The generation growing up today is already changed deep inside; it has, consciously or unconsciously, taken on the character of the new form. And this art has already proven to have the strength that brings forth life.

We can without doubt say this in regard to painting. But it does not yet apply, at least not yet in the same degree, to the plastic form of sculpture. *Nostra culpa.*

Who, after all, knows anything about the fact that sculpture, too, as is only natural, has experienced the

||

1. The jury of the Berlin Secession rejected twenty-seven Expressionist artists who thereupon founded their own exhibition group – the Neue Sezession. Among the rejected were the members of the Brücke (Kirchner, Pechstein, Schmidt-Rottluff, and Mueller), as well as Moriz Melzer, Caesar Klein, Walter Helbig, Georg Tappert, Jakob Steinhardt, and others. The Neue Sezession exhibited fifty-six paintings at the Galerie M. Macht in Berlin in 1910. – Ed.

||
2. Philipp Otto Runge (1777 – 1810): Outstanding painter recognized by Goethe and others as the founder of German Romanticism. – Ed.

Fig. 1
Kirchner
Nude with a Bath Towel/Bathing Woman (Akt mit Tuch/Badende),
1909–10 [1905]
Wood, painted
Formerly Museum für Kunst und Gewerbe, Hamburg
Destroyed by the Nazis in 1937

The 1905 date was provided in the original essay. For a discussion of the difficulties encountered in dating Kirchner's sculpture, see Henze, p. 114.

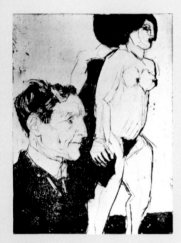

Fig. 2
Rolf Nesch
(German, 1893–1946)
Portrait of Max Sauerlandt (Bildnis Max Sauerlandt)
1929
Etching
45.3 × 33.5 cm. (17⅞ × 13¼ in.)
Museum für Kunst und Gewerbe, Hamburg
(in exhibition)

In the background of this portrait of museum director Max Sauerlandt is Kirchner's *Nude with a Bath Towel/Bathing Woman (Akt mit Tuch/Badende),* 1909–10, [1905], (fig. 1, p. 52).

same decisive new beginning during the same decisive years? If one runs through the old exhibition catalogues of the Berlin Secession from the first decade of our century, it becomes frighteningly clear to what extent the feeling for the true artistic value of plastic form had died off in Germany at that time. That the boundary between nature and art had been obscured by a "monstrous skillfulness" holds true even more for the sculpture of that time than for its painting.

And yet these years may be seen to have been of equally fundamental importance for sculpture when we look at the first plastic works of the same artists who initiated the new era of painting. But these first sculptures remained at that time, and even today, unseen in the studios. Or they remained accessible only to the few, in the rooms of individual confidants.

This achievement cannot be recognized completely, and will remain without effect, if these works do not also find their long-overdue place in public collections, as is now the case in Hamburg.

The *Nude with a Bath Towel / Bathing Woman* [fig. 1, p. 52] drying herself off, sculpted by Kirchner in 1905, is the first and perfect example of the meaning of the "rhythm of the closed form" and "closed composition" in plastic art. In *one* uniform motion of articulated limbs, the human form, its height towering diagonally to the left, has been projected into the full alder block. It has been cut out of the full block, carved out in the powerful and lively rhythm of the constructed masses of head, trunk, legs, and feet with heavy blocks underneath. The rhythm of color is equally grand, the strong and uniform yellow of the body being structured by the black, whereas the white of the bath towel heightens the intensity of the black and yellow, binding the mass of the block together.

The pure, full colors of the painted wood nowhere cover up the structure of the wood or the traces of the work. Every blow of the axe and every cut of the knife remain directly, sensually perceptible, touchable to the eye. This is a genuine, unconcealed art of wood sculpture, quite different from the colorful wooden sculptures of the Middle Ages in which the background of chalk and layers of paint and gilding make the wooden core completely disappear. In contrast, the particular artistic charm of this sculpture lies in the extremely fresh and lively treatment of the wood surface.

This is a figure that has been created by virtue of a truly admirable free spirit and inner independence, and its early year of creation initiates an era. Its spirit may be seen in all other wooden figures of this artistic circle, up to the present day: in the works of *Erich Heckel,* who uses color more sparingly most of the time; and in those of *Schmidt-Rottluff,* whose plastic forms themselves are so sharply and deeply structured, so markedly chiseled, that color is no longer required for the intensification of the rhythm of forms. On the contrary, color serves to bind the forms together into one unit.

This may be seen, for example, in the two birch *Heads* in the Hamburg Museum. They originated dur-

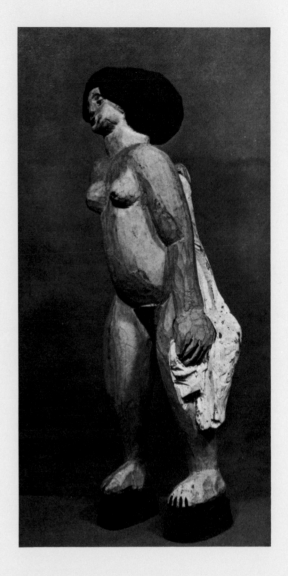

ing the War, in the year 1917. One of them is uniformly painted a dark red [*Red Head,* fig. 7, p. 54]; the other one, *Young Lithuanian Woman* [fig. 6, p. 54], a brilliant green. The colors hold their own beautifully next to the refracted, dense glass colors of Schmidt-Rottluff's first mosaic from the year 1924. The mosaic and sculptures are both in Hamburg; they are exhibited in the same staircase setting, which was remodeled in 1930.

The forms of drawing, painting, and sculpture grow out of one and the same root. Kirchner still has his drawings of the same model who served as the basis for the yellow *Nude with a Bath Towel / Bathing Woman.*

The idea for the *Lovers* [fig. 3, p. 53] of 1923 goes back even further. The woodcut *Before the People* (Schiefler, 65, ill. [Dube I, 45])[3] originated in 1900, as the fifth page of the cycle *Man and Woman.* [In the woodcut] in front of a light background the couple, embracing and walking on the crest of a hill, to the right; in the foreground, a sardonically laughing and finger-pointing crowd; on the left black margin, white ornamental lines repeat in abstract form the contents of the picture. Fully twenty-four years later, the final *painted* version of this motif followed, in the great painting of Kirchner's mature style [fig. 4, p. 53]. One year previously, he had carved the *Lovers* from a huge block of Swiss stone pine, the "wonderful high mountain tree," as he writes. In the entire alpine area, all the way down to Salzburg, its resinous wood is used for carving, particularly for the big masks.[4]

The composition of the painting, with its large areas of color, has been anticipated by the wooden sculpture, with its contrasting orange-colored ocher of the female and the reddish brown ocher of the male body, as in the painting of classical antiquity where the sexes are differentiated through a stark contrast in color. Again, as in the case of the *Nude with a Bath Towel / Bathing Woman,* in this instance of a couple speaking in subdued gestures, color serves not only to sexually differentiate but also to interpret the clear structure of the masses and to give a lively rhythm to the plastic-spatial form.

Schmidt-Rottluff's archetypal artistic method and Heckel's tender form contrast with Kirchner's ingenious mode, in spite of the identical pictorial material and the basically identical technique. This is exemplified for Schmidt-Rottluff by the aforementioned *Heads* of 1917, in which grim seriousness and heated passion are restrained; for Heckel, by a large *Standing Woman* [fig. 5, p. 54] of 1912, a Mary under the Cross, or even better, a Madonna of the Annunciation. It is a sculpture of maple wood which shyly covers its nakedness, so to speak, in itself.

One may be in doubt as to which of these plastic styles should be awarded the highest rank. Yet in each

||

3. Dube, 1967.** – Ed.

4. The "big masks" referred to here are an important southern German and Austrian form of folk art. These masks are worn at Fasching (the season prior to Lent) in parades and processions. – Ed.

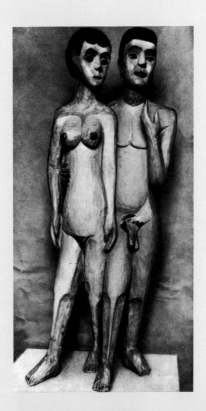

Fig. 3
Kirchner
Lovers (Liebespaar), 1923–24
Swiss stone pine
Formerly Museum für Kunst und Gewerbe, Hamburg; destroyed

Also known as *Couple.*

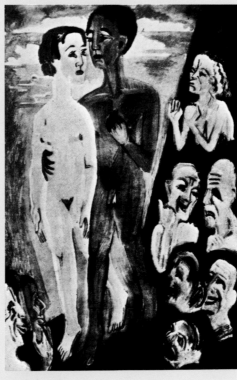

Fig. 4
Kirchner
Two Against the World (Das Paar vor den Menschen), 1924
Oil on canvas
150.5 × 100.5 cm.
(59¼ × 39½ in.)
Kunsthalle, Hamburg
Gordon, 765

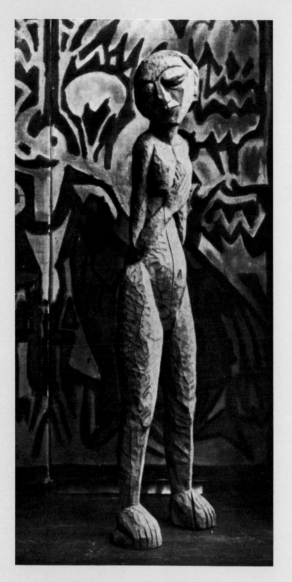

Fig. 5
Heckel
Tall Standing Woman (Grosse Stehende), 1912
Maple
h: 175 cm. (68⅞ in.)
Formerly Museum für Kunst und Gewerbe, Hamburg; lost since 1937
Vogt, 8

Acquired in 1930 by Max Sauerlandt for the Museum für Kunst und Gewerbe, Hamburg, this was one of Heckel's largest figures. Confiscated by the Nazis in 1937, it was illustrated in the *Entartete Kunst* catalogue (p. 19), where it was described as a work "which truly bears a greater likeness to gorillas than to human beings." Also exhibited at the *Freie Sezession* exhibition, Berlin, summer, 1920 (see fig. 1, p. 112).

one, the specific form is unequivocally defined in itself, as is also the case in the painting styles of the same artists, who thus once more prove their inner freedom and their independence.

Certainly, this is a kind of form we are unaccustomed to. Even today, all of this has a strange effect on us. But it is a kind of form that is speaking to us clearly, in the primeval sounds of plastic creativity and spiritual expression. These heavy and serious sculptures of our time emphatically declare that art is no child's play, that works of art are not being created for entertainment, and that the often misused word *beautiful* has lost all meaning in relation to the work of art, because its creation has a different starting-point and a different goal than the starting-point and goal of so-called classical art. Certainly, it is an art that grew *out of our time*, not in spite of it or *against it*. It reveals the deep spiritual problems of our present day. But by presenting them, it already contains their solution.

Such a form of art could be found only on individual paths, and he who before these works of art – be it in a laudatory or a shoulder-shrugging manner – speaks of "Negro art," only proves that he does not possess a sense for the decisive differences of artistically related phenomena, which it is all-important to see and to perceive. In order to become a work of art, every new perception demands its own *techne*, so as to unite the content and craft-method of the sculpture. If a new interpretation of the world were expressed in the usual form, by the usual means, it would have a literary originality at best. The new work of art can only find its inception in the fusion of new perception with new form, as we find in these modern sculptures.

Fig. 6
Schmidt-Rottluff
Young Lithuanian Woman (Litauisches Mädchen), 1917
Birch
Formerly Museum für Kunst und Gewerbe, Hamburg; destroyed
Grohmann, p. 280

Fig. 7
Schmidt-Rottluff
Red Head (Roter Kopf), 1917
Birch
Formerly Museum für Kunst und Gewerbe, Hamburg; destroyed
Grohmann, p. 280

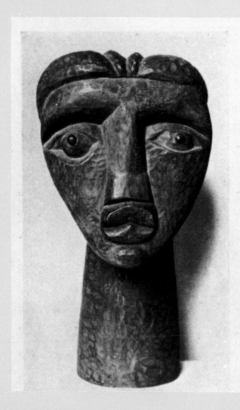
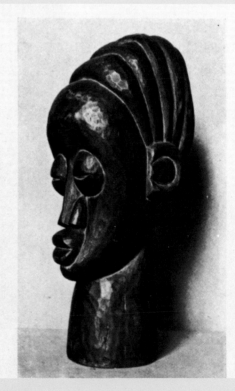

Fig. 8
Brücke art as installed by Max
Sauerlandt in the stairwells of
the Museum für Kunst und
Gewerbe, Hamburg, 1930–33.
From left to right: a Schmidt-
Rottluff mosaic; Heckel's *Tall
Standing Woman* (fig. 5, p. 54); a
Schmidt-Rottluff woodcut; and
Schmidt-Rottluff's *Red Head*
(fig. 7, p. 54).

Fig. 9
Brücke art as installed by Max
Sauerlandt in the stairwells of
the Museum für Kunst und
Gewerbe, Hamburg, 1930–33.
From left to right: Schmidt-
Rottluff's *Young Lithuanian
Woman* (fig. 6, p. 54); a woodcut
by Schmidt-Rottluff; Kirchner's
Lovers (fig. 3, p. 53); and
Kirchner's *Nude with a Bath
Towel/Bathing Woman* (fig. 1,
p. 52).

Archipenko

Alexander Archipenko

Born 1887 Kiev, Russia;

died 1964 New York, U.S.A.

Alexander Archipenko is regarded as one of the most experimental sculptors of the first third of our century. His numerous innovations in form, technique, and materials exerted an extraordinary influence on the course of development of modern sculpture.

In 1902, he entered the art school in Kiev, but, after a period spent studying the fundamentals of painting and sculpture, he developed a definite aversion to academic instruction. He moved to Paris in 1908 and began studying Egyptian, Assyrian, Archaic Greek, and early Gothic works on his own. Archipenko remarked of this time: "My real school was the Louvre and I attended it daily."[1]

While the earliest bronze sculptures that Archipenko created in Paris were influenced by the decorative lines of Jugendstil, or Art Nouveau (e.g., *Adam and Eve,* 1908), the works of the following year reveal a turn toward the primitive. His *Suzanne* of 1909 (stone, Norton Simon Museum, Pasadena, California), a voluminous torso with heavy hips, large hands, and reduced forms, would be unimaginable without the precedent of the blocklike sculptures of André Derain. Derain's *Crouching Figure* (1907, stone, Museum des 20. Jahrhunderts, Vienna) is immediately called to mind.

In 1910, Archipenko joined the Cubists and exhibited his works in the *Salon des Indépendants.* He began to engage in the geometric subdividing of the human body into the fragmented forms typical of Cubism. The figure became merely a vehicle to be transformed into a rhythmic interplay of volume and concave form, of light and shadow.

In this connection, the previously unpublished sculpture *Kneeling Couple in Embrace* (cat. no. 2) is exemplary. It combines the pronounced blocklike character of the sculptures of 1909–10 with a stylized interlacing of figures engaged in coordinated processes of motion. This latter motif is also apparent in the two sculptures entitled *The Kiss* (1910 and 1911, plaster *[Gips],* 1911 version destroyed), in which the bond of the figures to the block is further strengthened by a strong base. The special weight and expressive deformity assumed by the forms in the *Kneeling Couple* are not solely due to the choice of wood as a medium. In fact, as opposed to the sculptures of the Brücke artists, the effect of the wood as material has been considerably reduced. Archipenko was concerned with the extreme abstraction of the physical form and its transformation into a rhythmically animated configuration. In this particular sculpture, the differing degrees of abstraction evidenced in the various forms reflect a stage of the artist's development: the fusion of objective form and autonomous structure feels slightly forced.

1. Quoted in Wiese, 1923.

The bronze *Draped Woman* (cat. no. 1) is even more dominated by contrasting forms, which in this case comprise a traditional motif of figural sculpture – body and garment. The contrast of the softly rounded, stylized body and the hard, angular folds of the material is diminished by abstraction – notably the cutting off of the left arm. Apart from these characteristics, the figure owes its Expressionist effect to the tension of its proportions and to the dynamic equilibrium of the body. As in the *Kneeling Couple,* the shape of the base emphasizes the three-dimensionality of the sculpture.

In 1912, Archipenko sent his work to the Folkwang Museum in Hagen, where his first German one-man exhibition was held. In Germany, sculptors reacted slowly to Archipenko's innovations, due in part to the adverse conditions which existed during the First World War. In their ready-mades, the Dadaists were influenced by his novel creative techniques and combinations of materials, while the late Expressionists of the Berlin Novembergruppe (Belling, Emy Roeder, Garbe, and Herzog) took up his less provocative sculptural forms, concentrating on the Cubist reduction of form and on the activation of voids.

During the early teens, developments in Archipenko's work were various and complex. He arrived at an equal treatment of void and mass, as seen in his *Striding Man* (1912, bronze) and *Woman Combing Her Hair* (c. 1914, bronze). This dissolving of form was followed by constructions related to Synthetic Cubism. The *Walking Woman* (1912, bronze) consists of a combination of heterogeneous parts which no longer imitate organic forms but merely invite objective associations through structural context.

Apart from these pioneering works, a second group developed, which at first glance appears more conventional. It replaced the montage principle with the dynamic arabesque of motion. Like the first group, however, volume was reduced and composition lightened. In *Red Dance* (fig. 2, p. 58), the figure reaches out into or embraces space, animating the spatial environment. The figure's communication of specific sculptural values is more important than its objective motif of motion. The free proportioning of the body emphasizes the rhythm of movement, and the parallel and symmetrical relations of the individual parts of the body reveal the contrast of mass and space. *Blue Dancer* (1913, bronze) is a comparatively more balanced version of this dance motif.

A third group of works, even more important for the development of modern sculpture, also originated around 1912. The "sculpto-paintings" display rhythmic contrasts through new combinations of materials – wood, glass, wire, found objects – as well as novel techniques – for example the combination of collage and painting (e.g., *Medrano I,* 1912, figural construction of wood, glass, metal, metal wire; probably destroyed during World War I). In his selection of new materials on the basis of their aggressive modernity, Archipenko fulfilled Boccioni's demand as stated in

his *Manifesto tecnico della scultura futurista.*[2] Archipenko's technique of assemblage furthered the development of the collage into three dimensions.

Archipenko's *Carrousel Pierrot* (1913, painted plaster *[Gips],* The Solomon R. Guggenheim Museum, New York) synthesized some of his innovations; the robotlike sculpture demonstrates mechanization of the figure by the introduction of abstract geometric elements. The thin, flat planes and the mechanical formal connections of Archipenko's 1913 bronze head constructions and his sculpture *Boxers* (c. 1913, bronze) (the latter was described by art historian Carola Giedion-Welcker as a "plastic play of fugues") correspond to the principles of Synthetic Cubism found in Duchamp-Villon's *Horse* (1914, bronze) and Jacob Epstein's *Rock Drill* (1913–15, bronze).

By the beginning of the twenties, critical awareness of Archipenko's historical merits had lessened, in part due to the altered orientation toward Neue Sachlichkeit. The critic Carl Einstein attempted a polemical devaluation of Archipenko as an imitator of Picasso's Cubist painting. At times it appeared as if Archipenko was himself in compliance with such polemics, for during the twenties he was largely content with creating variations on his previous inventions, although some new figure types were added. An exhibition tour of Europe in 1919–21 made Archipenko's work widely known, and in 1921 he had his first American one-man exhibition at The Museum of Modern Art in New York. In 1921–23, Archipenko lived in Berlin, where he met his wife, the sculptor Gela Forster (née Angelica Bruno-Schmitz), who was a member of the Sezession: Gruppe 1919. (See pp. 30–33 of this catalogue for a contemporary account of Forster's work.) During this period, Archipenko's reputation in Germany was at its peak, but the artist's one-man exhibition at the Kunsthalle Mannheim in 1922 was to be his last German exhibition for many years.

When Archipenko moved to the United States in 1923, his work was already well known from his participation in the 1913 *Armory Show.* Upon his arrival in New York, he founded an art school and in 1924 invented the "Archipentura" – a variable image system or "movable painting" which presented that medium in temporal as well as spatial terms.

Sustained European connections are reflected in the artist's portraits of the twenties and thirties. From the very beginning of his career as a sculptor, Archipenko had created portraits, his stylistic range extending from naturalism to the extreme *Head Construction with Crossed Planes* (1913, bronze). Archipenko's portrait of Wilhelm Furtwängler (cat. no. 3) was based on his impressions of the conductor's performance at a concert in New York in 1927. The vivid modeling of the sculpture's surface, the impressive play of light and shadow, and the extension of gestures into space create a baroque realism that recalls the work of Rodin, whom Archipenko had so strongly opposed in his early work.

In 1937, Archipenko's works were removed from German museums as "degenerate." But his productivity in America was unabated. In 1928, he had become an American citizen; American museums were eager to acquire his work, and he was also in demand as a teacher. Invitations included one from László Moholy-Nagy to teach at the New Bauhaus in Chicago. Archipenko created an extensive oeuvre in America and continued to develop the themes of his earlier work. An Archipenko retrospective was organized by the UCLA Art Galleries in 1967. – J. H. v. W.

||

2. Umberto Boccioni, *Manifesto tecnico della scultura futurista,* published as a leaflet in Milan by *Poesia,* April 11, 1912; reprinted as *Technical Manifesto of Futurist Sculpture 1912,* trans. Robert Brain, in *Futurist Manifestos,* ed. Umbro Apollonio, London: Thames & Hudson, 1973, pp. 51–65.

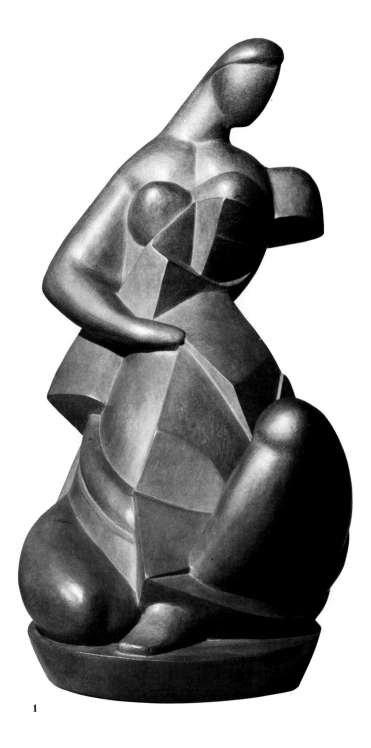

Fig. 1
Archipenko at work on *Woman in Vase-Form (Frau in Vasen-form)*, 1919.

Fig. 2
Red Dance (Roter Tanz),
1912–13
Plaster *(Gips)*, tinted red
h: 90 cm. (35.4 in.)
Karl Ernst Osthaus Museum,
Hagen

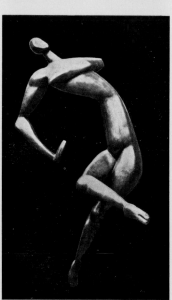

1

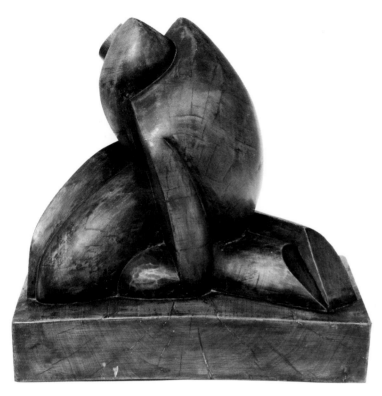

2

Cat. no. 1
Draped Woman (Frau mit Tuch), 1911 / cast later
Bronze, 6 / 6
56 x 29 x 32 cm.
(22 x 11½ x 12½ in.)
Kunsthalle Bielefeld

Inscribed *Archipenko / Paris* with casting number on base. From an edition of 6, cast at the Modern Art Foundry, New York.

Cat. no. 2
Kneeling Couple in Embrace (Kniendes Paar in Umarmung), 1911–14
Mahogany
32 x 33 x 23.4 cm.
(12⅝ x 13 x 9¼ in.)
Staatliche Kunstsammlungen Kassel, Neue Galerie

Cat. no. 3
Wilhelm Furtwängler Conducting (Wilhelm Furtwängler dirigierend), c. 1927–28
Bronze
93.5 x 85 x 72 cm.
(36¾ x 33½ x 28⅜ in.)
Hessisches Landesmuseum, Darmstadt

Inscribed *Archipenko* on r. sleeve; *W. Furtwängler dirige à New York 1927* on b. r.; *Dedié à Alfred Flechtheim en souvenire de son 50 anniversaire* on l. side of garment; *Lumière ⌀* on b. l. (indicating that a light should fall on the figure in the direction of the arrow). Baton added later. From an edition cast in 1928 on the occasion of Alfred Flechtheim's 50th birthday. Another edition was cast by H. Noack, Berlin in 1960 for the Philharmonie in the same city.

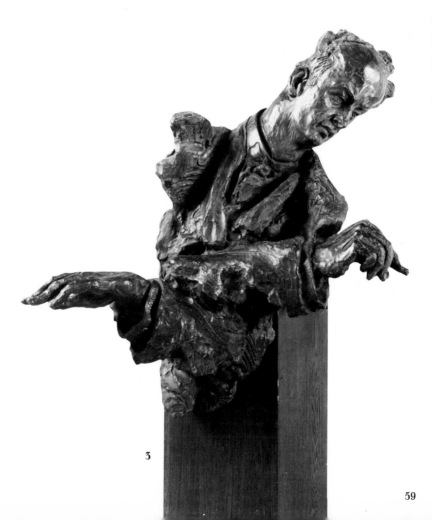

3

Barlach

Ernst Barlach

Born 1870 Wedel;

died 1938 Rostock.

Ernst Barlach was born in the northwest of Germany, the eldest son of a physician who died when he was only fourteen. From 1888 to 1891, he studied at the Hamburg Kunstgewerbeschule. He continued his education at the Dresden Kunstakademie, studying under the sculptor Robert Diez from 1891 to 1895, and additionally spent two short periods at the Académie Julian in Paris.

Upon finishing his studies, Barlach, although technically proficient and certainly aware of the semiclassical style preferred at the time, had not experienced any significant artistic development. He was hired by his friend Karl Gaber to assist in the execution of architectural sculptures for the city halls of Hamburg and Altona, but somehow felt dissatisfied. He stayed in Berlin for two years and then returned in frustration to Wedel, his hometown, where he began to make small ceramic sculptures. In 1904, he taught for a year at the Fachschule für Keramik in Höhr but returned to Berlin in 1905.

The year 1906, however, witnessed two important events: the birth of Barlach's illegitimate son Nikolaus, whom he adopted after a legal battle, and Barlach's emergence as a sculptor. For two months during this year, he traveled – to Warsaw, Kiev, and then to Kharkov to visit his brother. On this trip, he suddenly began to see the world and the human form in a new way. No single event effected this change; it was rather as if a vague but long-standing idea had finally made its importance felt. Barlach now fully realized that there was a way to fuse the depiction of man's inner emotions, hopes, dreams, disappointments, and sufferings with his outward appearance. The simplicity of the people Barlach encountered in the context of the vast Russian landscape proved to be a revelation.

In his Russian diaries,[1] Barlach described this new vision, and, shortly after his return to Berlin, he translated it into small sculptures. The garment of the *Blind Beggar* (cat. no. 4) already shows his characteristic avoidance of the particular and accidental. The *Russian Beggarwoman with Bowl* (cat. no. 5) was the artist's second attempt to represent his Russian experience. Paul Cassirer, the famous gallery owner, offered Barlach a contract with a yearly salary in 1907, and the artist, now thirty-seven, began to work intensely, almost as if to make up for lost time (see *Russian Beggarwoman II* [cat. no. 7]).

Barlach's first wooden sculpture was the bearded *Russian Shepherd* (1907; Schult, 77). In a diary entry of January 1908, he noted that his lack of experience in working with wood had resulted in his cutting himself while creating this sculpture.[2] Despite this mishap,

1. Barlach, 1958, pp. 239ff.

2. In a letter to Arthur Eloesser, October 1, 1932; see Ernst Barlach, *Leben und Werk in seinen Briefen*, ed. Friedrich Dross, Munich: R. Piper & Co. Verlag, 1952, pp. 174–75.

Barlach came to prefer wood as a sculptural material and maintained this preference throughout his life. His second work in this medium, the heavy *Seated Woman* of 1908 (cat. no. 8), resembles an archaic fertility figure. A human mountain with large hands resting on her spread knees, the *Woman*'s generalized forms emphasize her essential humanity. In the same year, Barlach made his first large wood sculpture, *Shepherd in the Storm* (Kunsthalle Bremen; Schult, 93).

In 1909, Barlach won the Villa Romana Prize which provided a stipend for a ten-month stay in Florence, but Italian art failed to influence him. While in Italy, he continued to work on pieces which he had brought with him from Germany, as well as spending time with the poet Theodor Däubler and the writer Moeller van den Bruck. Soon after returning to Germany, Barlach moved to the small northern town of Güstrow, where he remained for the rest of his life. He not only continued working untiringly in sculpture and graphics, but also began a serious writing career. In 1912, his first drama, *Der tote Tag (The Dead Day)*, illustrated with twenty-seven of his own lithographs, was published by Paul Cassirer. His work could now be divided into three parallel pursuits: sculpture, graphic art, and writing.

The First World War occasioned a three-month interruption of Barlach's work, during which he served in a nearby camp. Along with other German Expressionists, including Kirchner and Beckmann, Barlach initially welcomed the War as a vehicle for social change. Within two years, however, the artist, and most of the Expressionists with him, had come to recognize its inhumanity. *The Avenger* (cat. nos. 9 and 10), with its Cubist and Futurist elements, is one of the most dramatic and powerful of Barlach's works. It belongs to that group of sculptures designated *Berserker* (Schult, 105 and 118) by the artist. In 1914, Barlach could comment enthusiastically: "To me this *Berserker* is the crystallized essence of War, the assault of each and every obstacle rendered credible."[3] The same figure used in the *Avenger* appears in the lithograph *The Holy War* (cat. no. 11). Another wartime work, *The Ecstatic One: The Desperate One* (cat. no. 12), was modeled after a Güstrow bricklayer. It is one of Barlach's most dramatic figures and one in which gesture is all-important. Wearing a long, heavy overcoat, the figure takes a great stride forward; his face is raised, his mouth is agape, his elbows are sharply angled upward with his hands locked behind his head. The torso is one solid block and only a single large fold of the coat – reaching from the right hip to the left calf – defines the figure.

The first large exhibition of Barlach's work was held in 1917 in Paul Cassirer's gallery in Berlin. About two dozen wood sculptures, as well as numerous drawings, lithographs, and plaster models were shown. As important as the exhibition was, it did not prove to be a commercial success. Nevertheless, the critics became

3. Barlach, 1959, p. 43.

aware of the "new" sculptor; Cassirer was pleased; and later Barlach gratefully wrote in his autobiography, "He [Cassirer] took my lambs out to pasture, he cared for the freezing first born."[4]

Barlach's second play, *Der arme Vetter (The Poor Cousin)*, was published in 1918. In the same year, he created *Man in the Stocks* in wood (cf. cat. no. 14), a sculpture which communicates man's "imprisonment" in this world, as well as indicating the perception of a power that can release him. The position of the figure's head and hands in this sculpture is closely related to that depicted in the later lithograph *Ex profundis* (1924). Barlach also began to make his first woodcuts in 1918; these established a new standard of expressiveness and strength in his work. The woodcut *The Transformations of God: The First Day* (cat. no. 17) was based on drawings made in 1919–20 and was cut in wood in 1920–21. It is the first print from the portfolio *The Transformations of God* and inspired the sculpture *God the Father Hovering* (cat. no. 18).

The year 1919 saw Barlach made a member of the Preussische Akademie der Künste in Berlin and the creation of his sculpture *Hooded Beggarwoman/ Charity* (cat. no. 15). This work is a three-dimensional enlargement of the woman seen in the center of the relief *Death and Life* (cat. no. 13); this same figure reappears on the lower left of the *Magdeburg War Memorial* (1929; see below).

Throughout the twenties, Barlach's reputation grew. In 1924, he received the prestigious Kleist-Preis (Kleist Prize) for his dramatic and written works, and in 1925, he was made an honorary member of the Münchner Akademie der Künste. In February 1926, Cassirer's gallery presented thirty-seven wood sculptures in an exhibition which established Barlach's fame; he was then fifty-six years old. Cassirer himself, however, was unable to share in this "victory," having committed suicide shortly before.

Official commissions followed this success, including some for war memorials. The *War Memorial for the Güstrow Cathedral* (fig. 2, p. 68) was a life-size human figure suspended horizontally from two strong chains. The raised head and the garment, which becomes wider toward the naked feet, indicate less a flying than a hovering motion. Aside from the *Singing Man* of 1928 (Schult, 343), this memorial is probably Barlach's best-known work. The artist made a present of the work to the Güstrow Dom (cathedral); the congregation paid only for the bronze. The sculpture was dismantled in 1937 by the Nazis and melted down for scrap metal. A second bronze was made from the original form in 1942, and it survived the War. It is now installed in the Antoniterkirche in Cologne. An additional bronze was cast from this second one and has been installed in the Güstrow Dom. Barlach stated that he had the face of Käthe Kollwitz in mind when he sculpted the head.

Other sculptural commissions executed by Barlach include those for the Universitätskirche in Kiel (1928;

4. Barlach, 1928, p. 44.

cut in three parts 1937–38; reassembled and currently in front of the Nikolai-Kirche, Kiel); for the Magdeburg Dom (1929; in 1934 moved into the basement of the Nationalgalerie, Berlin, due to the protests of right-wing members of the congregation); and for Hamburg (the first proposal was rejected; a second commission was completed in 1932; it was removed in 1937). Some commissions were rejected upon submission: the city council of Malchin and right-wing groups protested Barlach's designs, and the same fate befell his *Pietà* intended as a war memorial for Stralsund. The nonheroic forms with which Barlach conveyed the sufferings of widows, orphans, and of the soldiers themselves, as well as his expression of resignation in the face of man's inhumanity to man, were clearly unacceptable to the increasingly nationalistic right wing.

In 1930, Barlach had been approached by Carl Georg Heise, director of the Museum für Kunst und Kulturgeschichte, Lübeck, to sculpt a group of sixteen figures which were to fill the niches of the Gothic brick west facade of St. Katharinenkirche in Lübeck. The plan allowed for the creation of two versions of each figure; one version was to be sold to cover expenses for each Lübeck figure. Between 1930 and 1932, Barlach made three figures, which he referred to as *Community of Saints: The Beggar* (cat. no. 22); *The Singer* (1931; Schult, 389); and *The Woman in the Wind* (1932; Schult, 411). But the sale of the duplicate versions was disappointing; protests in Lübeck were loud, and the project was discontinued. In 1932, Barlach suggested that Gerhard Marcks be asked to complete the group. Only after the Second World War did Marcks finish five figures, the cycle having been reduced to eight.

From among Barlach's sculptures of these years, *The Fluteplayer* (1936) is included in the exhibition in three versions: a plaster (cat. no. 24), a bronze (cat. no. 25), and a teakwood sculpture (cat. no. 26). These works were executed nearly sixteen years after the preparatory drawing of 1919–20 (cat. no. 16) and indicate Barlach's thematic continuity. They also permit a study of the way he worked in different media. The little shepherd, leaning backward and playing his shawm, is nearly covered by his large cloak. Only his sharply angled legs, his hands, and his face are articulated. Thus enveloped, he appears to be transported by his music.

Barlach's works give form to the most fundamental level of human life and suffering, frequently touching upon hunger and misery, death and grief. No accidental or nervous gesture breaks the closed forms; the heavy garments prevent detail from disturbing formal unity. The faces, too, avoid specifics, summarizing instead a state of existence. There are, however, no abstract forms in the works of Ernst Barlach. For this artist, only the human form was capable of carrying meaning for man. If the term *Expressionism* indicates an art which manifests in visible forms the inner life of mankind, then of all Expressionists Barlach must be considered the greatest.

Before the thirties, Barlach had refrained from entering into political discussions. Looking back at the First World War, however, he reproached himself for not speaking out against it. When the Nazis came to power in 1933, the shy and withdrawn Barlach gave a radio address in which he protested against the expulsion of Heinrich Mann and Käthe Kollwitz from the Akademie der Künste.

Both are degrading, silence and compulsion to silence. For example, when an artist may not create art because the realization of his most burning wish is prohibited everywhere by the ideological catechism of those in authority, this must be regarded as degrading, since it denies validation of his madness [from the outside] to equal his achievement of self-understanding.[5]

Although in February of 1933, Barlach was honored with the prestigious Orden Pour le Mérite (Order of Merit), the highest peacetime honor which Germany had to bestow, one month later, when the church council of Magdeburg began to demand the removal of his war memorial, he became aware of the bitter times ahead. Friends still bought or commissioned works, and the collector Hermann F. Reemtsma made it possible for him to complete *Frieze of the Listeners* (Schult, 317–31), which was originally begun as the base for a memorial to Beethoven (fig. 1, p. 62).

In 1935, however, the Nazi attack on Barlach's art became even more obvious. After a successful opening performance of his drama *Die echten Sedemunds (The Genuine Sedemunds)* in Altona, subsequent performances were prohibited. A sculpture, *Das Wiedersehen* (sometimes called the *Doubting Thomas;* Schult, 307), was removed from view at the museum in Schwerin.

||

5. Barlach, 1959, p. 421.

Barlach's works were taken out of the 1936 exhibition of the Preussische Akademie der Künste, together with those of Kollwitz and Lehmbruck, and a volume of Barlach's drawings, ready for distribution to the bookstores, was confiscated. By July–August 1937, 381 of Barlach's works had been seized from various museums and removed from public view. In December, he was informed that he would no longer be permitted to exhibit. One year later, Barlach died in a clinic in Rostock and was buried on October 28, 1938, in Ratzeburg with Georg Kolbe, Käthe Kollwitz, Gerhard Marcks, Karl Schmidt-Rottluff, and Hermann F. Reemtsma in attendance. – P.W.G.

Fig. 1
Barlach in his studio, 1935; in background, *Frieze of the Listeners (Fries der Lauschenden)* (Schult I, 317–331).

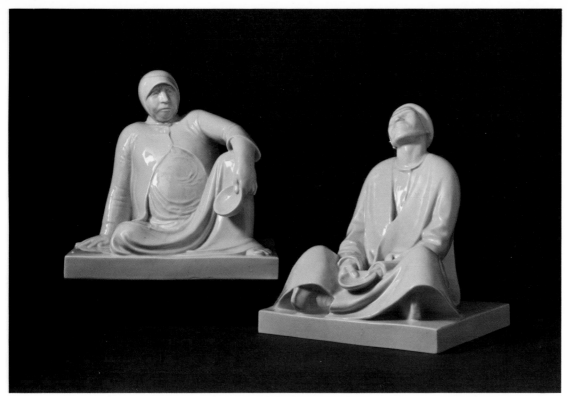

5 4

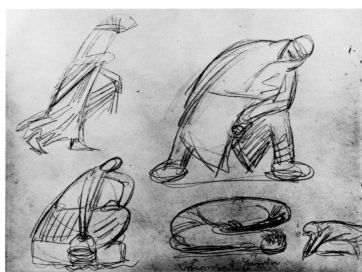

6

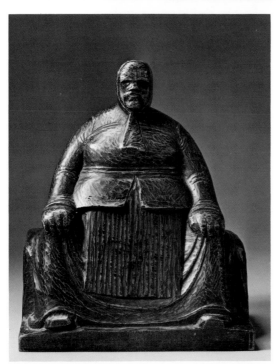

8

Cat. no. 4
Blind Beggar (Blinder Bettler),
1906 / cast 1912–13
Porcelain
25.6 x 23.1 x 19.6 cm.
(10 x 9 x 7⁷⁄₁₀ in.)
The Robert Gore Rifkind Collec-
tion, Beverly Hills, California
Schult I, 60

Inscribed *Schwarzburger*
Werkstätten für Porzellankunst on
underside of base next to form num-
ber *U 61;* blue insignia of running
fox on underside of base. From a
large, unnumbered edition cast in
1912–13. Cf. Schult I, 59 (Mutz
ceramic).

Cat. no. 5
Russian Beggarwoman with
Bowl (Russische Bettlerin mit
Schale), 1906 / cast 1912–13
Porcelain
23.5 x 25.3 x 18.2 cm.
(9¼ x 10 x 7⅓ in.)
The Robert Gore Rifkind Collec-
tion, Beverly Hills, California
Schult I, 62

Inscribed *Schwarzburger*
Werkstätten für Porzellankunst on
underside of base next to form num-
ber *U 62;* blue insignia of running
fox on underside of base. From a
large, unnumbered edition cast in
1912–13. Cf. Schult I, 61 (Mutz
ceramic).

Cat. no. 6
Five Figure Studies (Fünf
figürliche Studien), 1906–07
Pencil on paper
26.4 x 35.9 cm.
(10⅜ x 14⅛ in.)
Ernst Barlach Haus, Stiftung
Hermann F. Reemtsma,
Hamburg
Schult III, 473

Page 14 of Barlach's "Russian
Sketchbook"; one figure is inscribed
wärmt die Hände (warming the
hands). The figure on the bottom r.
is one of several sketches of Russian
beggarwomen; her pose strongly
suggests that of the sculpture *Rus-*
sian Beggarwoman II (cat. no. 7).

Cat. no. 7 (ill., p. 65)
Russian Beggarwoman II
(Russische Bettlerin II), 1907
Plaster *(Stukkoguss),* under
dark shellac
24 x 44.5 x 19 cm.
(9½ x 17½ x 7½ in.)
The Robert Gore Rifkind Collec-
tion, Beverly Hills, California
Schult I, 70

Inscribed *E. Barlach* on l. side of
base. Cf. Schult I, 71 (bronze). After
Barlach created the original clay
sculpture, this plaster *(Stukkoguss)*

was cast from the first mold, at the same time that the plaster model (*Werkmodell*) was made. The model for the bronze is in the collection of the Barlach family.

Cat. no. 8 (ill., p. 63)
Seated Woman (Sitzendes Weib),
1908
Spruce
20.5 x 17.2 x 10 cm.
(8⅛ x 6¾ x 3⅞ in.)
Germanisches National-
museum, Nuremburg;
on Loan from a Private
Collection, Pl 3048
Schult I, 80

Inscribed *E. Barlach* on b. lower r. A plaster *(Gips)* from 1906–07 (Schult I, 75) in the Ernst Barlach Nachlass in the Ernst-Barlach-Gedenkstätte der DDR, Güstrow — hereinafter referred to as Güstrow — was the model *(Werkmodell)* for this piece. Two numbered bronzes (Schult I, 76) were cast in 1947. An edition of bronzes, to be consecutively numbered 3–15 and to be cast at H. Noack, Berlin, was announced in 1981.

Cat. no. 9
The Avenger (Der Rächer), 1914
Plaster *(Stukkoguss)*, under
dark shellac
45.5 x 61 x 23 cm.
(18 x 24 x 9½ in.)
The Robert Gore Rifkind Collec-
tion, Beverly Hills, California
Schult I, 166
(Los Angeles only)
Ex-coll. Hallerman, Kiel

One of 3 plasters made in 1914 from Barlach's original clay model. Another plaster *(Stukkoguss)*, slightly damaged, is currently in Güstrow. The plaster work model *(Gips-Werkmodell)* used for the bronze edition begun in 1930 is still in the possession of the Barlach family and is housed at the H. Noack Foundry, Berlin. It shows the wear of many castings. The exhibited plaster is the only one of the 3 which retains its original character. One of the plasters served as the model for the larger 1922 wood version (Schult I, 271). The wood version, formerly in the collection of the National-galerie, Berlin, was sold by the Nazis at the Galerie Fischer sale, Lucerne, 1939 (lot 3). This sculptural image was initially called *Berserker Nr. 3*.

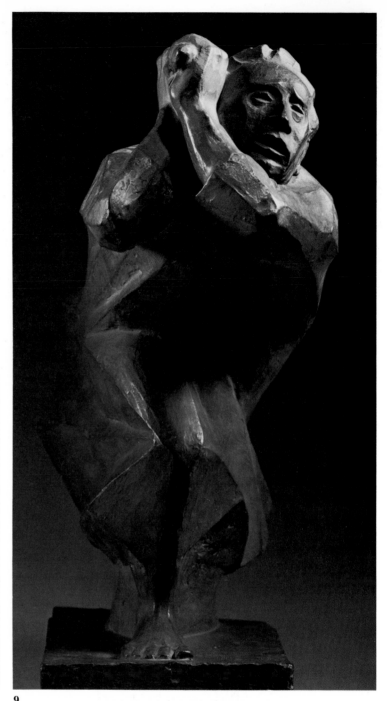

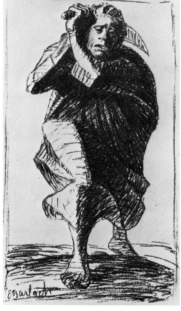

11

9

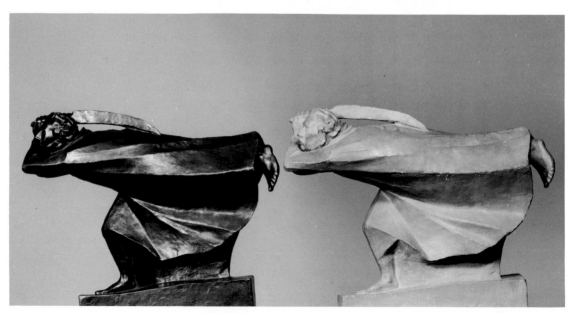

10　　　　　　　　　**9**

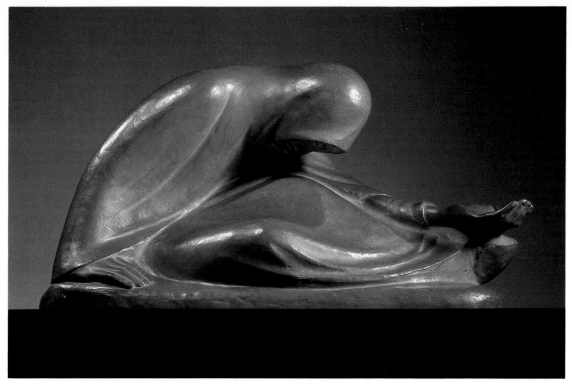

7

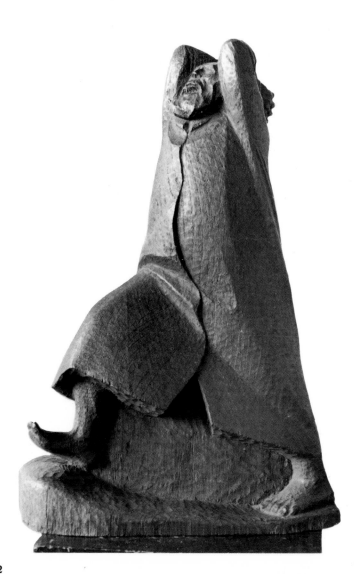

12

Cat. no. 10
The Avenger (Der Rächer),
1914 / cast after 1930
Bronze
44 x 22 x 58 cm.
(17⅛ x 9 x 23½ in.)
a) Hirshhorn Museum and
Sculpture Garden, Smithsonian
Institution, Washington, D.C.
(Los Angeles and Washington
only)
b) Museum Ludwig, Cologne
(Cologne only)
Schult I, 167

From a projected edition of 10
bronzes cast under the auspices of
Barlach's dealer Alfred Flechtheim
at the H. Noack Foundry, Berlin,
beginning in 1930. (Cf. Schult I, 166
[plaster] and Schult I, 271 [wood].)
Many editions have been cast at the
H. Noack Foundry from the plaster
work model *(Gips-Werkmodell)*
which is currently in the possession
of the Barlach family. The first
bronzes cast were numbered. After
1933, however, the numbers were
abandoned in part to frustrate any
Nazi attempt to determine the total
number of casts in existence; the Na-
zis considered Barlach a degenerate
artist. Schult has incorrectly indi-
cated that the bronze was stamped
with a date of 1922.

Cat. no. 11
*The Holy War (Der
heilige Krieg),* 1914
Lithograph, p. 3 from the pe-
riodical *Kriegszeit (Wartime),*
no. 17, December 16, 1914
41.3 x 25.4 cm.
(16¼ x 10 in.)
The Robert Gore Rifkind Center
for German Expressionist Stud-
ies, the Los Angeles County
Museum of Art. The Robert
Gore Rifkind Library, Pur-
chased with Funds Provided by
Anna Bing Arnold, Museum Ac-
quisition Funds and
Deaccession Funds
Schult II, 65

This lithograph was drawn after the
then-in-process plaster *(Gips)* of
The Avenger (Der Rächer). See cat.
no. 9.

Cat. no. 12
*The Ecstatic One: The Desperate
One (Der Ekstatiker: Der
Verzweifelte),* 1916
Oak
52 x 16 x 35 cm.
(20½ x 6¼ x 13¾ in.)
Kunsthaus Zürich
Schult I, 181

Inscribed *E Barlach 1916* on base,
l. l. The plaster from 1911–12
(Schult I, 119) in Güstrow was the
model *(Werkmodell)* for this piece.

Cat. no. 13
Death and Life (Tod und Leben),
1916–17/cast posthumously
Bronze relief
50.5 x 41.8 x 3.3 cm.
(19⅞ x 16½ x 1⅛ in.)
Ernst Barlach Haus, Stiftung
Hermann F. Reemtsma,
Hamburg
Schult I, 186

Inscribed *E Barlach* l. r. Four casts
are stamped *H. Noack Berlin.* An edi-
tion of 11 additional bronze casts
was announced in 1981. The plaster
from 1916–17 (Schult I, 185) was
the model *(Werkmodell)* for this
piece.

Cat. no. 14
*Man in the Stocks (Der Mann im
Stock),* 1918
Bronze
35 x 23 x 23 cm.
(13¾ x 9 x 9 in.)
Private Collection
Schult I, 205

Signed *E Barlach* and stamped *Rich.
Barth Bln. Mariendorf* on l.b. This
piece, formerly in the collection of
Gustav Stein, is one of a few bronzes
cast by the independent founder
Richard Barth in Berlin between
1940 and 1942. It is also one of a very
small number of Barlach sculptures
which were not cast by H. Noack in
Berlin. This latter occurence is ex-
plained by the fact that H. Noack, the
"official" foundry for Barlach sculp-
tures, was not permitted to operate
for a period of a few years during the
War.

Cat. no. 15
*Hooded Beggarwoman/Charity
(Verhüllte Bettlerin/Barm-
herzigkeit),* 1919
Wood
38 x 30.5 x 34 cm.
(15 x 12 x 13⅜ in.)
Private Collection
Schult I, 215

Inscribed *E Barlach 1919* on base,
l. l. The plaster *(Gips)* from 1919
(Schult I, 214) is in Güstrow. Some
bronzes were cast in 1961 (Ernst
Barlach Haus, Hamburg); a total edi-
tion of 15 casts was announced in
1981.

Cat. no. 16 (ill., p. 70)
*The Fluteplayer (Der Flöten-
bläser),* 1919–20
Charcoal on paper
34.8 x 25.1 cm.
(13⅜ x 9⅞ in.)
Ernst Barlach Haus, Stiftung
Hermann F. Reemtsma,
Hamburg
Schult III, 1366

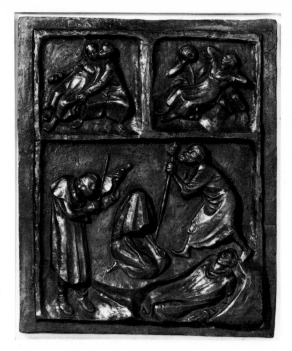

13

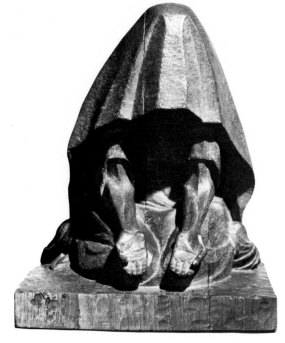

15

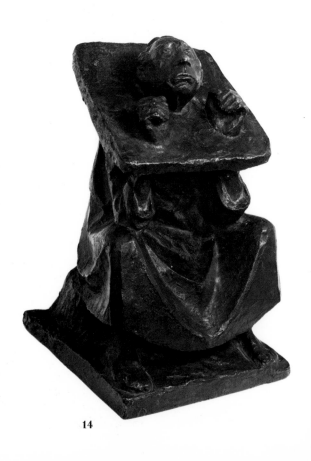

14

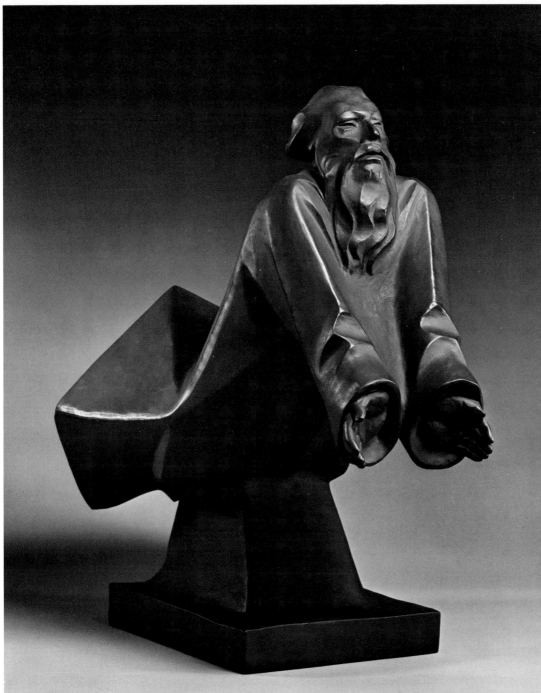

18

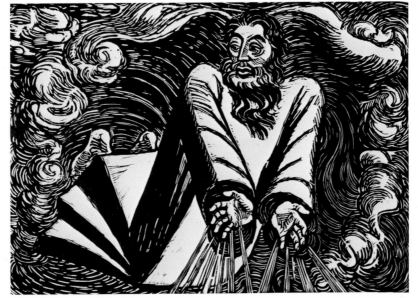

17

This drawing was originally a study for one of Barlach's wood sculptures for the home of Leo Levin in Breslau. The project was never realized, but the sculpture *Der Flötenbläser* (cat. no. 26), which follows the composition of this early drawing, was finally carved in 1936.

Cat. no. 17
The Transformations of God: The First Day (Die Wandlungen Gottes: Der erste Tag), 1920–21
Woodcut, pl. 1 from the portfolio *Die Wandlungen Gottes*
25.7 x 35.9 cm.
(10⅛ x 14⅛ in.)
The Museum of Modern Art, New York. Gift of Victor S. Riesenfeld
Schult II, 164

From a series of seven woodcuts based on Barlach's drawings from 1919–20. The sculpture *God the Father Hovering (Schwebender Gottvater)*, 1922 (cat. no. 18) was inspired by this woodcut.

Cat. no. 18
God the Father Hovering (Schwebender Gottvater), 1922/ cast later
Unglazed Meissen
50.5 x 33 x 50 cm.
(19¾ x 13 x 19¾ in.)
Los Angeles County Museum of Art, Gift of Dr. and Mrs. Ronald Lawrence
M.82.156
Schult I, 276

Inscribed *E Barlach* on l. side of base; Meissen casting stamp on back of base; casting number on underside. This work was originally cast in a large edition. Further casts were made beginning in 1956; this piece appears to be a fairly early example.

Cat. no. 19 (ill., p. 69)
The Dancer (Der Tänzer), 1923
Wood relief
92 x 43 x 9 cm.
(36¼ x 17 x 3½ in.)
Kunstmuseum Hannover mit Sammlung Sprengel
Schult I, 281

Inscribed *E Barlach 1923* at l. l. The plaster *(Gips)* from c. 1923 (Schult I, 280) in Güstrow was the model *(Werkmodell)* for this piece.

Cat. no. 20 (ill., p. 69)
The Spendthrift III (Der Verschwender III), 1923
Wood relief
92 x 42.7 x 9 cm.
(36⅕ x 16¾ x 3½ in.)
Kunstmuseum Hannover mit Sammlung Sprengel
Schult I, 279

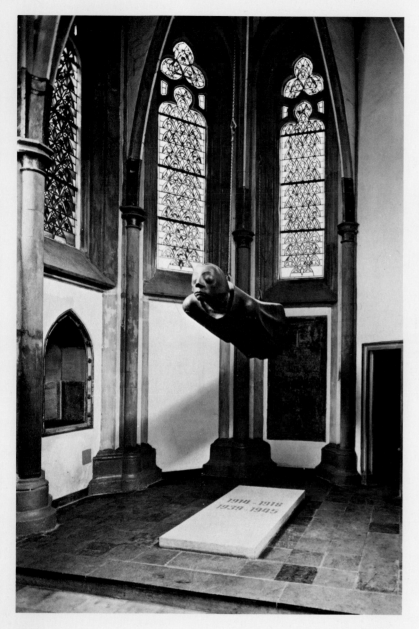

Fig. 2
*War Memorial for the Güstrow
Cathedral (Güstrower Ehren-
mal),* 1927 / cast 1952
Bronze
71 × 74.5 × 217 cm.
(28 × 29⅜ × 85½ in.)
Schult I, 336

Re-cast presently installed in
Antoniterkirche, Cologne.

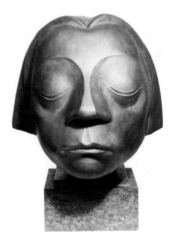

21

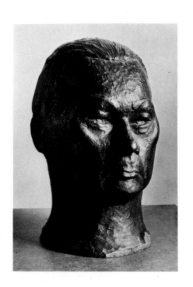

23

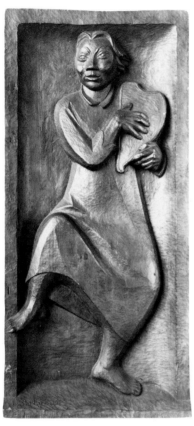

19

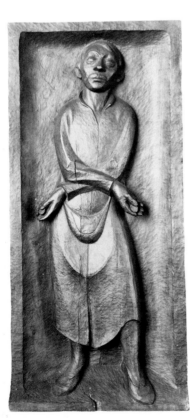

20

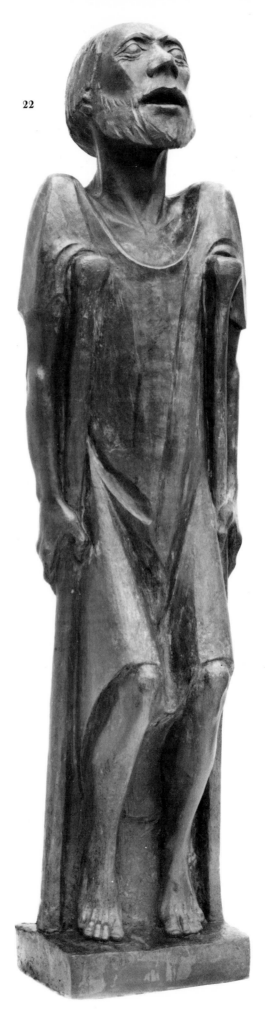

22

Inscribed *E Barlach* at l. l. The plaster *(Gips)* from c. 1923 (Schult I, 278) in Güstrow was the model *(Werkmodell)* for this piece; cf. Schult I, 256 (*Der Verschwender* [plaster]) and Schult I, 257 *(Der Verschwender II* [plaster]).

Cat. no. 21
Head: Detail of the War Memorial for the Güstrow Cathedral (Kopf: Teil des Güstrower Ehrenmals), 1927/cast after the War
Bronze
33 x 33.5 x 27.8 cm.
(13 x 13⅛ x 11 in.)
Öffentliche Kunstsammlung, Basel
Schult I, 337

Cf. Schult I, 335 (plaster [*Gips*], now destroyed, for the large bronze monument), and Schult I, 336 (bronze monument). An edition which would bring the total number to 15 was announced in 1981.

Cat. no. 22
The Beggar (Der Bettler), 1930/cast 1981
Bronze, 1/8
217 x 58 x 45 cm.
(85 ⅜ x 22⅞ x 17¾ in.)
Deutsches Brotmuseum, Ulm, Fed. Rep. of Germany
Schult I, 354

Inscribed with casting number. The original version of *Der Bettler* was from a series (never completed) of 16 figures intended to adorn the facade of St. Katherinenkirche, Lübeck. This piece is from an announced edition of 8, cast by H. Noack, Berlin, in 1981. The plaster from 1930 (Schult I, 353), now in Güstrow, was the model *(Werkmodell)* for the earlier casts. Cf. also Schult I, 352 and 355.

Cat. no. 23
Portrait of Paul Wegener I (Bildnis Paul Wegener I), 1930
Bronze
51.5 x 34.5 x 30 cm.
(20¼ x 13⅝ x 11¾ in.)
Bayerische Staatsgemäldesammlungen, Munich
Schult I, 360

Inscribed *E Barlach 1930* at neck, l. l., and *H. Noack Berlin-Friedenau*. Paul Wegener was a famous German film actor of the 1920s. This piece is from a projected edition of 10 cast in 1930 by H. Noack; the edition was not completed. (See discussion under cat. no. 10.) The location of the plaster is unknown (cf. Schult I, 359).

Cat. no. 24
*The Fluteplayer (Der Flöt-
enbläser)*, 1936
Plaster (*Gips*), under
light shellac
59.8 x 38 x 25.5 cm.
(23½ x 15 x 10 in.)
The Robert Gore Rifkind Collec-
tion, Beverly Hills, California
Schult I, 468

Following the creation of the origi-
nal clay form, Barlach created 2
plasters from the first mold: this
cast, which is preserved under light
shellac, and a second plaster used as
the model (*Werkmodell*) for the
bronzes (Schult I, 469) and currently
in the collection of the Barlach fam-
ily. See also the larger wood version
(Schult I, 470), and cf. Groves, (Eng.
ed.), p. 122.

Cat. no. 25
*The Fluteplayer (Der Flöt-
enbläser)*, 1936
Bronze
60 x 36 x 24 cm.
(23½ x 14¼ x 9½ in.)
Wilhelm-Lehmbruck-Museum
der Stadt Duisburg
Schult I, 469

Inscribed *E Barlach* on l. r. side, *H
Noack Berlin* casting stamp on back.
Cast from the plaster of 1936; cf. cat.
no. 24 (Schult I, 468). Cf. also Schult
I, 470.

Cat. no. 26
*The Fluteplayer (Der Flöt-
enbläser)*, 1936
Teakwood
81 x 52.5 x 34 cm.
(31⅞ x 20⅝ x 13⅜ in.)
Private Collection, West
Germany
Schult I, 470

Inscribed *E Barlach 1936* on base,
l. b. This is one of two wood versions;
cf. also Schult I, 471 and, further,
Schult I, 468 and 469.

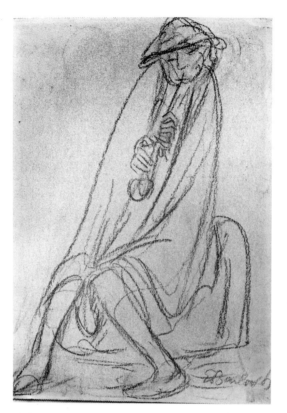

16

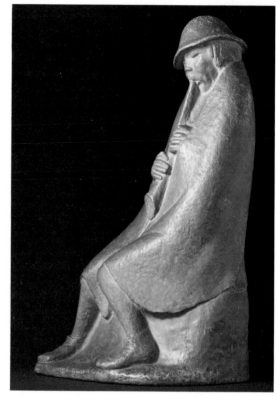

24

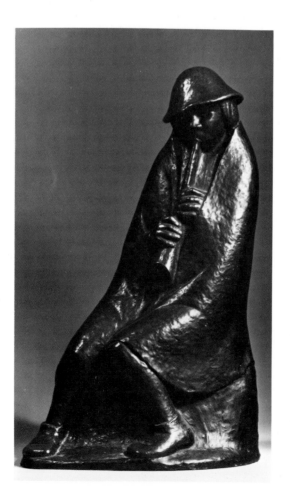

25

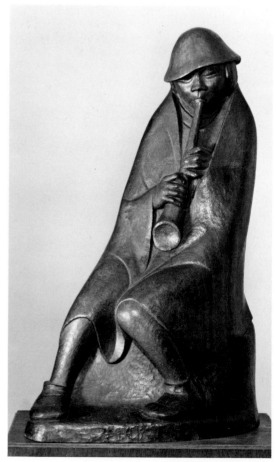

26

Beckmann

Max Beckmann

Born 1884 Leipzig;

died 1950 New York, U.S.A.

The painter Max Beckmann was already fifty years old when he produced his first sculpture, *Man in the Dark* (cat. no. 27), in 1934. It was the second year of Hitler's rule over Germany. To Beckmann, an avowed liberal and a passionate individualist, it seemed that deep darkness had fallen on his homeland.

The *Man in the Dark* interacts forcefully with the space surrounding him. His three-dimensionality is such that only the plastic medium could express and contain it. The arms, bent forward, sideways, and upward, define the three dimensions. The face is averted from the direction of the man's cautious steps, as if he were afraid of bumping into an obstacle. The feet seem enlarged and flattened by the will to cling to tactile, solid ground. The hands are fearful question marks: Where am I going? The folds of the garment are swept sideways by unseen forces. The psychological paradox of progressing against unknown odds leads to an almost baroque *contrapposto*. The idea of the individual menaced from all sides demanded to be rendered in the round. It remained doubtful as to whether the forlorn figure – like the artist himself – would find his way out.

Beckmann had become accustomed to recognition early in his career. Born in Leipzig in 1884, he entered the Weimar Academy in 1900 and received the coveted Villa Romana Prize in 1906. His works were acquired by many public and private collections. In 1925, he took over the master class at the Städelsches Kunstinstitut in Frankfurt. He had numerous exhibitions. His biting social criticism, his almost magical skill with colors and forms – these were the subjects of eager discussions in contemporary articles and monographs about him. Therefore, he was deeply hurt when, in 1933, the Nazis dismissed him from his teaching post in Frankfurt and forbade an exhibition already assembled in Erfurt. From then on, one *Verbot* followed another. Many of Beckmann's dealers and collectors emigrated from Germany. Together with all the other Expressionist, abstract, and Surrealist artists, he was designated as "degenerate." In 1936, the Berlin Nationalgalerie – where formerly he had enjoyed his own exhibition room – threw out the last Beckmann painting. In the cultural life of Germany, he was now a "nonperson."

The need to assert himself may have been the motive behind Beckmann's creation of his massive *Self-Portrait* (cat. no. 29). This 1936 bronze almost bursts with existence – it proclaimed to the fates that Max Beckmann was a presence to be reckoned with. Beckmann had painted and etched numerous self-portraits; their expressions range from sarcasm to philosophical introspection, from sociable amusement to pride. The bronze self-portrait is calm. It shows hardly any bitterness; it is animated with a searching earnestness. The wide, expressive mouth, turned down at the corners, seems on the verge of proclaiming some important truth. The eyes, in contrast, are coolly fixed on distant things: they show the reticent glance of a habitual observer, not a doer. The piece itself embodies a vital, weighty force, difficult to subdue.

Beckmann's reasons for trying sculpture were probably different in each case. The spiral movement of *Man in the Dark* would have been less effective on the flat surface of a stretched canvas. The *Self-Portrait* uses sheer mass as an artistic motif. *Adam and Eve* (cat. no. 28), like the *Self-Portrait* sculpted in 1936, realizes a juxtaposition of large and small. The very minuteness of Eve crouching on Adam's hand demanded definition in three dimensions. The proportion of this miniature female body would have been much less surprising if it were drawn or painted and could thus possibly suggest illusionary perspective. Cast in bronze, the intention of the artist is clear: he wanted Eve tiny, Adam large. The snake, symbol of lust, has already entwined Adam as he stares into the distance, trying to imagine what the future might hold.

In addition to the three sculptures in this exhibition, Beckmann created five more bronzes. *The Dancer* and *Crouching Woman* were made in 1935. On the opening day of the *Entartete Kunst* exhibition in 1937, Beckmann emigrated to Holland, and ten years later he moved to the United States. In 1950, the last year of the artist's life, when he was working contentedly in America, he executed his three last sculptures: *Back Bend, Snake Charmer*, and *Head of a Man*. These 8 sculptures, in comparison to his 835 oil paintings and more than 300 graphic works, may seem only a sideline of his vast oeuvre. But he took his excursions into the plastic realm seriously, including painted statues in some of his triptychs. The *Self-Portrait* sculpture, for example, appears in the *Still Life with Bust* (fig. 2, p. 73), providing a dark, looming presence between the pale green and pink flowers and curtains. His deep feeling for the sculptor's particularly sensuous activity was expressed in a fascinating oil painting, *The Sculptor's Dream*, of 1947 (Göpel, 737). The sculptor lies asleep on his bed; from behind him, two gigantic hands grip his shoulder and stomach, squeezing and molding his living body.

Beckmann knew all about the problems of being a sculptor. Yet we cannot consider him a born one. When Michelangelo, on orders from the Pope, painted the fantastically varied figures in the Sistine Chapel, he could not invent significant landscapes to set off the human bodies. When they use brush and ink or oil paint, most carvers and shapers of stone or clay neglect trees, flowers, houses, clouds, and other atmospheric phenomena. Beckmann, on the other hand, was an inspired painter of landscapes and on occasion brought this quality of inspiration to the medium of sculpture as well. – S.L.

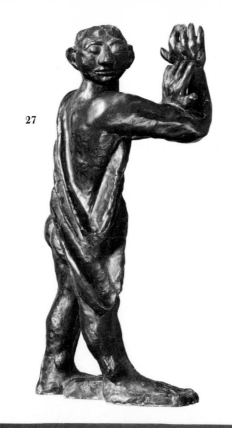

27

Cat. no. 27

Man in the Dark (Mann im Dunkel), 1934 / cast later
Bronze
h: 56 cm. (22 in.)
Bayerische Staatsgemälde-
sammlungen, Munich

All the plasters of Beckmann's sculp-
tures were shipped from Amsterdam
when he emigrated to America. In
1957, it was decided posthumously
by Beckmann's dealer Catherine
Viviano (New York), Dr. Alfred
Hentzen (Hamburger Kunsthalle),
and Dr. Kurt Martin (Munich) to
destroy each plaster after 5 casts had
been completed. Three additional
bronze casts of *Mann im Dunkel*
exist in German private collections.

Cat. no. 28

Adam and Eve (Adam und Eva),
1936 / cast 1968
Bronze
85 x 33.3 x 36.8 cm.
(33½ x 13⅛ x 14½ in.)
a) The Robert Gore Rifkind
Collection, Beverly Hills,
California (Los Angeles only)
b) Hirshhorn Museum and
Sculpture Garden, Smithsonian
Institution, Washington, D.C.
(Washington and Cologne only)

This piece is from an edition of 5,
cast between 1958 and 1968. Other
casts exist in the collection of Mr.
Stanley Seeger, Jr. (cast 1958–59);
the Busch-Reisinger Museum, Har-
vard University, Cambridge, Mas-
sachusetts (ex-coll. Irving Rabb);
and a German private collection
(formerly the estate of the artist).
There is a plaster in the collection of
Mathilde Q. Beckmann, New York.
Cf. painting *Studio: Night (Atelier:
Nacht),* 1931 / 1938 (Göpel, 510).

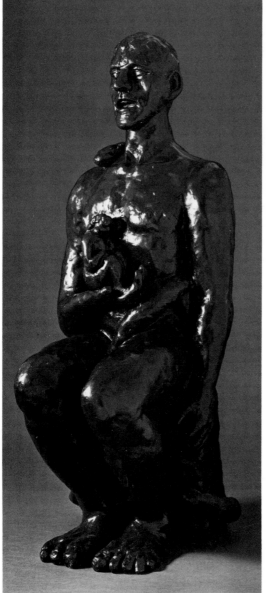

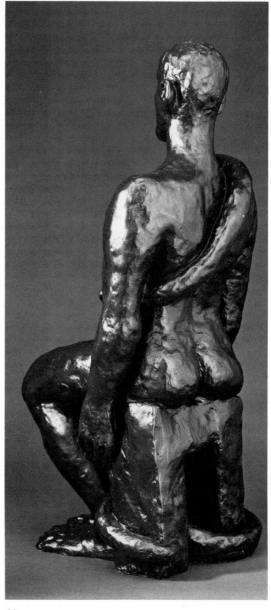

28

28

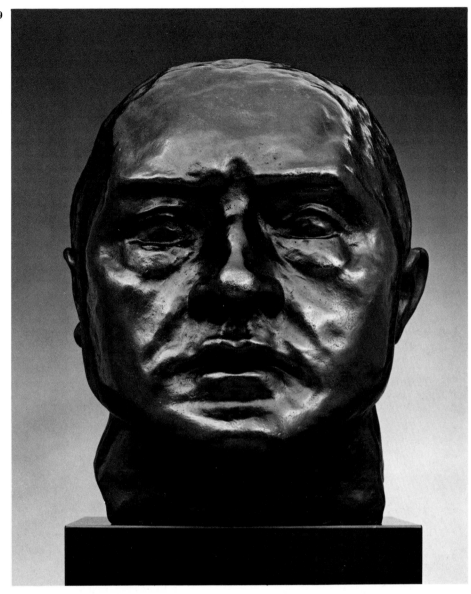

29

Cat. no. 29
Self-Portrait (Selbstbildnis),
1936 / cast later
Bronze
35.2 x 33 x 27.3 cm.
(13⅞ x 13 x 10¾ in.)
a) The Robert Gore Rifkind
Foundation, Beverly Hills,
California (Los Angeles and
Washington only)
b) Hamburger Kunsthalle
(Cologne only)

Three casts were executed by the
Curt Valentin Gallery, New York, in
the 1950s. These are now in The
Museum of Modern Art, New York;
the estate of Morton D. May, St.
Louis; and the Hamburger
Kunsthalle. In 1968, three additional
casts were executed. They are now
in the collection of Mathilde Q.
Beckmann, New York; The Robert
Gore Rifkind Foundation, Beverly
Hills, California; and the collection
of Peter Beckmann, Murnau. The
sixth cast was made for Peter
Beckmann with the permission of
Dr. Alfred Hentzen and Alfred Barr,
Jr., The Museum of Modern Art,
New York. A stone cast also exists in
the collection of Mathilde Q.
Beckmann, New York. Cf. Göpel,
448.

Fig. 1
Beckmann, late 1920s.

Fig. 2
*Still Life with Bust (Stilleben mit
Plastik),* 1936
Oil on canvas
80 × 50.5 cm.
(31.5 × 19.9 in.)
Mr. and Mrs. Stephan Lackner
Göpel, 448

Belling

Rudolf Belling

Born 1886 Berlin;

died 1972 Krailling, near Munich.

Rudolf Belling's posthumous fame in Germany as a pioneer of abstract sculpture is based primarily on two works, *Triad* (fig. 2, p. 77) and the robotlike head *Sculpture 23* (1923, bronze). These sculptures originated during the period following World War I, when Belling – one of the cofounders of the Novembergruppe and the Arbeitsrat für Kunst – adapted the ideas of Russian revolutionary art and attempted a synthesis of previous modernist inventions. A symbolic representation of three art forms – painting, sculpture, and architecture – *Triad* combines tendencies of Cubism, Futurism, and Expressionism. Its contrapuntal combination of mass and space, which is in some respects indebted to the work of Archipenko, anticipated Belling's later concept of space. The latter was clearly formulated in the artist's theoretical work and realized on a large scale in his "Cubist" design for the ceiling of the Scala Casino (1920, architect Walter Würzbach, Berlin; destroyed in World War II). Belling, a brilliant self-propagandist who understood his era, soon found himself celebrated as the spokesman of a new *Architekturwollen* (architectural will) in plastic art.[1] During the early twenties Belling created a number of remarkable works in conjunction with architects. These collaborations signal his transition from Expressionism to Neue Sachlichkeit and testify to his ability to integrate sculpture within architectural settings. In this respect, the fountain in front of the Berlin villa of the lawyer and notary Goldstein (1923, concrete with metal spirals; destroyed 1926) was noteworthy in its combination of Constructivism and the machine aesthetic that characterized this period. Yet during the late twenties, Belling disappointed many observers by moving in the direction of stylized, Art-Deco-like figural sculpture. After his 1937 emigration to Turkey, where he became chairman of the sculpture department at the Academy of Fine Arts in Istanbul and then joined the architecture faculty at the Istanbul Technical University, the artist attempted to reincorporate elements of his progressive early oeuvre, but the late abstract works manifest his metamorphosis from a genuinely experimental artist into a conforming modernist.

Belling began his career as a sculptor after serving an apprenticeship from 1905 to 1907 as a *Modelleur* (modeler), *Kleinplastiker* (maker of small sculptures), and sculptor. With his colleague Emil Kasedow, he established an independent studio for decoration, *Kleinplastik*, and arts and crafts in Berlin. In 1909, he began receiving commissions for set designs, including work for the important theater director Max Reinhardt. In 1912, he entered the Kunstakademie in Berlin-Charlottenburg, where he worked in the studio of

Peter Breuer, a sculpture professor at the Kunstakademie, until 1922.

Belling's earliest independent works in three dimensions, *Wounded Soldiers* (1915, bronze), *Combat* (1916, bronze), and *Female Dancer* (1916, gilded wood, three versions: Saarland-Museum, Moderne Galerie, Saarbrücken; Georg Kolbe Museum, Berlin; Kunstmuseum, Düsseldorf) justify art historian Alfred Kuhn's classification of him as a "sculptor of rhythmic motion." Belling later characterized this first phase of creativity himself: "Masses are broken and pierced, consciously turning away from the blocklike mass. At the beginning the figures are still realistic; then they become freer."[2] In its contrast between body and garment, *Female Dancer* is reminiscent of the Jugendstil character of such works as Hoetger's figure for the *Fountain of Justice* in Elberfeld (1910, bronze; destroyed). Its serpentine turning and the symmetrical posture of the arms may be compared to Georg Kolbe's *Dancer Nijinsky* (1914, bronze). But with respect to formal abstraction, Belling's figure surpasses these other sculptures. The starkly angled limbs create an expressive spatial dynamic of motion, foreshadowing later sculptures which share the dance motif, such as *Group Dance* (1917; destroyed). While neither the later work nor *Female Dancer* attained the level of the prewar works of Archipenko (e.g., *Red Dance,* 1912 – 13; fig. 2, p. 58), Belling did achieve this in his Expressionist groups of 1918, *The Man* (limestone, Museum Folkwang, Essen) and *Squatting Man* and *Standing Woman* (plaster *[Gips];* destroyed).

Belling continued to simplify physical forms, reducing the human figure to a cipher. With *Triad,* his second phase of creativity began. This sculpture was entered in the *Kunstausstellung Berlin* of 1920 in the true spirit of the *Gesamtkunstwerk,* and the artist supposedly intended to recreate it in another version "six meters high, built of brick and colorfully plastered."[3] The abstraction of the dancers' forms cannot be regarded as a singular phenomenon. Other Berlin sculptors such as Karl Herrmann and Garbe were pursuing a similar goal by this time. Herzog had attained completely abstract works in 1918–19, and Wauer was working even earlier, in 1916, with pierced masses (e.g., *Living Iron,* bronze). What distinguished Belling was the methodical nature of his ideas. *Triad* is a sculpture in the round, meant to be seen from multiple viewpoints. The formation of three-dimensionally effective *Raumkörper* (spatial bodies; Belling's term) through use of clear cubic forms was the consciously articulated, progressive element in Belling's sculpture. This element was cited by him as characteristic of his plastic art in intentional opposition to the "picturelike" compactness of the sculptures of the Munich classicist Adolf von Hildebrand.

Belling's concept of "tectonic form" was expanded

||
1. Paul Westheim, "Auftakt des Architekturwollens," *Das Kunstblatt,* vol. 4, no. 12, December 1920, p. 366.

||
2. Gallery Weyhe, New York, *Belling,* exh. cat., 1935.

3. This piece appears as number 1096 in the catalogue for the *Kunstausstellung Berlin,* 1920.

in his construction of entire rooms as *Raumkunst* (spatial art). These projects, as previously mentioned, originated in collaboration with Novembergruppe architects Walter Würzbach, Max and Bruno Taut, Alfred Gellhorn, and Wassili Luckhardt, and were followed by designs for advertising. The latter included a sculpture for an automobile company at the Berlin Avus Speedway (1920, painted cement; destroyed), designed in collaboration with Luckhardt, and papiermâché mannequins for the windows of department stores in Berlin and Paris. While these works were created primarily as a means of financial support, they reflected the eclectic styles and influences that are seen in Belling's sculptures of 1921.

In this same year, Alfred Kuhn declared: "Possibly after so much deceptive Expressionism, so much mendacious ecstasy, the exclusively intellectual, which without a doubt is more in tune with today's mentality than righteous screams and gestures of embracing mankind, must again be stressed."[4] In making this statement, Kuhn was referring to Archipenko's development, but he could have been describing that of Belling, whose *Gesture of Freedom* (1920, mixed media: wire, cloth, and plaster; destroyed) had already parodied Expressionist-revolutionary pathos. The *Mahogany Head* of the following year (cat. no. 30) presents a mixture of Expressionist characteristics and the Neue Sachlichkeit's smoothness of form. The head depicts a character typical of the revolutionary postwar era, the fanatic agitator (cf. Felixmüller's painting, *Otto Rühle Makes a Speech* [1920, Nationalgalerie, Berlin, DDR], and George Grosz's caricatures). The strong emotion and tight Cubist and Expressionist formal language of *Gesture of Freedom* are combined in *Mahogany Head* with the "spatial body" concept. The face is hollowed out so that the nose appears to be freestanding, as if stretched on a frame between forehead and upper lip, and the cylinders of the eyes protrude. A dynamic structure of individual forms has been developed out of alternating positive and negative volumes. At the same time, elements of abstract African sculpture have been combined with those of mimetic naturalism: the mouth is opened in a scream, the eyes in an excited glance. In such hybrid forms, the final stage of Expressionism, or rather its transition into other stylistic forms, is documented. The hollowness within the head, the abstraction of parts of the face (nose, lips) anticipate Belling's later head constructions (e.g., *Sculpture 23*), whereas the base combined with the shape of the neck anticipate characteristics of the portrait mask of the director Joseph von Sternberg (1930, bronze).

Organic Forms: Striding Man (cat. no. 31), of the same year as *Mahogany Head,* demonstrates how closely combined objective and expressive forms were in Belling's work at the beginning of the twenties. Of course, here the influence of Italian Futurism was stronger, as can be seen in the dynamic, spirallike,

turning motion of the figure, the opening up of volume, the simultaneity of man and machine, technical power and organic form (cf. Umberto Boccioni's *Unique Forms of Continuity in Space,* 1913/cast 1931, bronze).

In the course of the twenties, Belling's popularity increased, primarily as a result of his architectonic works. In 1924, a one-man exhibition was arranged for him in the Nationalgalerie, Berlin, and the wood version of *Triad* was purchased by that museum. Belling demonstrated his skill as a craftsman in large commissioned works for German and Dutch labor unions (1925–32), which he executed primarily in metal. One of the most original portrait masks of this time is that of the well-known Berlin collector and dealer Alfred Flechtheim (cat. no. 32). Here Belling has reduced the portrait to the most characteristic facial features, the fashioning of which is similar to a caricature (see fig. 3, p. 77). This sculpture, which appears to be without mass or weight, originated as a wire construction. In its utilization of negative form as a plastic means, it follows Archipenko's works of the early twenties.

When, at the beginning of the thirties, Belling's style changed to one of naturalistic classicism, this only increased his public recognition, as was evidenced by his election to the Akademie der Künste in 1931. In 1937, however, his artwork banned in Germany – *Triad* was shown at the *Entartete Kunst* exhibition – Belling emigrated to Turkey. After 1945, his final phase of creativity began, including abstract-symbolic and some neo-Jugendstil works. Not until 1966 did Belling return to Germany, settling in Krailling near Munich. – J. H. v. W.

||
4. Kuhn, 1921, p. 124.*

Cat. no. 30
Mahogany Head (Kopf in Mahagoni), 1921
Wood
53 x 20 cm.
(20⅞ x 7⅞ in.)
Von der Heydt-Museum, Wuppertal
Nerdinger, 37

Inscribed *Rudolf Belling 21.* This is one of 3 known examples of this subject; a second is in the Belling estate, while the present location of the third is unknown.

Cat. no. 31
Organic Forms: Striding Man (Organische Formen: Schreitender), 1921
Bronze, silver-plated
h: 54.6 cm. (21½ in.)
The St. Louis Art Museum, Missouri, Gift of Mr. and Mrs. Morton D. May, 236:1959
Nerdinger, 38

Inscribed *Rudolf Belling 21* on base. This is one of three known casts; the other two are in the Saarland-Museum, Moderne Galerie, Saarbrücken, and the Belling estate.

Cat. no. 32
Portrait of the Art Dealer Alfred Flechtheim (Bildnis des Kunsthändlers Alfred Flechtheim),
1927/cast after World War II
Bronze
18.7 x 12 x 13 cm.
(7⅜ x 4¾ x 5⅛ in.)
The Minneapolis Institute of Arts, The John R. Van Derlip Fund
Nerdinger, 58

Inscribed *Rudolf Belling 1927* on base. Three casts were produced originally; they are now in The Museum of Modern Art, New York; the Museum Boymans-van Beuningen, Rotterdam; and the collection of Wolfgang Werner, Bremen. Each measures 19.3 cm. (17½ in.) in height. The plaster model *(Werkmodell)* was destroyed during World War II, after which Belling created new models of a slightly smaller size from which this piece was cast. There are at least 9 of these newer casts.

30

31

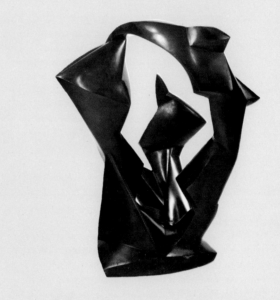

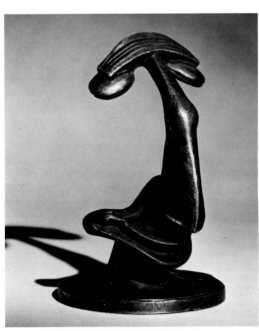

32

Felixmüller

Conrad Felixmüller

Born 1897 Dresden;

died 1977 Berlin.

Conrad Felixmüller worked in three dimensions for only a single year of his long artistic career. Five of an original group of either seven or nine wood reliefs and sculptures are preserved; all of them were made in 1923. These figures, as singular as they are when compared with his paintings and graphic works, are significant because they were made during a period in which the artist abandoned his earlier Expressionist convictions for the more naturalistic approach which he maintained for the rest of his life. Although they are not typical of either his earlier or later works, these sculptures are significant as examples of the stylistic search undertaken by many other artists of Felixmüller's generation at this time.

Felixmüller was a wunderkind – at age fourteen he began drawing lessons at the Kunstgewerbeschule in Dresden. From 1912 to 1915 he studied painting at the Kunstakademie, Dresden. His first exhibition was held in 1914 at the then-famous J.B. Neumann Galerie in Berlin. A year earlier he had completed a portfolio of thirteen woodcuts, *Songs of Pierrot Lunaire,* which was published in 1915 by Emil Richter's gallery in Dresden. In October of 1912, Felixmüller had attended a performance of Arnold Schönberg's melodrama *Pierrot Lunaire,* op. 21, based on poems by Albert Giraud. It featured Albertine Zehme, who spoke and sang dressed in a Pierrot costume, while the orchestra played behind a screen. This new music and its exciting performance moved Felixmüller deeply, prompting the woodcuts which, although obviously related to work by Munch and the Brücke artists, made free and individual use of the Expressionist idiom. Schönberg, impressed by the portfolio which Felixmüller had sent to him, invited the young artist to the first performance of his *Gurrelieder* in Leipzig. This meeting resulted in an astoundingly sure etched portrait of the composer, which swelled the graphic oeuvre of the seventeen-year-old artist to forty-four works. Perhaps the youngest accomplished artist in Dresden, Conrad Felixmüller was also undoubtedly one of the most talented. Fortunately, he was not drafted until almost the end of the War in 1917. He abhorred the fighting and refused to serve actively, deciding instead to work for a short period as a nurse in a psychiatric hospital in Arnsdorf.[1]

In 1916, Felixmüller had begun to attract like-minded men and women to the Expressionist soirees which he held in his Dresden studio to encourage young poets, writers, political activists, and artists to exchange their views of the times and of their art. During this period Felixmüller became acquainted with Herwarth Walden and his journal *Der Sturm,* and in 1915–16 contributed graphic works to that publication, as well as exhibiting in the Galerie Der Sturm. In 1916, he made contact with Franz Pfemfert, editor of the politically aggressive journal *Die Aktion,* and subsequently began to publish graphic works and articles there. This friendship lasted until 1928. Felixmüller's activities in Dresden multiplied. He published work in many of the Expressionist journals such as *Die Sichel (The Sickle), Die Schöne Rarität (The Beautiful Curio),* and others. He became cofounder of the influential journal *Menschen (Mankind)* and when the War was over became the leader of the Sezession: Gruppe 1919, which was composed of the most gifted young artists in Dresden, including Otto Dix, Lasar Segall, Otto Schubert, Otto Lange, Forster, and Voll.

After having organized the Sezession's first two exhibitions, Felixmüller became disappointed in his colleagues since they did not share his strong political commitments, and he left the group. In the meantime, he had married Londa Freiin von Berg, and after a short period spent in Wiesbaden visiting an early patron, the collector Heinrich Kirchhoff, he settled with his young family outside Dresden in the small town of Klotzsche and tried to earn a living. In 1920, Felixmüller received the Grosser Staatspreis für Malerei (Great State Prize for Painting), a prize which granted its winner one year of study in Rome. Instead of going to that inflation-ridden city, however, Felixmüller obtained permission to spend the allotted time in the Ruhr district, where his brother was a mining engineer. While there, he discovered the harsh and poverty-stricken world of the miners which he depicted so convincingly that the famous comedy writer and dramatist Carl Sternheim credited him with having painted the first true proletarians.[2]

A slowly developing disappointment with the Weimar Republic and the necessity of supporting his family led Felixmüller to a change in style. This began with slight modifications in the coloration of his paintings, greater naturalism in his graphic works, and increased classicism in his portraits. Felixmüller's great woodcuts of the well-known German painters Lovis Corinth (1925) and Max Liebermann (1926) and dramatist Carl Sternheim (1925) are high points of this new stylistic direction. Felixmüller never joined the Neue Sachlichkeit movement. He remained an "engaged" artist, but his work shifted from an agitated, political stance to a more balanced view of life. His concern with the didactic potential of his art is demonstrated by a number of graphic portfolios which he produced at this time.

In 1937, the Nazis confiscated 151 of Felixmüller's works from various public collections. Prior to this time, they had exhibited 40 of them in an exhibition of "degenerate" art called *Spiegelbilder des Verfalls (Mirror Images of Decay)* held in April 1933 in Dresden; now 7 works were included in the *Entartete Kunst* exhibition in Munich.

During the Nazi period, Felixmüller continued to work with no chance of exhibiting, and at the very end

1. See his autobiography entitled "Der Prolet (Pönecke)," *Die Aktion,* vol. 10, no. 23/24, June 12, 1920, cols. 333–36.

2. Carl Sternheim, "Felixmüller," *Der Cicerone,* vol. 15, no. 19, October 1923, pp. 881–87.

of the Second World War he was drafted. His house and studio in Berlin were bombed. He was taken prisoner on the Russian front and only returned to Germany in the fall of 1945. In 1949, he was appointed a professor of painting and drawing at the Martin-Luther-Universität, Halle. He retired in 1962, again moving to Berlin, where he died in 1977. Prior to his death, however, he had the satisfaction of seeing himself "rediscovered" in a number of exhibitions in prestigious museums in both East and West Germany. While his later, more realistic paintings and graphics received due recognition and praise, the public was especially surprised by his earlier, powerful Expressionist works, which had not been seen for many years. Felixmüller was none too pleased by this emphasis on works which he regarded as youthful aberrations; as early as 1926, he had attempted to "recall" such works, trying to exchange them for more recent productions.[3]

In the few sculptures that Felixmüller created, one can detect forms that he had used in graphics and paintings, in combination with hints of his new stylistic direction. All of the sculptures represent erotic female nudes. Yet while some of the sculptures are related in their reference to primitive fertility fetishes, the variety of the forms is remarkable.

The *Nude in Coat* (cat. no. 35) is the most Expressionist of these sculptures. The effect of the erotically distorted breasts and hip is strengthened by the triangular form of the face. Neither the feet nor hands are sculpted in detail and the elongated neck emphasizes the difference between the turn of the head and the focus of the eyes. An earlier color lithograph of 1918, *Loving Woman* (Söhn, 140) as well as the woodcut *Flowing Hair* of the same year (Söhn, 136) reveal the artist's preoccupation with hair as a dominant decorative motif. The similarity with the engraving entitled *Beloved Wife* (cat. no. 33) is obvious, although the relief is more provocative and forthright.

Standing Nude with Flowing Hair (cat. no. 36) again displays the hair motif and exaggerated Expressionist concerns. The torso of a nude woman is framed by an undulating mass of hair; her left hand supports her left breast. Her head is tilted to the right and slightly downward. The facial structure is simplified but natural enough to be interpreted easily as a thoughtful, meditative expression. The distance between chin and breasts is unnaturally extended and accentuated by the long, flowing hair.

While all of Felixmüller's reliefs and sculptures are erotic, their expression ranges from the bluntly provocative to the dreamy and contemplative. When one compares the earlier woodcuts and lithographs of 1918, for instance, with some of the etchings in the 1925 portfolio entitled *Woman,* the position of the sculptural works at the threshold of a changing style becomes clear. The Expressionist Felixmüller had begun to see life differently, as had so many other Expressionists of the "second generation." – P.W.G.

3. For example, from the collector Heinrich Kirchhoff in Wiesbaden. See the letter to Kirchhoff of September 28, 1926, in Archiv für Bildende Kunst am Germanischen Nationalmuseum, Nuremberg.

Cat. no. 33
Beloved Wife (Geliebte Frau),
1921
Steel engraving, from the
portfolio *6. Stahlstiche (6 Steel
Engravings)*
25 x 19.5 cm.
(9⅕ x 7⁷⁄₁₀ in.)
Titus Felixmüller, Hamburg
Söhn, 252

This engraving depicts the curva-
ceous female nude with long, wavy
hair favored by Felixmüller in the
1920s. This figure, embraced by the
male in the background, is seen
again in the sculpture *Lovers* (cat.
no. 34).

Cat. no. 34
Lovers (Liebespaar), 1923
Oak relief
85 x 25 x 3 cm.
(33½ x 9⅞ x 1⅛ in.)
Conrad Felixmüller Estate,
Hamburg

Signed and dated. No. P7 in the art-
ist's work catalogue in the archives
of the Germanisches National-
museum, Nuremberg.

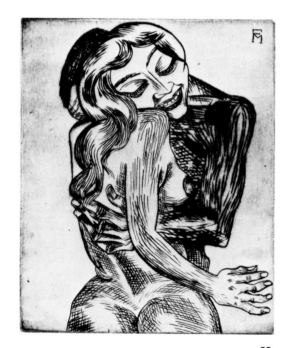

33

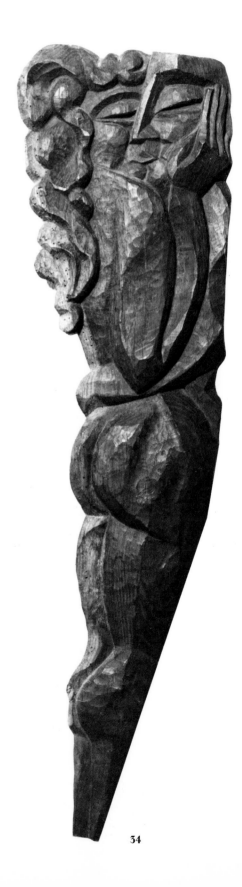

34

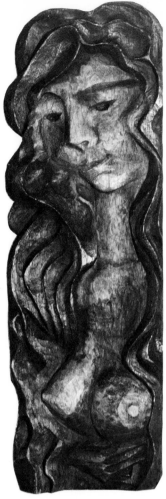

37

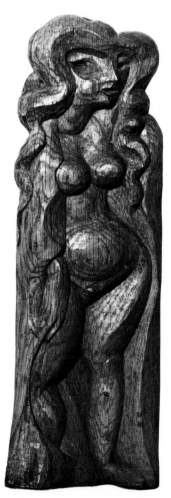

35

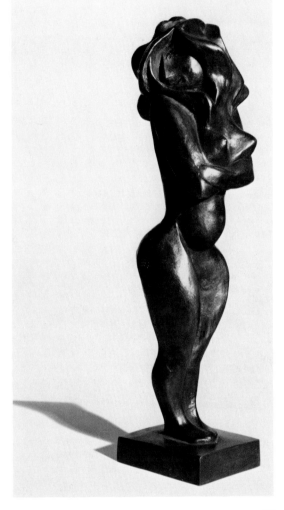

36

Cat. no. 35
Nude in Coat (Nackte im Mantel), 1923
Oak relief
39 x 12 x 6.5 cm.
(15⅜ x 4¾ x 2½ in.)
Conrad Felixmüller Estate,
Hamburg

Signed and dated.

Cat. no. 36
Standing Nude with Flowing Hair (Stehende Nackte mit offenem Haar), 1923
Bronze
33 x 7 x 8 cm.
(13 x 2¾ x 3⅛ in.)
Berlinische Galerie, Berlin

Inscribed with signature and casting number on base. No. P4 in the artist's work catalogue in the archives of the Germanisches Nationalmuseum, Nuremberg. The clay model *(Ton-Werkmodell)* and plaster *(Gips)* model no longer exist. Three editions cast in 1923 (March–June) resulted in 4 bronzes. Faience casts were also made in 1927. An edition of 6 bronzes, cast under the auspices of Gerhard Söhn, was executed in Hamburg in 1982 on the occasion of the 85th anniversary of the artist's birth. All bronzes are inscribed with a signature on the base; the 1982 edition is also numbered.

Cat. no. 37
Woman with Flowing Hair (Frau im offenen Haar), 1923
Oak relief
46 x 15 x 2 cm.
(18⅛ x 6 x ¾ in.)
Conrad Felixmüller Estate,
Hamburg

No. P1 in the artist's work catalogue in the archives of the Germanisches Nationalmuseum, Nuremberg.

Freundlich

Otto Freundlich

Born 1878, Stolp (Pomerania);

died 1942 or 1943, probably at the

Majdanek concentration camp,

near Lublin, Poland.

Otto Freundlich, one of the pioneers of abstract painting, left behind a small but incomparably original plastic oeuvre. Its importance for the development of modern sculpture, however, has only been recognized during the last few years. From 1902 to 1904, Freundlich studied art history with the famous scholar Heinrich Wölfflin. He did not begin his artistic career, however, until age twenty-nine, following a stay in Florence. Freundlich himself felt that his real talent was painting and not sculpture, in which he engaged only sporadically and in conjunction with his work as a painter. Paralleling the importance of his late pictures, his sculptures attained greatest significance after 1925. Expressionist characteristics imbue his entire oeuvre, which is indebted for its more Constructivist attributes to the Parisian avant-garde. (Beginning in 1908, Freundlich resided primarily in Paris.)

The artist's first creative period, from 1907 to 1924, had its roots in Jugendstil and turn-of-the-century ideas of *Gesamtkunstwerk*. His plastic art followed his growing painterly abstraction but with a certain lag; this is explained by the special problems inherent in sculptural realization.

Freundlich began a series of sculpted heads in 1906–07 with a mask, described by the artist himself as a "Medusalike, highly stylized self-portrait" (plaster *[Gips]*; lost). In the *Standing Mask* (cat. no. 39) and *Male Mask* (cat. no. 38), architectonic construction prevailed even more distinctly over the objective individual form. The absence of the neck in the *Standing Mask* emphasizes the plastic structure: chin, nose, mouth, and forehead are elementary building elements of the head. Yet the animated surface and undulating contours still display Rodin's influence. In his memoirs, Freundlich indicated that "from 1907, independent of any school, I began in my painting to utilize colorful, clear, and purely constructive spaces, lacking in either naturalistic or Impressionist elements, and from 1908 on I have been faithful to this technique."[1] Such tendencies in Freundlich's sculpture were first suggested by the 1910 *Bust of a Woman* (plaster *[Gips]*, Wallraf-Richartz-Museum, Cologne), in which the surface of the face is tightly stretched and rhythmically contrasted to the incised eyes and mouth. The series of heads reached its initial high point in the larger-than-life sculpture of 1912, *The New Man*. This work was illustrated by the Nazis on the cover of the 1937 *Entartete Kunst* exhibition catalogue and thus gained an unfortunate notoriety (fig. 1, p. 85). Here the head has been transformed into an architecture of basic plastic masses. Its surface is animated not in an Impressionistic manner, but by the building up of bits of clay, giving the sculpture the quality of masonry. The angular heaviness of this upturned head, the pro-

nounced facial features, compressed contours, and emphasized jaw are reminiscent of Easter Island heads. In the few paintings extant from this period (e.g., *Abstract Composition*, 1911, private collection, Hamburg), a comparable abstraction is noticeable – optical impressions were transformed into a system of rhythmically arranged, sharply delimited spaces, tectonically fitted together. Freundlich denied the influence of Cubist painting, although he was a friend of Picasso and well informed in regard to Cubist developments (in 1909 he had a one-man show at Clovis Sagot's gallery).[2] Yet a stylistic comparison of his paintings from 1911 to 1912 with those of Francis Picabia, for example, from the same period (e.g., *Procession in Seville*, 1912, Rothschild Collection, New York) reveals distinct parallels which are hardly conceivable without a knowledge of Cubism.

By the beginning of World War I, Otto Freundlich had created an important early oeuvre that had received recognition at a number of international exhibitions, such as the *Neue Sezession Berlin* (1911–12), the Cologne *Sonderbund* exhibition (1912), the *Moderne Kunst Kring* in Amsterdam (1912), Herwarth Walden's first *Herbstsalon* (1913), and the Cologne *Werkbund* exhibition (1914). The prewar years had provided him with new sources for the development of his ideas concerning *Gesamtkunstwerk*. His acquaintance with Jean Arp and Arp's circle, the tapestries he designed for the two Van Rees, and his study of Medieval stained glass were particularly influential in this regard.

Shortly before the beginning of World War I, Freundlich returned to Germany and served as a medic in Cologne, yet even these adverse conditions did not discourage him. In a letter of November 15, 1916, he wrote, "The more unspiritual, the more brutal the present, the more spiritual, the finer things one must do. That is strength."[3] Through the politically active writer Ludwig Rubiner, he established closer contacts with the antiwar movement surrounding the periodicals *Die Aktion* and *Zeit-Echo (Echo of the Time)*, for which he wrote articles and produced graphics.

Freundlich's first experiments with abstract sculpture began about 1916 and resulted in rhythmic configurations emphasizing the horizontal dimension; their biomorphic shapes were evocative of Arp. Freundlich's modeling in accordance with the principles of rhythmic planes was probably advanced considerably by his work in stained glass and mosaics.[4] The large mosaic *Birth of Man* (1918–19, Grosses Haus, Städtische Bühnen, Cologne) was commis-

||

1. Otto Freundlich, "Autobiographische Notiz," 1941, in *Schriften*, ed. Uli Bohnen, Cologne: DuMont, 1982, p. 252 ff.

2. The Parisian art dealers Clovis Sagot and Daniel Kahnweiler were two of the most important Cubist dealers.

3. Rheinisches Landesmuseum Bonn, 1978, p. 44.

4. In his text of 1934 "Die Wege der abstrakten Kunst," Freundlich himself cited the techniques of stained glass and mosaic as examples of the free organization of two-dimensional areas. See Aust, *Otto Freundlich 1878–1943: Aus Briefen und Aufsätzen*, 1960.

sioned by the Cologne merchant and collector Joseph Feinhals, who supported Freundlich as early as 1915 and financed his Cologne studio. During the period of 1919–20, a time of new beginnings and ideas of community, Freundlich created another large architectural mosaic, a memorial to the Wissinger family in the Stahnsdorf cemetery near Berlin. This work was a collaboration with two Novembergruppe colleagues: the architect Max Taut and the sculptor Rudolf Belling. Freundlich's contribution to this joint venture was the sculpture for the tombstone.

Freundlich's development during the twenties was characterized by increasing abstraction and the complete renunciation of objective detail. It can be traced particularly well by considering his stained glass windows from the first half of the decade. Work in this medium directed Freundlich's attention increasingly toward problems of light in painting, where his contrasts of light and dark communicate a polarity of meaning. Light is not a means of creating illusions of space, but rather a substance that constitutes forms. Freundlich's angular breaking up of two-dimensional planes came about when he became acquainted with what he termed

"The intimate combination of all pictorial planes, each one of which, like a cell in an organism, is transferring power to another cell, resulting in an uninhibited circulation of power throughout the whole organism. I had to eliminate the egocentric element, so closely associated with the depiction of man, plant, and object; I had to arrive at a kind of dialectic language of the colors themselves."[5]

Such insights had consequences for Freundlich's sculptural modeling. With regard to its degree of abstraction, the *Head* of 1925 (plaster; destroyed) might be considered a nonfigurative architecture of plastic masses. Yet the sculpture derived its blocklike expression specifically from this objective ambivalence. As in the case of the earlier heads, the composition is expressive but has become more compact and dynamic. The *Head*'s structure of restrained upward movement was developed through the contrast of towering and hanging volumes, as well as the consequent activation of the spaces between them. It is only a small step to the two monumental sculptures *Ascension* (1929, bronze) and *Architectural Sculpture* (1934, bronze), with which Freundlich, now a member of the Constructivist group Abstraction Création (Abstraction Creation),[6] attracted attention in Paris. These two sculptures display an ambiguous verticality; they are not modeled out of one mass but are built up from individual, independent forms – a process of accumulation comparable to the construction of prehistoric dolmens. These two pieces are the most significant in Freundlich's sculptural oeuvre.

||

5. See Otto Freundlich, "Bekenntnisse eines revolutionären Malers," 1935, in Aust, op. cit.

6. Members included Piet Mondrian, Jean Arp, Wassily Kandinsky, and Robert Delaunay.

Freundlich developed his late work with an amazing consistency and under the most difficult material conditions. During the thirties the constant theoretical reflection that characterized his career reached a philosophical penetration of the highest level, as is evidenced in his writings.[7] Whereas in Germany his works were removed from museums and displayed at the *Entartete Kunst* exhibition of 1937, they continued to draw attention at important international exhibitions, such as the Basel *Konstruktivisten* show (1937), the Amsterdam *Abstrakte Kunst* exhibition (1938), and the London *Modern German Art* exhibition (1938). At the beginning of 1939, Freundlich, who was Jewish, was interned. He was released the following year as the result of Picasso's intervention. Soon after, he succeeded in fleeing to the eastern Pyrenees, where he went into hiding until 1942. In December of that year, he was arrested at St. Martin-de-Fenouillet and ultimately deported to Poland. He either died en route or in the concentration camp of Majdanek near Lublin.

In the fifties, Freundlich's Paris studio in the rue Henri-Barbusse was opened to the public. The influence of his painting is recognizable in the vivid work of the Ecole de Paris (among others that of Serge Poliakoff and Maurice Estève). Since the sixties, considerable and growing interest has developed in Freundlich's late projects such as the *Lighthouse of the Seven Arts* (c. 1936, plaster *[Gips]* model, Estate of Otto Freundlich, Pontoise, France), a construction which was planned to accommodate the sculptures of a number of artists. – J. H. v. W.

||

7. Otto Freundlich, "Die Wege der abstrakten Kunst," 1934, in Aust, op. cit. no. 7; "Richtlinien für den Unterricht in der bildenden Kunst," 1935, 3-page typescript, Estate of Otto Freundlich, Pontoise, France; and "Ideen und Bilder," 1940–42, 82-page typescript, Estate of Otto Freundlich, Pontoise, France, abridged in Rheinisches Landesmuseum Bonn, 1978, pp. 262–66.

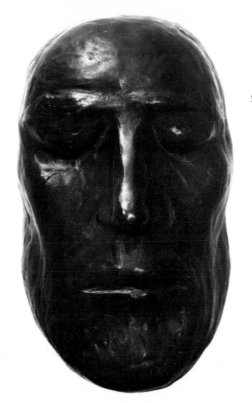

38

39

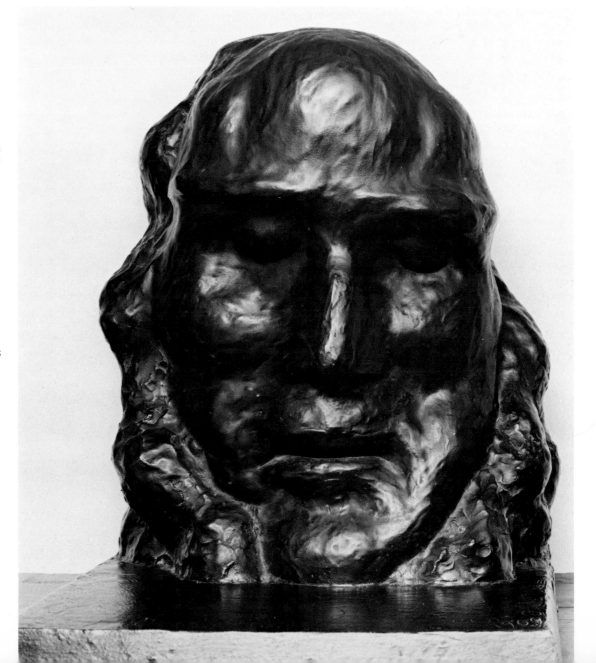

Cat. no. 38
Male Mask (Männliche Maske),
1909
Bronze
32.7 x 22 x 12 cm.
(12⅞ x 8⅝ x 4¾ in.)
Private Collection, Cologne
Heusinger von Waldegg, 54
(Cologne only)

Presumably 2 casts exist. This one is
unsigned; another cast is signed *O.F.*
under the chin.

Cat. no. 39
*Standing Mask (Stehende
Maske),* 1909
Bronze
51.5 x 42.5 x 44.5 cm.
(20¼ x 16¾ x 17½ in.)
Private Collection, Cologne
Heusinger von Waldegg, 55

Inscribed *Otto 1909* on base, r. f.
Exhibited at the *Neue Sezession 1.
Graphische Ausstellung,* 1910, no. 17;
and at the *Sonderbund,* Cologne,
1912.

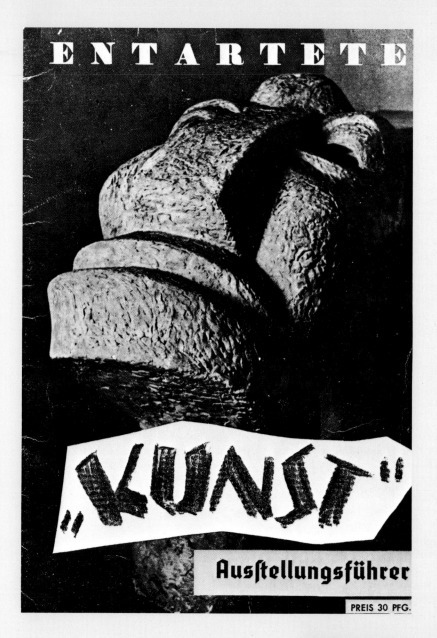

Fig. 1
Cover of *Entartete Kunst (Degenerate Art)* exhibition catalogue, 1937, with Freundlich's *New Man (Die neue Mensch)* 1912, plaster *(Gips)*; destroyed.

Fig. 2
Head (Kopf), 1912
Plaster *(Gips)*
Destroyed
Heusinger von Waldegg, 62

Garbe

Herbert Garbe

Born 1888 Berlin;

died 1945 as French prisoner of war.

Herbert Garbe studied sculpture at the Kunstgewerbeschule in Munich and at the Kunstakademie in Berlin (1910–12). After completing his training, he maintained a studio at the latter institution. His early sculptures, which the scholar Alfred Kuhn described as "graceful Rococo art," were figural, decorative, and characterized by rhythmic motifs depicting motion. Due to Garbe's military service during World War I, his early oeuvre is not extensive, yet it is important insofar as such works as the *Tragic Group* (1912, plaster *[Gips];* destroyed) reveal the beginnings of his later two-figure, dancelike sculptures of 1919–20. This later group represents the sculptor's brief Expressionist interlude, which would be unimaginable without the influence of the group motifs of Archipenko and Belling.

Even Garbe's striding nude of 1918, *Walking Woman* (plaster *[Gips];* destroyed), with its head leaning back and its hands groping and outstretched, is still so conventional in its static composition, geared toward a single view, that one could never have predicted Garbe's work of the following year – couples engaged in complicated, intertwined motions. The sculptures of 1919–20 are the work of an average artist who temporarily assumed progressive traits due to his association with the inspirational Novembergruppe. Garbe's most important encounter in this circle was with the sculptor Emy Roeder, whom he married in 1920. Shared characteristics may be seen in the work of these two artists, particularly around 1920, including the use of common motifs – for example, in *Sleep/ Lovers* of 1919 (cat. no. 40) and Roeder's *Sleeping Couple* (1920, stucco; destroyed). During this period, both artists were intensely preoccupied with the fashioning of reliefs (cf. Garbe's relief *Three Women,* 1919–20, wood, Nationalgalerie, Berlin), an interest which for Garbe served as pictorial clarification of his sculptural motion-motifs. Garbe's and Roeder's choice of wood as a preferred material allowed their plastic forms new concision and angularity.

There were, of course, significant differences in their work as well: whereas Emy Roeder was concerned with depicting her own spiritual experience by means of a closed, outwardly calm form, Garbe sought to convey the same feelings in extroverted depictions of motion. His sculptural groups of 1919 – *Eros* (wood; lost), *Blue Group* (terracotta; destroyed), *Sleep/Lovers,* and *Group of Death* (two versions; both lost) – now originated in quick succession. The themes of these works are those of Expressionism – eroticism, conflict, ecstasy. As in expressive dance, the motion-motifs are composed of rhythmic parallels and contrasts. The interweaving of the bodies, angular positioning of arms and legs, and inclusion of negative space are close to Belling's 1917–19 formulations. For example, the horizontal extension of the sculpture *Sleep* may be compared to that of Belling's *Group Dance* (1917;

destroyed); *Eros* is similar to Belling's *Standing Man with His Wife* (1918, plaster *[Gips];* destroyed). With respect to the contrast of movement involved in a standing figure bending toward a reclining one, both *Eros* and *Sleep/Lovers* are modeled on Archipenko's *Dance Duo* (1912, bronze). Archipenko's sculptures were shown in a large one-man exhibition in Herwarth Walden's Galerie Der Sturm in 1918.

Of course, these comparisons can only go so far; Garbe's dancelike groups appear more conventional when viewed in relation to Belling's *Triad* (fig. 2, p. 77) – an abstract sculpture which nevertheless depicts dancers. Belling was much more committed to structural problems of *Raumplastik* (space sculpture) and the equal treatment and interdependence of positive and negative volumes. Garbe's work is closer to the sculptures of Novembergruppe artists Georg Leschnitzer or Max Krause that are characterized by simple reductions of physical forms. The contrast between compressed and extended shapes seen in *Sleep/Lovers* is likewise limited in its relationship to Belling's *Group Dance,* for Belling has presented almost mechanical dynamics of motion with no mimetic quality, whereas Garbe in his motion-motifs has depicted elementary feelings of mutual affection and commitment. His fashioning of the surface similarly serves as an expression of life processes. The cubic strengthening and limiting of the plastic form in *Sleep/Lovers* resembles armor, corresponding to the protective, closed quality of sleep; the angular, broken surface of the lost *Group of Death* sculptures corresponded to ideas of growth and transformation.

Garbe and Roeder collaborated closely into the late twenties, but the differences between their sculptural ideas became more and more obvious. Garbe's inclination toward monumental individual figures was already noticeable in their joint exhibition at the Galerie Ferdinand Möller, Berlin, in 1927. At the beginning of the thirties, such a style was in complete agreement with then-prevalent neoclassicism and brought Garbe numerous public commissions for nudes, religious figures, and portraits. In 1936, the Nationalgalerie in Berlin bought the *Female Harvester* (1936, stone), an idealized depiction of a worker. At the same time, Garbe created genrelike studies of motion such as *Goal-Keeper* (1930, plaster *[Gips];* destroyed).

In 1936, Garbe was appointed as sculptor Richard Scheibe's successor to teach sculpture at the Städelsche Kunstschule in Frankfurt am Main. He held this post until he was fired in 1941, when the SS newspaper *Schwarze Korps* located some of his early Expressionist work, and he was declared a "cultural Bolshevik." – J. H. v. W.

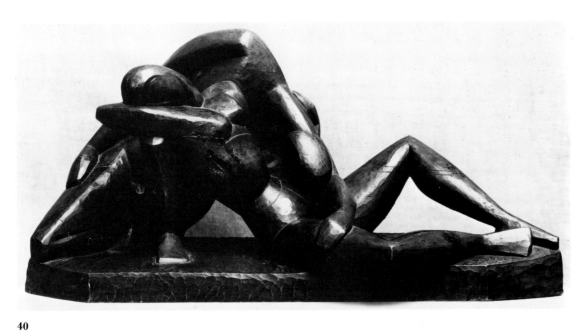

40

Cat. no. 40
*Sleep/Lovers (Schlaf/
Liebespaar)*, 1919
Wood
45 x 93 x 28 cm.
(17¾ x 36⅝ x 11 in.)
Kunstmuseum Hannover mit
Sammlung Sprengel

Cat. no. 41
*The Desperate Woman (Die
Verzweifelte)*, c. 1920
Oak
110 x 60 x 30 cm.
(43¼ x 23⅝ x 11⅞ in.)
Berlinische Galerie, Berlin

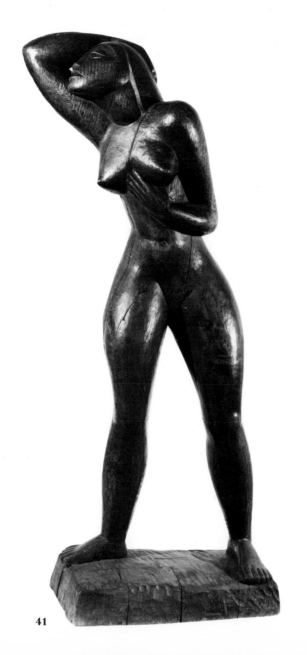

41

Gutfreund

Oto Gutfreund

Born 1889 Dvúr Králové,

Czechoslovakia;

died 1927 Prague, Czechoslovakia.

During the years prior to World War I, Cubism created no greater reverberations outside France than in Prague, where its interpretations were often wholly independent of French models. Art historians, collectors, and local artists' groups appeared as mediators between Paris and Prague. Between 1910 and 1913, the collector and theoretician of Cubism Vincenc Kramář acquired important works by Picasso, Braque, and Derain. Using Expressionism as a point of departure, the Czech painters Emil Filla, Bohumil Kubišta, Vincenc Beneš, and Antonin Prochazka, the sculptor Oto Gutfreund, and a few architects formed the Skupina vegtaruých umelců (Group of Fine Artists). Between 1911 and 1913, they propagated Cubism as the program of their generation both in exhibitions and in the periodical Umělecky měsičnik (Artistic Monthly). This popularization of Cubism was advanced by the application of its principles beyond the realms of painting and sculpture – in architecture and in decorative arts, such as furniture, ceramics, and glass.

Ideas concerning the picture or sculpture as organism, the logic of composition, the liberation of color from its imitative function, the use of planes, clear rhythm, and geometric forms – these were taken from French Cubism. But whereas the French one-sidedly stressed aesthetic categories, the Prague followers strove for a balancing of rational and emotional aspects, a harmony of geometric, constructive, and expressive orders. With reference to sculpture, this had the following implication: Gutfreund replaced the analytical French approach to sculpture, as seen, for example, in Picasso's early Cubist Head of a Woman (fig. 10, p. 18), with the idea of sculpture as materialization of feeling: "The sculpture is a materialization of the motif's effect.... The sculptor directly materializes the vision reflected in his soul...."[1] Gutfreund's sculpture is a fusion, characteristic for the Prague Cubists, of "Gothic" expressive mysticism, Baroque dynamics, and French Cubist rationality.

The intention to introduce a rational aspect into the treatment of emotion was already evident in Gutfreund's selection of the Frenchman Emile Antoine Bourdelle as his teacher. Bourdelle's tectonic concept of plastic art impressed Gutfreund when in 1909 he attended the artist's one-man exhibition in Prague; Gutfreund consequently studied with Bourdelle in Paris from 1909 to 1910. A certain proximity to the French sculptor's emotional stance may be seen in the firm, simplified form of one of Gutfreund's first independent works – a portrait of art critic and historian Antonin Matejcek (1910, bronze), a close friend of the artist during his stay in Paris and his traveling companion during a 1910 study tour of England, Belgium, Holland, and Germany. Yet with respect to the tectonic structuring of the portrait, Gutfreund set his own course. "For a sculptor," he wrote in his Paris diary, "it is not enough to be skilled in modeling. A sculptor must, above all, be a mathematician who fashions the mass according to a previously considered plan, that is, he must also be an architect."[2]

In 1911, Gutfreund executed a number of sculptures with literary subject matter that typify the aforementioned mix of elements from Expressionism, Cubism, and the Baroque. The latter term applies in the sense that the animated masses of these works function as a means of psychic dramatization. However, Gutfreund distinguished himself from Baroque sculpture and those who continued its tradition, such as Rodin, and in this difference lies his modernity. Instead of the dramatic fervour of the Baroque, he strove for an equalization of plastic energies; instead of structuring mass, he utilized organized planes: "The new sculpture does not know weight, since volume is replaced by plane. Consequently it does not know a center of gravity. This is the basic formal difference between Baroque and contemporary plastic art."[3] In addition to the deformation of natural forms, the Gothic lengthening and literary subject matter may be considered to be Expressionist characteristics. Gutfreund chose troubled protagonists from world literature: Job, Hamlet, Don Quixote – sceptics, ponderers, visionaries. Angst (cat. no. 42) recalls figures encountered in the writing of Dostoevski and in Edvard Munch's paintings (in 1907 there was a large Munch exhibition in Prague). Angst combines a formal system of rhythmic planes with expressive content; it embodies the welling up of fear. This impression is suggested more by the angular, broken surface than by mimetic expression. All lines direct the viewer's eye up the tapered form toward the head, which remains untouched by the system of lines. In comparison, the figure's gesture – the arms crossed over the chest and the head sunken into the garment – is formally less productive of this effect. Similar formal principles are noticeable in the figures Hamlet (1911, bronze) and Don Quixote (cat. no. 43), which originated during the same year. But whereas the surface of Angst was made dynamic through the faceting of planes, in Hamlet the surface is torn open and dramatized by differently accented concentrations of form. The alternation of hollowed-out and expressively protruding shapes, together with the farcical lengthening of proportions, creates a bizarre intensification of expressive meaning. With regard to the combination of Gothic verticality and Cubist dynamics, the figure has been compared to Lehmbruck's Rising Youth (fig. 3, p. 147).

The surfaces of the 1911 figures are deformed and geometric, but these qualities appear merely to have been imposed upon the sculptures as a transposition of the formal principles of Cubist painting. This treatment changed in works created from 1912 to 1913,

1. Oto Gutfreund, probably written in 1911, first published 1912. Quoted from Museum des 20. Jahrhunderts, Vienna, 1969, p. 14.

2. Muzeum Sztuki w Lodzi, 1971, p. 16.

3. Museum des 20. Jahrhunderts, Vienna, 1969, p. 19.

where the surface was increasingly torn up and ruptures of form occurred. The organic flexibility of the figures and literary subject matter were given up in favor of complex structures. The sculptures gained new spatial qualities; they were now dramatized from the inside out. In the *Violoncellist* (1912–13, bronze), a new systematic alternation of positive and negative volumes occurred, almost concurrently with Archipenko's experiments with concave plastic art. Gutfreund's portrait *Viki* (cat. no. 44) demonstrates the sovereign application of this newly acquired technique. Built up from an invisible core toward the outside, the forms may be read in a dynamic, turning motion, beginning at the neck through the rising cheeks, up to the curls of the hair. The individual forms of the face – mouth, nose, eyes – are included in a continuum of positive and negative volumes. Contours appear as lines of power, illustrative of the energies emanating from the center. Deep breaks in the mass and protrusions of form reveal an alternating play with space. Rhythmically structured, the composition of the head unites content and form, endowing the work with a particular kind of charm and at the same time marking its distance from the de-psychologized, systematically organized Cubist head constructions of Picasso and Archipenko. Viewing Picasso's *Head of a Woman* at a May 1913 exhibition in Prague, Gutfreund stated: "Picasso dissects the surface of the object, destroys its specific organism in order to build something new. The unity of organism and object must be preserved."[4]

The closeness of Gutfreund's sculpture to Cubist problems of form is probably greatest in *Cubist Bust* (1912–13, bronze). This development was interrupted by World War I, at the outbreak of which Gutfreund volunteered for the Foreign Legion and was consequently interned numerous times in a camp in southern France. There he created the abstract sculpture *Sitting Woman* (1916, Nationalgalerie, Prague), which, nailed together from old boards, may be regarded as an incunabulum of Constructivist sculpture. In line with the neoclassicist tendencies of the twenties, around the beginning of the decade Gutfreund's oeuvre took a turn toward objective, realistic sculpture with social subject matter. His group sculptures *Industry* and *Commerce* (1923, painted wood, Nationalgalerie, Prague) have appropriately been termed "industry genre" by Eduard Trier.

In 1926, Gutfreund was appointed professor of architectural sculpture at the Kunstgewerbeschule, Prague. The next year, before reaching the age of thirty-eight, Gutfreund drowned in the river Moldau. His most important sculptures are in the Nationalgalerie, Prague. Whereas his realistic work was favored for a long time, Gutfreund's significance as an important experimental creator of Cubist sculpture went unrecognized until barely two decades ago.
– J. H. v. W.

||
4. Muzeum Sztuki w Lodzi, 1971, p. 18.

Cat. no. 42
Angst, 1911
Bronze
h: 148 cm. (58¼ in.)
Private Collection

Inscribed *4/6 G.* This piece is from an edition of 6 cast during the artist's lifetime. The plaster model is in the Nationalgalerie, Prague. A small bronze maquette also exists; 2 casts are in a private collection in Washington. One larger version was commissioned in 1981 in commemoration of the Holocaust; it is installed in the Jewish Pavilion at the Auschwitz Museum.

Cat. no. 43
Don Quixote, 1911
Bronze
h: 38 cm. (15 in.)
Private Collection

Inscribed *4/6 G.,* l. r. This piece is from an edition of 6 cast during the artist's lifetime. The plaster model is in the Nationalgalerie, Prague. The plaster model was exhibited in 1913 at Herwarth Walden's Galerie Der Sturm, Berlin, in the *Erster Deutscher Herbstsalon,* no. 153.

Cat. no. 44
Viki, 1912–13
Bronze
h: 33 cm. (13 in.)
a) Reinhard and Selma Lesser (Los Angeles only)
b) Private Collection (Washington and Cologne only)

a) No inscription. From an edition cast in the 1960s by Fionrini and Carney, London. One of 3 or 4 casts from a proposed but incomplete edition of 7.

b) Inscribed *6/6 G.* Six casts were executed during the artist's lifetime from the plaster model. The plaster is now in the Nationalgalerie, Prague. Five additional casts are located in the Nationalgalerie, Prague (2 copies); National Museum of Wales, Cardiff; Museum Folkwang, Essen; and the Gutfreund Estate, Prague. Exhibited in 1913 at Herwarth Walden's Galerie Der Sturm, Berlin, in the *Erster Deutscher Herbstsalon,* no. 153.

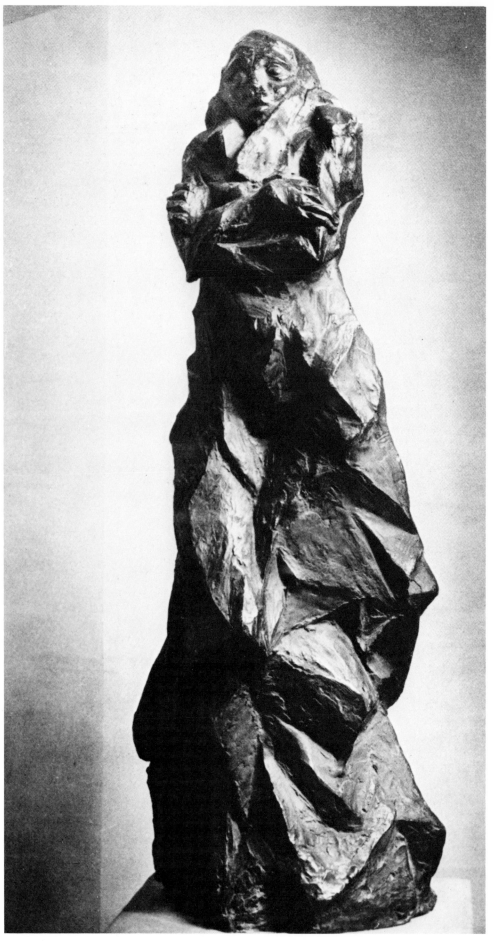

42

Fig. 1
Gutfreund in his studio, 1912;
left, *Don Quixote* (cat. no. 43),
far upper-right, *Angst*
(cat. no. 42).

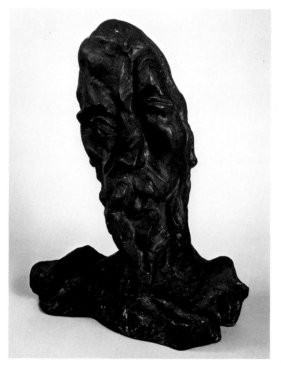

43

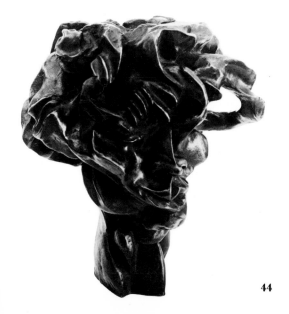

44

Heckel

Erich Heckel

Born 1883 Döbeln (Saxony);

died 1970 Hemmenhofen.

In one of her earliest letters to the Hamburg collector Gustav Schiefler, Emil Nolde's wife, Ada, wrote: "Here in Dresden I'm in contact with the young, active members of the Brücke, and it's very interesting and stimulating to be in touch with their art and their perceptions. Recently Heckel has produced beautiful raw wood sculptures, and he made me happy by placing two of them in my room. He is a fine human being, so lyrical, so much of a feeling for poetry and desire for beauty...."[1] This undated letter, probably written in March 1907, is an important document of the early Brücke years.[2] It confirms that Nolde and his wife – both considerably older than the members of the Dresden group and stylistically rooted in the nineteenth century – were able to recognize the future significance of a kind of art which only shocked most members of their generation. Nolde acknowledged his debt to the Brücke; his affiliation with this group was important not only for his own painting, but also because it brought about the subsequent contact of the other Brücke artists with Gustav Schiefler.

Ada Nolde's letter also indicates how important Erich Heckel's initiative and unifying influence were at this time for the artists' group that he had cofounded. What is perhaps most surprising is the willingness Nolde's wife expressed to have wood sculptures by Heckel, an artist who, in contrast to her husband, had never received any training in wood carving, in her home. Unfortunately it is impossible to ascertain exactly which figures she was referring to. Paul Vogt, who compiled a work index for Heckel during the artist's lifetime, identified the earliest works as a terracotta figure of a gnomelike old woman executed in 1904 (Vogt, 1) and two heads of 1905 (Vogt, 2 and 3), carved from alder. The natural, mythical qualities of the head of a bearded man suggest associations with the heads of mountain giants, which Nolde drew in 1895–96 and published as printed postcards.[3] In any event, mutual influences must be assumed, and they ultimately led to Nolde's resumption of his carving.[4]

Approximately twenty sculptures by Heckel can be identified from the period prior to World War I; six limestone reliefs were created after World War II. This count excludes clay reliefs and handicrafts, several of which are known. Aside from the terracotta of 1904, the early sculptures are exclusively wood figures, carved from various softwoods such as alder, linden, maple, birch, acacia, and poplar. Real hardwoods – such as oak – do not seem to have been used, perhaps

because it was not in Heckel's nature to willfully work against his material. The desired form had to grow out of the organic wood. Heckel sought a meeting of idea and material more intensely and certainly earlier than his Brücke colleagues. He researched and experimented with a variety of possibilities and freely shared his results. Any kind of purism, as far as materials were concerned, was as foreign to him as formal virtuosity. His expression was intended to reveal his inner disposition; the sculpted figure represented its creator. Those fortunate enough to have met Heckel know what this meant and can easily understand why Nolde felt so close to Heckel's wooden figures and why he was inspired by Heckel and other Brücke artists to create woodcuts. Interestingly, Nolde had not previously used this graphic technique, which may be thought of as the negative form of carving.[5]

Of the four Heckel sculptures in this exhibition, *Caryatid* of 1906 (cat. no. 45) was created first. Although an early work, it displays qualities which had already become characteristic of the artist's wood sculptures, such as a unique symbiosis of barbaric strength and sensitive tenderness. Here we also see Heckel's economical use of color, which appears to seep out of the wood, accentuating its primitive quality. When Heckel used color in his plastic art, he did so sparingly, predominantly in the area of the head. Black dominates, and more than two colors are rarely employed.

Like his colleagues, Heckel frequently depicted his wood figures on postcards which he sent to close acquaintances.[6] Of particular interest is one dated December 1, 1910 (fig. 5, p. 95), which was drawn in color and sent to the art historian Rosa Schapire.[7] On it, Heckel indicated that he had sent her three of his wood sculptures as well as a pewter cast by Kirchner. Of the two figures impulsively drawn on the image side, the left one can also be recognized in a still life of 1920 (Vogt, 16). Like several other Heckel sculptures, it fell victim to the Second World War.

From other such postcards and letters it is evident that after paying visits to the Brücke artists in Dresden, Gustav Schiefler was so impressed with their sculpture that at the beginning of 1911 he sent them trunks of maple trees from Hamburg (see p. 114). Heckel "chopped" two female figures out of this dense wood.[8] One of these, *Tall Standing Woman*, was acquired in 1930 by director Max Sauerlandt for the Hamburg Museum für Kunst und Gewerbe and was published in an essay by Sauerlandt (included in this catalogue in translation; see pp. 51–55; fig. 5, p. 54).

1. Letter in the estate of Gustav Schiefler, kindly made available by his daughter Ottilie.

2. Cf. Reinhardt, 1977/78, pp. 40ff.*

3. Cf. Altonaer Museum in Hamburg, 1973.

4. Cf. Schleswig-Holsteinisches Landesmuseum and Museum für Kunst und Gewerbe, Hamburg, 1960.*

5. Kirchner refers to this fact and to Nolde's communication of the art of etching to the Brücke artists. See Kirchner, 1913.**

6. Cf. Gerhard Wietek, *Gemalte Künstlerpost: Karten und Briefe deutscher Künstler aus dem 20. Jahrhundert,* Munich: Thiemig, 1977.

7. Cf. Gerhard Wietek, ed., *Maler der Brücke: Farbige Kartengrüsse an Rosa Schapire,* Wiesbaden: Insel, 1958; Wietek, 1964.

8. See Heckel's letter to Schiefler of February 1911.

The second figure carved from Schiefler's maple, *Standing Girl* (fig. 1, p. 94), remained in the artist's possession and was acquired by the Hamburg museum in 1966.[9] (The largest of Heckel's extant wood sculptures, this figure is unfortunately in fragile condition and could not be included in this exhibition.) The smaller *Crouching Woman* (cat. no. 46), carved out of soft linden, dates from the same year. It too, is riddled with cracks and shows considerable touching up of the surface by the artist. This sculpture can be identified in one of Heckel's paintings of the same period (Vogt, 1912/46) and in a woodcut as well (cat. no. 50). In Heckel's paintings, sculptures appear frequently (see Vogt, 1906/8), perhaps for the first time in a self-portrait of 1906 and certainly not for the last in a still life of 1960 (Vogt, 6) that most likely shows an early figure which no longer can be identified. Other paintings and drawings circa 1912 also depict sculptures; old studio photographs (figs. 2 and 3, pp. 94–95) provide an additional indication of Heckel's sculptural production at this time, which has been largely lost.[10] During this same period, Heckel began sending many of his works to exhibitions.[11]

In the essay mentioned above, Sauerlandt compared the *Tall Standing Woman* of 1912 to "a Madonna of Annunciation...which shyly covers its nakedness, so to speak, in itself." Thus he acknowledged the religious element in Heckel's art, which achieved particularly strong expression in his sculpture. In the same year, Heckel created the life-size figure of a naked praying man with arms uplifted (fig. 2, p. 94) and the clothed *Draped Woman* (fig. 6, p. 95), which has been at the Brücke-Museum since 1966. The latter work seems to have its models in Gothic sculptures of Mary under the Cross. Perhaps these works by Heckel also suggest that foreboding of the First World War with which the German Expressionists are often credited.

The erotic *Bathing Woman with Towel* of 1913 (cat. no. 47) is certainly one of Heckel's most powerful figures. It has been privately owned by the family of Max Sauerlandt since 1920.[12] Sauerlandt was acquainted with Heckel from before World War I, and he was the first German museum director to regularly include the sculpture of the Brücke in the exhibition and acquisition activities of a public museum.

Heckel served as a medic in Flanders during the First World War, which determined a more significant break in his sculpture than in his painting. The last wood figure to have been preserved is the *Standing Figure* of 1920 (cat. no. 48). The slender girl's figure, which has been peeled out of soft poplar wood and remains enveloped by it, surpasses the earlier figures in the flowing compactness of its rhythmic contours and smooth surface. The sculpture derives from a time when many of the nudes in Heckel's paintings, most of which he created at Osterholz on the Baltic Sea, looked like animated wood figures which had found their way out of the studio and back into nature.[13] On the occasion of a visit to the Breslau studio of his former Brücke colleague Otto Mueller, Heckel expressed great interest in Mueller's carved, jointed, marionettelike figures.[14]

Although we know from his letters that other figures originated in Osterholz during the summers between the two world wars,[15] it may be said that Heckel ended his activity as a wood sculptor and an Expressionist graphic artist with *Standing Figure.* In its wholeness and graceful dignity it may be interpreted as the expression of his own philosophy of life. From 1920 until his death, he devoted himself to exhausting the possibilities inherent in painting and graphics. – G.W.

||

13. In this respect the nude in the triptych *Bathing Woman* (Vogt, 1919/3) is exemplary.

14. Heckel drew these figures, which could not be located for this exhibition, on two postcards, ill. Wietek, 1977, op. cit., p. 111.

15. Communication in Heckel's letter to Sauerlandt of June 21, 1930.

||

9. Cf. Heinz Spielmann in *Jahrbuch der Hamburger Kunstsammlungen*, vol. 12, 1967, pp. 222ff., and in Museum für Kunst und Gewerbe, Hamburg, *Ausgewählte Werke aus den Erwerbungen 1962–1971 des Museums für Kunst und Gewerbe*, exh. cat., 1972, p. 342.

10. For example, letter from Heckel to Rosa Schapire of July 15, 1909, ill. as no. 39 in Altonaer Museum in Hamburg, 1973.

11. At the important Brücke exhibition held at Galerie Gurlitt, Berlin, in April 1912, Heckel was represented by twelve paintings, six drawings, and four sculptures. The exhibition traveled to the Galerie Commeter in Hamburg.

12. Cf. Heckel's letters to Sauerlandt of December 12 and 20, 1920, in the collection of the Staatsbibliothek, Hamburg.

Fig. 1
Standing Girl (Stehendes Mädchen), 1912
Maple, painted
h: 145 cm. (57⅛ in.)
Museum für Kunst und Gewerbe, Hamburg
Vogt, 6

Fig. 2
Sculptures by Heckel in his studio: left, *Standing Girl* (fig. 1); center, *Tall Standing Woman (Grosse Stehende),* 1912, maple, lost (Vogt, 8); right, *Praying Man (Betender Mann),* 1912, poplar, destroyed 1944 (Vogt, 10).

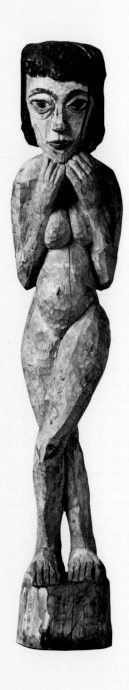

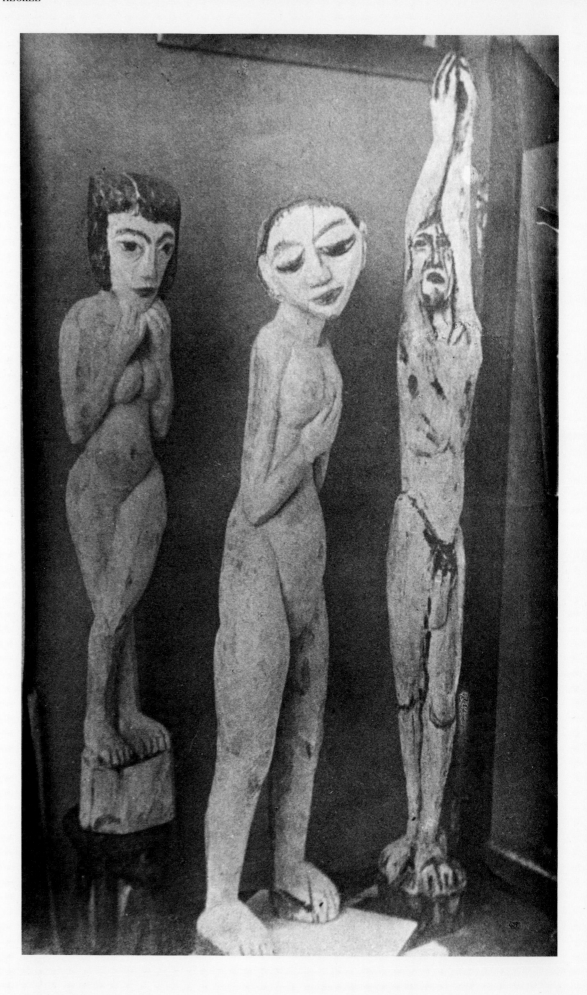

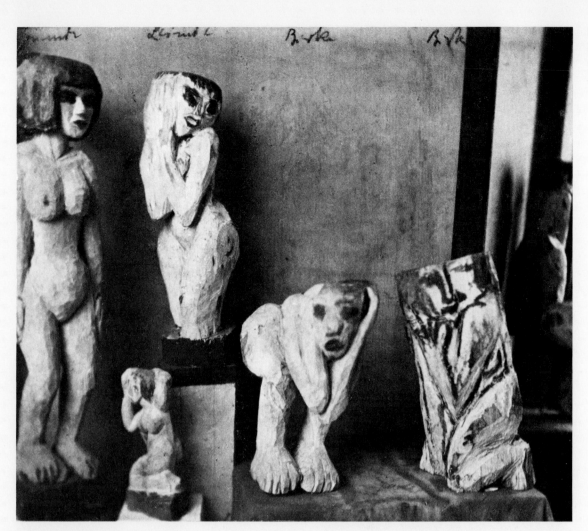

Fig. 3
Sculptures by Heckel in his studio: most are destroyed; lower left *Crouching Woman* (cat. no. 46).

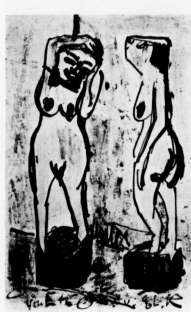

Fig. 4
Crouching Woman (Hockende), 1906
Painted linden
Destroyed
Vogt, 4
Photographed by Kirchner

Vogt dates this piece 1906, however, style and coloring correspond to Kirchner's sculptures of 1909–10.

Fig. 5
Postcard from Heckel to Rosa Schapire, December 1, 1910; Kunsthalle Mannheim.

Fig. 6
Draped Woman (Frau mit Tuch), 1912
Acacia
h: 103 cm. (40½ in.)
Brücke-Museum, Berlin
Vogt, 9

Cat. no. 45
Caryatid (Trägerin), 1906
Painted alder
h: 34.7 cm. (13⅝ in.)
Museum für Kunst und
Gewerbe, Hamburg
Vogt, 5

Cat. no. 46
Crouching Woman (Hockende),
1912
Painted linden
30 x 17 x 10 cm.
(11¾ x 6⅝ x 4 in.)
Erich Heckel Estate
Vogt, 7

Cf. painting Vogt, 1912 / 46 and
woodcut Dube, 432 C (cat. no. 50).

Cat. no. 47
*Bathing Woman with Towel
(Badende mit Tuch),* 1913
Maple, painted red and black
52 x 14 x 10 cm.
(20⅖ x 5½ x 4 in.)
Private Collection
Not in Vogt

Inscribed *EH* left f. Ill. in Schleswig-
Holsteinisches Landesmuseum and
Museum für Kunst und Gewerbe,
Hamburg, 1960, p. 6. Acquired from
the artist by Max Sauerlandt.

Cat. no. 48
Standing Figure (Stehende),
1920
Poplar
79 x 13 x 13 cm.
(31⅛ x 5⅛ x 5⅛ in.)
Erich Heckel Estate
Vogt, 12

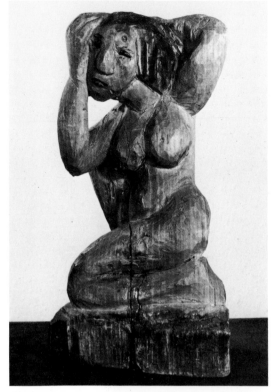

46

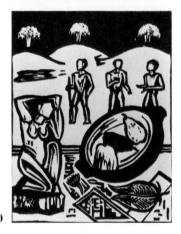

50

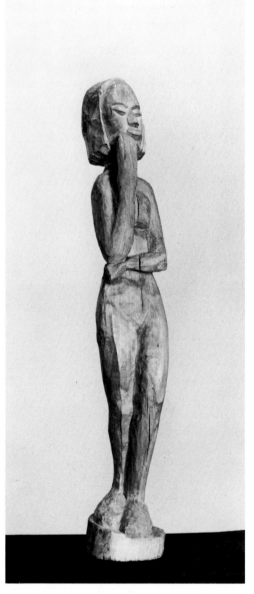

48

49

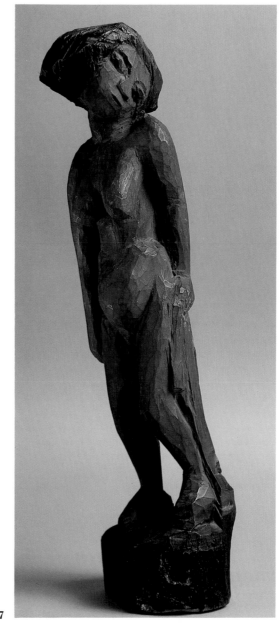

47

Cat. no. 49

Still Life with Stool and Wooden Figure (Stilleben mit Hocker und Holzfigur), 1924
Watercolor and crayon on paper
47.5 x 38.5 cm.
(18¾ x 15⅛ in.)
Private Collection

Although not identical in pose, the sculpture featured here is probably *Standing Figure* (cat. no. 48). The sketchy quality of the drawing may account for this discrepancy, although a similarly posed figure was depicted in 2 Heckel paintings: *Still Life with Wooden Figure (Stilleben mit Holzfigur)*, 1913 (Vogt, 1913/65), and *Zinnias: Still Life (Zinnien: Stilleben)*, 1921 (Vogt, 1921/28).

Cat. no. 50

Still Life with Wooden Figure (Stilleben mit Holzfigur), 1960
Woodcut
15.4 x 12.1 cm.
(6⅛ x 4¾ in.)
Dube, 432 C
Erich Heckel Estate

Heckel was fond of including depictions of his sculptures in his paintings, but rarely included them in his graphics. However, in this late woodcut the sculpture *Crouching Woman* (cat. no. 46) is seen as a decorative table ornament at l. l. of the composition.

45

Henning

Paul Rudolf Henning

Born 1886 Berlin;

lives in Berlin.

After studying architecture and sculpture at the Kunstgewerbeschule in Dresden, Paul Rudolf Henning opened his own studio in Berlin in 1907. Shortly thereafter he had his first exhibition at the famous Galerie Gurlitt, and from 1912 on he exhibited at the *Freie Sezession* in Berlin. In 1914, he moved to Paris, exchanging his studio with Wilhelm Lehmbruck.

Having served as a volunteer at the outbreak of World War I, he moved in 1916 to Zurich, where he quickly met Dadaist comrades such as Jean Arp, Viking Eggeling, and Marcel Janco. On April 11, 1919, these artists formed a group, calling themselves Artistes Radicaux (Revolutionary Artists). Henning signed the manifesto originated by this group, but it was never formally issued.

In 1919, prompted by his friend the architect Erich Mendelsohn, Henning returned to Berlin, where he became active in the Arbeitsrat für Kunst. His work at this time was primarily sculptural. He executed large terracotta reliefs for the facade of the Mossehaus, where the newspaper *Berliner Zeitung* was published, and for the Haus Grünfeld and the Haus Bahls in Berlin, including a work which employed quotations from Nietzsche's *Also sprach Zarathustra* as motifs. Henning also executed significant bronze portrait busts of the Italian composer Ferruccio Busoni, Mendelsohn's wife, Louise, the artist Max Pechstein (cat. no. 51A), and others, as well as creating large sculptural works for buildings in Aachen, Berlin, Cologne, and other cities. In the mid-twenties, however, he began to concentrate on architecture, designing a number of large apartment houses and planning building programs for a section of Berlin, as well as for Nuremberg and Troppau.

Henning's sculpture *The Dance of Charlotte Bara* (cat. no. 51) was created during a stay in Ascona, Switzerland, where he had redesigned the Castello San Materno for Paul Bacharach, Charlotte Bara's father. Bara was a famous dancer whose "Cathedral" dance was the inspiration for the sculpture. Its three nearly abstract terracotta forms are evocative of Bara's highly stylized performances and often hieratic costumes. In the newspapers of the time, her dances were compared to "age-old priestly rituals," and Bara herself was likened to sculptures from the cathedrals of Naumburg and Strasbourg or figures in the paintings of Domenico Ghirlandaio or even Mathis Grünewald. The Dutch publication *Het Volk* wrote:

Her dance is the realization of faith in God. It is as if in the quietude of a cathedral the figure of a saint steps from its niche and...personifies the spirit of the building, and our hearts thirst for the fountain of life. How does such a young child gain such depth and soulfulness? This is genius pure and simple, this is maturity born without the need for experience.[1] – P.W.G.

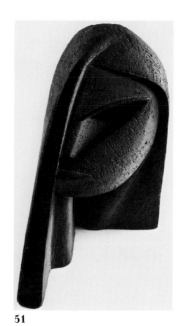

51

1. Quoted in Fritz and Hanna Winther, *Der heilige Tanz,* Rudolfstadt: Greifenverlag, 1923, pp. 24–25.

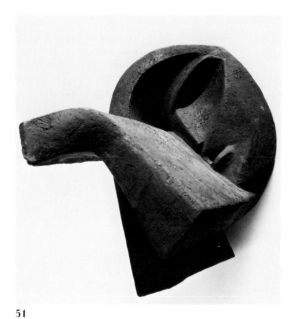

51

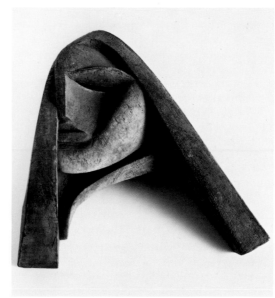

51

Cat. no. 51
*The Dance of Charlotte Bara
(Der Tanz der Charlotte Bara),*
1918
Terracotta
Three parts: 39 x 32 x 32 cm.
(15⅜ x 12⅝ x 12⅝ in.); 36 x 31 x
19 cm. (14⅛ x 12¼ x 7½ in.);
23 x 38 x 43 cm. (9 x 15 x 17 in.)
Berlinische Galerie, Berlin

Cat. no. 51A
*Three Portraits: a) H. M.
Pechstein, b) Professor Jessen,
c) Herr Escher,* c. 1918
Bronze
a: 37 x 25 x 17 cm.
(14⅗ x 9⅘ x 6⁷⁄₁₀ in.)
b: 38 x 28 x 26 cm.
(15 x 11 x 10⅕ in.)
c: 37 x 27 x 25 cm.
(14⅗ x 10⅗ x 9⅘)
Lent by the Artist, Berlin

The portrait of the artist Pechstein
(a) is inscribed *HMP/PRH* on the l. b.
and stamped *H Noack Berlin;* the
portrait of Professor Dr. Jessen of
Davos, Switzerland (b) is signed
Henning on the lower front and
stamped *H Noack Berlin;* the portrait
of the violinist Escher of Zurich,
Switzerland (c) is inscribed *F Escher
für Henning/Zurich 18* and stamped
H Noack on the l. l.

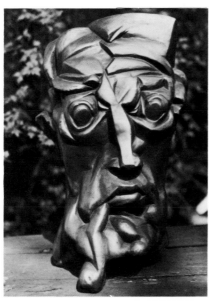

51A (a)

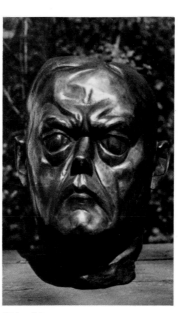

51A (b)

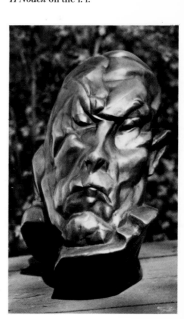

51A (c)

Herzog

Oswald Herzog

Born 1881 Haynau (Silesia);

date and place of death unknown.

Oswald Herzog's training as a sculptor began at an early age in Liegnitz, where he was engaged in the trade of *Stuckhandwerk,* or ornamental stuccowork. He came to Berlin in 1900 and continued to work as a craftsman while at the same time attending various art schools. Herzog was an established Berlin artist by the time he became associated with the famous Sturm circle led by publisher and gallery owner Herwarth Walden, who sponsored an exhibition of the artist's work at the Galerie Der Sturm in 1919. In a publication of the previous year, *Der Sturm: Eine Einführung,* Walden had introduced Herzog as an artist who was enlivening the European sculptural tradition much in the same manner as Archipenko.[1] Herzog in turn contributed woodcut illustrations to Walden's periodical *Der Sturm* in 1917 and 1919, as well as an essay entitled "Der abstrakte Expressionismus in der bildenden Kunst," which delineated some of his sculptural leitmotifs.[2]

As early as 1919, Herzog was included in the membership of the Novembergruppe, whose political and artistic activities were the focal point of postwar cultural life in Berlin. A series of art exhibitions was arranged by the group in 1919–20, and Herzog was frequently a participant. In later Novembergruppe exhibitions, he served as a jury member (1922), and in the *Ausstellung 10. Jahre Novembergruppe* (1929), he was on the exhibition committee as director of the sculpture section.

Although Herzog had achieved objectless sculpture by 1918–19, his contribution to the history of abstract sculpture has thus far been overshadowed by that of Rudolf Belling. While the latter's pieces were lauded as more formally vigorous and tectonic, Herzog's oeuvre was valued for its flexibility and lyricism. His contribution to abstract Expressionist sculpture was recognized by art critic Alfred Kuhn in his article "Die absolute Plastik Oswald Herzogs."[3] Kuhn described Herzog's work of 1914, a time when his sculpted subjects could still be identified as human forms, although the rhythm in these forms was the essential quality he sought. As articulated by Herzog in his *Der Rhythmus in Kunst und Natur (Rhythm in Art and Nature)* (1914), the task of Expressionist sculpture was to render the spiritual life of organic matter. External forms were seen to be expressions of inner processes of motion – "tectonics of nature" – which could be sculpturally translated through rhythm of line and plane. Herzog stressed that Futurism and Expressionism were to be succeeded by a Neue Sachlichkeit in which the artist would no longer allow his will to speak through the depiction of objects but would become like nature itself, his creative volition clothed in rhythmic, objective form. "Rhythm is the proportion of time and space – the absolute law of growth and decay," he wrote later.[4]

In Herzog's early works such as *Ecstasy* (fig 1, p. 101), the human form was not the measure of the sculpture, but an embodiment of a supernatural principle. In the next few years, it dissolved more and more; individualized modeling was minimized and soon disappeared. By 1918–20, as seen in *Kneeling Woman* (cat. no. 52), the human figure had been elongated, twisted, and distorted until it was only vaguely recognizable in its basic shape. Herzog's work had become what Kuhn termed "active sculpture," which "is not in conformity with anthropocentric thinking. It presupposes a type of man who is somehow cosmic or transcendental – a religious ascetic who sees himself as part of a larger whole, of a system which can no longer be comprehended intellectually...."[5]

"The forms originate individually in rhythmic impulse and fluctuate in the timely expiration of an experience," wrote Bruno Reimann in his preface to *Oswald Herzog: Sinfonie des Lebens* (1921),[6] and accordingly Herzog's works were often entitled using musical terms such as *Adagio, Furioso,* and *Harmony.* His sculptural demonstrations of the energies of movement, emotion, and music evolved further into complex compositions of planes, cubes, straight lines, and volute curves. Works such as *Ecstasy* (1919) (fig. 1, p. 101), *Symphony: Strength, Joy, Sorrow* (1921), and *Scherzo* (1927) represented the transformation of architectural elements into sculptural entities conveying clear and emotional meaning.

Herzog was active with the Novembergruppe until about 1931. In 1937, two of his sculptures were included with other Novembergruppe works in Wolfgang Willrich's book *Säuberung des Kunsttempels,* a Nazi-inspired assault on modern art in which artists were declared degenerates.[7] No death date is known for Herzog, who was by some accounts lost in the Second World War. – K.B.

||

4. Grohmann, 1928.

5. Kuhn, 1921, p. 245.*

6. Bruno Reimann, *Oswald Herzog: Sinfonie des Lebens,* photographic portfolio, Berlin, 1921.

7. Wolfgang Willrich, *Säuberung des Kunsttempels,* Munich and Berlin: J.F. Lehmanns Verlag, 1937.

||

1. "Die expressionistische Plastik" in Walden, [1918].*

2. Oswald Herzog, "Der abstrakte Expressionismus in der bildenden Kunst," *Der Sturm,* vol. 10, 1919/20, p. 29.

3. Kuhn, 1921.*

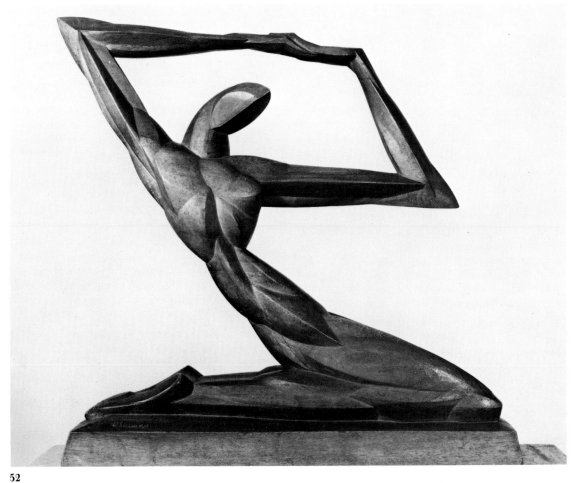

Cat. no. 52
Kneeling Woman (Kniende),
c. 1920
Wood
h: 50 cm. (19⅝ in.)
Staatliche Museen Preussischer
Kulturbesitz, Nationalgalerie,
Berlin

52

Fig. 1
Ecstasy (Verzückung), 1919
Wood
53.5×41 cm.
(21⅛×16⅛ in.)
On loan to Kunsthalle
Mannheim

Hoetger

Bernhard Hoetger

Born 1874 Hörde (Westphalia);

died 1949 Beatenberg, Switzerland.

"Art is world, is all-encom-passing, is totality, is GOD. The artist is the purifica-tion-vessel for the most beautiful and most awful experiences, a frightening aestheticist, a dancer on the fields of the dead, a fil-ter, a detoxifier. Art creates the ethical mind, becomes s t r e n g t h....Sculpture as art is monumental....Plastic art is rhythmical, it is open passion...."[1]

Written by Bernhard Hoetger in 1919, this passage testifies to the influence on him of Nietzsche's aes-thetic and to the synthesis of ethos and eros in the art of the years immediately preceding and following World War I. It also emphasizes the significant distinc-tion Hoetger made between "sculpture," which is antitransitory, bound to the large, blocklike form, and "plastic art," which is subject to the laws of painting and allows for the transitory and the momentary.[2] This latter notion recalls Rodin, whose influence was domi-nant at the turn of the century.

As Lehmbruck was to do later, Hoetger studied at the Kunstakademie in Düsseldorf. In 1900, he visited Paris on the occasion of the *Exposition Universelle (International Exposition)* and Rodin retrospective, and his enthusiasm for the city and for Rodin prompted him to remain there.[3] Between 1901 and 1904, working under the poorest conditions, Hoetger created a number of masterful sculptures, including *The Blind* (c. 1901, two versions: bronze and terra-cotta) and *Fertility* (fig. 1, p.104). Although stylistically influenced by Rodin, Hoetger's themes were close to the realism of Constantin Meunier, and his sculptures of workers became well known in Paris.

Together with the sculptor Carl Milles, Hoetger founded the Société des Artistes Réalistes Internationals (Society of International Realist Art-ists),[4] and the artist Theophile Steinlen arranged for him to work for the magazine *L'Assiette au Beurre (Butter Plate)*. In October 1903, this periodical devoted a special issue, entitled *Dur Labeur (Hard Labor)*, to Hoetger. Karl Ernst Osthaus, who had previously commissioned Minne to create *The Fountain of Kneeling Youths* for the Folkwang Museum in Hagen (see fig. 1, p. 157), met Hoetger at this time and arranged for the artist's first one-man exhibition.

In 1904, Hoetger created *Lovers* (plaster; probably destroyed), which was influenced by Picasso's rose period,[5] and the next year, after marrying Helene

1. Hoetger, 1919, p. 172.

2. See Hofmann, 1958.*

3. Werner, 1977; Dietrich Schubert, *Die Kunst Lehmbrucks,* Stuttgart and Worms: Werner'sche Verlagsgesellschaft, 1981, pp. 51, 63.

4. Werner, 1977.

5. Karl E. Schmidt, "Bernhard Hoetger," *Zeitschrift für bildende Kunst,* vol. 16, 1905, pp. 37ff.

(Lee) Haken, he executed two important sculptures: *Portrait of Lee Hoetger,* rigidly chiseled from marble (Museum Folkwang, Essen) and the beautiful *Elberfeld Torso* (bronze). Hoetger exhibited both works at the *Salon d'Automne,* where they were placed next to Maillol's *Woman* (1904, bronze). Seeing these works, Rodin commented: "Hoetger found the way I was looking for, and if I were not an old man, I would go this way, the way to the monumental, which is the only right one."[6] In 1906, Hoetger created two sculp-tures of women – *Smile* and *Flight of Thoughts* (each of which was executed twice, once in gilded bronze and once in cast stone) – works which further tran-scended the style of Rodin's bronzes in their dense and terse forms. Hoetger's works of this period also display his assimilation of ethnographic art and of Paul Gauguin's painting and sculpture. Thus, as early as 1905, Hoetger anticipated both Picasso's turn toward the "primitive" (cf. Picasso's *Head of a Woman* [fig. 10, p. 18]; *Self-Portrait* of 1906; and *Demoiselles d'Avignon* of 1907) and Brancusi's departure from Rodin's style in about 1907 (*The Prayer,* bronze).

The *Elberfeld Torso, Smile, Flight of Thoughts,* and the *Darmstadt Torso* (1909, bronze; commissioned by the art patron E. von der Heydt) established Hoetger's reputation. In 1907, the sculptor left Paris to return to Germany, where he began to concentrate primarily on crafts and furniture. He also built the Worpswede monument (still in existence) to his friend the painter Paula Modersohn-Becker, who had died in the same year. In 1910, he was commissioned by Von der Heydt to create the *Fountain of Justice* in Elberfeld (bronze; destroyed). In September of the same year, he exhib-ited with Wassily Kandinsky and Franz Marc at the sec-ond exhibition of the Neue Künstlervereinigung München. In 1911, he was invited to join the Darm-stadt artists' colony, and in the course of the next three years, he created four large reliefs with figural friezes for the sycamore grove there (fig. 2, p. 104).[7] These works delineate a lyrical Expressionism that drew in-creasingly upon exotic and primitive art. At this time Hoetger was engaged in studying Romanesque and Gothic sculpture, as well as the art of Africa and the Far East.

Unlike that of Lehmbruck, Hoetger's sculpture was not decisively influenced by the outbreak of the War. His art reached a highpoint in the Egyptian-style bust of the dancer Sent M'Ahesa (1917, gilded bronze). The works of this period, along with those of other leading Expressionists, deformed the human figure without ceasing to embody it.

Hoetger dedicated his *Pietà* (fig. 4, p. 105) to the workers who lost their lives in the November Revolu-tion in Bremen and erected it at the Bremen-Walle

6. Interview with Rodin by Louis Vauxcelles in *Gil Blas,* 1905, as quoted in Werner, 1977.

7. Hans Hildebrandt, *Der Platanenhain – ein Monumentalwerk Bernhard Hoetgers,* Berlin: Cassirer, 1915.

Cemetery.[8] An Expressionist monument like few others, it depicts a mourning mother with her dead son, a young worker. As in Lehmbruck's drawings, the Christian motif of the Pietà was adapted to an expression of contemporary sorrow.[9] In 1933, the National Socialist bureaucracy destroyed this work. Hoetger's membership in the Novembergruppe and devotion to the socialist goals of the revolution were the cause of this attack. He created another Expressionist monument to the men killed in action, particularly those of Worpswede – the *Peace Memorial: Lower Saxony Monument* (fig. 3, p. 105), which fortunately was not destroyed. Constructed of brick and resembling a huge bird rising above the landscape, this work is an Expressionist phoenix.[10]

Hoetger's social involvement is recognizable in other projects as well. Around 1916–17 he collaborated with Martel Schwichtenberg on plans for the Bahlsen cookie factory (the TET-city).[11] In 1927, Hoetger was commissioned to decorate the facade of the Gewerkschaftshaus-Volkshaus, Bremen (a labor union building; fig. 5, p. 106); this became the *Memorial to Labor*. In 1928, he completed the eight figures making up this composition, six of which are included in this exhibition: old and young people (cat. nos. 53, 54, 57, and 58), a weary worker (cat. no. 55), and a worker with a child (cat. no. 56). In the following year, Georg Biermann published an open letter to the artist, in which he described these works:

> The gesture of your figures is unnerving. You are revealing the sense of becoming and of passing away, of birth and of death...yet in this instance it is a sense which does not open the gate to the last freedom but brings eternal sleep, sinking into the finite

and resting from the miserable burden of everyday life. Almost cruel in this respect is the symbol of the old woman who, exhausted from the burden of labor, is barely able to stand on her feet any longer.[12]

In contrast to the idealized workers' memorials that were produced in the late nineteenth century (by Jules Dalou, Meunier, and Rodin), Hoetger, like Käthe Kollwitz, chose as his subject matter the exploitation of the worker by capitalist industry.[13] In the figures for the Bremen Volkshaus, all African and Egyptian influences were overcome in favor of a new kind of realism. Only the fact that the figures appeared nude and therefore timeless connects them with Expressionism. In 1933, the original figures were destroyed by the National Socialists; Hoetger was declared "degenerate" and in 1936 was harshly attacked in the SS publication *Schwarzes Korps*. For years only small bronzes of the Volkshaus figures were kept and exhibited in the Böttcherstrasse in Bremen. But in 1974, on the occasion of Hoetger's hundredth birthday, the senate of Bremen decided to reconstruct the sculptures, and in 1979 this cycle of "life under the stigma of labor" was again affixed to the former home of the labor union.[14]

A statement by Carl Uphoff in his 1919 evaluation of Hoetger remains significant:

> A new mankind will rise: a new spirit will come. Because to be human means to be spiritual....By means of the spirit man is able to produce and to form new things, things that never before existed. The new spirit of man is eager for community.[15]

– D.S.

||

8. Carl E. Uphoff, "Hoetger," *Der Cicerone*, vol. 11, 1919, pp. 427–38; Sophie D. Gallwitz, *Dreissig Jahre Worpswede*, Bremen: Angelsachsen-Verlag, 1922, pp. 47–51; Dietrich Schubert, *Festschrift Wolfgang Braunfels*, Tübingen: F. Piel / J. Traeger, 1977, p. 403; R.P. Baacke and M. Nungesser, "Ich bin – Ich war – Ich werde sein: drei Denkmäler der deutschen Arbeiterbewegung in den 20er Jahren," in *Wem gehört die Welt*, exh. cat., Berlin, 1977, pp. 291–92; Grosse Kunstschau, Worpswede, 1982, p. 48.

9. The Pietà is predominantly employed in those war memorials which, instead of celebrating heroes, bemoan the dead. Such memorials include those by F. Behn *(Viersen)*, Lehmbruck (drawings, 1918), and Hoetger (cf. Schubert, 1981, op. cit., pp. 206–12 and pp. 237ff.).

10. Hoetger himself wrote a short statement about the *Peace Memorial: Lower Saxony Monument* (see Gallwitz, 1922, op. cit., pp. 48–50; Roselius and Drost, 1974, pp. 75ff.); the text is in the Worpswede Archive, Haus in Schluh. (I would like to thank Mr. Hans H. Rief, Worpswede, for his kind assistance.) On May 10, 1931, Hoetger described the monument in a letter as follows: "...it did not turn out to be a war memorial, but a memorial of mourning, with a view toward peace."

11. Kunstverein Hannover, *Die neue T E T – Fabrik*, exh. cat., 1917; Roselius and Drost, 1974; W. Pehnt, *Die Architektur des Expressionismus*, Stuttgart: 1974. A TET is a type of Egyptian amulet in the shape of a knot that is usually placed in a grave to protect the dead. It is a symbol of eternal life.

||

12. Quoted from Biermann, 1929, p. 52 (also quoted in Roselius and Drost, 1974).

13. Claude Keisch, "Ein Bildhauertraum um die Jahrhundertwende: Das Denkmal der Arbeit," *Bildende Kunst*, (East Berlin), 1971, pp. 187–93; J. A. Schmoll [Eisenwerth, pseud.], "Denkmäler der Arbeit," in *Denkmäler im 19. Jahrhundert*, ed. Hans-Ernst Mittig and Volker Plagemann, Munich: Prestel Verlag, 1972, pp. 275ff. Concerning Rodin's project see also Renate Liebenwein-Krämer, "Le monument au travail," *Jahrbuch der Hamburger Kunstsammlungen*, vol. 25, 1980, pp. 117ff.

14. Biermann, 1929, pp. 49–53. About the reconstruction of Hoetger's Volkshaus figures in Bremen, see Wolfgang Schmitz, "Unter dem Stigma der Arbeit," *Tendenzen*, (Munich), nos. 126/127, 1979, pp. 80ff.; Grosse Kunstschau, Worpswede, 1982, pp. 49ff.

15. Uphoff, op. cit., p. 429.

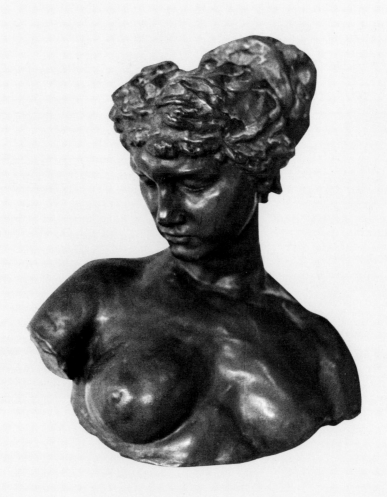

Fig. 1
Fertility (Fecondité), 1904
Bronze
h: 48 cm. (18⅞ in.)
Bremen Roselius Collection

Fig. 2
*Relief in the Sycamore Grove
(Relief im Platanenhain),*
1911–14
Stone
Mathildenhöhe, Darmstadt

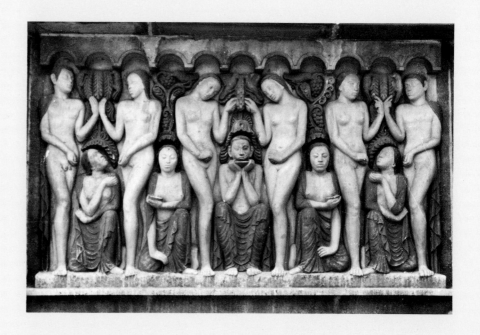

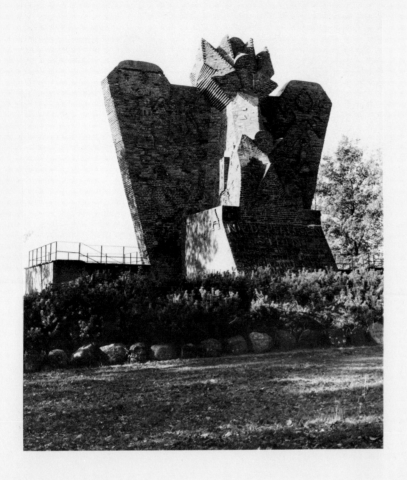

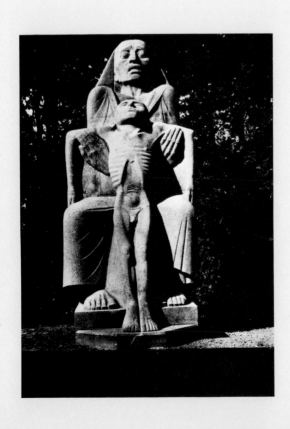

Fig. 5
Gewerkschaftshaus-Volkshaus,
Bremen, 1928, with sculptures
by Hoetger, front view.

Fig. 6
Photographs taken in 1928 of
cat. nos. 53, 54, 55, and 56

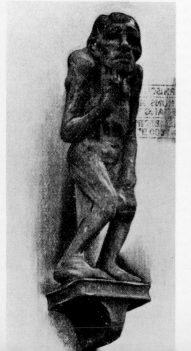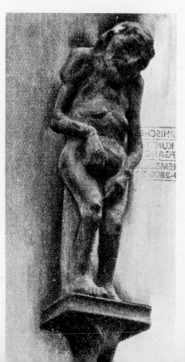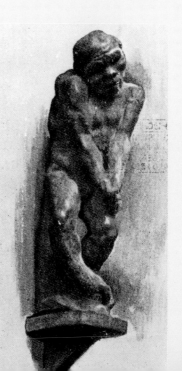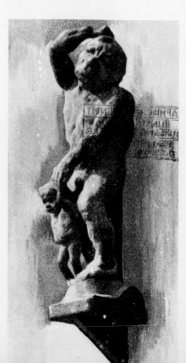

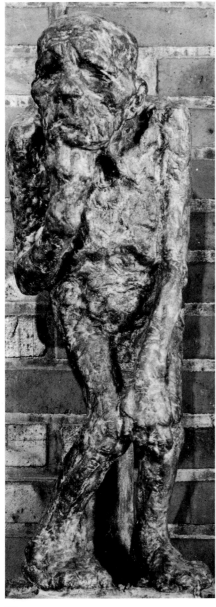

53

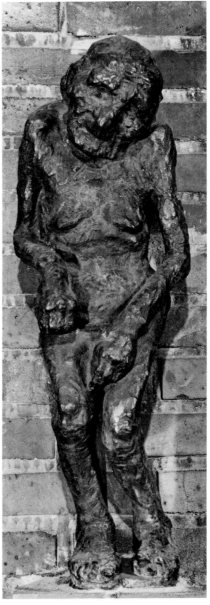

54

Cat. no. 53
Old Man (Alter Mann), 1928/
cast c. 1970
Bronze
h: 64 cm. (25¼ in.)
Private Collection

The 4 bronzes now in the
Nationalgalerie, Berlin (cat. nos. 54,
56, 57, and 58) and 2 additional ones
now in Dortmund were used to cre-
ate larger-scale versions which
were installed in 1928 at the
Gewerkschaftshaus-Volkshaus, Bre-
men. They were destroyed by the
Nazis and replaced in the 1970s with
replicas. *Old Man* and cat. no. 55
were recast in Dortmund around
1970 from the original bronzes.

Cat. no. 54
Old Woman (Alte Frau), 1928
Bronze
61 x 23 x 21 cm.
(24 x 9 x 8¼ in.)
Staatliche Museen Preussischer
Kulturbesitz, Nationalgalerie,
Berlin

Inscribed *Hoetger* and *A. Bischoff
Düsseldorf* on pedestal. See discus-
sion under cat. no. 53.

Cat. no. 55
Weary Worker with Crossed Arms (Müder Arbeiter mit gekreuzten Armen), 1928 / cast c. 1970
Bronze
h: 69 cm. (27⅛ in.)
Private Collection

See discussion under cat. no. 53.

Cat. no. 56
Worker with Child (Arbeiter mit Kind), 1928
Bronze
77 x 20 x 26 cm.
(30⅜ x 7⅘ x 10¼ in.)
Staatliche Museen Preussischer Kulturbesitz, Nationalgalerie, Berlin

Inscribed *Hoetger* and *A. Bischoff Düsseldorf* on pedestal. See discussion under cat. no. 53

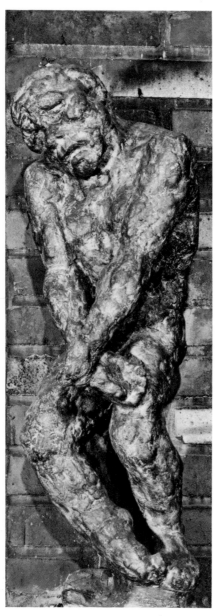

55

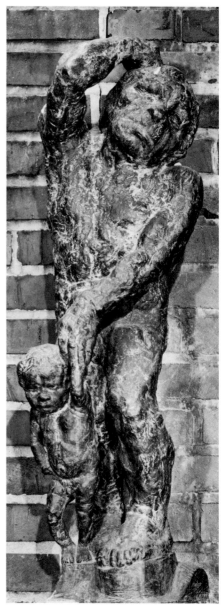

56

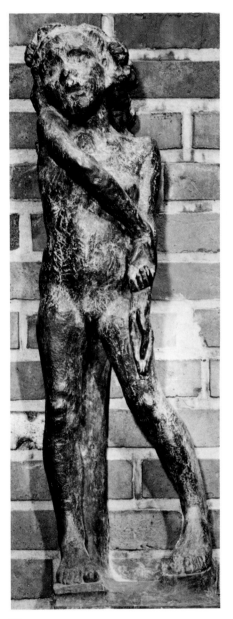

57

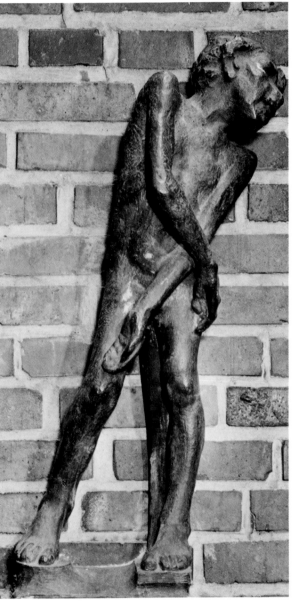

58

Cat. no. 57
Young Girl (Junges Mädchen),
1928
Bronze
76 x 16 x 17 cm.
(29⅞ x 6¼ x 6⅝ in.)
Staatliche Museen Preussischer
Kulturbesitz, Nationalgalerie,
Berlin

Inscribed *Hoetger* and *A. Bischoff
Düsseldorf* on pedestal. See discus-
sion under cat. no. 53.

Cat. no. 58
Young Man (Jüngling), 1928
Bronze
70 x 22 x 19 cm.
(27½ x 8⅝ x 7½ in.)
Staatliche Museen Preussischer
Kulturbesitz, Nationalgalerie,
Berlin

Inscribed *Hoetger* and *A. Bischoff
Düsseldorf* on pedestal. See cat. no.
53.

Karsch

Joachim Karsch

Born 1897 Breslau;

died 1945 Gandern.

Joachim Karsch's early Expressionist sculptures – primarily heads and individual figures – bear a critical relationship to the years 1917–20, during which they were created. Karsch had studied at the Kunstgewerbeschule in Breslau from 1911 to 1914 and from 1915 to 1917 at the Kunstakademie in Berlin, along with Garbe and Belling. During this period, he had already developed an interest in literary characters as sculptural subjects. In the inner conflicts of protagonists created by Dostoevski, Leo Tolstoy, Franz Werfel, and Rainer Maria Rilke, he perceived correspondences to the confusions prevailing in his own time. These same characters had previously attracted the attention of the "first generation" of Expressionists. In Karsch's work, however, they received a typically late Expressionist treatment; they were given a refined psychological characterization, which is conveyed through a mannered virtuosity of technique.

The use of the head as a subject provided the sculptor with an opportunity to combine naturalism and a heightened psychological symbolism. Thus, Karsch's mask of a prisoner of war, *Wikulow* (fig. 2, p. 112), created while he was fulfilling a civil service obligation in Silesia, is as much a psychological study as are the portraits he drew in 1917–18 for Dostoevski's *Brothers Karamazov* and Rilke's novel *Die Aufzeichnungen des Malte Laurids Brigge.*[1]

The head included in this exhibition, *A Friend of Job* (cat. no. 59), may also be understood as a psychological study. This bronze is a detail from a larger-than-life-size group of four kneeling figures, *Job and His Friends* (fig. 1, p. 112). Karsch created this group in 1919, the same year he moved to Berlin. It won him the Staatspreis (State Prize) – a Rome prize – given by the Preussische Akademie der Künste to enable young artists to study in Italy. Karsch, however, was unable to make use of his stipend, as the studios of the Villa Massimo had been confiscated by the Italian government at the end of World War I. Soon after *Job and His Friends* was exhibited in Berlin at the *Freie Sezession* exhibition of 1920, Karsch destroyed the group (except for the head-detail) because he was unable to store the sculpture in his small Berlin studio.

Closely following the Bible (Job 2:13), the original sculptural arrangement presented Job with his three friends, Eliphaz the Temanite, Bildad the Shuhite, and Zophar the Naamathite, who came to console and lament with him. They tore their clothes in grief: "So they sat down with him upon the ground seven days and seven nights, and none spake a word unto him: for they saw that his grief was very great." This theme and its formulation were clearly Expressionist, as may be seen in the elongation of the *Friend*'s head and its

emphatically realistic detail. Elegant and decorative lines of predominantly autonomous formal value are combined with realistically modeled, individual facial forms. The mannerism apparent in this sculpture, like that of the aforementioned drawings, is undeniably related to German late Gothic sculpture (cf. the work of Tilman Riemenschneider). The refinement of the modeling reveals a distinct, final stage of Expressionism. Significantly, Karsch later condemned this phase as a "mistaken direction" but, nonetheless, the motifs and spiritual context of such sculptures continue in different forms in his later work.

Melancholy, a bronze male head created in 1927, translates the expressive emotion of *A Friend of Job* into the classic formal language of the later decade. Yet the rough surface of *Melancholy* was intended to deny the calmness of the form. At this time, Karsch felt spiritually close to Lehmbruck and to the contemporary painter Carl Hofer, whose "clarity of soul and greatness of maturity"[2] attracted him. The simplification of form and the sincerity of its human message became more and more important to Karsch as the mendacious heroism and idealism of Nazi art challenged him to clarify his view. In 1937, the year of the *Entartete Kunst* exhibition, he articulated his goal:

> ...to ferret life out of its most hidden corners, where it silently reveals itself in the awkward, unbeautiful movements of the children, the dreamy state of girls in self-absorption, ugly in this thoughtlessness of which they themselves are not conscious.[3]

Karsch's individual and group sculptures and figural reliefs of the early thirties represent the mature phase of his work. *Reading Couple* (1931, wood, Nationalgalerie, Berlin) may be interpreted as a paraphrase of Barlach's *Reading Monks, III* (1932, wood, Nationalgalerie, Berlin). During this period Karsch was concerned with the depiction of figures who shared spiritual bonds and had become one in their loneliness. His bronze sculpture of 1940 is a resigned commentary on the unrealized possibilities of his generation. On February 27, 1941, depressed and worn out, he wrote:

> We are, as it turns out, a generation that simply has been used up by history. The waste that has fallen out in the Great Change. After this War we will be old people and we have not yet really lived.[4]

When in February of 1945 Karsch witnessed the Russian occupation and the destruction of his studio in Grossgandern near Frankfurt an der Oder, he committed suicide together with his wife. – J. H. v. W.

|||

1. Some of these drawings from 1917–1918 were published in Wolfradt, 1918.

2. Karsch, 1928, pp. 161ff.

3. Wilhelm-Lehmbruck-Museum der Stadt Duisburg, 1968.

4. Ibid.

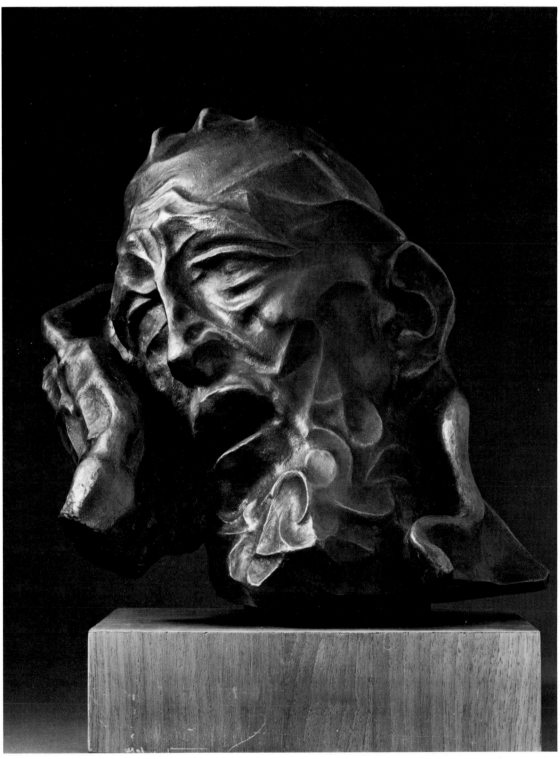

Cat. no. 59
A Friend of Job (Ein Freund Hiobs), 1919–20 / cast 1978
Bronze
26.2 x 28 x 21.4 cm.
(10⅜ x 11 x 8⅜ in.)
The Robert Gore Rifkind
Foundation, Beverly Hills,
California

Inscribed *Füssel Berlin* and *III* on l. b.
edge. One of 3 casts executed since
1967, this piece was made in 1978.
The plaster (*Gips*) is in the Joachim
Karsch Archiv, Berlin. It was
originally part of a life-size plaster
group, *Job and His Friends (Hiob
und seine Freunde)*, exhibited at the
Freie Sezession exhibition, Berlin,
1920.

59

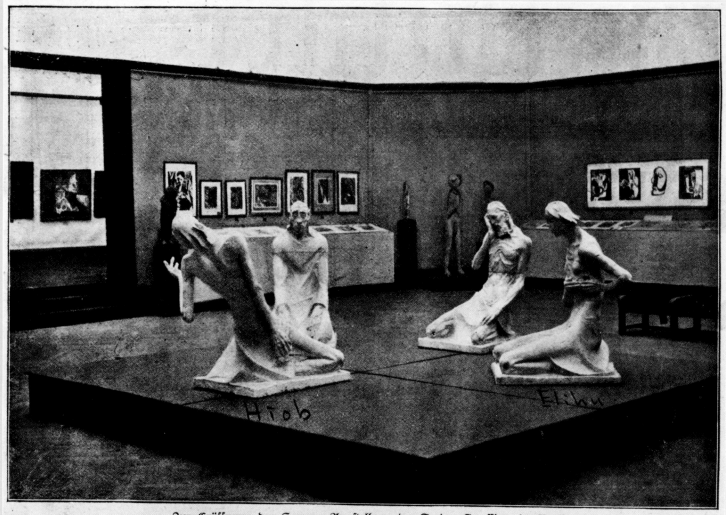

Zur Eröffnung der Sommer=Ausstellung der Freien Sezession in Berlin:
Blick in den Hauptsaal mit der Hiob=Gruppe des Bildhauers Joachim Karsch.

Atlantic-Photo.

Fig. 1
Installation view: *Job and His
Friends (Hiob und seine
Freunde)*, 1919, plaster *[Gips]*,
destroyed except for the head *A
Friend of Job* (cat. no. 59), at the
Freie Sezession exhibition, Ber-
lin, summer 1920; photograph
from the newspaper *Beilage zur
Vossischen Zeitung*, (Berlin), no.
16, April 25, 1920. In the back-
ground is Heckel's sculpture
*Tall Standing Woman (Grosse
Stehende)*, 1912 (Vogt, 8), for-
merly in the collection of the
Museum für Kunst und
Gewerbe, Hamburg (see
Sauerlandt essay, p. 53).

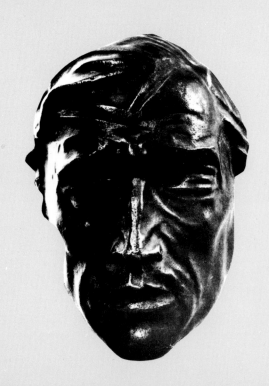

Fig. 2
*Wikulow (Maske, Bildnis eines
Russen)*, 1918
Bronze
h: 22.5 cm. (8⁹⁄₁₀ in.)

Kirchner

Ernst Ludwig Kirchner

Born 1880 Aschaffenburg;

died 1938 Frauenkirch, near Davos,

Switzerland.

On April 17, 1925, E. L. Kirchner wrote to art historian Will Grohmann: "My friend de M. [Louis de Marsalle, Kirchner's pseudonym] reminds me that the time has come to publish my sculpture. This agrees with your decision to publish, for historical reasons, my figures prior to those of the Swiss sculptors whom I inspired." Kirchner suggested that Grohmann base his essay on de Marsalle's which, however, appeared the same year. Since the publication of that essay (which is included in translation in this catalogue, pp. 43–46), no comprehensive study has been made of Kirchner's sculpture. A brief survey of his entire oeuvre and the state of research on it is necessary, however, prior to any discussion of the sculpture.

Kirchner was a draftsman, graphic artist, painter, sculptor, and photographer. Additionally, numerous textiles and rugs were produced according to his designs. He has left us an important body of theoretical work concerning art in general and his own art in particular; it includes essays, his diary, and one of the most voluminous correspondences known to art history. These writings complement Erika Billeter's portrait of Kirchner as an artist who sought to express himself in virtually all media.[1] They complete the "environment" which Kirchner created around himself; an environment which, by virtue of the intense interrelationships of media it proposed, continuously provided the artist with a rich source of inspiration. Kirchner's theories relating to sculpture in particular have been considered by Eduard Trier, although he refers exclusively to Kirchner's aforementioned essay.[2]

Kirchner's paintings have been published by Donald Gordon and his graphic work by Annemarie and Wolf-Dieter Dube in oeuvre catalogues. Lothar Grisebach has already published much of Kirchner's written work, and his correspondence with the Hamburg collector Gustav Schiefler will soon be edited by Annemarie Dube. Karlheinz Gabler has made a special effort to produce a scholarly commentary on the drawings, sculptures, and photographs, and Hans Bolliger's secondary bibliography on Kirchner goes far beyond the usual. Oeuvre catalogues for the drawings, pastels, and watercolors, as well as for the sculptures, must still be published. This exhibition brings us closer to a serious consideration of the sculpture; the fact that one of the exhibited works, *Female Dancer with Necklace* (cat. no. 60) previously was known only through a studio photograph of 1910 (fig. 1, p. 120) raises hopes that other Kirchner sculptures may eventually be found.

A large part of Kirchner's sculptural oeuvre has disappeared and is known only through photographs and written references. These losses were due primarily to three catastrophes. Kirchner sculptures were among the 639 works confiscated from German museums in 1937, as part of the Nazi campaign against "degenerate art." *Nude with a Bath Towel/Bathing Woman* (1909–10; fig. 14, p. 129) and *Couple* (1923–24) (fig. 3, p. 53), which were taken from the Museum für Kunst und Gewerbe in Hamburg, for example, were lost or destroyed in this manner.[3] Kirchner scholar Eberhard Kornfeld has described the second cause contributing to losses as follows:

> When on March 13 [1938] the news of Austria's annexation sends shock waves throughout the world, [Kirchner] begins to fix more and more on the idea that some day German soldiers will also stand before his "Haus auf dem Wildboden." The sculptures decorating the exterior of the home are removed and destroyed.[4]

Available information suggests that many of the house's interior carvings were also destroyed. Kornfeld further affirms: "Undisputed…is the fact that Kirchner destroyed and burnt all his wood blocks, and, above all, his Adam and Eve chair." A third loss most likely occurred when the Wildboden household inventory was publicly auctioned after Erna Kirchner's death in October 1945. Whatever was not sold was burned in front of the house. Presumably some of Kirchner's decorative works and smaller sculptures perished at this time. The Kunstmuseum Basel catalogued twenty-three sculptures in the estate.

In comparison to the regrettable state of preservation of the actual works, our knowledge of the many sculptures Kirchner created is very good. Aside from the theoretical statements already mentioned and his references to his sculptural works in correspondence, Kirchner began to depict his sculptures in paintings and graphics in 1909, and in 1910, he began to photograph them.[5] Although Kirchner was often a hesitant participant in negotiations concerning publications about himself, many books and articles discussing his works appeared during the twenties, and these often included reproductions of his sculptures. Beginning in 1912, Kirchner sent his sculptures to various exhibitions and always made sure that good catalogues were prepared to document them. On the basis of these varied sources, today we can establish a sculptural oeuvre of over one hundred works. Nearly all pieces were in wood; the exceptions consisted of early cast, modeled, or stone sculptures and a few embossed and ham-

1. See Billeter, "Kunst als Lebensentwurf," in Nationalgalerie, Berlin, 1979.

2. Trier, 1971.*

3. Paul Ortwin Rave, *Kunstdikatur im Dritten Reich*, Berlin: Gebr. Mann, 1950; and Franz Roh, *Entartete Kunst: Kunstbarbarei im Dritten Reich*, Hannover: Fackelträger-Verlag Schmidt-Küster, 1963.

4. Kornfeld, 1979, pp. 321–22.

5. Kirchner's photographs and other important photo documentation of his life were made available in 1981 in the Fotoarchiv Ernst Ludwig Kirchner of Hans Bolliger and Roman Norbert Ketterer, Campione d'Italia, Switzerland. Also see Gabler, 1979–80.

mered items executed in a small format. Considering the size of this body of work and the importance of Kirchner's sculptural theories, the artist's plastic work goes far beyond that of a *peintre sculpteur* (painter-sculptor). Kirchner produced sculpture throughout his entire creative life; not only is it an integral part of his whole oeuvre because of its theoretical and practical interrelationships with other techniques, but qualitatively it is also extraordinarily important. Kirchner was a sculptor, and, as was the case with his work in other media, he was a sculptor possessed of the highest degree of individuality.

From late 1901 through 1905 Kirchner received architectural training at the Technische Hochschule in Dresden, although this period was interrupted by studies of pictorial art in Munich from 1903 to 1904. By his own account, he began to both paint and sculpt before the summer of 1903. The plastic work known to us, however, cannot be dated earlier than 1909, although it is possible that his small modeled clay figures could have originated before then. Based on a photograph illustrating six of Kirchner's clay figures, it seems that these works were closer in style to his post-Impressionism of 1906–08. Only a single clay relief of 1909 survives from this period.[6] The pewter figures, one of which Kirchner photographed (see fig. 3, p. 120), represent a transition to the Brücke style of 1909–10.

The discrepancy between the dates which Kirchner assigned to his sculptures and those we have established may be explained by the fact that, after the 1913 dissolution of the Brücke, he tended to predate especially his works created in Berlin and Dresden, fearing that people might claim he had imitated other artists. As the years went on, this tendency increased and was compounded by Kirchner's failing memory. This latter development sometimes resulted in errors involving postdating as well. The dating of one of the early surviving pewter sculptures illustrates this problem. The work is a standing female nude, thirteen inches in height, illustrated by Grohmann in 1926 and dated 1913 by the artist. Yet this figure was, without a doubt, created by 1911 in Dresden, during Kirchner's preoccupation with Benin sculpture. (At this time the collection of the Völkerkunde-Museum in Dresden strongly inspired Kirchner and the other Brücke artists). While in Dresden, Kirchner also created sandstone sculptures; three of these survive.

In 1904, Kirchner had begun to draw on numerous European sources, which initially influenced his painting. Beginning in March 1910 when he encountered Palau and Cameroon sculpture, his plastic art was greatly affected as well. As Donald Gordon has observed, Kirchner's art attained liberation and independence by adopting the swelling physicality and mature plasticity of the figural frescoes of Ajanta, India, which he observed from photographs in the Dresden library

in 1905 and copied from in 1910–11.[7] Gordon reported only their influence on Kirchner's painting, but the obvious impact on his sculpture must also be noted, for after the Ajanta contact his human figures are full and spatial in both two- and three-dimensional media. This is clearly demonstrated in the sculptures of 1910–11 (fig. 14, p. 129) and in the volumes and basic position of *Dancing Woman* (cat. no. 61). However, in the latter sculpture the elegance of Ajanta was surrendered in favor of the more angular and compact forms of African plastic art.

Apart from the aforementioned early works, Kirchner's sculptures from 1910 on were carved or "hewn" exclusively from wood. As was the case for his works in other media, they were conceived with a definite sense of immediacy, following a few sketches. On June 27, 1911, Kirchner wrote to Gustav Schiefler:

> The maple wood that you sent us lends itself well to being worked; it has such short fibers and is, as a whole, completely homogenous. One is tempted to polish it. I've made a sitting figure with a bowl on her head, and now am working on a standing one in dancing position. It is so good for painting and drawing, this making of figures, it lends wholeness to drawing and is such a sensual pleasure when blow by blow the figure grows more and more from the trunk. There is a figure in every trunk, one must only peel it out.

In October-November of the same year, the artist moved from Dresden to Berlin. From there he continued his periodic visits to the Baltic island of Fehmarn, where in 1912 he drew *Sketch for Sculpture* (fig. 4, p. 121). The sketch shows a tree trunk which, although healthy, is rendered with attention to its deformities and sprouting branches. Incorporated in the trunk is a sketch of a female dancer with a raised arm. On the back of the drawing the artist wrote:

> The figure on the verso remains incomplete. It is probably still lying on the Fehmarn beach today. In 1912 I wanted to create a dancer, and in Fehmarn I accidentally found a piece of wood suitable for her. I just drew the form of the trunk and composed and drew the figure within it. This is the drawing. E. L. Kirchner 1912.

From a piece of wood either found by chance or received from Gustav Schiefler, the latent figure was composed and peeled out. By avoiding any polishing, the power of the material was reinforced; the roughly carved surface usually remained visible, although from their inception Kirchner always imagined adding

6. See Grisebach, no. 62 with ill., in Nationalgalerie, Berlin, 1979.

7. Regarding the extra-European influences on Kirchner's art, cf. Schleswig-Holsteinisches Landesmuseum and Museum für Kunst und Gewerbe, Hamburg, 1960;* Schneckenburger, 1972;* Hentzen, 1959;* and others, who refer primarily to Cameroon and Palau. Regarding the assimilations from Ajanta, see Donald E. Gordon, "Kirchner in Dresden," *Art Bulletin*, vol. 48, 1966, pp. 335–66.

color to these works. He only polished his sculptures under special circumstances; this occurred later while he still was living in Berlin and then in Davos, where he moved in 1918.

Kirchner's sculpture *Head of a Woman, Head of Erna* (cat. no. 67, and fig. 3, p. 44) may now be dated with certainty to the summer of 1913, on the basis of a postcard (fig. 10, p. 125) and letter to Schiefler. On the postcard, a photo of the head, Kirchner wrote, "Here is a wood sculpture which I've carved from oak wood that drifted ashore." And in the letter of August 12 which followed he added:

> The head which I sent you is a wood carving (oak); I've made a few figures of this kind here. They give, in addition to the freedom of drawing, the cogent rhythm of the form enclosed in the block. And these two elements provide the composition of the picture.

The *Head of a Woman* had been initiated in many drawings, paintings, and graphics of 1912 and 1913. It constitutes a high point in Kirchner's preoccupation with portraying his wife, Erna, which, however, is evidenced only two more times in his plastic art: in the "abstract" double portrait of 1928–30, *Self-Portrait and Erna* (Swiss stone pine, Galerie Roman Norbert Ketterer, 44), and in the subdued *Erna Kirchner* of 1935 (Swiss stone pine, Galerie Roman Norbert Ketterer, 42). In Davos, Kirchner had discovered the type of wood frequently employed there for carving – Swiss stone pine *(Arve)* that grows at altitudes between five and eight thousand feet. On November 2, 1918, he wrote about it to Nele van de Velde:

> Now I have a wonderful kind of wood for carving, the Swiss stone pine. I've never seen any other wood which lends itself so well to cutting. These pines grow high up, close to the snow line. The wood, despite its softness, is very resistant.[8]

In the firm, full forms of *Female Dancer with Necklace* (cat. no. 60) Kirchner transcended his Ajanta models, and his Brücke friends as well, for whom sculpture remained a less autonomous discipline that was more dependent on its "primitive" models. After his move to Berlin, Kirchner kept a large African sculpture in his studio, and most likely used it in direct imitations. As of 1912 and later it was depicted many times;[9] a tall, relatively slender figure with a rigid

form and smooth surface, it displays characteristics which we also find in Kirchner's own sculptures of 1912. *Female Dancer* (fig. 5, p. 121, right) is typical in this regard, and both *Nude Girl* (cat. no. 64) and *Nude Woman, Sitting with Her Legs Crossed Under Her* (cat. no. 65) were also created using these slender but full forms. The harsher and more extended forms typical of the summer of 1913 find expression in *Head of a Woman, Female Dancer with Extended Leg* (cat. no. 66, and fig. 1, p. 43)), *Turning Nude* (cat. no. 68), and *Standing Female Nude* (cat. no. 69). Kirchner's sculptural activity in Berlin came to an end with military service and an illness which began in 1915–16. The projects of this period remained plans: these included the memorial *Blacksmith of Hagen; Symbol of War;* a relief for a private residence, entitled *Soldier's Death;* and a type of cast-iron cooking pot which was designed for use during wartime in order to conserve the copper traditionally used for this purpose.

After the confusing years of war and sickness, Kirchner settled down in September 1918 in the "Haus in den Lärchen" in Frauenkirch near Davos, completely furnishing it with carved Swiss stone pine. As early as October of that year Helene Spengler reported to Eberhard Grisebach: "What...amazed me, was a tray which Kirchner has carved for his own use, incredibly exact and pretty." Letters and diary entries detail his activities further: in February 1919, he was working on two reliefs for the studio door; a painted chest with figural supports had already been completed; the first carved chairs were finished in March, in April the first bed. The first freestanding Davos sculpture, *Boy with Hatchet* (private collection, Frankfurt), appeared in October, and in the same month work began on a carved bed for Erna (Collection Eberhard Kornfeld, Bern). Several sculptures with farm life as their subject were done, among them *Cow* (fig. 7, p. 46), *Farmer with Cow, Prancing Horse,* and *Female Ancestors.* Kirchner was inspired not only by his new home and environment, but also by the plans of Belgian architect Henry van de Velde to build "Homes on the Lake" in Uttwil, which would have included large commissioned sculptural projects executed by Kirchner. These plans, along with all larger commissions, remained unrealized.[10] In furnishing his own home, Kirchner created what he had always desired – a total work of art. Even the pillowcases and tablecloths were embroidered by Erna and other

8. Kirchner's letter of November 2, 1918, to Nele van de Velde in Ernst Ludwig Kirchner, *Briefe an Nele und Henry van de Velde,* Munich: R. Piper & Co. Verlag, 1961, pp. 10–11.

9. Kirchner first mentioned the title *Erna with Idol (Erna mit Götze)* to Schiefler as the title for a woodcut (Dube, 205). When Schiefler inquired about its meaning, Kirchner changed the title (in his letter of July or August 1918) to *Woman with African Sculpture (Frau mit Negerplastik).* In Nationalgalerie, Berlin, 1979, Grisebach describes drawing no. 136 as an "imitation of an African sculpture, created for the MUIM-Institut, jointly founded by Kirchner and Max Pechstein in 1911...(oral communication by Karlheinz Gabler, Frankfurt)."

10. Kornfeld gives an exact description of the correspondence with Henry van de Velde from the end of April 1917 to the year 1924, when Uttwil had already ceased to be a topic of discussion, yielding to plans for Kirchner's sculptural decoration of the new building for the Kröller-Müller-Museum. The failure of these two plans seems to have had the same cause as the failure of Kirchner's other large commissions, e.g., the painting of the interior hall in the Folkwang Museum in Essen (1927–37). If one analyzes the manner of working and thinking of the persons responsible for the commissioning of these large projects, one must conclude that they lacked understanding of Kirchner's art; in the Van de Velde projects, despite complete mutual respect, an all-too-divergent concept of design obtained.

women according to his designs. He decorated both the interior and exterior of the home affectionately and exactly. In 1927, after giving a detailed description of all the furnishings he had created for the living room, he wrote in his diary: "Everything is Kirchner's work. And all these figures have dreamlike large faces, and they are filled with heavy inner movement."[11] Only within the context of this larger environment can Kirchner's sculptures of 1919–23 be judged fairly. In crowded reliefs and compact forms, Kirchner related parables drawn from his own life and the lives of the peasants around him. The timeless *Dance Between the Women* and the continually recurring *March to the Meadows* were depicted framing each side of the studio door; nude women supported the seats of the chairs; and time and again he employed the theme of Adam and Eve. Yet only a few sculptures per se originated during these years.

This changed when the failure of Van de Velde's plans became clear and when, during 1923–26, Kirchner received new impetus from his young disciples, the Swiss artists Hermann Scherer and Albert Müller. To be sure, during the summer of 1924 he did keep working with Scherer on the furnishings for the new Wildboden home, to which he had moved in October 1923. As Kirchner expressly remarked in a letter to Schiefler of December 10, 1924, he and Scherer together created the sculpted posts for the patio. Their collaboration had already begun in August of the previous year, when Scherer visited Kirchner for the first time. Whereas Kirchner's sculptures of 1919–23 were in most cases intended to be viewed from one side only, now he recommended creating sculptures meant to be seen in the round. *Mother and Child/Woman and Girl* (fig. 6, p. 121) of 1923 combines the sculptural experiences of Dresden, Berlin, and the "Haus in den Lärchen" – the swelling physicality, power of serious expression, and representation of the simple life.

During the years 1924–26, Scherer created – often together with Kirchner at Wildboden – his own limited but intense sculptural oeuvre. Kirchner summarized the results of his collaboration with Scherer in a photograph (fig. 13, p. 128) taken in the fall of 1924, which shows three Scherer sculptures next to the house. Scherer's *Mother Nursing Child* (cat. no. 117) is elevated, and on the right is Kirchner's *Two Friends*, a portrait of Scherer and Müller (see also cat. no. 72, and fig. 12, p. 128). During this same period, Müller also created sculptures in this "early Wildboden style" that Kirchner photographed in front of the house or under the trees, observing irregular lighting. Müller presented him with a self-portrait carved from wood. A few of Kirchner's sculptures from these years have been transmitted to us by his photographs; unfortunately, hardly anything has been preserved.

Kirchner had high expectations that Müller and Scherer would be able to pass on his ideas about art to the next generation. When both died, one shortly after the other in December 1926 and May 1927, Kirchner

lost hope, and in Müller, he lost a true friend as well. The disappointment Kirchner felt may help to explain why he primarily destroyed sculptures which originated at this time. In contrast, we know of twenty-one sculptures by Hermann Scherer which originated during these three years, most of which have been preserved. They give a more comprehensive picture of the endeavors undertaken by the three artists than do the few Kirchner sculptures from the period which have survived.

Thus around the mid-twenties Kirchner's Expressionist period as a sculptor came to an end. During the following years his sculpture, paintings, and graphics became more abstract, reaching their most reduced forms in the early thirties, for example, in the *Self-Portrait with Erna* (1932, Gordon, 946) and in the *Reclining Woman* (1933, Galerie Roman Norbert Ketterer, 43).

Kirchner always defended himself vigorously when the influence of other artists on his work was mentioned, but he did not extend this practice to earlier German or extra-European art.[12] These are the influences which were most important in his plastic art; the former may be seen in the direct relationship between *Nude Girl* (cat. no. 64) and portrayals of the female body by the German artist Lucas Cranach.[13] In December 1919, while working on the carvings for the bedframe he created for Erna, Kirchner wrote in his diary: "How much more advanced is the African in this kind of carving." Although the British art historian Frank Whitford would have us disregard Kirchner's own statements about his art in favor of relying solely on an examination of his works,[14] this is not entirely possible. The explanation of why Kirchner categorically refused to acknowledge some of the obvious influences on his work while confirming others with equal conviction may provide us with new insight.

Of course, the jealousy that made Kirchner disclaim his contemporary models would have been inappropriate to those more removed in time and space. But the true explanation certainly lies deeper: we may approach it by considering the chronological sequence of the influences on Kirchner's sculptural oeuvre. Extra-European art was experienced first and most powerfully from March 1910 to the spring of 1911 and was the last significant influence on Kirchner's work. Together with his appreciation of earlier German art, this remained the only effective influence until the mid-twenties.

||

12. In his 1925 draft for the Grohmann monograph of 1926 (Grisebach, [1968], pp. 84–85), for example, Kirchner wrote in detail about his encounter with African and Palau carving, as well as with Indian temple paintings and sculptures. The same references are to be found in the Brücke chronicle.

13. Cf. Lothar Grisebach, "Kirchner und Cranach," in *E. L. Kirchner: Aquarelle, Zeichnungen und Druckgraphik aus dem Besitz des Städel Frankfurt am Main*, exh. cat., Bonn-Bad Godesberg, 1980.

14. Frank Whitford, "Kirchner und das Kunsturteil," in Nationalgalerie, Berlin, 1979.

||
11. Grisebach, [1968], p. 156.

The development of works within the various media Kirchner employed was not independent; there were, as previously stressed, intense interactions between them. The nudes in the painting *Five Bathers at the Lake* (1911, Brücke-Museum, Berlin; Gordon, 194) – which reveals the first and most definitive formal influence of the Ajanta figures – were still painted in the white-pink incarnate that Kirchner had used customarily for nudes in his paintings. In 1911, Kirchner's sculpture, which had previously been only partially painted with black outlining the contours, began to show the use of overall yellow-ocher or yellow-brown incarnate as in the Moritzburg bathers.[15] This yellow was heightened only by a dark color (black or dark brown) for hair, eyes, and mouth. From 1912 on we find this woodlike coloring in his paintings as well, particularly in close-up bathing scenes and in interiors, for example, in the painting *Striding into the Sea* (fig. 15, p. 129). Not only are the yellow incarnate and full "plastic" form of this painting's two swimmers surprising; their motion is definitely "wooden." They seem to be sculptures, striding into the sea! We observe the same phenomenon in the painting *Brown Nude at the Window* (Westfälisches Landesmuseum für Kunst und Kulturgeschichte, Münster; Gordon, 260; Nationalgalerie, Berlin, 140). It almost seems as if not the real Erna, but Kirchner's sculptural incarnation of her, is standing by the window in this work. In fact, the image here represents a careful preparation for the *Head of a Woman, Head of Erna.* Kirchner confirmed these observations when on June 6, 1913, he wrote from Fehmarn to Gustav Schiefler:

To be sure, I don't notice exactly how I'm changing, but what is new comes from the interactions between painting and drawing, between the sculptural working with wood and the material demands of graphic art.

On December 18, 1914, he wrote from Berlin:

The sculptures have also been completed. This working in conjunction with the plastic is of more and more value to me; it facilitates the translation of spatial concepts onto the two-dimensional plane, just as it helped me earlier in finding the large closed form.

Of interest here also are the prices which Kirchner asked for his sculptures at exhibition, which were equal to those for his most expensive paintings and even higher than those of his paintings during the last years of the War. These indicate the value which Kirchner himself assigned to his plastic work.

Kirchner's amazingly open admission of the extra-European influences on his oeuvre is explained by his understanding of their overwhelming importance.

15. From 1909 to 1911, the Brücke artists spent summers at the Moritzburg lakes, and many renditions of this locale appear in their works of these years. – Ed.

The earlier influences did not extend beyond short-lived effects in isolated areas and individual cases. The plastic art of Cameroon and the frescoes of Ajanta, however, remained a continual inspiration for him and his sculpture. In this context, the valences of Kirchner's individual expressive techniques must be reevaluated. Our knowledge of Kirchner's art will be expanded and transformed by the monograph with oeuvre catalogue now being prepared for his sculpture.[16] With its publication, it will no longer be possible to ignore this work, which, along with that of Expressionism as a whole, has been previously overlooked all too frequently. – W. H.

16. Now in preparation by Dr. Wolfgang Henze. – Ed.

60

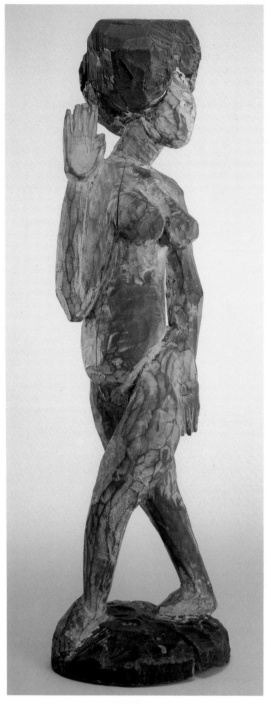

All Kirchner titles and dates have been proposed by Wolfgang Henze, who is preparing a catalogue raisonné of Kirchner's sculpture. Newly ascribed dates are followed by previously known or published dates in brackets.

Cat. no. 60
Female Dancer with Necklace (Tänzerin mit Halskette), 1910
Painted wood
54.3 x 15.2 x 14 cm.
(21⅜ x 6 x 5½ in.)
Lent Anonymously

Inscribed *ELK* on base and signed *E. L. Kirchner* under base. For an extended period of time, *Female Dancer with Necklace* stood on a wooden pedestal to the right of the mirror in Kirchner's Dresden studio. The *Crouching Woman* (1909-10, painted wood, private collection; Nationalgalerie, Berlin, 63) stood on another pedestal to the left. Both sculptures were depicted in a painting shown in a Brücke exhibition at Galerie Gurlitt, Berlin, in 1912 (not in Gordon). Cf. drawing, 1911, Grisebach, [1968], p. 189, woodcut, Dube, 708, and fig. 1, p. 120.

Cat. no. 61
Dancing Woman (Tanzende), 1911
Wood, painted yellow and black
87 x 35.5. x 27.5 cm.
(34½ x 14 x 10⅞ in.)
Stedelijk Museum, Amsterdam
(Los Angeles only)

Sticker inscribed *Holzplastik Tanzende / [E.] L. Kirchner/Berlin-Wilmersdorf / [Durlacher] stras[se] 14 II* affixed under base. This sculpture is depicted on a postcard to E. Heckel, dated 6.19.1911, now in the Altonaer Museum in Hamburg. Cf. painting Gordon, 58 (verso), and woodcut Dube, 193.

Cat. no. 62
Interior II (Interieur II), 1911
Ink and pencil on paper
33.5 x 28.5 cm.
(13¼ x 11¼ in.)
Brücke-Museum, Berlin

Both pedestals flanking the mirror in Kirchner's Dresden studio hold sculpture; on the right, *Crouching Woman (Hockende)*, 1910, and on the left *Female Dancer with Necklace* (cat. no. 60).

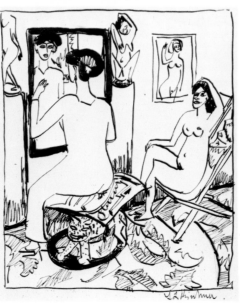

62

61

66

69

Cat. no. 63 (ill., p. 122)
Nude with Black Hat (Akt mit schwarzem Hut), 1911–12
Woodcut
65.8 x 21.5 cm.
(25⅞ x 8½ in.)
Graphische Sammlung,
Staatsgalerie Stuttgart
Dube, 207 III

See the discussion concerning *Nude Girl* (cat. no. 64).

Cat. no. 64 (ill., p. 122)
Nude Girl (Nacktes Mädchen),
1912 [1917]
Painted wood
h: 63 cm. (24¾ in.)
Städtische Galerie im
Städelschen Kunstinstitut,
Frankfurt am Main

Inscribed *ELK* in pencil on sole of foot. This work was previously dated 1917, based on Grohmann. However, a comparison with the painting *Standing Nude with Hat (Stehender Akt mit Hut)* of 1910 (Gordon, 163) and with cat. no. 63 indicates a date for the sculpture in the same period. Cf. etching Dube, 528 II. (In recent correspondence, Annemarie Dube suggested 1919, and Karlheinz Gabler, 1917, while Eberhard Kornfeld concurred with the Frankfurt museum's and the author's 1912 dating).

Cat. no. 65 (ill., p. 123)
Nude Woman, Sitting with Her Legs Crossed under Her (Nackte, mit untergeschlagenen Beinen sitzende Frau), 1912 [1914]
Sycamore, hair painted black
h: approx. 48.5 cm. (19½ in.)
Galleria Henze, Campione d'Italia

This piece was previously dated 1914 on the basis of a 1933 exhibition catalogue of Kirchner's work from the Kunsthalle Bern. However, stylistic considerations suggest a date of 1912.

Fig. 1

Sam and Milly in Kirchner's Dresden Studio, c. 1910, photograph by Kirchner. Sam and Milly were performers from the Circus Schumann and favorite models of the Brücke artists. *Female Dancer with Necklace* (cat. no. 60) is on wood pedestal at right, to its left, flanking the mirror, is *Crouching Woman (Hockende),* 1909–10, painted wood, private collection (Nationalgalerie, Berlin, 63). Above the mirror is one of Kirchner's clay reliefs (Nationalgalerie, Berlin, 62), originally intended for a tiled stove.

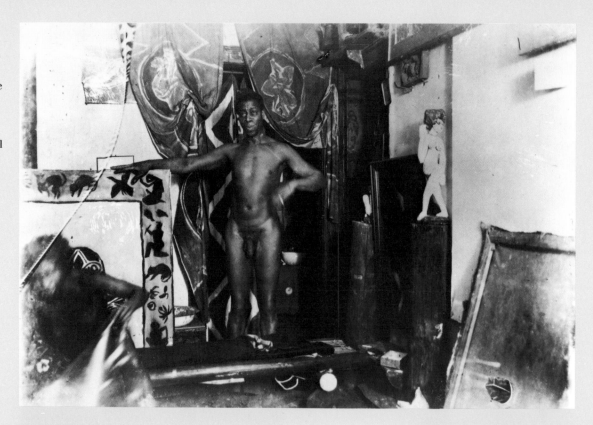

Fig. 2

Standing Female Nude (cat. no. 69), photograph by Kirchner. This photograph was taken in the Haus in den Lärchen in Davos in front of the still unfinished painting *Team of Horses with Three Farmers (Pferdegespann mit drei Bauern),* 1920–21 (Gordon, 675).

Fig. 3

Crouching Woman (Hockende),
1909–10
Pewter
h: approx. 20 cm. (7¾ in.)
Photograph by Kirchner

Exhibited at the Galerie Arnold, Dresden, September 1910.

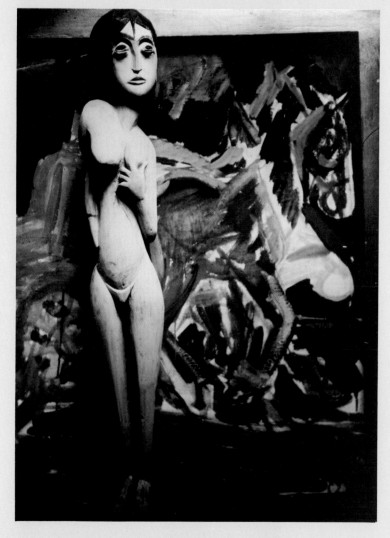

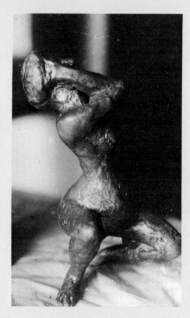

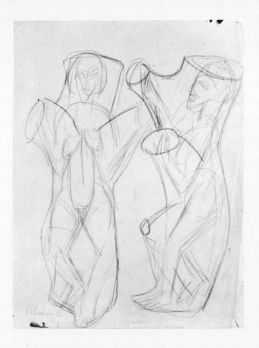

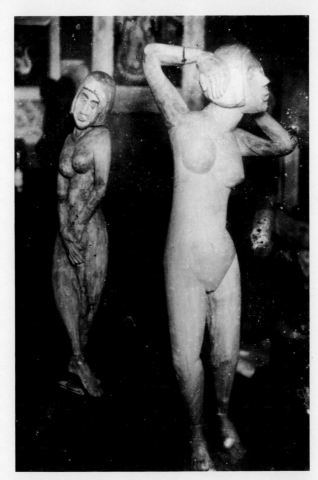

Fig. 4
Sketch for Sculpture (Skizze zu Skulptur), 1912
Pencil and chalk on paper
48.5 × 38 cm.
(19⅛ × 15 in.)
Bündner Kunstmuseum Chur

Fig. 5
Two Sculptures with Background of Paintings, c. 1913, photograph by Kirchner. Right: *Female Dancer (Tänzerin)*, 1912, h: 134 cm. (52¾ in.), private collection. Left: *Standing Woman (Stehende)*, 1912. Both paintings in background dated by Gordon to 1912.

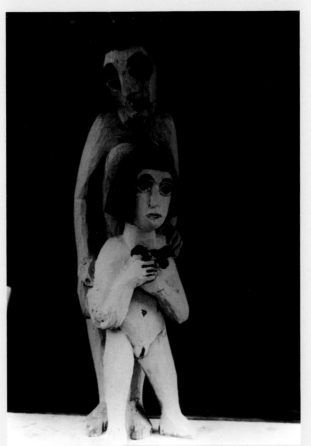

Fig. 6
Mother and Child/Woman and Girl (Mutter und Kind/Frau und Mädchen), 1923
Wood, painted
h: 90 cm. (35⅜ in.)
Private Collection
(Nationalgalerie, Berlin, 355)
Photograph by Kirchner

This sculpture stands at the beginning of Kirchner's association with Scherer and Müller at Wildboden House, during which time Kirchner created a remarkable number of two-figure works.

63 **64**

Cat. no. 66 (ill., p. 119)
Female Dancer with Extended Leg (Tänzerin mit gehobenem Bein), 1913
Black punk oak, painted blue and black
66.5 x 21 x 15 cm.
(26⅛ x 8¼ x 5⅞ in.)
Private Collection

This work is illustrated in Kirchner [de Marsalle, pseud.], 1925, pp. 695ff. It was exhibited in Kirchner exhibitions at the Kunstverein, Jena, and in 1933 at the Kunsthalle Bern, no. 238.

Cat. no. 67 (ill., p. 124)
Head of a Woman, Head of Erna (Frauenkopf, Kopf Erna), 1913 [1912]
Wood, painted ocher and black
35.5 x 15 x 16 cm.
(14 x 5⅞ x 6¼ in.)
The Robert Gore Rifkind Collection, Beverly Hills, California

Ill. de Marsalle, 1925. pp. 695ff., and Grohmann, pl. 31 (dated 1912). A photograph of this sculpture on a postcard from Kirchner to Gustav Schiefler, dated July 23, 1913, confirms a date of 1913. See text and fig. 10, p. 125. Cf. woodcut Dube, 414.

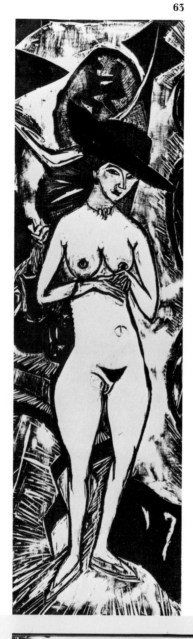
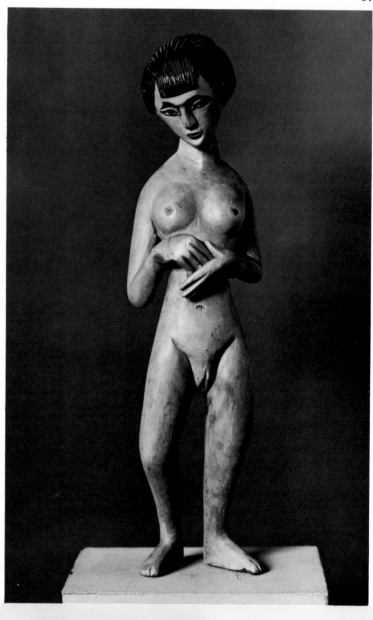

Fig. 7
The Dancer Nina Hard in Kirchner's "Haus in den Lärchen" in Davos, photographed by Kirchner during the summer of 1921. On the left is *Nude Girl* (cat. no. 64). The photo demonstrates Kirchner's photographic abilities; here, just as in his paintings, the female nude is seen as sculpture and consciously contrasted with the wooden figure.

Fig. 8
Nude Girl (cat. no. 64), photograph by Kirchner.

65

Cat. no. 68 (ill., p. 126)
Turning Nude (Akt, sich umdrehend), 1913
Wood
65.9 x 14 x 13 cm.
(26 x 5½ x 5⅛ in.)
The St. Louis Art Museum, Missouri, Gift of Mr. and Mrs. Morton D. May, 402:1955

This work was exhibited in 1919 at the Kunstsalon Schames, Frankfurt (as no. 51) and was acquired by Rosi and Ludwig Fischer.

Cat. no. 69 (ill., p. 119)
Standing Female Nude (Stehender weiblicher Akt), 1914 [1919]
Hardwood, oiled and painted
h: 96.5 cm. (38 in.)
Allen Memorial Art Museum, Oberlin College, Oberlin, Ohio, R. T. Miller, Jr. Fund, 55.29
(Los Angeles only)

Stylistic similarities with Kirchner's mature Berlin style of 1914 suggest this date as opposed to the previous dating of 1919. Illustrated in de Marsalle, 1921, p. 252.

Fig. 9
Nude Woman, Sitting with Her Legs Crossed Under Her (cat. no. 65), photographed by Kirchner in the Haus in den Lärchen, Davos, in front of an unidentified painting.

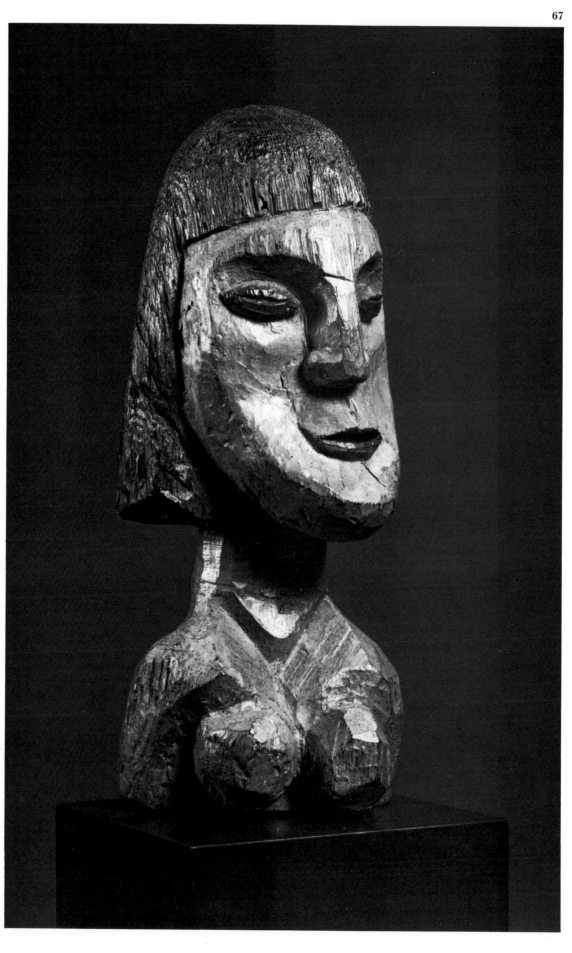

67

67

Fig. 10
Postcard from Kirchner to Gus-
tav Schiefler with photograph of
Head of a Woman, Head of Erna
(cat. no. 67), July 23, 1913; pri-
vate collection, Hamburg.

Cat. no. 70
*Mirror of the Four Times of Day
(Viertageszeitenspiegel),*
c. 1923
Swiss stone pine, painted
oxblood red
173 x 82 x 16 cm.
(68⅛ x 32¼ x 6¼ in.)
Germanisches National-
museum, Nuremberg
HG 11616

This mirror frame is depicted in an
etching (Dube, 552).

Cat. no. 71
*Rider: Table Leg (Reiter:
Tischfuss),* 1923–24
Swiss stone pine
62.5 x 38 x 38 cm.
(24⅝ x 15 x 15 in.)
Bündner Kunstmuseum Chur,
Switzerland

This sculpture is described by Nele
van de Velde in her discussion of a
visit to Kirchner's *Haus in den
Lärchen,* October 1920 (E. L.
Kirchner, *Briefe an Nele und Henry
van de Velde,* Munich: R. Piper & Co.
Verlag, 1961, pp. 28–30).

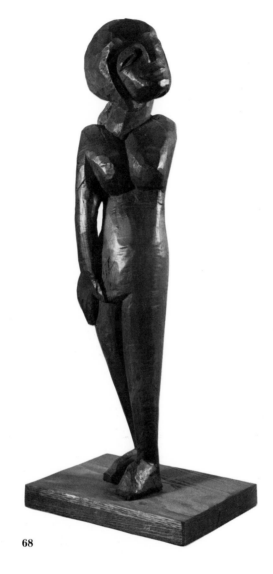

68

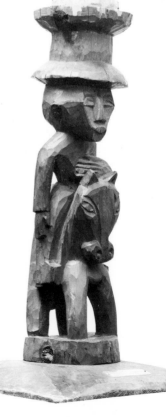

71

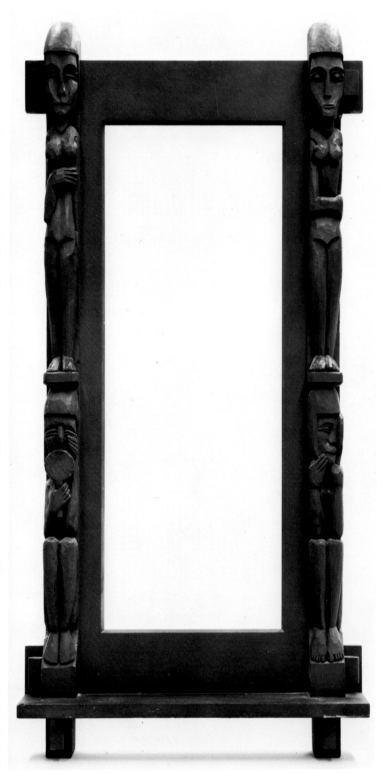

70

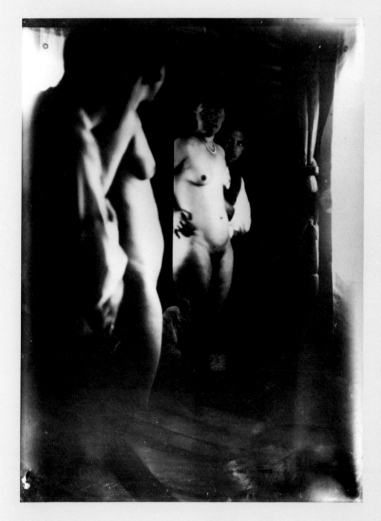

Fig. 11
*The Organist Spina and his
Wife,* c. 1926, photographed by
Kirchner before the *Mirror of
the Four Times of Day*
(cat. no. 70).

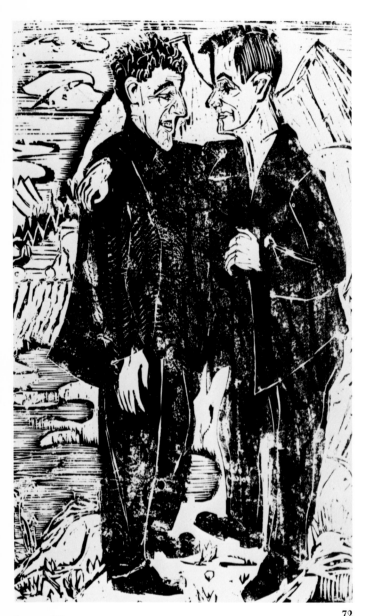

12

13

72

Cat. no. 72
The Friends (Die Freunde), 1924
Woodcut
84 x 54.5 cm.
(33⅛ x 21⅜ in.)
Grunwald Center for the
Graphic Arts, University of
California at Los Angeles
Dube, 552 I

This is the woodcut version of
Kirchner's painting with the same
name of 1924–25 (Gordon, 763) and
of the sculpture *The Two Friends
(Die Zwei Freunde),* also from c.
1924–25 (fig. 13, p. 128). The sub-
jects are Albert Müller (left) and
Hermann Scherer (right). See fig.
12, p. 128.

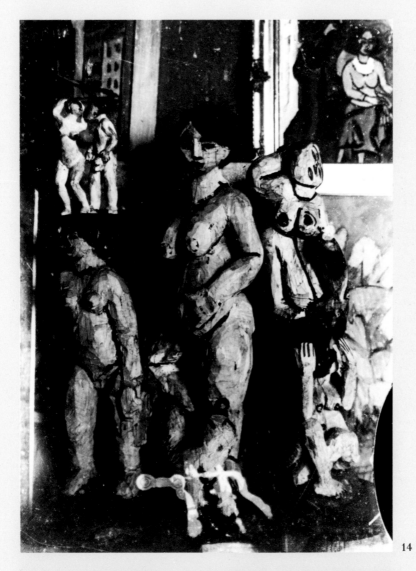

14

15

Fig. 12
Rot-Blau members Müller (left) and Scherer (right), c. 1925.

Fig. 13
Group of Sculptures by Hermann Scherer Together with "The Two Friends" by Kirchner, c. 1924–25, photographed by Kirchner in Front of Wildboden House. Scherer's sculptures have been dated to 1924. The crates on which they stand were probably used to send them to the April 1925 *Rot-Blau* exhibition in Basel. Scherer's *Lovers* (cat. no. 114) is at left and his *Mother Nursing Child* (cat. no. 117) is in the center.

Fig. 14
Kirchner sculptures from the year 1910–11, all now lost or destroyed, photographed by the artist, 1911–12. *Nude with a Bath Towel/Bathing Woman (Akt mit Tuch/Badende),* formerly in the Museum für Kunst and Gewerbe, Hamburg, is pictured at lower left.

Fig. 15
Striding into the Sea (Ins Meer Schreitende), 1912
Oil on canvas
146 × 200 cm.
(57¼ × 78¾ in.)
Staatsgalerie Stuttgart
Gordon, 262 and Nationalgalerie, Berlin, 141, color

Knappe

Karl Knappe

Born 1884 Kempten;

died 1970 Munich.

Karl Knappe received his training as a sculptor at the Munich Kunstgewerbe-schule and Kunstaka-demie. He became familiar with architectural sculpture at an early date; in 1910, he worked on the monumental sculptures designed by his contemporary Georg Wrba for the Dresden railway station. In 1911, he received the Rome Prize, which enabled him to study the sculptures of Michelangelo. From 1912 to 1918, he created numerous works – crafts as well as artworks – in collaboration with various architects; he was encouraged in this direction by his friendship with the sculptor Ludwig Gies (see pp. 37–40).

Knappe's work did not exhibit obvious Expressionist traits until the early 1920s, when he began to execute expressively deformed works in wood. He subordinated artistic ideas to the "laws" governing the material itself which, in his view, already contained all of its sculptural possibilities. Knappe developed his own technique of working, hollowing out a tree trunk or a stone and leaving the material close to its raw state (cf. *Great Harvest,* 1935, wood, Staatsgalerie Stuttgart, and *Tree of Stone,* 1929, created for a housing development in Munich-Schwabing). The characteristics of the material dictated the results, which ranged from baroque and exuberant to strictly bound forms. In his limestone reliefs for the Munich memorial to the dead of World War I (1922–26), the sculptor shallowly carved marching soldiers into the stone. The figures are rhythmic in their repetition; concave and convex forms speak with equal clarity. Knappe employed this technique of the "negative-cut" several times in varying materials (cf. *Woman Playing the Violin, with Deer and Bee,* 1926, brick, location unknown). This form, which suggests the cinematic motion of the Futurists, had been developed by sculptors such as Gies, particularly for the modeling of plaques.

One of the most original works executed in this somewhat Cubist technique is Knappe's portrait of the well-known Berlin painter Max Liebermann (cat. no. 73). This work is illustrative of Knappe's special attention to positive and negative values and to the quality of the material – in this case, the bronze patina. The lengthy neck is intercepted by the condensed form of the skull and is thus transformed into an image of psychic energy. Knappe intensified the ambiguity of Liebermann's features, recalling the sculptural character studies of the eighteenth-century artist Franz Xaver Messerschmidt and of Honoré Daumier. The artist was particularly concerned with implying contrasts in the character of the person portrayed, for example, those of distance and spiritual alertness, calmness and keen intellect.

Knappe continued working in Expressionist forms, despite the dominance of neoclassicism in the late twenties. This fact contributed to his being fired in 1933 by the Nazis from his teaching position at the Technische Hochschule in Munich. His studio with most of his early works was destroyed in 1944, but after 1945 the rebuilding of West Germany brought him numerous commissions for windows, mosaics, and sculptures. – J. H. v. W.

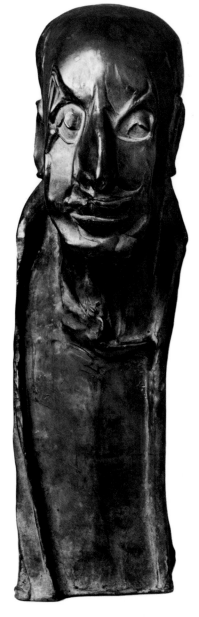

Cat. no. 73
Max Liebermann, 1925
Bronze
63.5 x 18 x 26 cm.
(25 x 7⅛ x 10¼ in.)
Private Collection, Germany

Liebermann was a famous Berlin
painter who was the leader of the
Berlin Secession.

73

Fig. 1
Max Liebermann, 1932.

Kolbe

Georg Kolbe

Born 1877 Waldheim (Saxony);

died 1947 Berlin.

Georg Kolbe enjoyed critical and financial success throughout a long and productive career, during which he was briefly linked with German Expressionism. His initial training in Dresden, Munich, and at the Académie Julian in Paris was devoted to drawing and painting. In 1898, while pursuing an independent plan of study in Rome, Kolbe stopped painting and, under the tutelage of Louis Tuaillon and August Gaul, learned the fundamentals of sculpture. By 1903 he had established permanent residency in Berlin, but that city was to serve him only as a home base. During the next two years he traveled to Egypt, England, France, Greece, Italy, Russia, and Spain. In 1905, he was awarded the Villa Romana Prize and spent the year in Florence.

In 1909, Kolbe visited Rodin's Paris studio, and a great deal of critical attention has since been devoted to determining the degree and nature of Kolbe's ties to the French sculptor. Stylistic affinities with Rodin's work seem particularly pronounced in Kolbe's sculpture prior to 1920, his preoccupation with the nude being an obvious common characteristic. Maria von Tiesenhausen, the artist's granddaughter and former director of the Georg Kolbe Museum in Berlin, has indicated, however, that "Kolbe and Rodin never talked with one another even when Kolbe visited Rodin's studio in 1909."[1]

Kolbe's early years of travel seem to have provided a more significant basis for his eclectic and complex blending of styles and sources. His youths and maidens are embodiments of a gentle, contemplative aesthetic that reveals none of the vigor apparent in Rodin's work. The softly mottled treatment of Kolbe's bronzes results in a diffused flickering of light, unlike the high drama of Rodin's extremely personal and heavily worked surfaces. Through the rhythmical arrangement of limbs and body, Kolbe investigated mass, contour, and proportion, concerns which maintained primacy over the exploration of an Impressionist exterior.

Aristide Maillol must also be considered in an examination of Kolbe's aesthetic. Formal simplification became increasingly important to Kolbe, and he consistently represented the female body in firm, rounded forms. The vaguely sensual, passive, monumental woman stands above all as an expression of grace and architectonic clarity. Kolbe looked to Maillol and to Adolf von Hildebrand for a reaffirmation of the traditional emphasis on formal structure and proportion, while at the same time, he was influenced by the very different spirit he found in the work of Rodin, who "grasps life with a genial hand and refined impres-

sion."[2] Committed to an aesthetic that studied, assimilated, and synthesized the art of the past, Kolbe wrote: "By attaching threads to the most noble epochs of sculpture, they [today's sculptors] serve their art with keen understanding. In this manner sculpture conquers the expression of contemporary life."[3]

In the early twenties, Kolbe's regard for the sculpture of antiquity found expression in such works as the *Assumption of the Blessed Virgin* (1921, bronze). The frontality, extreme stylization, and monumentality of these sculptures recall both Egyptian and Archaic Greek art.

A lifelong association with Karl Schmidt-Rottluff began in 1919, when the two artists met at Lehmbruck's funeral. At this juncture, an important shift took place in Kolbe's art, which during the next few years was allied with German Expressionism. His passive monumentality gave way to the expression of emotion through gesture, as seen most vividly here in *Anger* (cat. no. 75). He altered anatomical proportions to conform to a surge of emotion represented not in the facial expression, but in the gesture that arcs and ricochets through the entire body. The limbs and the drapery covering them were reduced to a severe angularity. The exaggerated gesture of the arms, vehemently extending upward, is complemented by the counterthrust of the trunk. The face of this figure remains strangely impassive, as if the gesture alone were the subject of the work. This piece appears to contradict the interpretation of Alfred Barr, who included Kolbe in the important exhibition *Modern German Painting and Sculpture* at The Museum of Modern Art, New York, in 1931. Barr emphasized Kolbe's classical bronzes and perceived the artist as a "mild and gracious spirit..." whose work did not carry the emotional impact of that produced by some of his peers: "Kolbe rarely informs his figures with strong emotion. Even when their postures are violent they seem posed rather than convincing expressions of pain or joy."[4]

Anger is especially noteworthy for its use of wood as a material. Kolbe may well have been inspired by Schmidt-Rottluff and other Brücke artists to utilize this material, with which he had had very little prior experience. His early work was almost exclusively modeled in clay and then cast in either plaster or bronze. There is no bronze version of *Anger*. In contrast to the Brücke commitment to carving directly in wood, however, Kolbe made a small plaster model of his sculpture and then commissioned another artist, Gobes, to produce the large version in wood from this maquette.[5]

||

1. See Maria von Tiesenhausen's foreword to Andrew Dickson White Museum of Art, Cornell University, Ithaca, 1972, unpaginated.

2. Quoted from Kolbe's essay, "Ausdrucks-plastik," 1912, in Heller, 1974, p. 52.

3. Ibid., p. 53.

4. Museum of Modern Art, New York, 1931, p. 41.*

5. This information was provided in correspondence of October 1982 with Dr. Ursel Berger, Director, Georg Kolbe Museum, Berlin.

Like *Anger,* Kolbe's *Bather* (cat. no. 74) is an expression of pure rhythmic gesture. The figure is partially enveloped by heavy drapery which defines the contour of the body. *Nun I/Dancer,* included in this exhibition in both bronze (cat. no. 79) and wood (cat. no. 78) versions, goes even further in the expressive use of drapery. The figure is completely sheathed; the folds and patterns of the cloth accentuate and articulate the body's gentle curve. Based on two drawings also in the exhibition, and both entitled *Dance Study* (cat. nos. 76 and 77), the subject of these sculptures would seem to be a dancer, rather than a nun as has been previously suggested.

Kolbe devoted considerable attention to drawing throughout his life, yet he believed that drawing and sculpture were radically different pursuits and that the sculptor must be capable of full expression without depending on two-dimensional studies. In 1921, he wrote: "To the sculptor, drawing is a special language, a language which can live next to his work – but which has nothing in common with the nature of his sculptural methods of expression."[6]

Kolbe's interest in emotional expression through angular stylization soon abated; the works from the late twenties reveal his return to a more realistic conception of the human form. By the 1930s he was portraying grandiose, idealized visions of the Nordic race in heroic poses. These young, muscular men and women provoked the following description by Rudolf Binding in 1933: "...A keen ambitious self-conscious race, asserting its own youth and contemporaneity and emblazoning this on its banners. Such a race is demanded by the world we are entering: Georg Kolbe's world."[7] Curiously, Hitler had wanted to include Kolbe in the list of degenerate artists, and it was Goebbels who actively campaigned to maintain the artist's standing.[8] Kolbe continued his work virtually undisturbed during the Third Reich. Although he never actually joined the Nazi party, he was consistently included in Nazi-approved exhibitions of the late thirties and forties. His ambivalence, however, can be felt in his remarks on the Nazi destruction of Lehmbruck's *Kneeling One:* "The wonderful sculpture...they destroyed.... stupid warriors and monuments of princes enjoy the approval of the bourgeois."[9] – S.P.

6. Kolbe, 1921, pp. 15–16.

7. Quoted from Rudolf Binding, *Vom Leben der Plastik*, 1933, in Heller, 1974, p. 51.

8. Ibid., p. 50.

9. Grzimek, 1969, p. 85.*

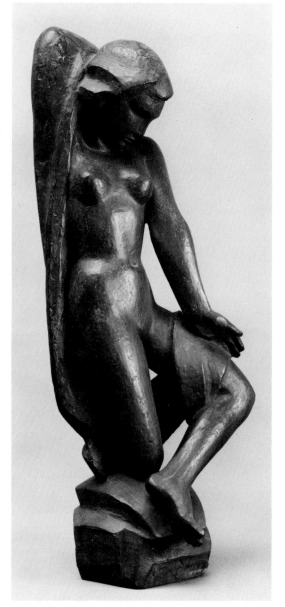

Cat. no. 74
Bather (Badende), 1921
Bronze
h: 71 cm. (28 in.)
Georg Kolbe Museum, Berlin

Inscribed *GK* and *H Noack Berlin Friedenau* on b. of plinth. This is a unique cast.

Cat. no. 75
Anger (Zorn), 1923
Wood
h: 165 cm. (65 in.)
Georg Kolbe Museum, Berlin

Inscribed *GK* on b. of plinth. Originally referred to as *Flame (Flamme)*, this sculpture was carved by the sculptor Gobes after a model, but was probably supervised and finished by Kolbe. The plaster model executed at a smaller scale, is now lost.

74

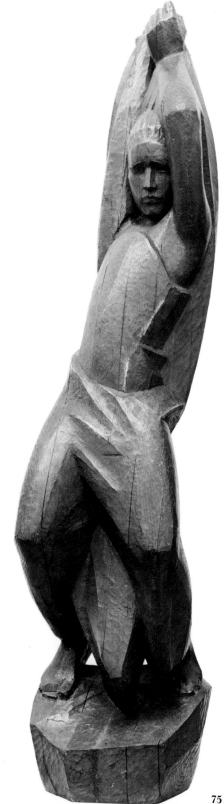

75

76

77

79

78

Cat. no. 76
Dance Study (Tanzstudie), 1923
Pen, pencil, and sepia on paper
49.5 x 34.6 cm.
(19½ x 13⅝ in.)
Georg Kolbe Museum, Berlin

Based on the existence of this draw-
ing and cat. no. 77, a more appro-
priate title for the sculpture known
as *Nun I (Nonne I)* would be
Dancer (Tänzerin).

Cat. no. 77
Dance Study (Tanzstudie), 1923
Pen, pencil, and sepia on paper
49.5 x 34.6 cm.
(19½ x 13⅝ in.)
Georg Kolbe Museum, Berlin

Cat. no. 78
*Nun I / Dancer (Nonne I /
Tänzerin),* 1923
Wood
h: 70 cm. (27½ in.)
Georg Kolbe Museum, Berlin

Inscribed *GK* on b. of plinth. See
discussion under cat. no. 76.

Cat. no. 79
*Nun I / Dancer (Nonne I /
Tänzerin),* c. 1923 / cast later
Bronze
27.7 x 8.6 x 10.8 cm.
(10⅞ x 3⅜ x 4¼ in.)
The Robert Gore Rifkind Collec-
tion, Beverly Hills, California

Inscribed *GK* and *H. Noack Berlin* on
b. of sculpture. The size of the edi-
tion is unknown.

Kollwitz

Käthe Kollwitz

Born 1867 Königsberg;

died 1945 Moritzburg.

Käthe Kollwitz is well known for her powerful depictions of the human condition in masterful graphic form. She is less known for her sculpture, an oeuvre of approximately twenty-five pieces created throughout her career with the same power and many of the same themes and compositions which characterize her graphic work.

Kollwitz probably learned the fundamentals of sculpture at the Académie Julian in Paris, where she studied in 1904. As an established artist new to this medium, she admired the work of Meunier, and while in Paris actively sought to broaden her knowledge of contemporary work with visits to the studios of Rodin and Hoetger. Rodin's sculpture greatly impressed her; his influence can be seen in her early work, particularly in *Lovers I* (1911, plaster; destroyed) and *Mother with Child on Her Shoulder* (undated, bronze).

In 1910–11, after she had returned to Germany following her studies in Paris and also in Italy, Kollwitz devoted herself almost exclusively to sculpture because, as she explained, her artistic work was in need of "rejuvenation." She had already attained great popular success with her graphic cycles; sculpture presented a challenge beyond the secure base of graphic media.

Kollwitz's intense early work in sculpture (she created at least eight pieces from 1911 to 1917) marked the beginning of a difficult relationship with plastic techniques. Throughout her diary entries and letters to friends there are references to being "afraid of sculpture,"[1] yet at other times she reported that it was bringing her success: "I should have more confidence in myself, considering my ability even in sculpture."[2] Toward the end of her life she took special pleasure in creating thematically powerful sculptures whose small size reflected her failing strength, modest income, and the severe restraints imposed on her career by the Nazis.[3]

Apart from her initial studies in Paris, Kollwitz received no additional formal training, declining opportunities for professional criticism so as to avoid becoming academic. Most of her pieces were modeled in clay or plaster – only a few were cast in bronze. Some, such as the monumental *Memorial: The Parents* (1924–32; stone copies made in 1954 installed in St. Alban's Church, Cologne [fig. 18, p. 20]), were chiseled in stone by other sculptors after Kollwitz's plaster

1. See diary entry of April 30, 1922, in Kollwitz, 1955, p. 104.

2. Diary entry of September 1913, quoted in Museum Villa Stuck, Munich, *Käthe Kollwitz; Zeichnung, Graphik, Plastik*, exh. cat., 1977.

3. Cf. letter of May 6, 1937, to Hanna Loehnberg in Käthe Kollwitz, *Briefe der Freundschaft und Begegnungen*, Munich: List, 1966, p. 36.

models. Kollwitz sometimes worked on several sculptures simultaneously. Based on extant drawings, it seems that she made numerous preparatory sketches for some but not all of her sculptures.

From 1917 to 1920, Kollwitz came under the direct artistic influence of Barlach, whom she greatly admired and with whom she shared an artistic focus on the human predicament. Seeing Barlach's woodcuts greatly affected her graphic and sculptural style. For both artists, the block form was the basis from which sculptural figures emerged. Protruding limbs were rare; in fact, much of the figure was often concealed by folds of heavy drapery. One side of the sculpture was usually treated as the main view, with emphasis being placed on frontality. Figures often coalesced until they were indistinguishable from one another. This style demanded careful attention on the part of the viewer in order to determine the meaning of the figure's placement. However, Kollwitz was not concerned with formal aspects per se. When she visited Milly Steger's studio, she declared that for Steger there existed "only formal problems"; she was "setting out from quite another end than I."[4] Steger's extreme Expressionism astonished Kollwitz, perhaps because the strength of her own sculpture lay in the Expressionistic themes employed, rather than in exaggeration, abbreviation, and distortion of form.

Käthe Kollwitz created her sculptural representations entirely from personal perceptions, which often necessitated a transformation of the accepted compositional mode. This approach becomes evident when one compares her two *Lovers*. The first version, of 1911, known today only from photographs, appears to derive from Rodin's *Kiss* (c. 1880–82, bronze). The second version, *Lovers II* of 1913 (cat. nos. 80 and 81), is a distinct departure from the standard depiction of an ecstatic, passionate pair of mature lovers. Instead, Kollwitz's couple is young and serious, exhibiting an awkward, slightly restrained sensuality. Her impressively individual treatment was well received by the jury of the Berlin Freie Sezession when it was exhibited in 1916, but it was not popular with the public at large. This initial coolness may have been due to the difficulty found in reading the sculpture as a pair of lovers, or even as a man and woman; it has also been called a mother and child. Kollwitz nevertheless continued to maintain that "art for the average onlooker does not need to be shallow."[5]

In a sculpture of 1937–38, *Tower of Mothers* (cat. no. 86), the subject is more easily readable, and the meaning of the composition can be clearly understood as mothers protecting their children from a threatening presence or force. Kollwitz first conceived of this sculpture-in-the-round much earlier, when she began work in 1922 on the graphic cycle *War* (1922–23, series of seven woodcuts); there a woodcut of the identical subject was included (cat. no. 82). When in 1938 the sculpture was finally realized, the Nazis

4. Kollwitz, 1967.

5. Rauhut, 1966, p. 250.

removed it from an exhibition at the Klosterstrasse Studio, Berlin, on the grounds that "in the Third Reich, mothers have no need to defend their children. The state does that for them."[6]

During this period, Kollwitz was also working on another group, the *Pietà* (cat. no. 85). In her preliminary work on this piece Kollwitz had intended to depict an old person, but "it turned out to be something like a Pietà, a mother sitting with her dead son lying in her lap, between her knees. It is no longer grief, but meditation."[7] Once the Pietà figures were realized, she intended to transform the Christian theme into a secular, more universal one, for "...mine is not religious.... My mother is musing upon her son's failure to be accepted by men. She is an old, lonely, darkly brooding woman."[8] The piece is an unmistakably personal work, certainly a reflection of the artist's maternal and humanitarian compassion and perhaps, as in other works, an expression of her deep feelings about the loss of her own son in World War I.

While the woman of the *Pietà* is not specifically herself, Kollwitz's likeness does appear in several other sculptures such as *Memorial: The Parents (Mother)* (fig. 18, p. 20), *The Lamentation* (cat. no. 87), and a self-portrait bust (cat. no. 83) on which she worked from 1926 to 1936. Kollwitz called it a "face mask," a literal image of herself. The facial expression is calm, weary, and somber, very much like the self-portrait drawings of this period (see cat. no. 84). In its larger-than-life size and detailed modeling, the *Self-Portrait* is a symbol of Kollwitz's simple, earnest, and direct humanity. – K.B.

||

6. Otto Nagel, *Käthe Kollwitz,* Greenwich, Conn.: New York Graphic Society, 1971, p. 78.

7. Cf. diary entry of October 22, 1937, in Kollwitz, *Ich sah die Welt mit liebevollen Blicken: Ein Leben in Selbstzeugnissen,* Hannover: Fackelträger-Verlag, 1968, p. 311.

8. Cf. diary entry of December 1939 in Kollwitz, 1955, p. 126.

Cat. no. 80
Lovers (Liebespaar), 1913
Plaster
h: 74.3 cm. (29¼ in.)
Museum of Fine Arts, Boston,
Gift of Mr. and Mrs. Hyman W.
Swetzoff in Memory of Mr. and
Mrs. Solomon Swetzoff

Some confusion has surrounded the
history and title of this sculpture,
stemming from the fact that 2 plas-
ters exist, this and a second one in
the Kollwitz Estate, Berlin. In 1913,
Kollwitz wrote in her diary: "I am
working on the group of lovers with
the girl sitting in the man's lap"
(Kollwitz, 1955, p. 61, entry of
September 1913; the German ver-
sion of the diary and the Kollwitz
family's personal copy, however,
both give a date of November 1913.)
The Boston plaster was brought to
the United States by Hyman Swetzoff
around 1954, and 6 signed and num-
bered casts were made from it by the
Modern Art Foundry, New York, un-
beknownst to the Kollwitz family.
This sculpture has also been known
as *Mother and Child.*

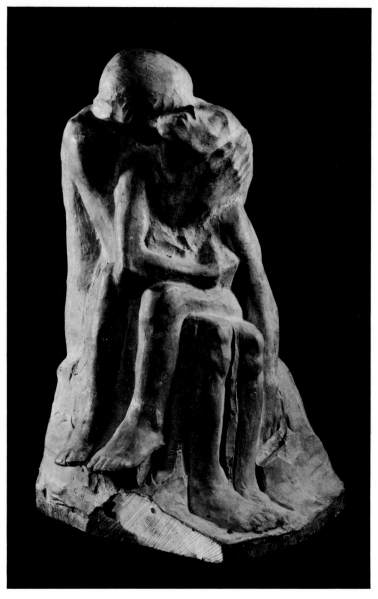

80

Fig. 1
Käthe Kollwitz in her studio
with *Mother with Twins (Mutter
mit Zwillingen),* 1924–37.

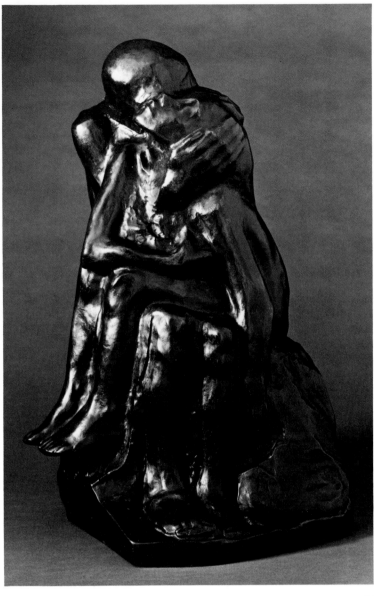

81

Cat. no. 81
Lovers II (Liebespaar II)
1913 / cast after 1954
Bronze
71 x 47 x 49 cm.
(28 x 18½ x 19¼ in.)

a) The Robert Gore Rifkind Collection, Beverly Hills, California (Los Angeles only)
b) Hirshhorn Museum and Sculpture Garden, Smithsonian Institution, Washington, D.C. (Washington only)
c) Private Collection (Cologne only)

The plaster used to cast this sculpture was evidently in a private collection in Canada after World War II and was subsequently returned to the artist's family in the 1960s. Ten numbered casts were made from this plaster by H. Noack, Berlin. The Rifkind bronze (a), cast from the Kollwitz family plaster, is 4/10. The Hirshhorn bronze (b), cast from the Boston plaster, is 6/6; see discussion under cat. no. 80. The Cologne bronze (c) is 5/10. As of June 1983, 7 of the 10 bronzes had been cast by H. Noack from the Kollwitz family plaster.

83

84

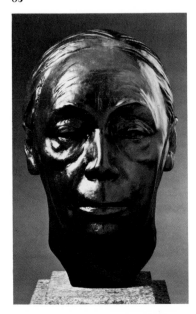

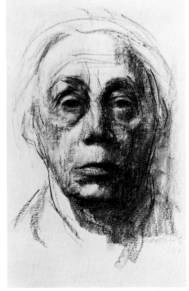

Cat. no. 82
The Mothers: The War (Die Müt-ter: Der Krieg), 1922–23
Woodcut, pl. 6 from the portfo-lio *The War (Der Krieg)*
34 x 40 cm.
(13⅜ x 15¾ in.)
Arnhold Collection
Klipstein, 182

This woodcut is Kollwitz's third graphic version of the subject, fol-lowing an etching and a lithograph, both from 1919. She first thought of executing this composition in sculp-tural form in the spring of 1922; it was finally realized in 1937–38 as *Tower of Mothers* (cat. no. 86).

Cat. no. 83 (ill., p. 139)
Self-Portrait (Selbstbildnis),
1926–36 / cast after 1945
Bronze
37 x 23 x 28 cm.
(14½ x 9 x 11 in.)
a) Los Angeles County
Museum of Art, Purchased with Funds Provided by the Mira T. Hershey Memorial Collection 79.3 (Los Angeles only)
b) Hirshhorn Museum and Sculpture Garden, Smithsonian Institution, Washington, D.C. (Washington and Cologne only)

Inscribed: *Kollwitz,* b. r.; *H. Noack Berlin,* l. b. edge. Nine or 10 casts made during the artist's lifetime bear the stamp *H. Noack Berlin-Friedenau.* Another 9 or 10 were cast posthumously by the family from the original plaster and are marked *H. Noack Berlin.* No additional casts are planned.

Cat. no. 84 (ill., p. 139)
Self-Portrait from the Front (Selbstbildnis en face), 1934
Charcoal and black crayon on paper
43 x 33.5 cm.
(17 x 13¼ in.)
Los Angeles County Museum of Art, Los Angeles County Funds 69.1
Timm-Nagel, 1246

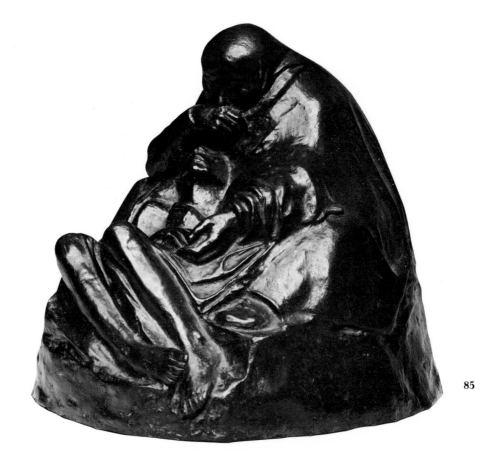

85

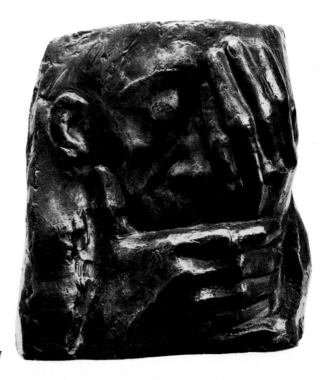

87

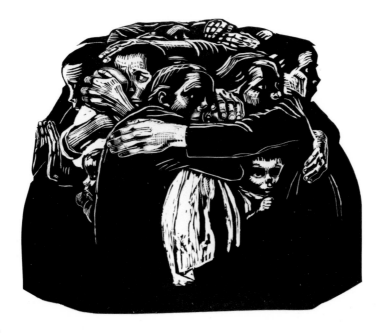

82

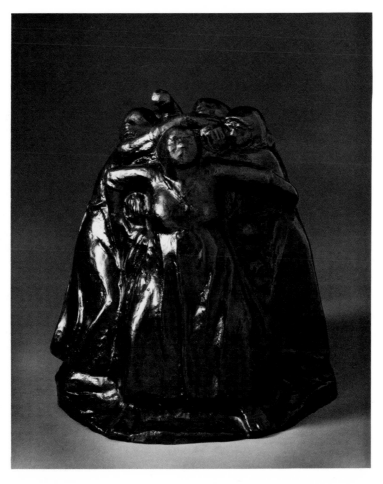

86

Cat. no. 85
Pietà, 1937–38 / cast before
1945
Bronze
38 x 28.5 x 39 cm.
(15 x 11¼ x 15⅜ in.)
Gary and Brenda Ruttenberg

Inscribed *Kollwitz* at l. b. edge;
Noack Berlin on lower b. r. A small
number of casts were made before
1945. Since the War, Hans Kollwitz
and his son, Dr. Arne Kollwitz, have
authorized approximately 20 casts
by H. Noack, Berlin. No additional
casts are planned.

Cat. no. 86
*Tower of Mothers (Turm der
Mütter),* 1937–38 / cast later
Bronze
27 x 27.5 x 28 cm.
(10⅝ x 10⅞ x 11 in.)
a) The Robert Gore Rifkind
Collection, Beverly Hills,
California (Los Angeles only)
b) The Baltimore Museum of
Art; Given in Memory of Joseph
Katz, by His Children, BMA
1965.38.1 (Washington and Co-
logne only)

Inscribed *Kollwitz* and *H. Noack
Berlin* at l. b. edge. Only a small
number of bronzes was cast before
1945. Approximately 20 casts exist
today. No more are being made.

Cat. no. 87
*The Lamentation: To the Mem-
ory of Ernst Barlach, Who Died
in 1938 (Die Klage: Zum
Gedenken des 1938 verstorbenen
Ernst Barlach),* 1938
Bronze
26 x 26 x 10 cm.
(10¼ x 10¼ x 3⅞ in.)
Mr. and Mrs. Henry Sieger

Inscribed *Kollwitz* and *H. Noack,
Berlin.* A few examples may have
been cast prior to 1945. Today,
according to Dr. Arne Kollwitz,
approximately 40–50 bronzes exist;
this was the artist's most popular
sculpture.

Lehmbruck

Wilhelm Lehmbruck

Born 1881 Duisburg-Meiderich;

died 1919 Berlin.

Wilhelm Lehmbruck was born the son of a laborer. During his relatively short career from 1901 to 1919, he explored the entire spectrum of modern sculpture. In 1901, he studied under Carl Janssen at the Kunstakademie Düsseldorf, modeling figures (*Bathing Woman*, fig. 2, p. 147), portrait busts, and reliefs. His eclectic, searching oeuvre combined social naturalism, literary symbolism, the influences of Rodin and Meunier, and the Academic themes of the German Empire. Within these works were hints of the new modes of creativity that came to the fore in 1909–10, when Hoetger, Constantin Brancusi, and Barlach began to react against the heritage of the nineteenth century. As Lehmbruck's contemporaries and critics, such as Theodor Däubler, Paul Westheim, and Carl Einstein, soon came to recognize, his works as early as 1902 displayed an intense concentration on the animated individual figure and on the depiction of space.[1] In works such as *Anita K.* (1906), *Mother and Child* (1907, bronze), and *Small Standing Woman* (1908, bronze), however, Maillol's influence can be seen. This is because Lehmbruck's works of around 1909 demonstrated a short-lived synthesis of the French sculptor's quietness of form with Hans von Marées' technique, thus combining Mediterranean sensuality with the axial dominance of Northern nudes. In October 1910, at the eighth *Salon d'Automne* exhibition, Lehmbruck exhibited his *Tall Standing Woman* (1910, cast cement) next to Maillol's *Pomona* (c. 1910, plaster).

Yet most Lehmbruck scholars, including the authors of exhibition catalogues since 1949, consider this significant early oeuvre only to have become truly interesting around 1911, when Lehmbruck was able to move to Paris. At this point, he abruptly turned away from Rodin and broke with his previous style. *Kneeling Woman* (fig. 13, p. 19) was described by Däubler as a preface to Expressionist sculpture.[2] Lehmbruck distinguished himself as an Expressionist by lengthening the human figure and emphasizing its significance as the bearer of emotions, ethical attitudes, and ideas. In 1913, he reached an artistic high point in the creation of *Rising Youth* (fig. 3, p. 147), a sculptural prototype of the Expressionist adolescent. A drawing in the Staatsgalerie Stuttgart confirms the sculpture's Nietzschean origins; here a youth, next to a tree, gestures as if illustrating the dialogue in *Also sprach Zarathustra* – "Von Baum am Berge" ("By the Mountain Tree").[3]

Lehmbruck's fame, prior to World War I, was established by his participation in many important exhibitions. In April of 1912, the exhibition *Wilhelm Lehmbruck – Egon Schiele* was organized by Karl Ernst Osthaus at the Folkwang Museum in Hagen, demonstrating the kinship between the two artists. The significant *Moderne Kunst* exhibition at the same museum in June–July 1912 included Lehmbruck's watercolors and oil studies as well as sculptures, indicating that he regarded himself as both a two- and three-dimensional artist.[4] From May to September of 1912, the Westdeutscher Sonderbund sponsored an international exhibition, in which Van Gogh, Cézanne, Gauguin, Munch, and Picasso were well represented. Fourteen sculptures by George Minne were also on view, as well as sculptures by Richard Engelmann, Barlach, and Hans Haller. Lehmbruck exhibited two important works: *Tall Standing Woman* and *Kneeling Woman*. He also sent works to the 1912 *Sonderbund* exhibition, the 1913 *Armory Show* in New York, Chicago, and Boston, and the *Werkbund* exhibition of 1914 in Cologne.[5] In the same year, he had a one-man exhibition at the Galerie Levesque in Paris.

Thus the years before World War I saw Lehmbruck as the great hope of the new sculpture. This art was in no sense given over to mere formal experimentation with concave and convex surfaces, but rather used the human figure to convey the *ideas* of Expressionism. In 1920, the art historian Willi Wolfradt emphasized that the subject of Expressionist sculpture was the human body.[6] The abandonment of the human figure as a carrier of symbols, promoted by Brancusi between 1908 and 1913, led to a crisis in European plastic art around 1912, a crisis which must be recognized as that of the human figure versus abstraction – "inner sound" (Kandinsky and Marc) versus objectivity and the depiction of man (Beckmann, Lehmbruck, Schiele).[7]

While this crisis was occurring in painting and

|||

1. Theodor Däubler, *Der neue Standpunkt,* rev. ed., ed. Fritz Löffler, Dresden: Jess, 1957, p. 162 (originally published in 1916, Dresden: Hellerauer Verlag); Westheim, 1919; Carl Einstein, *Wilhelm Lehmbrucks graphisches Werk,* Berlin: Cassirer, 1913; idem, *Die Kunst des 20. Jahrhunderts,* 3rd ed., Berlin: Propyläen-Verlag, 1931, pp. 221ff.

2. Däubler, 1957, op. cit., p. 162.

3. Friedrich Nietzsche, *Also sprach Zarathustra,* in *Werke: Kritische Gesamtausgabe,* ed. Giorgio Colli and Mazzino Montinari, vol. 6, pt. 1, Berlin: de Gruyter, 1967, pp. 47–48.

4. Here we cannot deal with Lehmbruck's paintings, pastels, or watercolors; see Margarita Lahusen, "Aspekte der Malerei Lehmbrucks," in Wilhelm-Lehmbruck-Museum der Stadt Duisburg, 1981, pp. 200–211.

5. Gerhard Händler, "W. Lehmbruck in den Ausstellungen und der Kritik seiner Zeit," in *Sonderband Wilhelm Lehmbruck,* Duisburger Forschungen, vol. 13, Stadtarchiv Duisburg, 1969, pp. 21ff.; National Gallery of Art, Washington, D.C., 1972, p. 181, Cologne exhibit date incorrectly given as 1913; Schubert, 1981, pp. 181–84.

6. Wolfradt, 1920, p. 34;* and Kuhn, 1921, pp. 114ff.*

7. Regarding the significant controversy between Beckmann and Marc in *Pan,* vol. 2, 1912, pp. 469, 485, 556, see Selz, 1957, pp. 238–40;* also Dietrich Schubert, "Die Beckmann-Marc Kontroverse von 1912: 'Sachlichkeit' versus 'innerer Klang,'" in Kunsthalle Bielefeld, *Max Beckmann: die frühen Bilder,* exh. cat., 1982, pp. 175–87.

sculpture, the First World War broke out in the summer of 1914, and Lehmbruck had to leave Paris. He became a medic; deeply horrified by the slaughtering of nations, he was able to move to Zurich at the end of 1916. But even before that, he began to create male rather than female figures. Their style represents Lehmbruck's achievement: the tight, tectonic human figure symbolizes the period's intense strife. *Violent Man* (cat. no. 89), created in 1914–15 in Berlin, was Lehmbruck's first sculptural reaction to the War. It would be more aptly called *Man Struck*.

During this period Lehmbruck expanded his contacts with artists and writers such as Theodor Däubler, Ludwig Rubiner, Max Liebermann, Carl Einstein, Fritz von Unruh, and others. After the dissolution of the Berlin Secession in 1913–14 and the establishment of the new Freie Sezession, Lehmbruck joined the latter, thus making the acquaintance of the painters Waldemar Rösler and Beckmann. The three served together on the executive committee and jury of the Freie Sezession. Thus Beckmann's and Lehmbruck's acquaintance was firmly established; the latter's large figures created in 1915–17, such as *The Fallen Man* (cat. no. 91) and *Seated Youth* (cat. no. 92), must have had an effect on Beckmann. Most of the work on *The Fallen Man* was done in Berlin in 1915, and it was exhibited for the first time in February of the following year at the second exhibition of the Freie Sezession. In contrast to numerous war memorials of those years, this symbolic figure is nude; it is a symbol for all the war dead of Europe. In its bridgelike tectonics it constitutes, along with *Seated Youth*, the pinnacle of Lehmbruck's art and a central work of twentieth-century sculpture. *Seated Youth* originated in Zurich and in September of 1916 was exhibited in the Kunsthalle Basel with the title *Bowed Figure* and later in Berlin at the fourth *Freie Sezession* exhibition with the title *The Friend*.[8] Whereas *Fallen Man* of 1915 primarily symbolizes the fate of European youth in World War I, *Seated Youth* expresses universal mourning for those who die in war.

Although his art had achieved great importance, in March of 1919 Lehmbruck committed suicide. His works of the period prior to his death include portraits of such cultural figures as Däubler (1916–17, crayon, Lehmbruck Estate), von Unruh (1917, cast stone), and Clara Burger (1917–18, cast stone), as well as drawings of Rubiner (fig. 5, p. 149), and Leonhard Frank. A few sculptures which reduced the human figure but did not formally abandon it also were developed: *Head of a Thinker with Hand* (cat. no. 96) and the animated *Female Torso* (cat. no. 95). The latter work reflects Lehmbruck's love for Viennese actress

Elisabeth Bergner, embodied in the form of a Daphne.[9] *Head of a Thinker with Hand* is both a compressed continuation of the 1913 *Rising Youth*, with the elongated head representing the dwelling place of the spirit, and a self-portrait of Lehmbruck at the end of World War I, in both material and spiritual trouble. Undoubtedly Von Unruh had this work in mind when he wrote in a 1919 letter to the writer Kasimir Edschmid:

> In the final analysis a man presents himself to us, whose mind comprises all of the feelings of conscious humanity, just as the dome of a cathedral contains the prayers of the faithful. A type that the great German sculptor Lehmbruck, who recently passed away, tried to create intimately and constantly.[10]
> – D.S.

||

9. Wilhelm Weber first recognized that this was a Daphne: see " 'Wolle die Wandlung'...zur Daphne von Wilhelm Lehmbruck," in Städtische Museen Heilbronn, 1981, pp. 66– 72. Regarding Lehmbruck's late work, cf. Kunstmuseum der Sozialistischen Republik, 1976, cat. no. 70,* and Dietrich Schubert, "Deutsche Bildhauer," *Weltkunst*, vol. 47, no. 6, March 15, 1977, pp. 546–47.

10. Schubert, 1981, pp. 247–49; Kasimir Edschmid, ed., *Briefe der Expressionisten*, Frankfurt am Main: Verlag Ullstein, 1964, pp. 145–46, and idem, ed., *Schöpferische Konfession*, rev. ed., Berlin: E. Reiss, 1920, pp. 21–24.

||

8. National Gallery of Art, 1972, no. 48; Schubert, 1981, pp. 230ff. We cannot discuss fully here the different coloration of the terracotta, stone, and bronze versions; cf. color pl. in Wilhelm-Lehmbruck-Museum der Stadt Duisburg, 1981, no. 52, and in Städtische Museen Heilbronn, 1981.

Cat. no. 88
Head of an Old Woman (Kopf einer alten Dame), 1913
Plaster, colored ocher
52 x 13.5 x 19 cm.
(20½ x 5⅜ x 7½ in.)
Wilhelm-Lehmbruck-Museum der Stadt Duisburg

Cat. no. 89
Violent Man / Man Struck (Stürmender / Getroffener),
c. 1914–15
Cast cement *(Steinguss)*, colored black
45 x 19 x 21 cm.
(17¾ x 7½ x 8⅜ in.)
Wilhelm-Lehmbruck-Museum der Stadt Duisburg

A plaster also exists in the Nationalgalerie, Berlin, and a bronze in the Kunstmuseum Hannover mit Sammlung Sprengel.

Cat. no. 90
Sketch for the Fallen Man (Skizze zum Gestürtzten),
c. 1915
Charcoal on paper
26.7 x 42.6 cm.
(10½ x 16¾ in.)
Lehmbruck Estate

Cat. no. 91
The Fallen Man (Der Gestürzte),
c. 1915–16 / cast posthumously
Bronze
78 x 239 x 83 cm.
(30¾ x 94⅛ x 32⅝ in.)
Bayerische Staatsgemälde-sammlungen, Munich

The plaster and a cement cast are in the Wilhelm-Lehmbruck-Museum der Stadt Duisburg. Another bronze is in the Nationalgalerie, Berlin.

Cat. no. 92 (ill., p. 146)
Seated Youth (Sitzender Jüngling), 1916–17 / cast c. 1919
Bronze
109.5 x 76.8 x 114.8 cm.
(43⅛ x 30¼ x 45¼ in.)
Wilhelm-Lehmbruck-Museum der Stadt Duisburg

Inscribed *W. Lehmbruck* and *Gegossen Erzgiesserei Ferd. V. Miller München*. This work has also been referred to as *The Friend (Der Freund)* or *The Bowed Figure (Der Gebeugte)*. A plaster, cast in 1917, exists in the National Gallery of Art, Washington, D. C. A tinted cement cast is in the Städelsches Kunst-institut, Frankfurt.

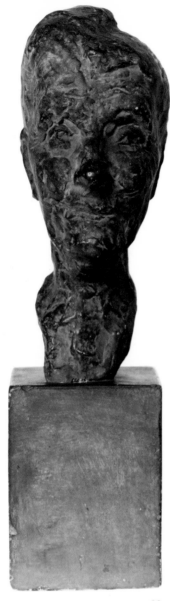

88

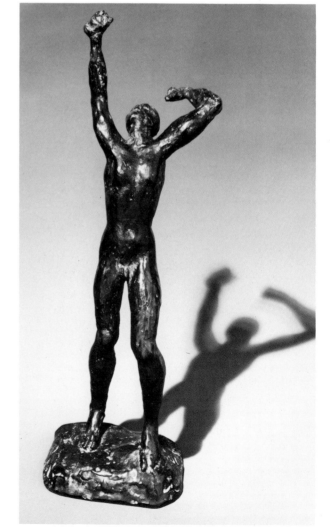

89

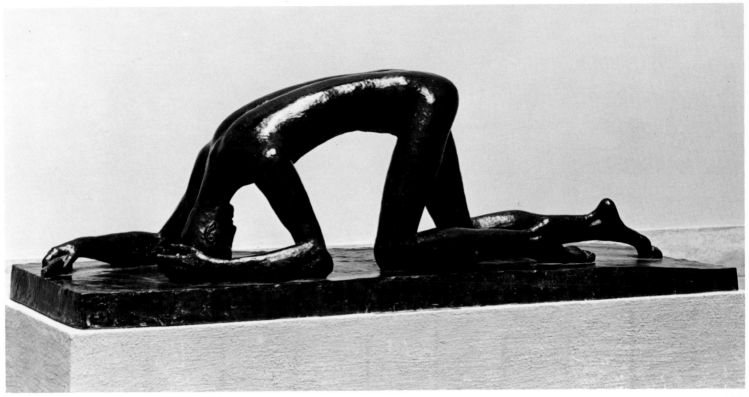

91

90

93

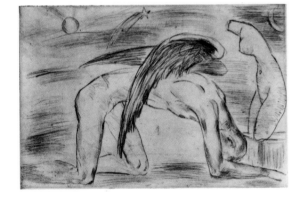

94

Cat. no. 93 (ill., p. 145)
*Collapse: Dying Warrior
(Zusammenbruch: Sterbender
Krieger)*, 1917
Etching
11.5 x 20.5 cm.
(4½ x 8⅛ in.)
Lehmbruck Estate
Petermann, 165

This etching closely resembles
Lehmbruck's many preparatory
drawings for the sculpture *The
Fallen Man* (cat. no. 91).

Cat. no. 94 (ill., p. 145)
*Ode to the Genius II (Ode an den
Genius II)*, 1917
Etching
19.3 x 30.2 cm.
(7⅝ x 11⅞ in.)
Wilhelm-Lehmbruck-Museum
der Stadt Duisburg
Petermann, 162

The winged genius figure seen in
this etching is identical in pose to
the fallen man in the sculpture *The
Fallen Man* (cat. no. 91). Lehmbruck
has included elements of landscape
in his etching (unusual within his
printed oeuvre).

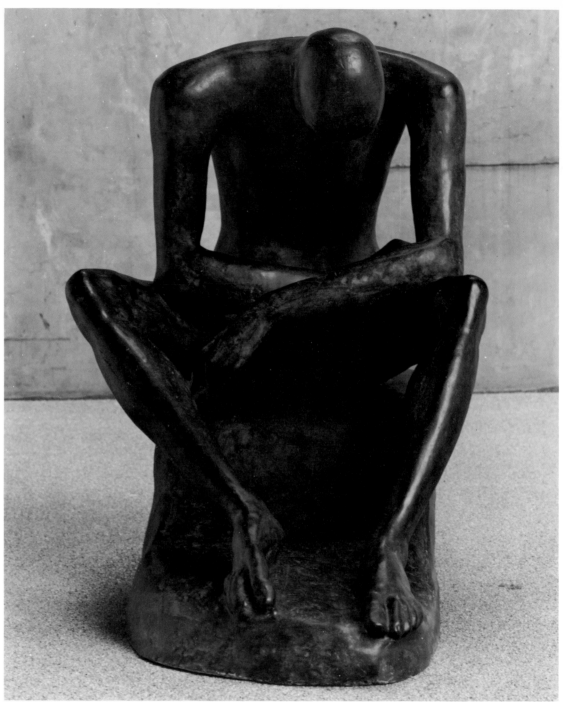

92

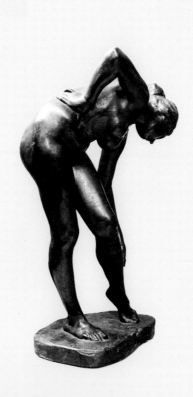

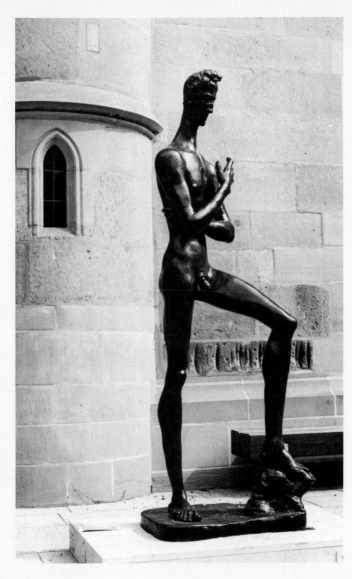

Fig. 1
Lehmbruck in 1918 with his
sculpture *Seated Youth*
(cat. no. 92).

Fig. 2
Bathing Woman (Badende),
1902
Bronze
66 × 38 × 24 cm.
(26 × 15 × 9½ in.)
Wilhelm-Lehmbruck-Museum
der Stadt Duisburg

Fig. 3
*Rising Youth (Emporsteigender
Jüngling)*, 1913
Bronze
228 × 76 × 62 cm.
(89¾ × 29⅞ × 24⅜ in.)
Lehmbruck Estate

Cat. no. 95
Female Torso (Weiblicher Torso), 1918
Cast cement *(Steinguss)*
77.5 x 42 x 19.5 cm.
(30½ x 16½ x 7⅝ in.)
Wilhelm-Lehmbruck-Museum
der Stadt Duisburg

This piece is also referred to as
Daphne. Bronze casts exist in the
Pfalzgalerie, Kaiserslautern, and the
Lehmbruck Estate.

Cat. no. 96
*Head of a Thinker with Hand
(Kopf eines Denkers mit Hand)*,
1918 / cast later
Bronze
64.5 x 57.2 x 29.8 cm.
(25⅜ x 22½ x 11¾ in.)
Lehmbruck Estate

Inscribed *Lehmbruck* and *H. Noack
Berlin.* Stone casts exist in the
Museum des 20. Jahrhunderts, Vi-
enna; the Nationalgalerie, Berlin;
and the Museum am Ostwall,
Dortmund.

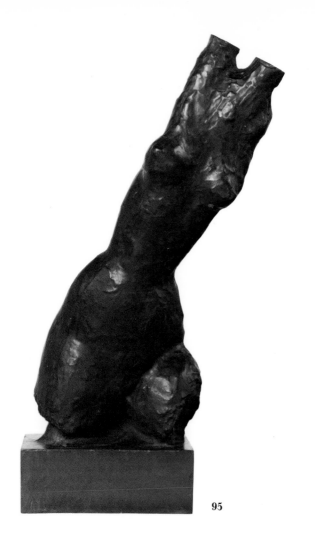

95

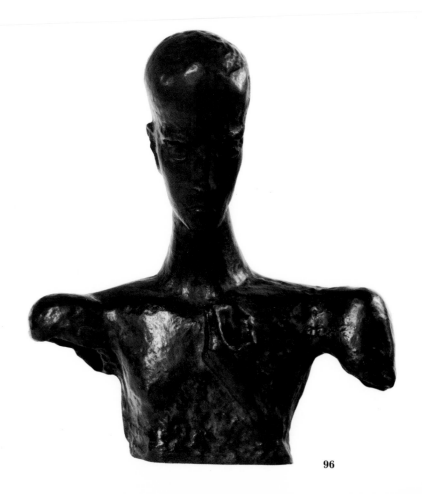

96

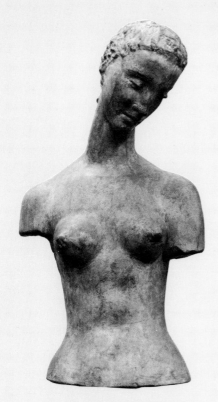

Fig. 4
Torso of Kneeling Woman (Torso der Knienden), 1911
Cement Cast
h: 82 cm. (32¼ in.)
Nationalgalerie, East Berlin

Porträt Ludwig Rubiners
Für die AKTION gezeichnet
von W. Lehmbruck

Fig. 5
*Portrait of Ludwig Rubiner
(Bildnis Ludwig Rubiner)*,
c. 1917
Drawing
Photograph from the periodical
Die Aktion, vol. 7, April 1917

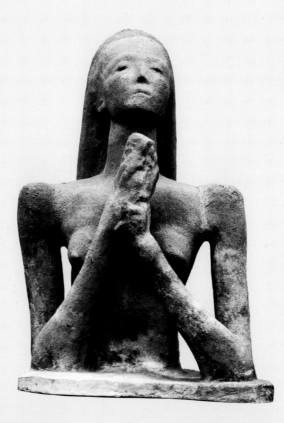

Fig. 6
Praying Woman (Betende), 1918
Stone cast
83 × 56 × 50 cm.
(32¾ × 22 × 19¾ in.)
Kunsthaus Zürich

Marcks

Gerhard Marcks

Born 1889 Berlin;

died 1981 Burgbrohl / Eifel.

The sculptural and graphic works of Gerhard Marcks provide proof that Expressionist form was also deeply indebted to Archaic Greek models. Marcks, who decided to become a sculptor at an early age, rejected the common Academic approach to sculpture and in 1907 became a kind of apprentice to August Gaul, a sculptor famous for his depictions of animals. The following year, Marcks began working in the studio of the sculptor Richard Scheibe, who served as his "teacher, Maecenas, enemy, model, public, and tuxedo lender."[1] The two worked together creating sculptural reliefs for an exhibition hall to house machinery which was designed by Walter Gropius for the *Werkbund* exhibition of 1914.

Marcks spent a compulsory year in the army in 1912, and the First World War saw him in uniform once again. Following the War, in 1919, Gropius asked Marcks to join the faculty of the newly founded Bauhaus in Weimar. Marcks taught there until 1925, developing a close friendship with painter and graphic artist Lyonel Feininger. On one occasion, Feininger wrote to Marcks: "You are a form-giver far beyond the mere representation of nature, translating nature instead into its pure essentials in order to reveal its deep character."[2] It was also Feininger whom Marcks credited with having inspired him to begin his woodcuts which, strongly abbreviated in form, are typically Expressionist in their stark combination of black and white. As the head of the ceramics department at the Bauhaus, Marcks used the material at hand to create *Small Head* (cat. no. 97) and other small ceramic sculptures. These works are Expressionist in their decreased emphasis on individual features in favor of more "universal" representation. Marcks created a large number of drawings and small models of this type of head, indicating the seriousness of his search for a new form.

When the Bauhaus moved to Dessau in 1925, adopting the motto "Art and Technology – a New Unity," Marcks felt that he no longer belonged there and accepted a teaching position at the Kunstgewerbeschule Burg Giebichenstein near Halle. While at Giebichenstein, he concentrated on his sculpture. His time for creative work became limited, however, when in 1930 he took over as interim director after the resignation of the school's founder, the highly respected architect Paul Thiersch. In 1928, Marcks had traveled to Greece, where he discovered Archaic sculptural forms, which

he regarded as an affirmation of his commitment to the human figure. For Marcks, the characters of Greek mythology – Orpheus and Tantalus, Prometheus and Odysseus, Oedipus and Ariadne – provided true and vital models of human experience. In regard to his 1957 bronze sculpture of *Orpheus,* Marcks stated: "I wanted to express that Orpheus was an ordering principle ([like] J. S. Bach) in contrast to ecstasy. He was torn apart by the maenads, spirits of trance, passion, and disorder...for me, he was a statement of faith."[3] The last figure Marcks completed depicted Prometheus being set upon by the eagle (plaster, 1980).

The Nazis fired Marcks from his position at Giebichenstein in 1933 and included his work in the *Entartete Kunst* exhibition of 1937. He then moved to Mecklenburg, but shortly thereafter returned to Berlin. Forbidden to exhibit, he resumed his work in graphics, a medium he had neglected after moving to Giebichenstein. During the Second World War, he lost his house, studio, and many of his works in one of the bombings of Berlin, and he returned once again to Mecklenburg.

Immediately following the War, the Landeskunstschule in Hamburg appointed Marcks a professor. It was here that he received the important commission to complete the cycle of eight figures for the west facade of St. Katharinenkirche in Lübeck (see fig. 35, p. 27). Ernst Barlach had already executed three of these figures (1930–32; see his *Beggar,* cat. no. 22) and suggested that Marcks complete the cycle. Today the eight figures stand in their niches like different tones in a single melody. Barlach and Marcks shared the same credo. They were convinced that the sculptor's task is to render visible man's vulnerability and strength, his misery and joy. While formal differences in the figures reflect the artists' unique personalities, this group of sculptures as a whole is remarkable for its success in blending a modern treatment of the human image with the church's Gothic brick architecture.

Prometheus Bound II of 1948 (cat. no. 98) was the culmination of Marcks' attempt to solve the problem of creating a truly expressive figure in a static position. Its precedents are to be found in graphic studies (cat. nos. 99 and 100) as well as the earlier sculptures *Seated Boy* and *Tantalus* (both 1944, bronze). Chronologically the latest Expressionist sculpture in this exhibition, *Prometheus Bound II* is a mature work that joins Expressionist elements with Marcks' inherent understanding of the Greek genius. Prometheus, punished for bringing fire stolen from Olympus to man, sits in bitter defeat and grief. His fettered hands rest on one knee, his head on the other. His spirit has deserted him and with it the will to protest or rebel against his punishment. Marcks created this figure as a symbol of the sufferings endured in the Second World War. It is reminiscent of Lehmbruck's *Seated Youth* (cat. no. 92), but it does not convey the same

|||

1. Letter from Gerhard Marcks in Berlin to his brother Herbert, dated August 31, 1910, and published in Germanisches Nationalmuseum, Nuremberg, 1979, p. 21.

2. Letter from Lyonel Feininger in New York to Gerhard Marcks, dated March 9, 1941, and published in Kölnischer Kunstverein, *Gerhard Marcks Werke der Kölner Jahre: 1950 bis 1969,* exh. cat., 1969.

|||
3. Letter from Gerhard Marcks in Cologne to Peter Guenther dated August 2, 1971.

sense of the defeated and suffering revolutionary. Thus, in sensibility, it is perhaps even more closely related to Lehmbruck's *Fallen Man* (cat. no. 91).

In 1949, Marcks executed a monument to the people of Cologne who had died during the Second World War, and in the same year he received the Goethe-Medaille (Goethe Medal) from the city of Frankfurt in recognition of his achievements. In 1950, he moved permanently to Cologne, where he completed a commissioned monument dedicated to the civilians who had died in the bombing raids on Hamburg. In 1952, he was made a knight of the Orden Pour le Mérite and was awarded the Stephan Lochner-Medaille from the city of Cologne. Commissions for the cities of Frankfurt, Aachen, Bremen, and others followed, frequently competing for time with works which Marcks wished to do for himself. Woodcuts, lithographs, and in the later years landscape pastels became more frequent in his oeuvre, along with a number of animal sculptures. In an interview given in 1978, Marcks said: "...one gathers experiences and only becomes human by correctly using these experiences. For this, later life is the best time. Then one can think: what is really important?"[4] His works have provided us with his own answer. – P.W.G.

||

4. Gerhard Marcks Stiftung, Bremen, *Gerhard Marcks zum 90. Geburtstag,* exh. cat., 1978.

Cat. no. 97
Small Head (Kleiner Kopf),
c. 1923
Terracotta
21 x 12.7 x 11.5 cm.
(8¼ x 5 x 4½ in.)
Private Collection, New York
Busch-Rudloff, 108a

Cat. no. 98
*Prometheus Bound II
(Gefesselter Prometheus II),*
1948
Bronze
79 x 51 cm.
(31⅛ x 20⅛ in.)
Museum Ludwig, Cologne
Busch-Rudloff, 522

Busch and Rudloff have identified
6 casts of this piece, 4 without cast-
ing numbers and 2 inscribed with
casting numbers *IV* and *VI.* Cf.
Busch-Rudloff, 431 and 440 for
descriptions of the now-destroyed
plasters, *Prometheus,* 1943, and
*Prometheus Bound I (Gefesselter
Prometheus I),* 1944.

Cat. no. 99
*Study for Prometheus (Studie
zum Prometheus),* 1948
Pencil on paper
28.3 x 21.8 cm.
(11⅛ x 8½ in.)
Gerhard Marcks Stiftung,
Bremen, St. 72/1298

Cat. no. 100
*Study for Prometheus (Studie
zum Prometheus),* 1948
Pencil on paper
29.5 x 21 cm.
(11⅝ x 8¼ in.)
Gerhard Marcks Stiftung,
Bremen, St. 72/1295

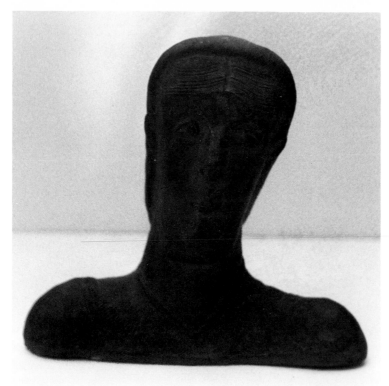

97

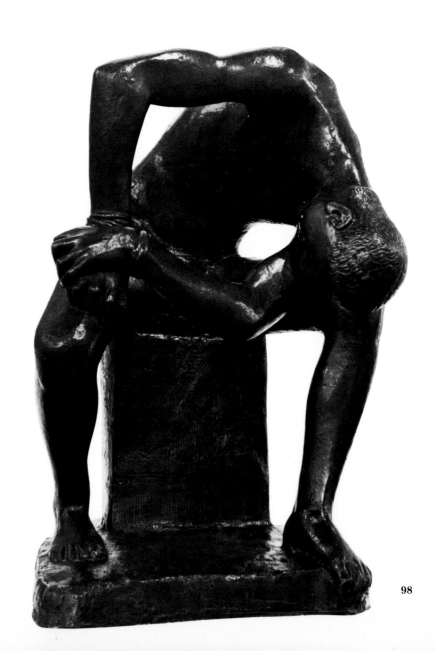

98

99

100

98

Minne

George Minne

Born 1866 Ghent, Belgium;

died 1941 Laethem-Saint-Martin,

Belgium.

George Minne's works from about 1885 until 1909 are outstanding examples of the close connections which existed between three ostensibly very different stylistic directions. Through his friendship with the great Belgian poets and writers Maurice Maeterlinck, Grégoire le Roy, and Emile Verhaeren, Minne was drawn early to a Symbolist aesthetic; at the turn of the century and the height of his career, he lived and worked amid the reigning spirit of Art Nouveau. It was George Minne's special gift to combine Symbolist and Art Nouveau elements with forms and concepts which are clearly forerunners of Expressionism.

In 1882, Minne entered the Koninklijke Academie voor Schone Kunsten in Ghent as a student of architecture, his father's profession, and studied there until 1884. Contrary to his family's wishes, he worked on his own from 1885 to 1889. His early paintings and sculpture show an Academic orientation in their use of standard historical subjects and classical forms. An important breakthrough for Minne came in 1886, when Maeterlinck and Le Roy returned from a trip to Paris, where they had met the French Symbolists and established a strong friendship with Villiers de l'Isle-Adam and his circle. At the Belgians' request, Minne produced a number of drawings and woodcuts as illustrations for Le Roy's Symbolist poetry and Maeterlinck's plays. He became a member of the important Belgian Symbolist art group Les Vingt (The Twenty) with which he exhibited beginning in 1890. This group had been founded in Brussels in 1884 by Octave Maus, a lawyer, art critic, and editor of the influential *Revue de l'Art Moderne (Modern Art Review)*. Les Vingt's more famous members included Fernand Khnopff, James Ensor, Theo van Rysselberghe, and Henry van de Velde.

Minne was deeply committed to the Symbolist credo, which held the inner world of the soul to be of primary importance. Problems addressed by the Realists and Impressionists were those of the visible, external world, and as such were considered unimportant when compared with the Symbolist aim of comprehending underlying and universal truths. Minne drew on the art of the Pre-Raphaelites, as well as Gothic and Northern Renaissance traditions. He was also impressed with the work of Rodin and in 1890 traveled to Paris to meet him. In 1898, Minne settled permanently in Laethem-Saint-Martin, a small town near Ghent which gradually developed into an artists' colony.

Minne is best known as a sculptor, and it is in his three-dimensional works that the presaging of Expressionism is most visible. The Symbolist intention and Expressionistic distortions of *The Prayer* (cat. no. 101) not only exemplify Minne's capacity for synthesis, but also effectively counter the sweetness which is generally associated with late nineteenth-century treatments of religious subjects. The nun's cowl covers her forehead close to the brow, and the roughly worked garment appears to deny that she has shoulders; thus the hands and the wrinkled, quiet face are dominant. Significantly, Minne carved this piece in wood aware that the roughness would enhance and strengthen the mysterious expression of the face. Is it grief, contemplation, or the apprehension of a vision which Minne has depicted? This ambiguity is characteristic of the Symbolist approach.

Minne's renown arose primarily from one specific motif – the kneeling boy. First established in 1896 with *Small Kneeling Figure,* this image preoccupied the artist for many years. It was repeated in *The Small Relic-Carrier* (1907, marble, Koninklijk Museum voor Schone Kunsten, Antwerp) and again in *Kneeling Figure* of 1898 (cat. no. 102), reaching its culmination in *The Fountain of Kneeling Youths* (fig. 1, p. 157). This latter work was commissioned by Karl Ernst Osthaus, the founder of the Folkwang Museum in Hagen, who already owned a number of Minne's works. When Henry van de Velde designed the new Folkwang Museum building, he suggested that a work by Minne should stand in the circular entrance hall under the colored glass dome. The sculptor made a number of sketches and models until he arrived at the composition of five identical boys kneeling on the unadorned rim of a circular basin. Their bodies, whose elegance echoes Italian Mannerist sculpture of the late sixteenth century, are held in precarious balance, since each boy leans slightly backward while his head is tilted forward and downward. The complexity of this position is denied by the smoothness of the marble's white surface, which achieves near-abstraction. Calm, ennui, narcissism, inner pain...all of these can be read into the sculpture. Art historian Julius Meier-Graefe wrote that the repeated figure of the boy bears a "paroxysm of pain transcending physical affliction,"[1] indicating his fine understanding of the contradictions expressed by this form. The seeming awkwardness of the attenuated bodies gives way to a strange and moving power when seen in their rhythmic circle. Each of the figures is completely self-occupied; the Flemish poet Karel van de Wiestyne called the fountain *Narcissus in Five-Fold Reflection.* The image of Narcissus was important to both the Symbolists and practitioners of Art Nouveau.[2]

When either the single figures or the group of five was exhibited, the public was hardly prepared for this violation of the still-dominant semiclassical style. They were less understanding of Minne's other adolescent figures from this same period, which display even more expressive gestures. This expressiveness continued to increase until 1911, when Minne turned to more realistic forms. He taught drawing at the Academy in Ghent from 1912 to 1914 and spent the

1. Julius Meier-Graefe, "Das plastische Ornament," *Pan,* vol. 4, no. 4, 1898, p. 259.

2. See Paul Valéry, "Narcisse parle," in *Album de vers anciens,* Paris: Editions de la N.R.F., 1933.

War years in England, primarily making charcoal drawings. After the War, he took up sculpture again, concentrating on maternal figures which conform closely to the marble block. His influence on Lehmbruck is an important direct link to German Expressionist sculpture.

Honors came late to Minne. In 1930, he was given the title of Baron and had the Grand Officer's Cross of the Order of Leopold bestowed upon him. – P.W.G.

101

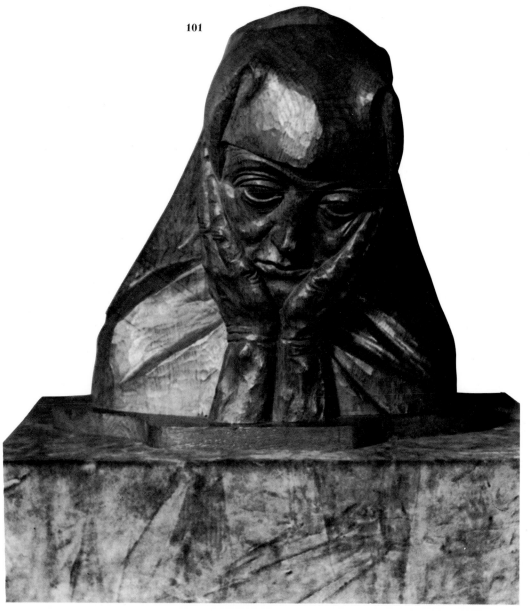

Cat. no. 101
The Prayer (Oraison), 1894
Wood
h: 46 cm. (18¹/₁₀ in.)
Museum Folkwang, Essen
Puyvelde, 16

This work was also executed in marble and bronze.

Cat. no. 102
Kneeling Figure (L'agenouille),
1898
Marble
h: 78 cm. (30¾ in.)
Mr. and Mrs. Nathan Smooke
Puyvelde, 26

This piece was formerly in the
collection of Robert von Hirsch.
Minne's original marble sculpture
group of 5 kneeling youths (1898–
1905) was commissioned by Karl
Ernst Osthaus for the Folkwang
Museum, Hagen. Today the original
group is in the Museum Folkwang,
Essen, and a copy is in the original
location in the Karl Ernst Osthaus
Museum, Hagen. This sculpture is
one of several versions Minne ex-
ecuted of the same figure type used
in the fountain.

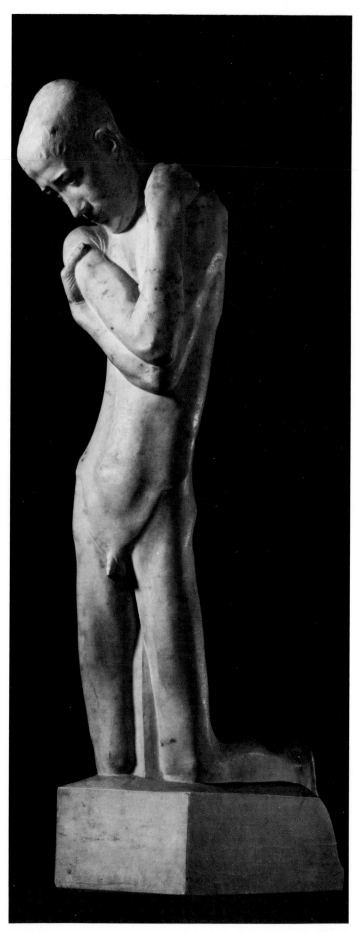

102

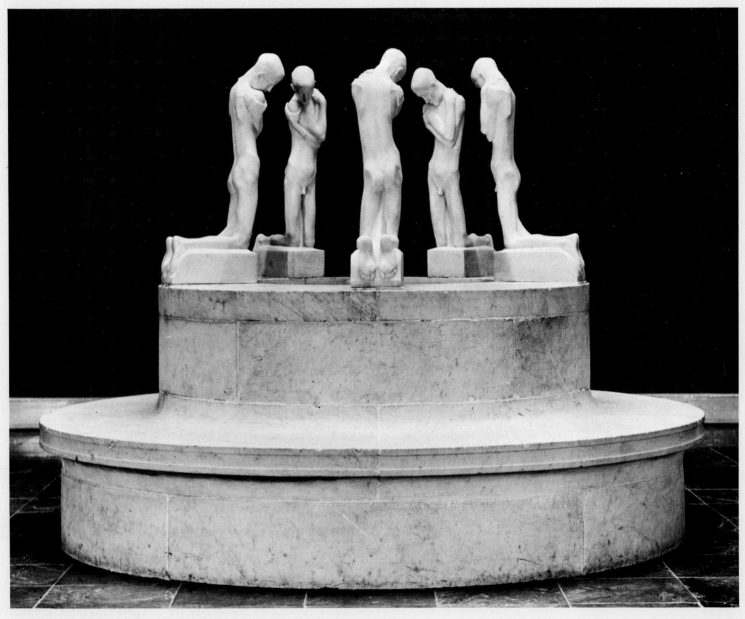

Fig. 1
*The Fountain of Kneeling Youths
(Brunnen mit fünf knienden
Knaben)*, 1898–1905
Marble
Formerly Folkwang Museum,
Hagen; presently Museum Folk-
wang, Essen

Müller

Albert Müller

Born 1897 Basel, Switzerland;

died 1926 Basel, Switzerland.

The Swiss painter Albert Müller first was exposed to the work of Ernst Ludwig Kirchner during the 1923 Kirchner exhibition held at the Kunsthalle Basel. As a result of this encounter, specific changes occurred in Müller's own art. Prior to the Kirchner exhibition, he had studied in Paris and Munich, traveled to Italy, and worked briefly with the Swiss painter Cuno Amiet. He had not received any formal training as a sculptor, but had already generated a modest oeuvre of paintings on glass in addition to his canvases and graphics. Müller's paintings from after the exhibition are characterized by stark coloration and compelling frontality. Further, along with his friend and fellow Basel artist Hermann Scherer, Müller began to carve wood sculptures.

Müller, Scherer, Paul Camenisch, and other young Swiss artists were inspired by Kirchner's work to form a group modeled after Die Brücke, which they called Rot-Blau. Like Kirchner and the members of the Brücke, the Rot-Blau artists were committed among other things to an aesthetic which would encompass carved objects intended for everyday use, as well as painting and sculpture. Of all the sculpture by members of this group, Müller's most clearly reflects Kirchner's influence.

Müller was personally encouraged by Kirchner, whom he visited at Frauenkirch in 1924, to explore working in wood. Immediately after this visit, Müller carved his first sculpture, *Standing Figure* (cat. no. 103). Scherer was also encouraging. Responding to a photograph of *Standing Figure* that Müller had sent to him, Scherer wrote, "...the figure which you sent the photo of looks very good. It would be wonderful if very soon a small army of sculptors existed."[1]

The works in Müller's modest sculptural oeuvre all bear the mark of his hand on their rough-hewn wood surfaces. The artist seems to have been primarily interested in carving out his form as opposed to refining it. Müller painted his sculptures, but in a manner that was quite different from that of Scherer, whose plastic works are almost entirely covered with striking hues. In *Crouching Woman* (cat. no. 104; see Kirchner's own photograph, fig. 2, p. 159), for example, Müller limited his application of color in order to emphasize certain aspects of physiognomy – e.g., hair, nipples, face – in much the same way that Kirchner applied paint. This coloration gives the sculptures a starkness which in turn emphasizes their naiveté and straightforwardness. Several of Müller's carvings were objects intended for personal use, for example, a decorative, carved bed which resembled in spirit the *Kunsthandwerk* of the Brücke artists.

Müller's work of 1925–26 continued to resemble Kirchner's in its attitude toward the sculptural surface, as well as in its composition. Both artists created sculptures which were not particularly complex in their organization or their basic structure, as most of them were fashioned from a single piece of wood. For both Kirchner and Müller the basic form remained the tree trunk, and their sculptures were linked to this form. The notion shared by these artists that each sculptural detail, each cut made in the wood, should reflect a deliberate choice on the sculptor's part, as well as an expression of himself and his feelings, had been outlined in Kirchner's article of 1925 "Concerning the Sculpture of E.L. Kirchner," written under his pseudonym (see pp. 43–46).

While all that remains of Müller's sculpture today is three finished and two unfinished sculptures and three bedframes made for his children, he most likely created many other sculptures which have not survived. Some were probably unfinished at the time of his death and were subsequently discarded or lost.

In December of 1926, Müller died unexpectedly from an attack of typhus. He and Scherer were represented by Kirchner in his life-size sculptural portrait *The Two Friends,* c. 1924–25 (figs. 5, p. 46, and 13, p. 128). – S.B.

|||

1. Stutzer, 1981, p. 169.

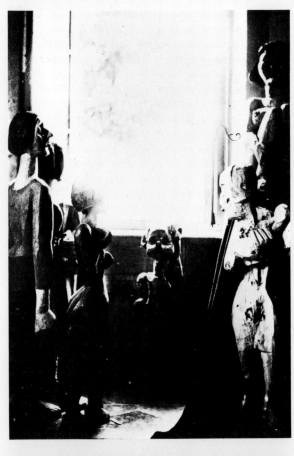

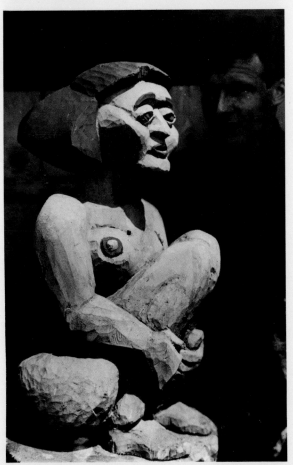

Fig. 1
Müller's sculptures in his house in Obino, probably photographed by the artist.

Fig. 2
Müller with his sculpture *Crouching Woman* (cat. no. 104), photographed by Kirchner.

Fig. 3
Müller with one of his sculptures at Frauenkirch.

Cat. no. 103
Standing Figure (Stehende Figur), 1924
Stained wood, with painted face
h: 105 cm. (41⅜ in.)
Kaspar Müller, Basel
Stutzer, S.1

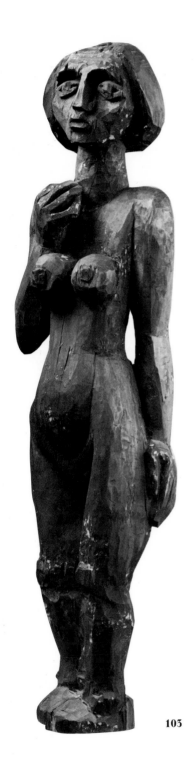

103

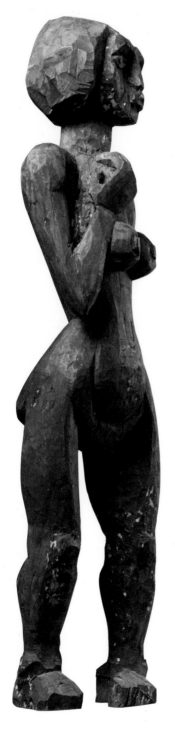

103

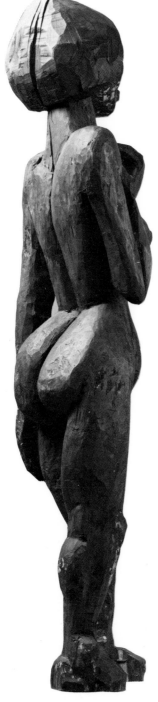

103

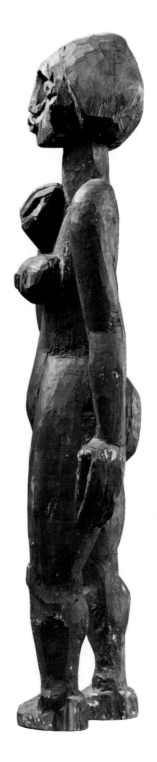

103

Cat. no. 104
Crouching Woman (Hockende),
c. 1925
Painted wood
68.5 x 36.5 x 39.5 cm.
(27 x 14⅜ x 15½ in.)
Öffentliche Kunstsammlung,
Basel
Stutzer, S.2

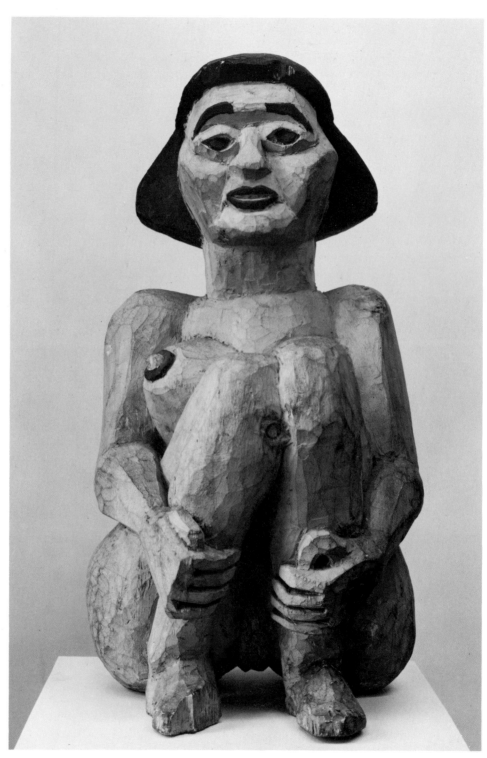

104

Nolde

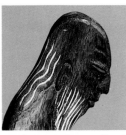

Emil Nolde

Born 1876 Nolde (Schleswig);

died Seebüll 1956.

Emil Nolde, born Emil Hansen, grew up on the land far removed from art. It was thought that he would become a farmer like his father and forefathers. But the boy dreamt of being an artist – he loved colors and painting. Finally his father realized that his son was of no use for work on the farm and sent him to apprentice at the Sauermann carving school and furniture factory in Flensburg. At the age of twenty Nolde was certified as a journeyman sculptor. One of his final projects in this capacity was a group of four melancholy owls for the desk of Theodor Storm, the country's most famous writer (see fig. 1, p. 164).

Nolde thus received training as an expert craftsman – a wood-carver, if not exactly a sculptor. He was experienced in dealing with wood, knew its properties, and had learned to judge it in terms of its practical quality and usefulness. This was, however, something of an obstacle to his development as an artist. Thus, almost two decades passed before Nolde was able – in an act of spiritual and artistic liberation – to free himself from the restrictions of both his experience as a wood-carver in furniture factories and of his employment from 1892 to 1897 as a drawing teacher in a St. Gall trade school. In 1898, he resigned his secure teaching position to become a painter. He traveled to Munich, Paris, Copenhagen, and Berlin, finally settling in a remote fisherman's house on the island of Alsen.

About 1904–05, Nolde hesitantly emerged in public as an independent and original painter. When the young artists of the Brücke group saw some of his paintings in a Dresden exhibit, they were excited by his "storms of color" and in 1906 wrote him a letter praising his work and offering him membership in their group.[1] Schmidt-Rottluff came to Alsen for four months to work near Nolde, who, from the fall of 1906 to the end of 1907, participated as an active member in all of the Brücke exhibits, proclamations, and activities. At this time, however, Nolde thought of himself only as a painter. When in 1906, after a long hiatus, he again picked up the carving knife, it was only to make printing blocks for woodcuts, following a suggestion from Schmidt-Rottluff who procured the necessary tools for him. Nolde was aware that his Brücke friends Kirchner and Heckel were sculpting in wood, as Heckel had sent him a photograph of his own sculpture at the end of 1906. On March 2, 1907, as if to encourage Nolde to do similar work, Heckel wrote to him: "I have finished two new wood sculptures. The wood was very hard, but it was wonderful to come up

against resistance and also to have to bring all one's physical strength into play."[2]

It was not until his journey of 1913–14 to the South Seas, New Guinea, the Palau Islands, Java, and Burma that Nolde yielded to temptation. During the long sea voyages he discovered the stove wood in the ships' galleys: "I was looking for particularly beautiful kinds of wood, which were in ample supply and were used only as firewood." He picked up his pocketknife and carved a number of small, narrow figures. Corresponding to the size of the firewood, they are only 25 centimeters (9⅘ inches) high or even smaller. One of these works was lost on the trip, but twelve survive and are in the collection of the Nolde-Stiftung Seebüll. Five of them are included in this exhibition (cat. nos. 105, 106, 107, 108, and 109).

Are these pieces more than playful products of craftsmanship? Nolde assessed them thusly: "I just tried to get a little beauty out of the firewood." He protested nonetheless when the figures were viewed as casual amusements. They originated effortlessly during the voyages "with their vegetative calm," and this differentiates them from the sculptures of Heckel, who spoke of the challenge of having "to bring all one's physical strength into play." Heckel's sculptures are heavier, denser, and larger than Nolde's; his *Draped Woman* (fig. 6, p. 95), for example, is over a meter high.[3] Heckel could also claim to have retained the identity of his material; the peculiarities and structure of the wood are integral parts of the expression and content of his sculpture. The traces of workmanship were not erased or smoothed over, but remain visible and expressive. But while Heckel, like Kirchner and Schmidt-Rottluff, used tools appropriate for working with tree trunks – hatchets, planes, and chisels – Nolde picked up light, narrow pieces which could be held in one hand and carved them only with his pocketknife. He traced the forms of growth, the flow of the grain, the branching, and the knots in a tender dialogue. In each piece of wood he "saw all kinds of little figures which only needed to be released." The slender *Young Woman with Raised Arms* (cat. no. 109) grows like a mandrake out of the narrow firewood. The posture and gesture of *Prophet* (cat. no. 107) were predetermined by the fork of a branch. The dual figures in *Couple* or *Woman with Child* (both 1913–14, Nolde-Stiftung Seebüll) are bound together in an organic unity, fused like the wood fibers.

Nolde loved collaborations with nature. He enjoyed seeing colors blossom "as if by chance," taking form by themselves. He was pleased when rain and sand were driven by a storm onto a canvas or when the cry-

1. Letter from Schmidt-Rottluff, as representative of the Brücke, to Emil Nolde, April 2, 1906, in the archive of the Nolde-Stiftung Seebüll. Reprinted in Emil Nolde, *Jahre der Kämpfe*, Berlin: Rembrandt Verlag, 1934, pp. 90–91, and in idem, 1976, p. 146.

2. Postcard from Erich Heckel in Dresden to Emil Nolde in Jena, March 2, 1907, in the archive of the Nolde-Stiftung Seebüll.

3. See pl. in Schleswig-Holsteinisches Landesmuseum and Museum für Kunst und Gewerbe, Hamburg, 1960, p. 19.*

stalline patterns of frost became part of a picture's creation. In his etchings, he utilized the "arbitrary" structures formed in the corrosion process. Similarly, when producing his woodcuts, he liked to incorporate the grain and knots of the soft pine surface in his representation.

Most of his figures originated without preliminary drawings – "with the raw material in the hand, between the fingers."[4] Two small statues based on female dancers Nolde saw at a Javanese wedding (cat. no. 106) and in Mandalay, Burma, are exceptions. In his memoirs he wrote that the fiery, wild twirling of these dances made him extremely excited. He captured them in several colored pencil drawings and carved two figures from his sketches. The dancers wear tight gowns of a shining bronze – the actual garments were of yellow silk – and the eyes of the Burmese dancer are small rubies. Some of Nolde's other wood sculptures are also lightly tinted.

In 1925, Nolde created two brick sculptures, a man's head and the smaller *Two Heads: Man and Woman* (cat. no. 110). Their concisely simplified forms join with the peculiarly crumbly texture and deep red color of the unusual material. The complete agreement of form and material goes far beyond a craftsman's sense of doing justice to the material. The same holds true for Nolde's work in embossed metal, for the jewelry of gold and simple stones, silver, tortoise shell, and ivory that he made for his wife, Ada, or for his ceramic works made in 1913 in a pottery in Flensburg – plates

||

4. This is how Nolde described "the works of primitive peoples" in a book about the "artistic expressions of primitive peoples" on which he worked in 1911–12 (the book never got any further than the introduction). It is, however, an apt interpretation of his own creations.

with masks, female dancers, and animals, and colorful versions of reliefs of two dancing girls, reminiscent of the painting *Candle Dancers* of 1912 (Nolde-Stiftung Seebüll). His work in other materials, whether wood, stone, metal, or ceramics, cannot be divorced from his paintings. Thus, we frequently come across his carved wooden figures, just as we do the exotic sculptures, masks, and other objects from his own collection, in his paintings and watercolors.[5] The small watercolor in this exhibit, *Cyclamen and Stone Sculpture: Two Heads* (cat. no. 111), is an example of this. – M.U.

||

5. See Martin Urban's introduction in Kunsthalle, Bielefeld, 1971.

Fig. 1
Owl (Eule), 1888
Wood
Nolde-Stiftung Seebüll

Created for the desk of the
writer Theodor Storm.

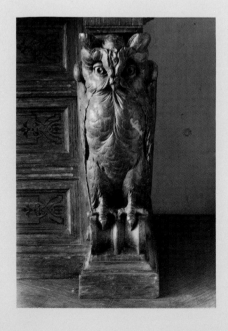

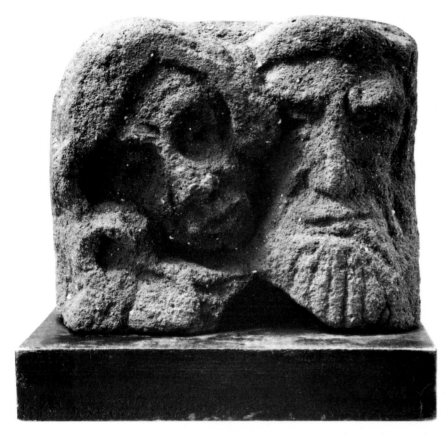

110

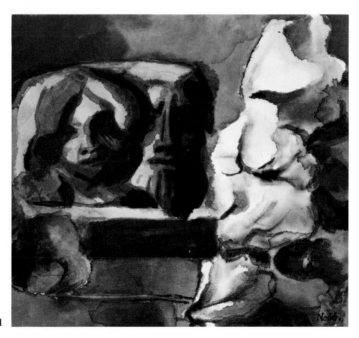

111

Cat. no. 105 (ill., p. 167)
Bearded Man (Bärtiger Mann),
1913–14
Wood, partially colored
h: 24.3 cm. (9⅝ in.)
Nolde-Stiftung Seebüll

Cat. no. 106 (ill., p. 167)
Javanese Dancer (Java-Tänzerin), 1913–14
Wood, partially colored and burnished
h: 22.6 cm. (8⅞ in.)
Nolde-Stiftung Seebüll

Cat. no. 107 (ill., p. 166)
Prophet (Prophet), 1913–14
Painted wood
h: 24.2 cm. (9½ in.)
Nolde-Stiftung Seebüll

Cat. no. 108 (ill., p. 167)
Standing Woman (Stehende Frau), 1913–14
Wood, partially colored
h: 24.3 cm. (9⅝ in.)
Nolde-Stiftung Seebüll

Cat. no. 109 (ill., p. 166)
Young Woman with Raised Arms (Mädchen mit erhobenen Armen), 1913–14
Wood, partially colored
h: 22.4 cm. (8⅞ in.)
Nolde-Stiftung Seebüll

Cat. no. 110
Two Heads: Man and Woman (Zwei Köpfe: Mann und Frau),
1925
Brick
9.8 x 12 x 7.5 cm.
(3⅞ x 4¾ x 3 in.)
Nolde-Stiftung Seebüll

Cat. no. 111
Cyclamen and Stone Sculpture: Two Heads (Alpenveilchen und Steinplastik: zwei Köpfe),
c. 1930
Watercolor
22.6 x 26.2 cm.
(8⅞ x 10⅜ in.)
Nolde-Stiftung Seebüll

The sculpture in this watercolor is *Two Heads: Man and Woman* (cat. no. 110).

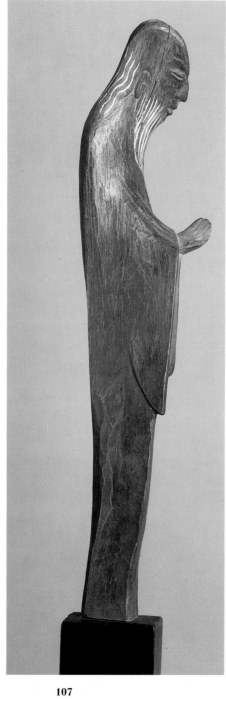

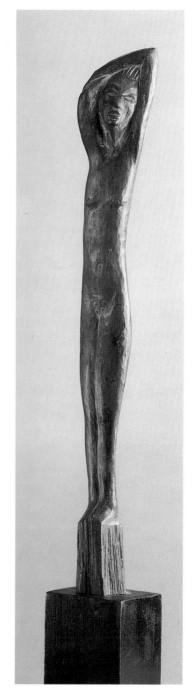

107

109

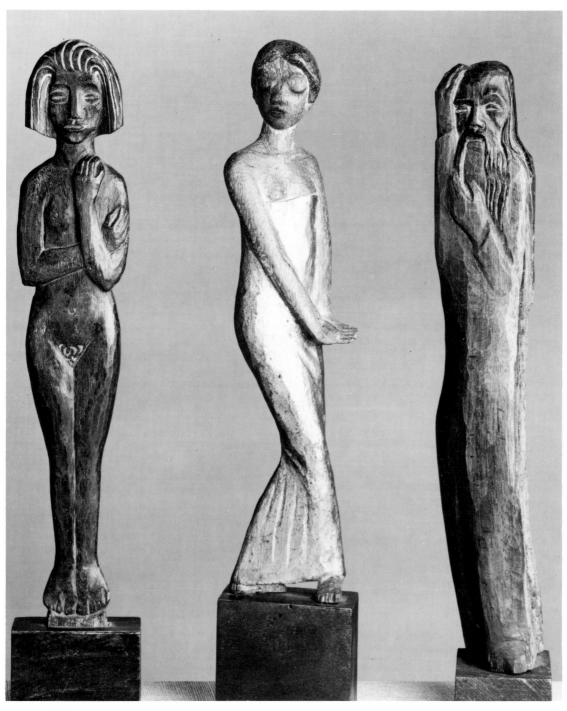

108 106 105

Pechstein

Max Pechstein

Born 1881 Eckersbach,

near Zwickau;

died 1955 Berlin.

Max Pechstein joined the Brücke artists – Kirchner, Heckel, Schmidt-Rottluff, and Fritz Bleyl – in 1906 and left the group in 1912, one year before it disbanded. Although not a founder, during the years of his participation Pechstein was the group's best known and most successful member. He was the first to receive recognition, honors, and significant commissions; he traveled widely and made the acquaintance of many other artists.[1]

Today this situation seems almost to be reversed. The work of Kirchner, Heckel, and Schmidt-Rottluff has been the subject of much scholarly investigation and is easily accessible in museum collections. Yet there is still no comprehensive monograph on Pechstein, and his entire graphic oeuvre has not been published.[2] Moreover, the presentation[3] and concentration of his widely scattered artistic legacy in public collections,[4] necessary for an objective evaluation of his achievements, is still incomplete. The reasons for this relative neglect are many. The rediscovery and scholarly investigation of German Expressionism began in the late 1950s, and by this time, unlike Schmidt-Rottluff and Heckel, Pechstein was dead. Consequently the chief documentary source for a study of his work, the artist himself, was no longer available.[5] In addition, even during Pechstein's lifetime there was a wide difference of opinion in evaluations of his work, and this has most probably influenced later judgments.[6] Finally, a vast amount of his work was lost or destroyed in the War or as a result of political persecution.

The collector and art historian Lothar Buchheim's consideration of Brücke sculpture refers to Heckel, Kirchner, and Schmidt-Rottluff, but not to Pechstein, who is treated exclusively as a painter and graphic artist.[7] However, contemporary scholars did not neglect this aspect of Pechstein's oeuvre.[8] In his memoirs, Pechstein wrote that while a student at the Dresden Kunstgewerbeschule, he participated in a competition on the occasion of the 1902 *Internationale Raumkunst-Ausstellung* and was awarded the prize for sculpture.[9]

Pechstein, who came from a family of craftsmen and was himself trained as one, saw no need for Kirchner's philosophical claim for the equal status of the fine and applied arts. This background also helps to explain why Pechstein devoted so much space in his memoirs to methods of fabricating objects, particularly in the detailed description of his 1914 visit to the Palau Islands. Pechstein made this journey "to look for Elysium in Palau" and to find the "unity of nature and man,"[10] but with the outbreak of World War I he curtailed his travels and returned to Germany. The artist considered his use of native sculpting tools to be essential, and acquired them specifically for utilitarian purposes from private ethnological collections and dealers. Pechstein took pleasure in the creative process and for him it was uncomplicated by theory; this does not facilitate the separation of his sculpture per se from related works of craftsmanship.

In Dresden and Berlin, Pechstein was just beginning his artistic career. He had married early, in 1911. His economic situation provided a practical motivation for creating his own furnishings and decorations, as well as a rationale for accepting work outside the strict boundaries of painting and graphic arts. This commercial work included murals, mosaics, stained glass windows, glazed tiles, painted wall coverings, and embossed works in precious and common metals.[11] His numerous pieces of metal and amber jewelry differ only in their smaller scale from those objects commonly referred to as sculpture.[12]

At present, approximately twenty sculptures by Max Pechstein can be identified in photographs and graphics. Most have been lost or destroyed. They can be divided on the basis of date and material into three groups of roughly equal size. A brief chronological note is of use here. In the fall of 1907, after having been awarded the Sächsischer Staatspreis für Malerei (Saxon State Prize for Painting), Pechstein traveled to Rome and then to Paris, where he stayed, with occa-

1. For the most comprehensive documentation available, see Reinhardt, 1977/78, pp. 204ff.*

2. Ibid., p. 155.*

3. The last major exhibition (including a catalogue) of Pechstein's paintings was sponsored in 1982, on the occasion of his hundredth birthday, by the Pfalzgalerie, Kaiserslautern.

4. Even in the Brücke-Museum, Berlin, which was established through Schmidt-Rottluff's endowment and augmented by Heckel's estate, Pechstein is not yet well represented.

5. A number of years ago the artist's two sons, Frank Pechstein (b. 1913) and Max K. Pechstein (b. 1926), began recording their personal knowledge of their father's life and art, as well as documenting it as the basis for eventual scholarly investigation. I would like to thank both of them for giving me important information and making documents available for this study.

6. Hentzen, 1959,* does not mention Pechstein. He was, however, included in the 1960 exhibition organized by Martin Urban; see Schleswig-Holsteinisches Landesmuseum and Museum für Kunst und Gewerbe, Hamburg, 1960.*

7. Buchheim, 1956, pp. 77ff.*

8. Friedeberger, 1913, pp. 760ff; Fechter, 1921, p. 45 (ill.); Heymann, 1916, illustrates two sculptures; Kuhn, 1921;* Osborn, 1922.

9. Pechstein, 1960.

10. Ibid., pp. 54ff.

11. Krüger, 1965.

12. Schleswig-Holsteinisches Landesmuseum and Museum für Kunst und Gewerbe, Hamburg, 1960.*

sional visits to Berlin, until the summer of 1908. His final move to Berlin probably did not take place until the spring of 1909.

The works of the first group date from 1908 to 1909; they were probably created by the time Pechstein moved from Dresden to Berlin, but after his travels to Rome and Paris. These sculptures were initially modeled in plaster and then cast in metal. Among them are a male bust and an acrobatic group consisting of three nudes.[13] Of this group the only piece which survived is the *Vase Carrier* (cat. no. 112), a relief made from the tin of discarded paint tubes. This work conveys Pechstein's intention to free himself in his sculpting from traditional techniques and to indulge his urge toward experimentation. The model for this relief was Pechstein's future wife, Lotte, then seventeen years old.[14] The motif of a person carrying a burden on the head, which occurs frequently in Pechstein's work, derived from his time spent in Italy; the light-catching and animatedly reflective surface with its Impressionist effect points to France and especially to Rodin's work. Rodin's influence is even more evident in other sculptures of this group, for example in a head of 1908 (fig. 1, p. 47). With creative results such as these, Pechstein proved himself to be a mediator between French elements and the art of the Brücke.[15]

The six identifiable sculptures of the second group all date from 1913. Pechstein's nude figures *Dancer* and *Female Dancer* (probably destroyed)[16] characterize the calculated attention which the Brücke artists brought to the study of the human body's form and freedom of movement.[17] Dance had played a central thematic role in Pechstein's work for many years. The two dance figures are Expressionist in their exaggerated motion. The Expressionist quality of *Runner* of the same year (probably destroyed) is focused in the figure's head, which is depicted at the moment of greatest strain. *Runner* is certainly the strongest piece among the sculptures of 1913, most of which were intended to be cast in bronze and are now lost.[18] In choosing bronze, a traditional material in Academic sculpture, Pechstein differed from his Brücke friends, who favored wood. Only one wood sculpture of his from 1913 is known – a head (fig. 2, p. 48) with magical, spellbinding features that for the first time betray Pechstein's earlier encounter with exotic sculptures in the Völkerkunde-Museum in Dresden. This wooden figure recurs in several of Pechstein's paintings. Its

distinct forms and metallike surface treatment further distinguish it from the contemporaneous wood figures of Kirchner and Heckel, with whom Pechstein had particularly close contact.[19] Closer to the Brücke style are *Mermaid* (1913; fig. 4, p. 49) and *Young Mermaid* (1917; fig. 5, p. 49). Two letters, both dated May 27, 1917, bear pen-and-ink drawings which depict the latter sculpture next to others also carved from marl and thus far unidentified (fig. 1, p. 170).

Five carvings of 1919 form a discrete third group. These sculptures are Pechstein's most direct and compelling transformations of Palau motifs. Because they were so heavily based on personal experience, their abstraction and individual adaptation did not go as far as Kirchner's and Schmidt-Rottluff's wood figures which had been inspired by similar models. The latter two artists were neither as impressed nor as bound by a knowledge of their figures' original significance and context as was Pechstein. He had not only acquired and used native tools, but had also used names common in Palau as titles for some of his sculptures – for example *Moon* (fig. 9, p. 50) and *Quarter Moon* (fig. 6, p. 49). He also carved furniture with the forms and motifs he had seen in the South Seas.[20] After 1919 there does not seem to have been another similarly productive period of concentrated sculptural work. Yet Pechstein did intensify his contact with sculptors such as Belling and Garbe, friends with whom he joined the Novembergruppe and the Arbeitsrat für Kunst in Berlin. Most probably Pechstein did create occasional carvings or sculpture – they often occur in his later paintings, drawings, and graphic works. But because he surrounded himself with sculptures, cult objects, and tools from the South Seas, it is often difficult to ascertain which works are from his own hand. – G.W.

|||

19. I am referring to their time spent together in 1910 at the Moritzburg lakes near Dresden and to the unsuccessful MUIM-Institut that Pechstein attempted to establish.

20. Cf. chest (destroyed) ill. in Osborn, 1922, p. 239.

|||

13. Documented in a photograph in Pechstein's estate.

14. Lotte also served as model for one of Kolbe's most famous sculptures, the *Female Dancer* of 1912 (Nationalgalerie, East Berlin).

15. Cf. Reinhardt, 1977/78, p. 142.*

16. Ill. Heymann, 1916, pl. 28.

17. Kirchner stressed this goal, which also was articulated by others, in the *Chronik der K[ünstler] G[emeinschaft] Brücke*, 1913.**

18. Fechter, 1921, p. 45.

Fig. 1
Letter from Pechstein to Herr
Kerstenberg, May 27, 1917.
Drawing includes the sculpture
Meerjunges (Young Mermaid);
see fig. 5, p. 49.

112

Cat. no. 112
Vase Carrier (Vasenträgerin),
1909
Tin relief
21 x 16 x 5 cm.
(8¼ x 6¼ x 2 in.)
Private Collection, Hamburg

Signed and dated. Osborn assigned a
date of 1908 to this work.

Cat. no. 113
*Self-Portrait with Idol and Nude
Figure / Self-Portrait in the Stu-
dio (Selbstbildnis mit Götzen
und Aktfigur / Selbstbildnis im
Atelier),* 1922
Woodcut
50 x 40 cm.
(19⅝ x 15¾ in.)
Private Collection, Hamburg
Not in Fechter

The figure of the idol, l. r. of com-
position, might well be one of Pech-
stein's own primitivistic pieces, per-
haps the now-lost *Moon* of 1919 (see
fig. 9, p. 50).

113

Scherer

Hermann Scherer

Born 1893 Rümmingen;

died 1927 Basel, Switzerland.

Any discussion of the work of Swiss artist Hermann Scherer inevitably leads to an examination of his complex relationship with Ernst Ludwig Kirchner. While Scherer was trained as a stonemason and created rather academic sculptures under the tutelage of Swiss sculptors Otto Roos and Carl Burckhardt, he cast aside this training when introduced to Kirchner's work in Basel in 1923. The large exhibition of Kirchner's paintings and graphics held in June of that year at the Kunsthalle Basel provided an opportunity for Scherer and the young Basel artists Albert Müller and Paul Camenisch to study and discuss Kirchner's work in depth. Scherer was so moved by it that in August he went to visit Kirchner, who had been living at Frauenkirch near Davos since 1918. The next year, Scherer created his first sculpture directly influenced by Kirchner; subsequent paintings and prints reflect Kirchner's style as well.

Scherer, Müller, and Camenisch visited Kirchner frequently over the next two years, forming the Rot-Blau group which they modeled on Die Brücke. Kirchner – who for years had dreamt of forming a school of artists with views similar to his own – was delighted by the excited response he found among these young artists. While the group lasted only a few years (cut short by the early deaths of Scherer and Müller), for a while it fulfilled Kirchner's hopes for a progressive artistic community. Kirchner commemorated Müller and Scherer in a life-size sculpture and in a large woodcut entitled *The Friends* (fig. 13, p. 128, and cat. no. 72; also see fig. 12, p. 128).

During his brief career, Scherer is known to have created over twenty wood sculptures; today almost all are extant. The subjects of these works are human figures in direct, emotional relationships – a mother and child, lovers, and friends – many of whom are depicted in startlingly primal postures. Kirchner wrote, "The woman that Scherer creates is neither a Venus nor a Madonna; she is a woman who, half bent over and looking around with the eyes of a mother, is taking a child across a shabby-looking street. She is a certain type of our time."[1] Compositionally, Scherer's works have a complexity generally absent from Kirchner's carvings; he was undaunted by large-scale groups of intertwined figures. In three sculptures, *Mother Nursing Child* (cat. no. 117), *Lovers*, c. 1926 (cat. no. 120), and *Sleeping Woman with Boy* (cat. no. 121), Scherer combined a reclining figure with another interwoven body. Although the positions and perspectives are awkward, Scherer managed to convey a sense of compressed space.

Lamentation (cat. no. 118) is Scherer's most ambitious sculpture, depicting a mother with her dead son

and mourning daughter. The smooth surfaces of this work, as well as those of *Sleeping Woman with Boy* and *Lovers*, c. 1926, were painted with eerie, lifeless, and unreal colors. These uncharacteristic yellows, greens, and oranges were applied to extremely naturalistic figures, creating a contrast that leaves a haunting image in the viewer's mind. Unlike much of Kirchner's and Müller's sculpture, which is rough-hewn and bears chisel marks, Scherer's sculpture has carefully smoothed and polished surfaces.

Not surprisingly, many of Scherer's sculptures are related to large, forceful woodcuts which depict similar subjects. *Lamentation* is represented in the woodcut *Self-Portrait with "Lamentation"* (cat. no. 119). The *Lovers* sculpture of 1924 (cat. no. 114, and fig. 2, p. 175), three-quarters life-size, is also directly related to a woodcut of the same title (cat. no. 116). The latter share a directness of approach; one feels that the artist attacked the wood with similar force in both the print and the sculpture.

At the April 1925 *Rot-Blau* exhibition at the Kunsthalle Basel, Scherer's sculpture appeared in great proliferation and made a very strong public impression. Although by this time Kirchner already had a large oeuvre of carved sculpture (though slight in comparison with his graphics and paintings), little of it had been seen publicly. Perhaps it was this *Rot-Blau* exhibition which prompted Kirchner's concern that his own sculpture would be overlooked. At this time he wrote to art historian Will Grohmann, "My friend de M. [Louis de Marsalle, Kirchner's pseudonym] reminds me that the time has come to publish my sculpture."[2] He was concerned that the work of the Swiss artists would become known without recognition of their inspirational source – his own sculpture. Immediately thereafter, under his pseudonym, Kirchner wrote an article in *Der Cicerone* that was the first extensive publication of his sculptural accomplishments (see translation included in this catalogue, pp. 43–46).

Unfortunately, the Rot-Blau group did not last long, for Müller died unexpectedly in 1926. That same year Scherer fell ill, and he died in May 1927. A memorial exhibition of his work was held at the Kunsthalle Basel in 1928. On the occasion of his death, Scherer was lauded in newspapers and periodicals by artists and critics, including Kirchner and the critic Georg Schmidt. – S.B.

||

2. Grisebach, [1968], p. 215;** also in Stutzer, 1981, p. 171.

||

1. Kunsthalle Basel, *Gedächtnisausstellung*, exh. cat., 1928, reprinted in Galerie Thomas Borgmann, Cologne, 1981, unpaginated.

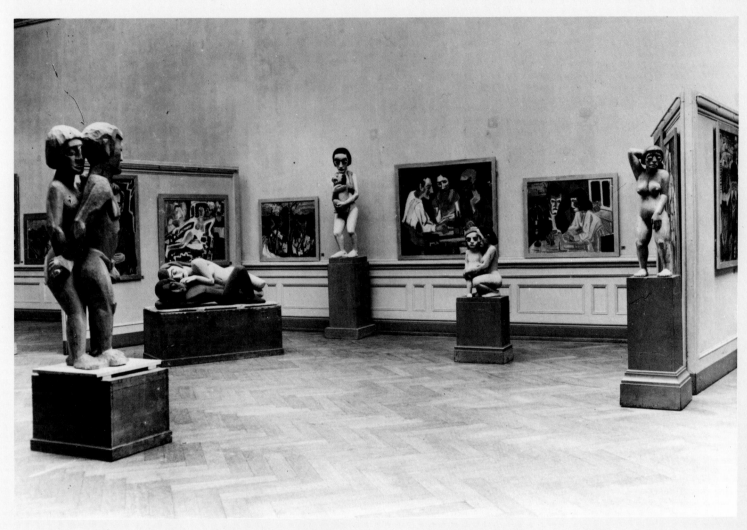

Fig. 1
Photograph of the *Jüngere Basler* exhibition, held at the Kunsthalle Basel, spring 1925, showing sculptures by Herman Scherer.

Cat. no. 114
Lovers (Liebespaar), 1924
Wood
h: 112 cm. (44 in.)
Collection Scherer, Efringen-Kirchen
Borgmann, 2

Cat. no. 115 (ill., p. 178)
Lovers (Liebespaar), 1924
Wood
66 x 22 x 23 cm.
(26 x 8½ x 9 in.)
Private Collection, Basel
Borgmann, 8

Cat. no. 116
Lovers (Liebespaar), c. 1924
Woodcut
84.5 x 54.5 cm.
(33¼ x 21½ in.)
Öffentliche Kunstsammlung Basel, Kupferstichkabinett

The mirror-image printing of the woodcut process reversed the position of the male and female figures in the sculpture being depicted, *Lovers* (cat. no. 114).

Cat. no. 117 (ill., p. 178)
Mother Nursing Child (Mutter Kind säugend), 1924
Wood
w: 70 cm. (27½ in.)
Collection Scherer, Efringen-Kirchen
Borgmann, 1

This photograph was taken by Kirchner.

Cat. no. 118 (ill., p. 176)
Lamentation (Totenklage), 1924–25
Painted wood
h: 166 cm. (65⅜ in.)
Collection Scherer, Efringen-Kirchen
Borgmann, 11

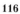

114

116

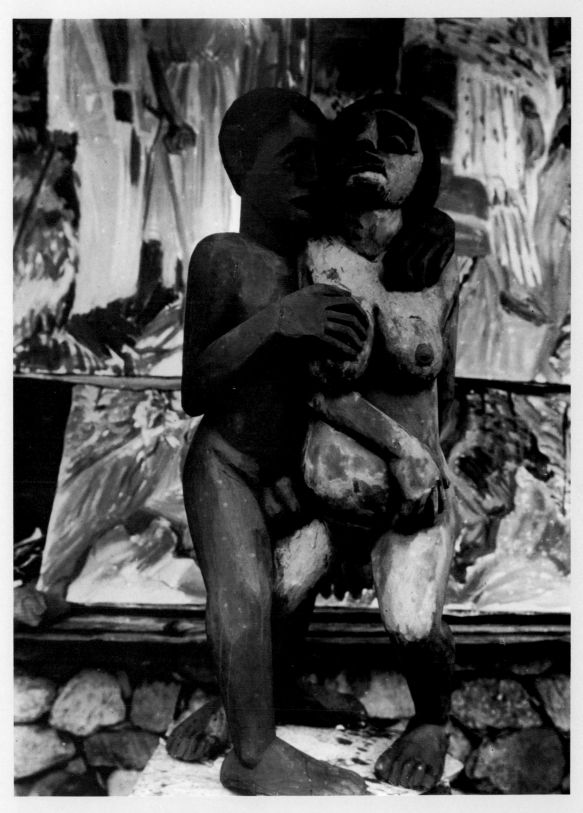

Fig. 2
Lovers (cat. no. 114), photograph by Kirchner.

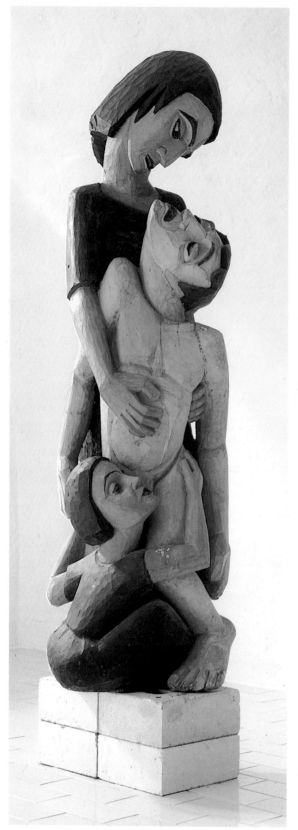

118

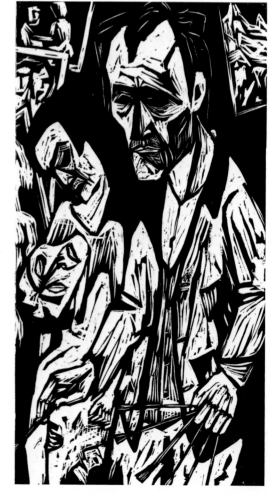

119

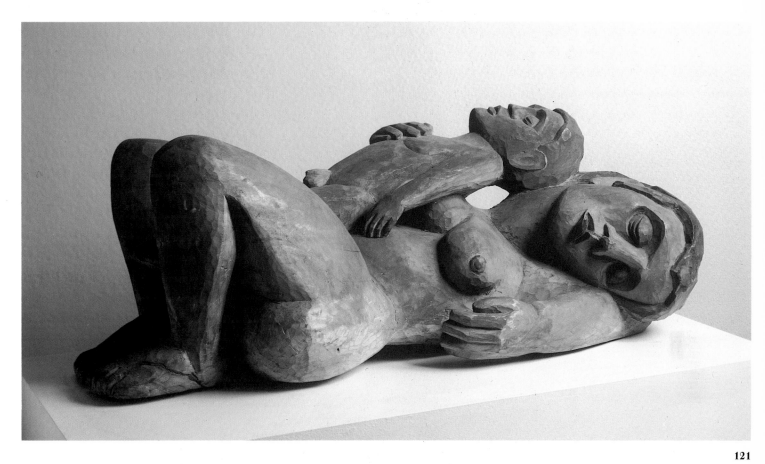

121

Cat. no. 119 (ill., p. 176)
Self-Portrait with "Lamentation" (Selbstbildnis mit "Totenklage"), c. 1924–25
Woodcut
63 x 44 cm.
(24¾ x 17⅜ in.)
Collection Scherer, Efringen-Kirchen

The scene, obviously the artist's studio, shows the upper portion of his sculpture *Lamentation* (cat. no. 118) amidst painted canvases.

Cat. no. 120
Lovers (Liebespaar), c. 1926
Linden, painted with tempera
54.5 x 125 x 51 cm.
(21½ x 49¼ x 20⅛ in.)
Öffentliche Kunstsammlung Basel, Kunstmuseum
Borgmann, 13

Cat. no. 121 (ill., p. 177)
Sleeping Woman with Boy (Schlafende Frau mit Knaben), 1926
Painted wood
50 x 135 x 5 cm.
(19½ x 53¼ x 2 in.)
Private Collection
Borgmann, 18

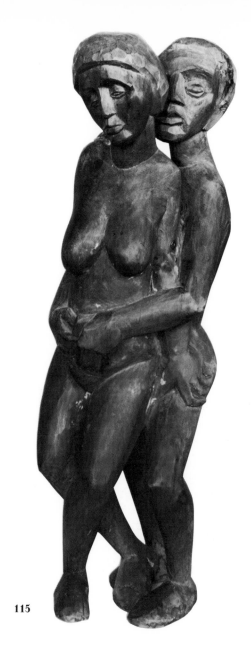

115

117

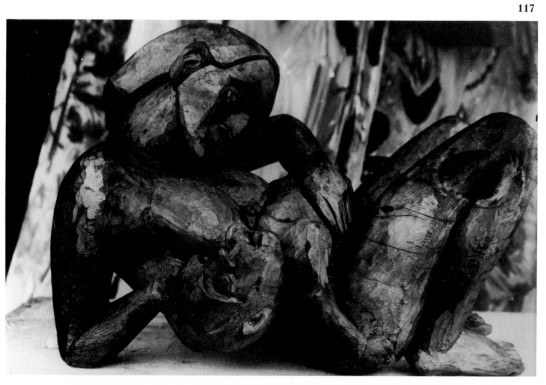

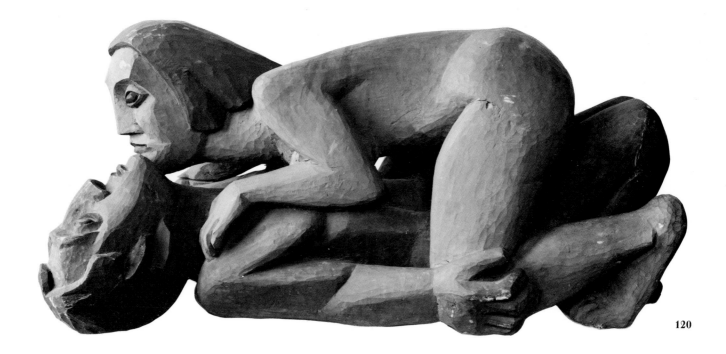

120

Schiele

Egon Schiele

Born 1890 Tulln, Austria;

died 1918 Vienna, Austria.

Egon Schiele belongs among those Austrian artists who made truly significant contributions to modern art after the turn of the century. Early in his career he exhibited frequently in Germany, gaining considerable recognition there. In 1916, the German journal *Die Aktion* devoted a special issue to him. Although by this time he had begun to sell some of his works to a small circle of admirers, his definitive success did not occur until the great 1918 exhibition of the Vienna Secession, where the central room was reserved for nineteen of his oil paintings. We will never know if this new stature might have occasioned a change in his view of man or the arts. He died at age twenty-eight – three days after the death of his pregnant wife – during the influenza epidemic of 1918 that devastated a hungry and exhausted Central Europe.

Most of Schiele's paintings and even more of his drawings and watercolors are dominated by line, which often acts as a border limiting his strong and freely employed colors. This line is fervent, nervously sensitive, and frequently abstract, without ever becoming physically inaccurate. The human figure was often placed within undefined or vacant space. The concentration on the body's form and gesture functions as a seismographic notation of the emotions and humanity of the model.

Schiele began studies at the Art Academy of Vienna in 1906, and the following year established a friendship with the artist Gustav Klimt, who was twenty-eight years his senior. At this time, Klimt was both a famous and, due to his expressively erotic works, an infamous artist. Recognizing Schiele's talents, Klimt introduced him to some of his own patrons, as well as advising him and encouraging him to break with the traditional academy after only three years of study.

In 1910, with some fellow students, Schiele founded the Neukunstgruppe (New Art Group), even writing a manifesto which proclaimed that "the new artist is and must be himself without reservations; he must be a creator, he must unreservedly – without recourse to the historical or acceptable – build the foundations [of the new art] entirely by himself."[1] This nonprogrammatic stance gained the group a few exhibitions, but ultimately made a rather negligible impact on the Viennese art scene. For a while Schiele worked for the Wiener Werkstätte, the famous Viennese design association which ushered in a new style in utilitarian objects, everyday clothing, and interior design.

Schiele left Vienna twice for short periods but found the provincial towns of Krumau and Neulengbach depressing and their inhabitants resentful of his lifestyle. He lived with his model, Valerie Neuzil, in Krumau and while in Neulengbach was falsely accused of seducing a minor. During this latter incident, the police confiscated some of his drawings as pornographic, and one of them was burned by the judge. Schiele was sentenced to twenty-four days in jail, but having already been detained for twenty-one, he had nearly served his time.

The unabashed and often shocking frankness with which Schiele depicted men and women as sexual beings brought him greater fame than did his large number of portraits. These portraits can be compared in the power of their psychological insight to those of the other great Austrian Expressionist, Oskar Kokoschka. The latter portrayed the intense individuality of his sitters using changing approaches and techniques, while Schiele invariably uncovered vulnerable, haunted personalities. This is particularly true of his many self-portraits, in which he accentuated mood by emphasizing harshly confrontational postures and masochistic forms which seem to border on self-flagellation.

All of Schiele's works challenged the society of the period. Contrary to the contemporary bourgeois ideal of an elegant, cleverly designed appearance, Schiele depicted man and woman as prisoners of their sexuality and demonstrated the loneliness of their existence. It was nearly impossible for the public of his time to recognize that his work was not voyeurism, but instead a brutally honest expression of what society tried to conceal beneath civility and silence. The Vienna of this era was, after all, the arena in which Sigmund Freud worked and lived and in which Otto Weininger published *Geschlecht und Charakter (Sexuality and Character)* in 1903, committing suicide shortly thereafter. Weininger had separated man and woman into irreconcilable opposites, and it is this strain in society that Schiele made visible.

Schiele created only one sculpture during his lifetime, a self-portrait (cat. no. 122). When compared with his drawn and painted self-portraits, this bust initially seems to lack their overwhelming strength, conviction, and near-brutality. The tilt of the head, the wide-open yet empty eyes, and the carefully shaped mouth present a self-image free from the strains so pronounced in his other self-portraits. The bust shows an openness new in Schiele's work that can only be partially explained by the difference in medium. Far removed from the driven, martyred images of earlier years – best exemplified in a 1914 drawing of himself as St. Sebastian – this sculpture with its upward gaze signifies a spiritual search and a new and more self-tolerant vision. It reveals Schiele's youthful death as an even more profound loss. – P.W.G.

1. Egon Schiele, "Die Kunst – Der Neukünstler," *Die Aktion,* vol. 4, no. 20, May 16, 1914, col. 428.

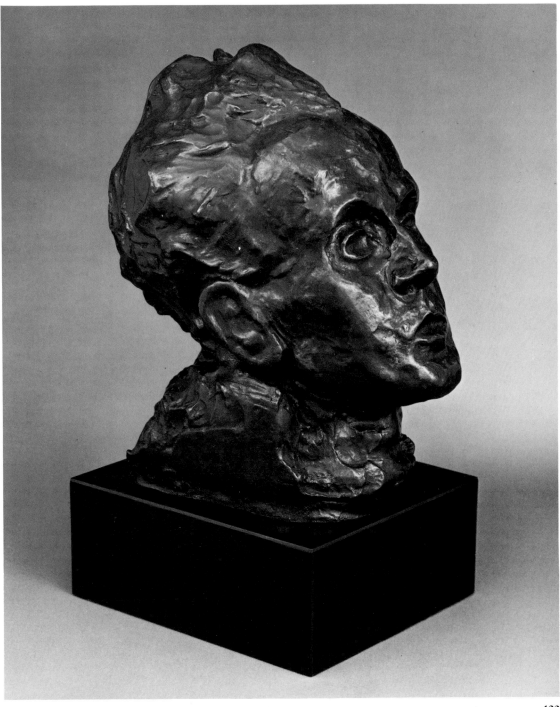

Cat. no. 122
Self-Portrait (Selbstbildnis),
c. 1917–18 / cast 1920s
Bronze
28.5 x 18 x 25.5 cm.
(11¼ x 7⅛ x 10 in.)
The Robert Gore Rifkind Collection, Beverly Hills, California

No inscription. An edition of 3 bronzes was cast in the 1920s and an additional 2 bronzes were cast in 1961. Both editions were taken from the plaster (*Gips*) now in the Historisches Museum der Stadt, Vienna. An edition of 7 stone casts was also executed. In 1980 an edition of 300 bronzes (measuring 26.5 cm. [10½ in.] in height and inscribed *Egon Schiele 1980*) was announced.

122

Schmidt-Rottluff

The art of Karl Schmidt-Rottluff, the youngest founding member of the Brücke, is rigorous and uncompromising. It was not intended to please, to meet the viewer halfway, or to be beautiful in any traditional sense. When asked about his artistic goals, the artist responded:

Karl Schmidt-Rottluff

Born 1884 Rottluff (Saxony);

died 1976 Berlin.

> Concerning myself I know that I have no program, only the inner longing to grasp what I see and feel and to find its purest expression. At this point I only know that these are things I come close to through art, not intellectually nor by means of the word.[1]

Before he became a painter, Schmidt-Rottluff, like most of his Brücke friends, had wanted to be an architect, and the laws and logic of construction came to figure centrally in his work. Sculpture, with its immediacy of material, has a definite and unshakable place in his oeuvre.[2] The distinction between fine and applied art was basically foreign to the Brücke artists,[3] and Schmidt-Rottluff in particular would have been the last to value his signature more highly on a painting or sculpture than on a carved and painted wooden chest, an amber pendant set in silver, or a napkin ring of ivory or horn.[4]

In 1913, in the *Chronik der K[ünstler] G[emeinschaft] Brücke*, Kirchner credited Schmidt-Rottluff with having made "the first lithographs on the stone," and the title page of the 1909 Brücke *Jahresmappe (Annual Portfolio)*, which was devoted to Schmidt-Rottluff, bore Kirchner's own woodcut of his reticent friend.[5] Nonetheless, Schmidt-Rottluff undoubtedly attained his greatest success as a graphic artist in his woodcuts,[6] which led him directly to wood sculpture. The colored relief with two female nudes of 1911 (Brücke-Museum, Berlin) can also be considered a wood block on the basis of its pictorial, flat composi-

tion.[7] The same might be said of the carved and colorfully painted wooden boxes, many of which the artist created during his summers at Dangast between 1907 and 1912.[8] Emma Ritter, the Oldenburg painter then staying with Schmidt-Rottluff, witnessed "a creative power and abundance I have never seen anywhere before," and she expressly records his "releasing of wood sculptures from large blocks."[9]

Yet it seems as if Schmidt-Rottluff – in contrast to Heckel or Kirchner – did not execute any truly three-dimensional figures before World War I. The heads created prior to that time retain the form of the original wood block. Simply cleaved from it, they are finished only frontally.[10] These faces, torn rather than carved out of the wood, bring to mind Schmidt-Rottluff's four embossed brass reliefs of the evangelists (1912, Brücke-Museum, Berlin), which were included in the Cologne *Sonderbund* exhibition.[11] A mask, now in the collection of the Schleswig-Holsteinisches Landesmuseum, is similar to them in material and technique, although it is even more stylized. During this period Schmidt-Rottluff's dialogue with Cubism and abstraction was less visible in his works that address the human figure than in the wooden and metal objects which he was prolifically creating. After returning from a 1911 stay in Norway – during which he probably encountered wood and stone as materials – he exhibited no less than fifteen wooden boxes adorned with colorfully painted carvings. In the aforementioned *Sonderbund* exhibition of 1912, he was the only Brücke painter who exhibited works of craftsmanship, specifically jewelry.[12] In the *Werkbund* exhibition of 1914 he exhibited a cabinet made to his specifications, as well as a small chest. One might say that Schmidt-Rottluff developed his ideas in painting and graphic arts and then expressed them in his sculptural work a few years later, achieving great success. His oeuvre of 1916 and 1917 alone justifies high praise when considered in the context of German Expressionist sculpture as a whole.

||

1. "Das Neue Programm: Antwort auf eine Rundfrage über künstlerische Programme," *Kunst und Künstler,* (Berlin), vol. 12, 1914, p. 308.

2. In 1956, Grohmann catalogued only thirteen sculptures by Schmidt-Rottluff (pp. 159 ff.; all ill.).

3. Both forms of creativity were combined in a Schmidt-Rottluff exhibition arranged by Max Sauerlandt in 1925 for the Museum für Kunst und Gewerbe in Hamburg. Cf. Max Sauerlandt, "Karl Schmidt-Rottluff – Ausstellung im Museum für Kunst und Gewerbe," *Hamburger Fremdenblatt,* June 11, 1925. The next comparable exhibition in which Schmidt-Rottluff was well represented did not take place until 1960 at the Schleswig-Holsteinisches Landesmuseum in Schleswig (see Schleswig-Holsteinisches Landesmuseum and Museum für Kunst und Gewerbe, Hamburg, 1960).*

4. Schmidt-Rottluff signed the major portion of his *Kunsthandwerke* and occasionally dated such pieces.

5. Dube, 706; ill. in Grohmann, 1956, p. 160.

6. See Wietek, 1971.

||

7. Color ill. in Westfälisches Landesmuseum für Kunst und Kulturgeschichte, Münster, *Reliefs: Formprobleme zwischen Malerei und Skulptur im 20. Jahrhundert,* exh. cat., 1980, p. 110.

8. Most of Schmidt-Rottluff's *Kunsthandwerke* are preserved in the Brücke-Museum, Berlin, and they are partly published in the 1977 catalogue of that museum. As far as other public collections are concerned, one may refer to the Museum für Kunst und Gewerbe in Hamburg and the Schleswig-Holsteinisches Landesmuseum in Schleswig.

9. As quoted in Landesmuseum für Kunst- und Kulturgeschichte, Oldenburg, *Maler der Brücke in Dangast von 1907–1912,* exh. cat., 1957, pp. 298–314.

10. Photographs of these works are in Rosa Schapire's estate.

11. Leopold Reidemeister, "Die 4 Evangelisten von Karl Schmidt-Rottluff und die Sonderbund-Ausstellung in Köln 1912," *Brücke-Archiv,* vol. 8, 1975–76.

12. Sonderbund Westdeutscher Kunstfreunde und Künstler, Cologne, *Internationale Kunstausstellung,* exh. cat., 1912, nos. 1258–60.

Approximately forty wood sculptures are extant today, although they were originally probably greater in number. These works date from an immensely creative period and may be seen as representing Schmidt-Rottluff's response to World War I:

I now feel strong pressure to create something as intense as possible. The War has swept away for me all that is past, all appears weak, and I suddenly see things in their awesome power. I never liked that sort of art which is a beautiful fascination for the eyes and nothing more, and I feel in an elementary way that one must grasp even more powerful forms, so powerful that they can withstand the impact of a people's lunacy.[13]

Although Schmidt-Rottluff never saw front-line duty, the pressure of the War is captured and concentrated in his sculptures. In 1916, he was transferred to the press department of Hindenburg's headquarters in Kovno, Russia,[14] where he was in the company of fellow painters Magnus Zeller and Hermann Struck, as well as poets such as Alfred Brust, Herbert Eulenberg, Arnold Zweig, and Richard Dehmel. Unable to paint during this period, the artist must literally have used every free moment to have created such a large number of sculptures. Birch, alder, and pine were obtained from the surrounding forests and worked with the most primitive tools. The significance of trees in Schmidt-Rottluff's work deserves considerable attention, for it is not only the wood itself with which he had such a close relationship, but with its original form.

More than a quarter of the documented sculptures from the War years are total figures (females and a few male nudes, as well as clothed figures), while the majority consists of heads and some masks. Typologically and psychologically, the heads are highly differentiated, although connections between them do exist. In several instances their closest relatives are to be found in Schmidt-Rottluff's graphic art. Wilhelm Niemeyer, the art historian and co-organizer of the *Sonderbund* exhibition, emphasized how wrong it would be to view these sculptures as simple transformations or even imitations of ethnographic, and in particular African, plastic art. In 1920, he wrote:

Not the content, but the deepest creative spirit of natural peoples is in Schmidt-Rottluff's art, which is entirely structural in form. In order to arrive at his purely spiritual creations, he completely breaks down the natural appearance into units of pure imaginative form and out of these units reconstructs the worldview as a structure of deep intimacy.... In dealing with all this, there is no talk of exterior, intended imitation; this affinity of form is an inner

harmony. A new feeling for the earth, which lifts European man above his narrower, more familiar artistic traditions, is at work here....[15]

With one exception, all of the sculptures in the present exhibition are from the War years, which were so decisive for Schmidt-Rottluff's plastic and graphic art. The *Green Head* (cat. no. 123) is the earliest piece, and in this sculpture we find the greatest tension between the fibrous wood, intact in its natural state, and the carving, which sharply defines the form. Of the two full figures in the exhibition, *Adoring Man* of 1917 (cat. no. 125) was created together with at least two male nudes that are variations on the same theme.[16] Their surfaces, appearing to be embossed, simulate metal. In fact, bronzes were cast from some of these wood sculptures – for example, a praying figure, which with a number of similar works has been lost.[17] In some of these figures, the hands and feet are missing, yet the basic rhythm of motion is unimpaired. Through this reduction, expressiveness is increased. The *Sitting Man* of 1917 (cat. no. 128) is one of Schmidt-Rottluff's strongest creations, and its hieratic severity is reminiscent of early Romanesque or Archaic sculpture. In such monumentally stylized heads as the *Green-Red Head* (cat. no. 127), Schmidt-Rottluff's work achieved its final formal appearance. As the artist wrote in a letter to Gustav Schiefler:

On various occasions I arrived at an intensification of forms which, to be sure, contradicts scientifically determined proportions yet in its spiritual dimensions is well balanced. In relation to other parts of the body, in many instances I increased the head to monstrous size – it is the gathering point of the whole psyche, of all expression. But all other parts of the body tend in their spiritual motions toward the head; they gather in it. Thus the form develops such large scale completely on its own. With breasts it is no different. They are an erotic moment. But I want to separate this from the flux of experience; I would like to establish a connection between the universal and what is of this earth. Perhaps one may say this is an eroticism intensified into the transcendental....[18]

The question of the relationship of Schmidt-Rottluff's sculpture to that of tribal art, briefly addressed above by Niemeyer, occasionally led during the artist's lifetime to exhibitions in which his works

||

13. Undated letter of 1914 to the lawyer Ernst Beyersdorff, who was one of the so-called "passive" members of the Brücke.

14. Cf. Hans Frentz, "Brücke im Krieg: Der Maler Schmidt-Rottluff und seine Gefährten," *Die Furche*, no. 14, April 5, 1958.

15. Niemeyer, 1921. Also see Gerhard Wietek, "Wilhelm Niemeyer und Karl Schmidt-Rottluff," *Nordelbingen*, vol. 49, 1979, pp. 112ff.

16. Grohmann, 1956, p. 280 (ill.).

17. See Schleswig-Holsteinisches Landesmuseum and Museum für Kunst und Gewerbe, Hamburg, 1960, no. 273 (ill.).* Also cf. Brücke-Museum, 1977, no. 99 (ill.).

18. Undated [1913] letter to Gustav Schiefler.

were juxtaposed with African art.[19] Such installations had the artist's approval. Schmidt-Rottluff, who surrounded himself with ethnographic objects and who frequently included them in his still lifes, could be assured that such proximity would only make obvious the great distinction between influence and original creation. Formal concerns and their possible sources were only one aspect of the phenomenon known as German Expressionism, in which content and conviction played a role of at least equal value. During the 1916–17 period in Russia, Schmidt-Rottluff had already begun to create his first religious graphic works, and his *Christ* cycle of 1918 constitutes a high point of Expressionist religious art.[20]

The art historian Rosa Schapire, with whom Schmidt-Rottluff had been friends since 1908, was the first to be concerned with his sculptures, and she planned to publish them after completing the catalogue of his graphic art in 1923.[21] Schapire personally owned the largest collection of his sculptures, and in 1921 Schmidt-Rottluff had decorated her Hamburg apartment with wall paintings, furniture, carpets, and other objects made either by him or according to his designs, as well as with his paintings and sculptures. If these rooms still existed, as Will Grohmann has rightfully stated, one would have to "transport them to a museum as a document of the artistic spirit of the time."[22] During the Second World War they were destroyed; Schapire was forced to emigrate to England, taking with her a large part of her art collection. Although she was unable to realize her plan to publish Schmidt-Rottluff's plastic work, some of the sculptures went to other private collections or were returned to the artist, who had lost most of his own work. Shortly before her death, Schapire instigated an exhibition of Schmidt-Rottluff's art at the museum in Leicester, England, which included recent stone carvings.[23] Although few people in Germany were then familiar with the artist's work, the British art historian A. C. Sewter recognized the carvings of the early 1950s as representing "a post-war development of Schmidt-Rottluff's work...more primitive and more calm in effect than most of his earlier creations. Vaguely reminiscent both of Gauguin's sculpture and of early Mexican carvings, they nonetheless have a distinctive character and an appealing simplicity and vitality."[24] In

Schmidt-Rottluff's later years, he maintained an Expressionist style far longer than any of his fellow Brücke artists who survived the Second World War. The stone carvings constitute a second phase of intensive occupation with plastic and craftsmanlike tasks, one which is not inferior to the earlier period. Throughout his oeuvre, Schmidt-Rottluff's paintings and graphics were strongly interconnected with the sculptural and craftsmanlike works, and these mutual interpenetrations await further research. – G.W.

19. The first such juxtaposition occurred in the exhibition of the Kestner-Gesellschaft, Hannover; see the exhibition catalogue *Schmidt-Rottluff und Negerkunst*, 1920.

20. Cf. Wietek, 1971, pp. 163ff.

21. Wietek, 1964.

22. Grohmann, 1956, p. 47.

23. Leicester Museum and Art Gallery, 1953.

24. Sewter, 1953.

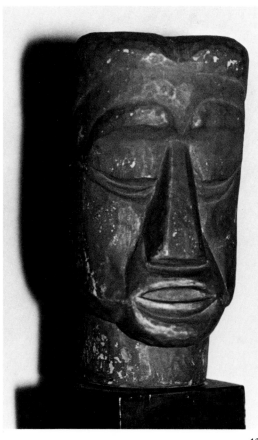

124

128

Cat. no. 123 (ill., p. 187)
Green Head (Grüner Kopf),
1916–17
Polychromed alder
h: 41 cm. (16⅛ in.)
Schleswig-Holsteinisches
Landesmuseum, Schloss
Gottorf in Schleswig
Not in Grohmann

Cat. no. 124
*Red-Brown Head (Rot-
brauner Kopf),* 1916–17
Painted wood
h: 17.6 cm. (6⅞ in.)
Private Collection, West
Germany
Not in Grohmann

Cat. no. 125 (ill., p. 187)
Adoring Man (Adorant), 1917
Painted wood
h: 37.5 cm. (14¾ in.)
Private Collection, Hofheim
Not in Grohmann

Cat. no. 126 (ill., p. 187)
Blue-Red Head (Blauroter Kopf),
1917
Stained wood
h: 30 cm. (11¾ in.)
Brücke-Museum, Berlin
Grohmann, p. 280, ill.

Cat. no. 127
Green-Red Head (Grün-roter Kopf), 1917
Painted wood
h: 41 cm. (16⅛ in.)
Brücke-Museum, Berlin

One of at least 2 Schmidt-Rottluff sculptures known as *Green Head (Grüner Kopf)*.

Cat. no. 128 (ill., p. 185)
Sitting Man (Sitzender Mann), 1917
Painted wood
62 x 17 x 19 cm.
(24½ x 6⅝ x 17½ in.)
Stedelijk Museum, Amsterdam
Grohmann, p. 280
(Los Angeles only)
Ex-coll. Dr. Rosa Schapire, Hamburg

Cat. no. 129
The Mourner (Trauernder), 1920
Wood, stained green
80 x 36 cm.
(31½ x 14⅛ in.)
Brücke-Museum, Berlin
Grohmann, p. 239, ill.

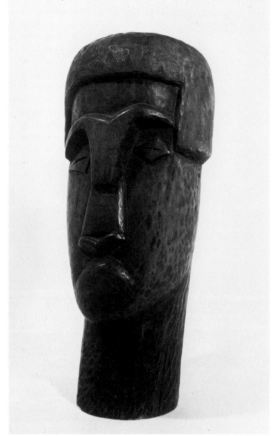

127

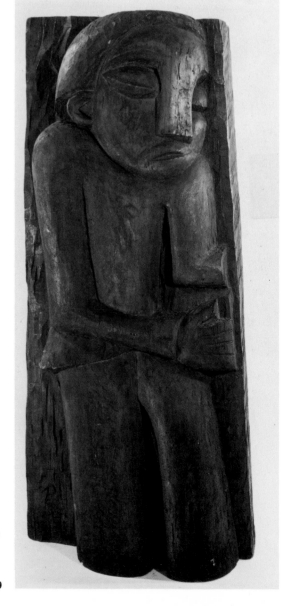

129

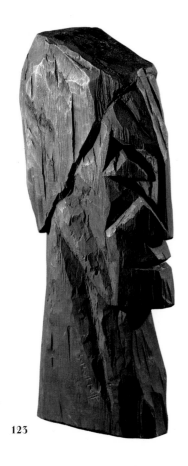

123

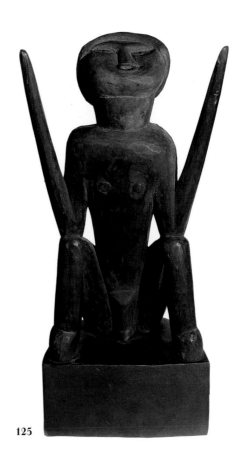

125

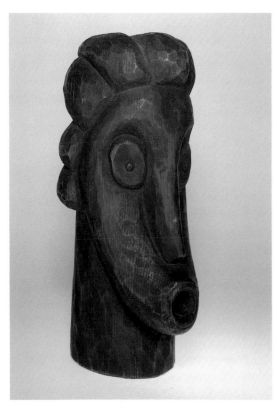

126

Schwichtenberg

Martel Schwichtenberg

Born 1896 Hannover;

died 1945 Sulzburg (Baden).

Although the painter Martel Schwichtenberg was one of the best-known German artists of the period between the wars, her work and achievement currently await rediscovery.[1] In both her life and her art, she was a prototype of the Golden Twenties. Her father, a petty civil servant, having died young, Schwichtenberg was raised by her mother, who arranged for her to receive private art instruction in Hannover. She began formal studies in 1914 in Düsseldorf, first at a private school and then at the Kunstgewerbeschule, where she studied under Wilhelm Kreis, one of the most important German architects of his generation. At this time she published her first woodcut series, *Cinnabar*, which already reveals the influence of Futurism. Her first one-person exhibition was held in Hagen, Westphalia, in 1915, followed by another at the Folkwang Museum, Hagen, where she met its founder, Karl Ernst Osthaus, as well as artists active in that area such as Henry van de Velde, Christian Rohlfs, and the sculptor Milly Steger. It was here that she may also have met Bernhard Hoetger, with whom she worked at the Bahlsen cookie factory in Hannover, beginning in 1917.[2] Liberally sponsored by the company's owners, art lovers who favored modern marketing techniques, Schwichtenberg's employment at Bahlsen provided her with permanent economic support. She designed the Bahlsen trademark, which is still in use today, containers, and posters, as well as creating murals and large windows for the factory itself. The extent of her participation in Bahlsen's TET-city plan, a collaboration with Hoetger that failed due to inflation and Hermann Bahlsen's death, must still be clarified. Woodcuts which appear to have been executed by Schwichtenberg and are included in her estate extended this realistic construction project into utopian dimensions.

Schwichtenberg spent the summers of 1918 and 1919 at the artists' colony in Worpswede near Bremen, where the natural lyricism of her early years gave way to a revolutionary socialist phase.[3] In 1920, she acquired a studio of her own in Berlin, at that time an intellectual, artistic, and social center, and adopted the city's demanding fox-trot rhythm. Courted by literary

men, including Johannes R. Becher,[4] in 1920 she married the painter Robert W. Huth, who was particularly influenced by Schmidt-Rottluff's monumental Expressionism. During this short marriage, the couple spent the summers of 1921 and 1922 near Schmidt-Rottluff's house in Pomerania, and Schwichtenberg also came under his influence. This influence is documented in the six lithographs of the *Aus Pommern (From Pomerania)* series as well as in the two wood reliefs discussed below.[5] During the winter months, Schwichtenberg made the acquaintance of many artists, including Nolde, Otto Mueller, Pechstein, Archipenko, and Belling, but her closest friendship, which began in 1920, was with art historian William Valentiner and his wife. In 1923, the three traveled to Italy, where against the background of the clear architectonics of the Italian landscape, Schwichtenberg's individual style emerged – an unshaded and colorful Neue Sachlichkeit.

During the following decade Schwichtenberg determined, particularly with her portraits, the atmosphere of Berlin's numerous art exhibitions prior to the Hitler era. She had personal and reciprocal relationships with those who commissioned her work – including Valentiner, Barlach, the actress Tilla Durieux, and art dealer Alfred Flechtheim. Flechtheim, for example, displayed her work alongside that of Marie Laurencin and Sintenis, creating in this exhibition a harmony in which the various sounds retained their individuality. Schwichtenberg's close circle of friends was made up primarily of writers such as Walter Hasenclever, René Schickele, and Colette, some of whom she had met during her extended friendship with publisher Kurt Wolff.

When the National Socialists assumed power, Schwichtenberg emigrated by way of Italy to South Africa, whose landscape and people fascinated her and inspired numerous watercolors. Unfortunately most of these, along with her other belongings, burned in a 1938 fire that destroyed her Johannesburg home. At the beginning of 1939 she accepted an invitation from the Valentiners, who had emigrated, to join them in the United States.[6] But in August of that same year, she decided to return to Germany, where the outbreak of the War took her freedom of choice from her. After spending the first winter of the War in Berlin, she took

||

1. Apart from short entries in artists' dictionaries and the like, no detailed appreciation of Martel Schwichtenberg exists thus far. Biographical data provided here is based on the artist's manuscript *Mein Leben*, which was written in abbreviated fashion shortly before her death and left to her friend, the art historian Hans Hildebrandt.

2. *Hermann Bahlsen: Festschrift zum 75jährigen Bestehen*, Hannover, 1969, pp. 62, 153ff.

3. Cf. Wietek, 1976, pp. 100ff. (see contribution by K. V. Riedel).

4. Johannes R. Becher, who began as an Expressionist, joined leftist-radical movements as a young man. After his return from the Soviet Union in 1954, he became East Germany's state secretary of cultural affairs and author of its national anthem. See Becher, 1920.

5. Published in 1923 by the Kestner-Gesellschaft in Hannover as the fourth in their famous graphic series, following works by El Lissitzky, Schmidt-Rottluff, and Max Kaus. Ill. Wieland Schmied, *Wegbereiter zur modernen Kunst: 50 Jahre Kestner-Gesellschaft*, Hannover: Fackelträger Verlag, 1966, p. 297.

6. In 1930, Schwichtenberg had participated in Valentiner's exhibition *Modern German Art* at The Harvard Society for Contemporary Art, Cambridge, Mass. (April–May).

refuge in the Black Forest, moving from place to place. At the beginning of this period she painted landscapes and, toward the end, still lifes of her immediate surroundings. Though mortally ill, she nonetheless invented a new graphic process. A few months after the end of the War, Martel Schwichtenberg died before reaching the age of fifty. She bequeathed her estate to Eva Klinger, a friend of many years, and to her husband.[7] It then passed into the custody of the Schleswig-Holsteinisches Landesmuseum, which is still engaged in the scholarly investigation of it. The legacy, which has been augmented by the Klingers, is an important one.[8]

There are few sculptural works in Schwichtenberg's oeuvre. The catalog of her 1922 exhibition at the Galerie Ferdinand Möller in Berlin lists three wood reliefs, in addition to twenty-five paintings, nineteen watercolors, and numerous drawings and graphics. The reliefs – *Self-Portrait* (cat. no. 130) and the two reliefs entitled *Pomeranian Women* (figs. 1 and 2, p. 191) – are perhaps the artist's only works which may properly be considered sculpture, and even these are close to woodcuts in technique. Schwichtenberg had become familiar with the latter process at an early age, and she created a total of approximately forty woodcuts. The *Self-Portrait,* part of the estate now owned by the Schleswig-Holsteinisches Landesmuseum, is the smallest of the three panels, each of which is carved from a thick wooden board and occasionally brightened with red color. Self-depictions play an important role in the artist's work, and the signature carved at the lower right seems to confirm that this is indeed a self-portrait.[9] Stylistic considerations indicate that this work originated no later than 1920, when Schmidt-Rottluff's influence was not yet dominant, and the artist was still close to her collaborative work with Hoetger. The preservation of large planes, the concave differentiation of forms, and the occurrence of unexpected ornamentalism are reminiscent of Hoetger's brick reliefs, in which he broke his Jugendstil ties and drew closer to Expressionism,[10] a transition which in Schwichtenberg's case was less abrupt. The *Pomeranian Women* reliefs, acquired in 1972 by the Altonaer Museum in Hamburg,[11] were probably created later than the *Self-Portrait.* Published in 1921,[12] they already revealed Schmidt-Rottluff's influence. The three reliefs are not necessarily related to each other; created for their own sake, they are intended as autonomous pictures which require individual frames. – G.W.

||

7. Cf. Klinger, 1976, pp. 148ff.

8. Cf. Schleswig-Holsteinisches Landesmuseum, 1981, pp. 27ff.

9. Ibid., pp. 180, 183.

10. Cf. C. W. Uphoff, *Bernhard Hoetger,* Junge Kunst, vol. 3, Leipzig, 1919.

11. Knupp, 1972, p. 148.

12. Wilhelm Niemeyer and Rosa Schapire, eds., *Kündung – eine Zeitschrift für Kunst,* ser. 1, no. 9/10, September / October 1921.

Cat. no. 130
Self-Portrait (Selbstbildnis),
c. 1920
Painted wood relief
35 x 32.5 cm.
(13¾ x 12¾ in.)
Schleswig-Holsteinisches
Landesmuseum, Schloss
Gottorf in Schleswig

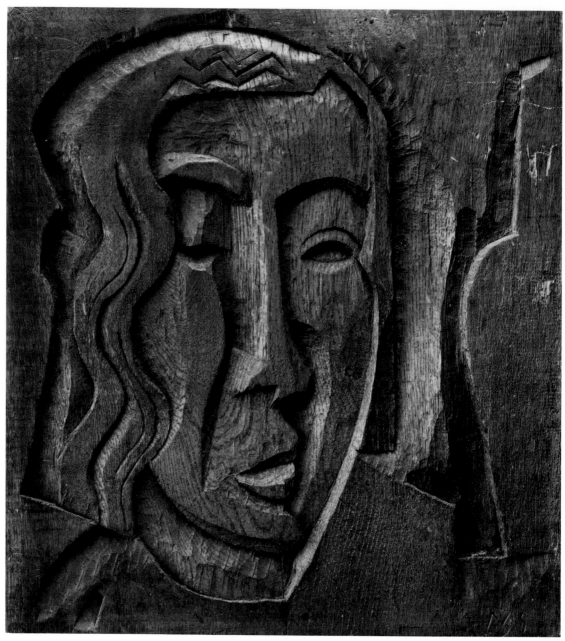

130

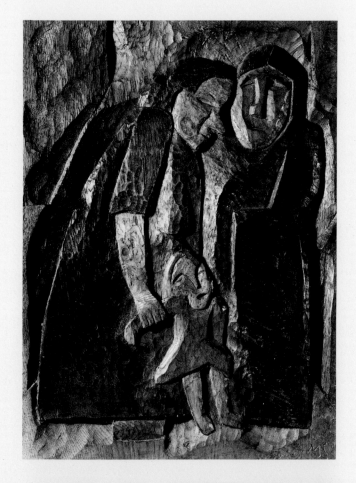

Fig. 1
Pomeranian Women (Pommern-frauen), c. 1921
Oak relief, lightly tinted
45 × 32.2 × 2 cm.
(17¾ × 12⅝ × ¾ in.)
Altonaer Museum in Hamburg

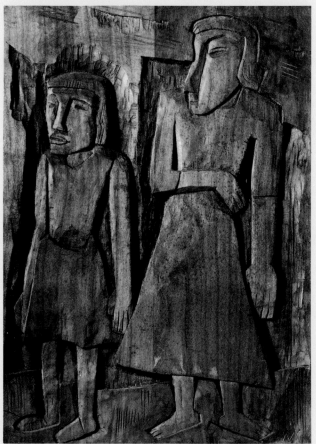

Fig. 2
Pomeranian Women (Pommern-frauen), c. 1921
Fruitwood relief, lightly tinted
43.5 × 30.5 × 2 cm.
(17⅛ × 12 × ¾ in.)
Altonaer Museum in Hamburg

Seiwert

Franz Seiwert

Born 1894 Cologne;

died 1933 Cologne.

The works of Franz Seiwert, an important but little-known graphic artist, painter, and sculptor, clearly demonstrate the writer Ivan Goll's assertion that Expressionism was not "the name of an artistic form but that of a belief, a conviction."[1] Seiwert was one of the most politically active of the Expressionists. A strong and faithful Catholic who had attacked the church for failing to prevent the horrors of World War I, he belonged to a number of antiwar groups, particularly that centered around Franz Pfemfert and his journal *Die Aktion* in Berlin. Later Seiwert became a member of the Anti-Nationale Sozialisten Partei (Anti-National Socialist Party) and was a close friend of Ret Marut, the editor of the radical journal *Der Ziegelbrenner (The Brick-maker).* (Marut is better known as B. Traven, the nom de plume he adopted after his participation in the Munich revolution and subsequent flight to Mexico.)

Seiwert himself wrote a great number of articles for various political and artistic journals, and like so many "second-generation" Expressionists, he demanded a new didactic art capable of communicating its message to the masses. He opposed the self-glorification of artists; gallery promotions; aesthetic criticism; and the practices of the art trade in general. With a group of friends he formed the Gruppe Progressiver Künstler (Group of Progressive Artists) in the early twenties, and in 1929 he became cofounder and editor of the radical journal *a–z,* which existed until 1933. His political activities were uniformly pacifist and socialist, based upon his strong religious convictions.

Seiwert studied at the school of the Rautenstrauch-Joest-Museum in Cologne from 1913 to 1915, and he worked for an architect prior to beginning independent work as an artist in 1916. His earliest works were graphics (wood and linoleum cuts), many of which were published in *Die Aktion.* From 1917 to 1919, he published a number of woodcut portfolios, the first of which consisted of seven works appearing under the title *Sieben Klänge zum Evangelium Johannis (Seven Sounds for the Gospel of John).* These early graphics do not differ greatly in form from the idiom prevalent in most contemporary Expressionist journals.

When Seiwert began to paint around 1919, he quickly developed a very different style. He abbreviated the human form into a deindividualized, static type. Faces became masklike, bodies flat and stylized, and space was indicated by the overlapping of forms. Most, if not all, of Seiwert's paintings express his strong social concerns. It was only logical that he would ultimately extend this same formal canon to his graphics, and the power of these human hieroglyphs became even more obvious when he employed them in advertising and exhibition design. During this same

||

1. Ivan Goll in an article on the "death" of Expressionism written for the Yugoslavian journal *Zenit,* vol. 1, no. 8, 1921, p. 9.

period, Seiwert also painted a number of abstract compositions which retain his characteristic orderly, nearly geometric approach.

Seiwert was acquainted with many artists during his lifetime, among them Max Ernst. This friendship faded in 1919, however, when Seiwert recognized that the Cologne Dadaist did not share his social concerns. In contrast, the friendships he formed with the painter Heinrich Hoerle and with Freundlich, both of whom shared his political and social convictions, were especially important to him. It was undoubtedly Freundlich who encouraged Seiwert to begin to sculpt, and many of Seiwert's three-dimensional works were made during Freundlich's stay in Cologne. Seiwert, in turn, influenced several younger artists, among them Gerd Arntz and August Tschinkel, who later transformed Seiwert's painting style into the graphic forms employed to develop the first successful visual presentation of statistics (known as the Vienna Method of Pictorial Statistics).

Seiwert's sculptural work is unique in his oeuvre for its relative lack of political content. Constantly changing his approach to the three-dimensional form, Seiwert made approximately sixty sculptures, mostly in a small format. Few of them are extant, and very few can be securely dated. These works consist of highly imaginative heads, a few figures characterized by strongly expressive gestures, and some Constructivist compositions. The small *Head of Christ* (cat. no. 131) conveys an expression of suffering which seems due in part to the artist's obvious struggle with the clay medium. The head is tilted to the right; the face is elongated, and this elongation is accentuated by the wavy forms of the hair and beard. The crown is iconographically indistinct, but it enhances the dignity of the head. It is well known that Seiwert was deeply moved by the Medieval sculpture found in many Cologne churches, and the angle of this particular head recalls that often seen in Medieval sculptures of saints, where it was used to indicate mourning or suffering.

The Caller I of 1919 (cat. no. 132) is one of Seiwert's few sculptures dominated by a single, strong gesture. Leaning slightly backward, the figure has cupped his hands around his mouth to give additional volume to his call. Conventionally dressed in trousers and jacket, he was assigned no indication of social status, and the extremely abbreviated facial features make his age difficult to ascertain. His legs are placed slightly apart, emphasizing the urgency of his call. This increases the symbolic import of this sculpture, which suggests a rallying cry addressed to the Expressionists during this period of revolution.

Seiwert's friendship with Freundlich and the encouragement of the older and more experienced sculptor undoubtedly influenced the *Head* of about 1919 (cat. no. 133). Its form is related to Freundlich's masks of 1909–12. The elongated and slightly undulating head is an extreme abbreviation and has roots in the ancient or ethnographic art which stimulated younger artists at this time. The nose ridge recalls Cycladic sculpture, joining the two deep hollows of the

eyes and ending in a tight, small mouth. The *Head* is a hierarchic, haunting image of man's confrontation with life; its abstraction prevents any precise definition of underlying emotions. It shows a greater mastery of the medium and a far more advanced sense of three-dimensionality than is seen in the *Head of Christ.*

The *Large Head with Open Mouth* (cat. no. 134) appears as a further step toward a concept of "man" which is so abstract that the head alone is capable of representing his very being. Here the open mouth evokes less a cry of strength and urgency (cf. *The Caller I*) than one of pain and suffering. Contrary to the hierarchic and meditative *Head,* this work articulates the theme of man's vulnerability introduced by the earlier *Head of Christ.*

Only a photograph of the plaster model of the sculpture entitled *Worker* of about 1925 (Bohnen, 393, 394) remains. (A variation of the same figure is extant, however, as a wooden replica in the collection of Professor Kubicki, Berlin.) In this sculpture, Seiwert most closely approximated a three-dimensional translation of the figures seen in his paintings. The degree of stylization permits the viewer to describe the work as an idol. Another sculpture meriting special attention is Seiwert's memorial for his mother (stone, 1929, Nordfriedhof Köln; Bohnen, 397). Based on Brancusi's famous *Kiss* for the grave of Tanosa Gassevskaia (1910, Cimetière Montparnasse, Paris), Seiwert's sculpture modified its source into a flat relief which articulates his concern with geometric order.

Within the development of Expressionist sculpture, Seiwert's works are important examples of the continuous effort made by a very talented artist to perfect an additional medium of expression. Seiwert was occupied with sculpture for only a limited period during his artistic career, the years between 1916 and approximately 1926 (the aforementioned memorial of 1929 is an exception, but Seiwert only made the model for this work and left the execution to a stonemason). These plastic works as a whole are of less significance as Expressionist accomplishments than as examples of Seiwert's search for new forms.

Seiwert died in 1933 of an X-ray burn, which he had sustained at the age of seven and suffered from all his life. His death came just before the Nazis could destroy his work and, in all probability, the artist himself.
– P.W.G.

131

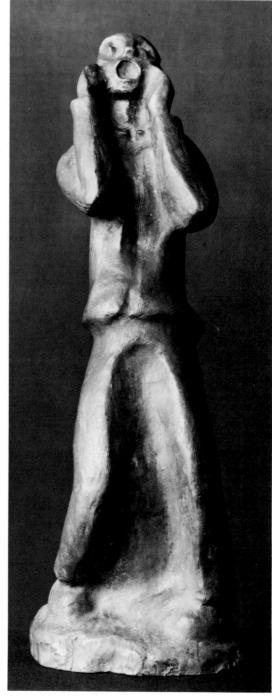

132

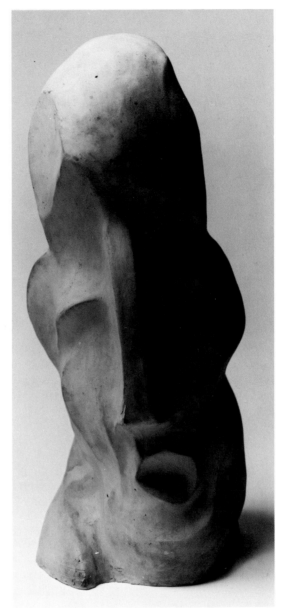

Cat. no. 131
Head of Christ (Christuskopf),
c. 1916–17
Terracotta
h: 27 cm. (10⅝ in.)
Museum Ludwig, Cologne
Bohnen, 342

Cat. no. 132
The Caller I (Der Rufer I), 1919
Bronze
h: 42 cm. (16½ in.)
Museum Ludwig, Cologne
Bohnen, 352

Two versions in fired clay exist in
German private collections. *The
Caller II (Der Rufer II),* fired clay
(Bohnen, 353), is lost.

Cat. no. 133
Head (Kopf), c. 1919
Plaster *(Gips),* painted
h: 35.5 cm. (14 in.)
Kamiel and Nancy Schreiner,
Amsterdam, The Netherlands
Bohnen, 357

Cat. no. 134
*Large Head with Open Mouth
(Grosser Kopf mit offenem
Mund),* c. 1920
Fired and stained clay
38 x 18 x 18 cm.
(15 x 7 x 7 in.)
Private Collection, Cologne
Bohnen, 369

134

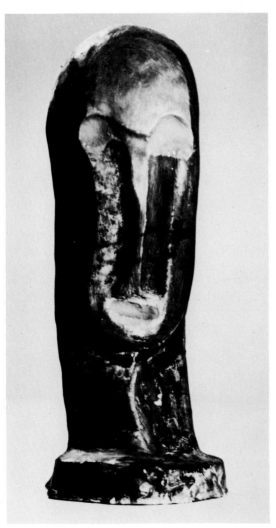

133

Sintenis

Renée Sintenis

Born 1888 Glatz (Silesia);

died 1965 Berlin.

In 1908, at age twenty, Renée Sintenis began her artistic training at the Kunstgewerbeschule in Berlin, where she studied portrait painting under Leo von König and then sculpture under Wilhelm Haverkamp. Early in her career she made sculpture her primary commitment and adopted a style and choice of motifs that were to become her trademark. The majority of her work is not Expressionist in character; there are many examples of small, delicately modeled bronzes, often portraying young animals at play or at rest. Her sentimental treatment of the leggy, often awkward, stances of such beasts brought her an invitation to exhibit in 1915 with the Berlin Secession. This opportunity, no doubt, led her into association with important members of the Berlin art circle, including Barlach, Kolbe, Lehmbruck, and Ernesto de Fiori. Her early works won the acclaim of Rainer Maria Rilke. This famous poet, who had served as Rodin's secretary and been associated with the Worpswede artists' colony, became a patron to the young Sintenis and introduced her to important contemporary literary figures. Her work excited a great deal of attention, and she was included in Alfred Hentzen's important publication, *Deutsche Bildhauer der Gegenwart* of 1934,[1] as well as being represented in the seminal 1931 exhibition held at The Museum of Modern Art in New York – *Modern German Painting and Sculpture.*

Sintenis' oeuvre of basically sentimental animal figures was punctuated by her most important large-scale commission, *Daphne* (cat. no. 135), which marks an exceptional moment in her career. A small bronze maquette, *Small Daphne,* created over a decade earlier in 1918, served as its prototype. A continuing thread of interest in subjects from Greek mythology can be traced throughout Sintenis' career. Here the legend of Daphne, as related in Ovid's *Metamorphoses,* served as an inspiration. Desperate to escape Apollo's sexual advances, the virgin nymph Daphne invoked her father, Peneus, a river god, who transformed her into a laurel tree.

> No sooner had she finished this prayer then a deep lethargy seized her limbs, her tender breasts were covered over by a delicate bark, her hair grew out in leafy sprigs, her arms in branches, and her swiftly fleeing feet were held fast by sluggish roots.[2]

In this work, Sintenis captured Daphne's transition from woman to tree. The attenuated body has begun to lose its human proportions. An extremely slender form has superseded any reference to human physical breadth. Knees, elbows, and breasts have become

gnarled, and hair is represented by soaring, flamelike leaves. The angular silhouette describes changes typical of the direction and growth observed in a tree's trunk and branches; the woman's limbs no longer carry the promise of their anatomical function. (The Daphne legend had also inspired Lehmbruck's *Female Torso* of 1918 [cat. no. 95]. Lehmbruck's anatomical distortions, however, are even more pronounced than those of Sintenis.)

Sintenis' *Daphne* was commissioned by Carl Georg Heise, director of the Museum für Kunst und Kulturgeschichte, Lübeck, for the museum's sculpture garden. At the museum, the piece was installed in close proximity to a tree standing on the border of the neighboring property, in such a manner that the work's raised arms merged with the tree's upper branches. Four casts of the sculpture were made. The version at Lübeck was the only one in the edition to be gilded. A year after Sintenis created *Daphne,* Heise commented on the significance of the step she had taken:

> The art of Sintenis has been called precious and there has been an attempt to confine her to the salon. But without losing any charm she here enters the demanding realm of "free sculpture" in a presentation of a work of outwardly enlarged measurements – Daphne, two-thirds life-size. Thus she most conspicuously reveals her nature, which is not one of playful daintiness but of the true grace that arises from mature mastery.[3]

In the remainder of her oeuvre, Sintenis concentrated largely on male athletes and animal figures. Her *Self-Portrait* of 1933 (cat. no. 136), however, is another unusual example of her potential for expression. The self-portrait was explored by a significant number of German Expressionist sculptors. Sintenis' treatment of the three-dimensional volume was radical; she presented herself literally as a mask, as if the face had broken free from the head. The androgynous quality of the face and the attention to the signs of age conveyed in the mottled surface are Expressionist in sensibility.

Sintenis was nominated to the Berlin Academy in 1947, where as a professor she enjoyed considerable popularity until 1955. She died in 1965 in Berlin, relatively forgotten after a decade of secluded retirement. – S.P.

||

3. Heise, 1931, p. 72.

||

1. Hentzen, 1934, pp. 60–62.*

2. Satia and Robert Bernon, *Myth and Religion in European Painting: 1200–1700,* New York: George Braziller, 1973, p. 79.

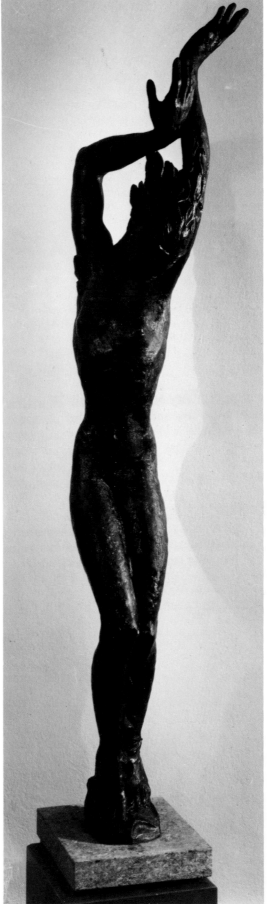

Cat. no. 135
Daphne (Daphne), 1930
Bronze
h: 145 cm. (57 in.)
a) The Museum of Modern Art,
New York (Los Angeles and
Washington only)
b) Museum Ludwig, Cologne
(Cologne only)

A smaller bronze version, *Small
Daphne (Kleine Daphne)*, 1918,
is 30 cm. (11⅞ in.) in height.

Cat. no. 136
Self-Portrait (Selbstbildnis),
1933
Bronze
26.5 x 14.2 x 13.5 cm.
(10⅜ x 5⅝ x 5⅜ in.)
The Robert Gore Rifkind Collec-
tion, Beverly Hills, California

A terracotta version is in the collec-
tion of the Leicestershire Museums
and Art Gallery, England.

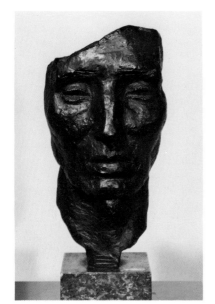

136

135

Steger

Milly Steger

Born 1881 Rheinsberg;

died 1948 Berlin-Wannsee.

Milly Steger studied sculpture with Carl Janssen in Düsseldorf, with Kolbe in Berlin, and with Rodin and Maillol in Paris. Very early in her career, she received the support and recognition of renowned art critics and museum directors such as Hans Hildebrandt, Alfred Kuhn, and Max Sauerlandt (see p. 51). This esteem was evoked primarily by her special gift for architectural sculpture. Karl Ernst Osthaus, the director of the Folkwang Museum in Hagen and a promotor of the integration of modern art in public spaces, recognized the architectonic qualities of Steger's sculpture. Following Steger's participation in the Berlin Secession of 1910, he invited her to Hagen. There she became a member of the am Stirnband artists' colony, meeting congenial artists such as Jan Thorn-Prikker, who had revived the art of stained glass; the painters Christian Rohlfs and Emil Rudolf Weiss; and the architect and craftsman J. L. M. Lauweriks. At this time Steger created a number of decorative architectural sculptures for her own home, as well as for several public buildings.

In 1911, the Hagen city building office commissioned four large, pillarlike, female stone figures for the newly opened municipal theater. The sculptures Steger created were not traditional; they emphasized structural elements, Cubist abstraction of form, and the substantive quality of the material. The citizens of Hagen rejected these works as immoral, and the efforts of the Berlin sculptor August Gaul, as well as those of museum directors Ludwig Justi, Hans Swarzenski, and Hans Tschudi were required to appease the populace. (After they were damaged in World War II, the figures were repaired by Hagen sculptor Karl Niestrath.) Other commissions followed, among them two larger-than-life plaster *(Gips)* figures which Steger designed for the niche next to the entrance of the Folkwang Museum. Due to the War, the sculptures could not be cast in bronze; today a single bronze head above the entrance testifies to this thwarted project. Through Osthaus' contacts, Steger was able to show her sculptures at a number of important international exhibitions both before and during World War I, and in 1914, he succeeded in having her appointed Hagen's city sculptor.

Of the few sculptures for public spaces which Steger made or designed between 1914 and 1918, only the *Blacksmith of Hagen* memorial design need be mentioned. Ernst Ludwig Kirchner also entered the competition for this sculptural commission, but neither he nor Steger was selected the winner. This sculpture, as well as others, such as a panther for the city hall of Hagen, demonstrate the characteristic quality of Steger's modeling, which was determined by the tectonic conditions of architectural sculpture. In all phases of her work the influence of George Minne, whose sculpture was so visible at the Folkwang Museum (fig. 1, p. 157), remains unmistakably present.

Not until Steger's return to Berlin in 1918 did the blocklike compactness and static quality of her figures loosen under the influence of Expressionism. Steger now chose wood rather than stone as her material. The motion of her figures became freer, the rhythm more excited; dancelike, they often display extreme torsions (cf. *Jephthah's Daughter,* fig. 1, p. 199) and constant shifts of equilibrium. Alfred Kuhn has commented on Steger's expression of a polarity of psychic states: "The tendency on the one hand toward life, physicality, affirmation of the senses, roundness, and the tactile, and on the other striving for desensualization, asceticism, a turning away from the physical: these are the two poles from whose antithesis the work of the artist creatively emerges."[1] By comparing Steger's *Youth Rising from the Dead* (cat. no. 138) with Minne's *Kneeling Figure* (cat. no. 102), one may discern how Steger incorporated such expressive values within the architectonic modeling of her figures through the use of flowing contours, contrasts of horizontal, vertical, and diagonal lines, and emphasized breaks at shoulder, waist, and knee. In contrast to the more stereotyped facial features of contemporary figures by Hoetger, Emy Roeder, and Garbe, the dramatically enlarged eyes and open mouth of the *Youth Rising from the Dead* are more expressively modeled. In *Kneeling Youth and Two Girls* (cat. no. 137), we see a similar Expressionist concentration on psychological characteristics, such as the inclination of the head and mimetic details. As in the earlier, architecturally related figures, the interplay of body and garment is an important element which intensifies the composition's expressiveness.

Beginning in 1923, Steger returned to a more naturalistic style while retaining some Expressionist features, such as an inclination toward the decorative and the use of certain characteristic postures, for example, the crouching female figure. Because of this continuity, the stylistic boundaries of the sculptor's Expressionist phase, which may be said to fall roughly between 1918 and 1922, are not absolute. Steger's close contacts in the world of dance are documented in a number of portraits, such as those of the actresses Gertrud Eysoldt (executed in the 1930s) and Helene Thimig (c. 1924, bronze) and of the dancer Mary Wigman (c. 1920; destroyed). With the exception of Steger's architectural works in Hagen, only a few of her sculptures survive. Works by her can be found in the collections of the Rijksmuseum Kröller-Müller, Otterlo; the Wilhelm-Lehmbruck-Museum der Stadt Duisburg; and the Nationalgalerie, Berlin. – J.H.v.W.

|||
1. Kuhn, 1923.

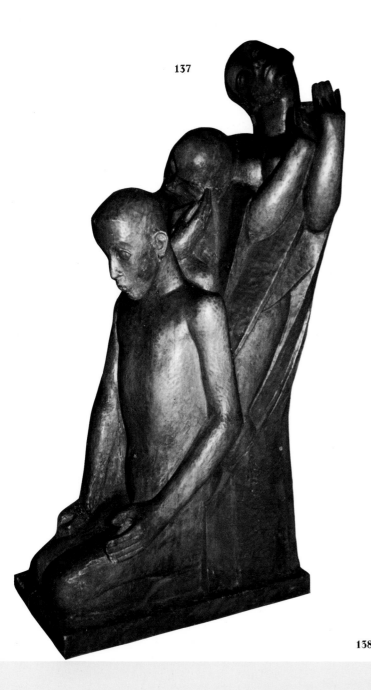

137

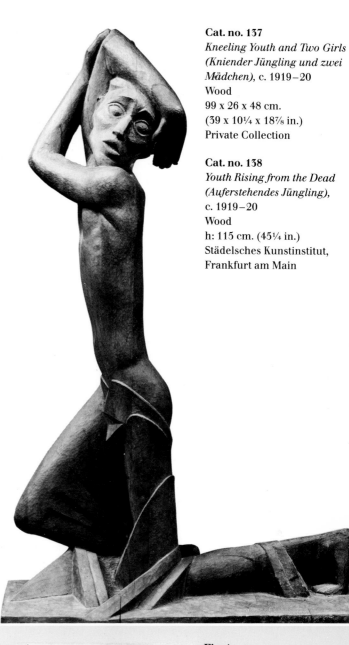

138

Cat. no. 137
*Kneeling Youth and Two Girls
(Kniender Jüngling und zwei
Mädchen),* c. 1919–20
Wood
99 x 26 x 48 cm.
(39 x 10¼ x 18⅞ in.)
Private Collection

Cat. no. 138
*Youth Rising from the Dead
(Auferstehendes Jüngling),*
c. 1919–20
Wood
h: 115 cm. (45¼ in.)
Städelsches Kunstinstitut,
Frankfurt am Main

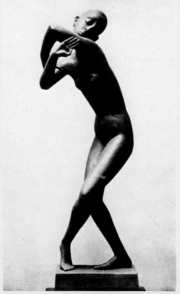

Fig. 1
*Jephthah's Daughter (Jeptas
Tochter),* c. 1918
Plaster
Formerly Museum Folkwang,
Essen; destroyed in 1944

Voll

Christoph Voll

Born 1897 Munich;

died 1939 Karlsruhe.

Christoph Voll was a member of the generation which inherited an Expressionist legacy from the artists of Die Brücke and Der Blaue Reiter. This second generation of Expressionists had to interrupt its studies to endure the First World War and in doing so not only lost four years, but returned home far more politically and socially oriented than its predecessors.

It is still unknown why, after the death of his father, Voll's mother left her small child in an orphanage in Kötzing, Bavaria. Only in Voll's earliest works can we perceive the influence of these inflexible and depressing surroundings. At age fourteen, Voll refused to accept religious training and was instead apprenticed to a stonemason in Dresden. The War interrupted this training, and he served from 1917 on, largely at the front line. Interestingly, this experience was rarely interpreted in his work. When the War ended, Voll returned to Dresden where he attended the Kunstgewerbeschule for a short time and then entered the Kunstakademie to study for three years (1919–22).

There was never any question as to whether Voll would become a sculptor. He initially worked in hardwood, literally hacking out figures of nuns with small children. Typical of this period are sculptures such as *Children's Funeral* (cat. no. 144) and *Blind Man with a Boy* (c. 1925–26, oak, Staatliche Kunsthalle, Karlsruhe). Concerning the latter sculpture, Voll stated that the child would feel the blind man's hand on his head even if he lived to be seventy years old. All these sculptures were based on memories of the artist's youth and convey the loneliness and frightening isolation of children among adults. The strength of the rough wood surface contrasts with, and thus accentuates, the figure's vulnerability.

Voll's many drawings were generally ideas for sculptures and usually placed the figure in an undefined space. His earliest woodcuts show a dependency upon the forms used by the young artists of the Sezession: Gruppe 1919 in Dresden. This group included, among others, Felixmüller, Forster, Otto Dix, Eugen Hoffmann, and Lasar Segall and provided an opportunity for them to interact with poets and writers. All of these artists were convinced of the new art's potential to make men better by confronting them with images of inner truth and human misery, which would in turn bring about radical changes in society.

No work catalogue exists for Voll, but it is likely that his graphics were done primarily between 1919 and 1924, since some of them were shown at his first large exhibition at the Dresden gallery of Emil Richter in April 1922. Others were shown in the 1924 exhibition of the Sezession: Gruppe 1919. He also created watercolors whose sketchlike freshness, simplicity of composition, and use of limited colors handled with a broad brush make them remarkable complements to the sculpture, drawings, and graphics. Voll's use of

bold, bright colors derives from the Brücke artists and other Expressionists, but the blocklike treatment of the figures is very much his own; see *The Family* of about 1922 (cat. no. 139). In confronting the viewer with this fused image of three family members, he emphasized the inherent strength of a tightly interlocked group.

The Family may depict the same models seen in two of the early wood sculptures, *Male Worker with Child* (cat. no. 140) and *Worker's Wife with Child* (cat. no. 141). In the former, the man wears the typical worker's cap and carries a small container in his hand. Considering the period in which the sculpture was made, this may indicate that he was going to receive the bread and milk distributed daily by the Hoover-Speisung, the food program for children initiated by President Hoover. The latter sculpture, *Worker's Wife with Child,* makes a clear political statement. Although the body of this middle-aged woman looks strong, her hanging breasts and protruding belly beneath her simple dress reveal a past of hunger and need. The artists of the Sezession: Gruppe 1919 wanted to agitate to change a society which remained unmoved by such examples of misery. While both of these works suggest a narrative, they are also examples of a consummate artist's ability to make highly abbreviated statues approximate realism and simultaneously to express the inner state of man.

The Beggar (cat. no. 143) parallels the works of such artists as Otto Dix, whom Voll knew well in Dresden, and George Grosz. Crippled war veterans, such as the one depicted in this sculpture, were frequently forced to resort to begging or attempting to sell shoelaces or matches on the streets. Voll made use of all the available Expressionist devices in order to heighten the impact of this work. The base retains the form of the original tree trunk and the surfaces remain rough. The indistinct but rather primitive features of the figure, the slightly open mouth with thick lips, the broad nose, and the worker's cap pulled down over the forehead make this image that of a "typical" proletarian. The human and helpless gesture of this cripple, however, displays Voll's full commitment to the Expressionist call for a humanization of society. In all the preparatory drawings for this beggar (see cat. no. 142), the figure retains its outstretched hands.

In *Children's Funeral* (cat. no. 144), the strong but wrinkled face of the man forms the top of a nearly pyramidal structure. His deep-set eyes and straight moustache, accentuating closed but well-formed lips, create a rather nondramatic appearance. Until one recognizes that he carries the coffin of a child under his arm, the sculpture seems confusing in its forms. The smaller nuns lack all dramatic impact; the group of children has been placed at the front. Hardly more than sketches, these children move forward with folded hands, probably singing a hymn, as if to emphasize that what takes place behind them is beyond their understanding. Yet they can also be read as recognizing their own fate reflected in this experience.

In October of 1923, Voll obtained a job teaching at

the art school in Saarbrücken. By this time he had married and had a daughter, and for the first time, he was able to count on a regular salary. Although he continued to work in wood, he also began to use more expensive materials, such as stone, and to work on a larger scale. His exclusive prior use of wood may therefore have been at least partially motivated by economics. With the change in location from Dresden to Saarbrücken, the orphanage subjects began to fade and a new, more realistic style became apparent.

In *Nude with Drapery* (cat. no. 145), the direction of German Expressionist sculpture became obvious: details were regarded as disruptive to the perception of form as an elucidation of a state of mind. It was from this image that Voll's large, warm, expansive, and frequently idealized female statues developed.

Nude, Ecce Homo (cat. no. 146), a life-size depiction of pain, age, and sadness, is an outstanding example of German Expressionist sculpture. The figure bends forward with closed eyes, one hand held out as if asking for a gift. Despite his wrinkled, aged body we sense that this man was once strong. As a number of preparatory studies indicate, Voll was inspired by the figure of a beggar whom he saw frequently in Saarbrücken. But the sculpture is far from being a realistic depiction of this man. Usually interpretations of the *Ecce Homo* theme – Christ standing before Pilate – depict an individual confronting a crowd. This figure, though alone, makes its plea so emotionally that no viewer can escape its directness. The gift which the empty hand requests is not material. Voll has used distortion to dramatize the image, so that not only the hands perform the important gesture, but the whole figure of the nude man has become one moving accusation of mankind.

The Saarbrücken community was not extremely supportive of Voll, but he did obtain a commission for a mother and child for the facade of the savings association there (1927, bronze). This work quite obviously took the taste of the commissioners into account. In the same year, however, Voll exhibited in Berlin at the J.B. Neumann Galerie and at Galerie Nierendorf, receiving fine reviews of his more Expressionist works. The year after, he won the prize for sculpture at the exhibition of the Akademie der Künste in Berlin. On the basis of this recognition and his reputation as a creative and successful teacher, Voll was named Professor of Sculpture of the Karlsruhe Kunstakademie. There he continued to work in hard stone (Carrara marble and both black and red Swedish granite) on larger-than-life figures, primarily female ones. Many successful exhibitions followed. At an international sculpture exhibition in Zurich in 1931, Voll was represented by the sculpture *A Worker* (1926; lost) which, however, was defaced. Voll was a tireless artist and according to his daughter completed approximately 140 large and small sculptures and a very large number of drawings, graphics, and watercolors – all in a lifespan of forty-two years.

When the Nazis began to enforce their "ideas" of art, Voll was immediately dismissed from his teaching position. The director of the Nationalgalerie in Berlin, Dr. Alois Schardt, borrowed a black granite statue, *Eve* (1933), for an important planned exhibition of modern German art, but the Nazis prevented the show from opening. Furthermore, Voll's works were represented in the *Entartete Kunst* exhibition and catalogue of 1937 (see fig. 8, p. 17).

As with so many other German Expressionists of his generation, Voll's works fall into two clearly delineated periods: the Expressionist period, which lasted until about 1924–25, and a second, more classical or realistic period. In his last international exhibition at the Kunsthaus Zürich in 1937, his nine sculptures and seventeen drawings were shown next to works by Karl Albiker, Wilhelm Gerstel, Kolbe, Marcks, and Otto Schiessler. In short, Voll was rightfully considered one of Germany's important sculptors. The fact that so many of Voll's works survive is due to a circumstance almost accidental in nature. Edvard Munch, the great Norwegian artist, had backed an exhibition of Voll's work in Scandinavia. By the time the Nazis had prohibited this exhibition, the sculptures were already in Denmark and were hidden there during the War. Since that time, Voll's widow and daughter have seen to it that the works were returned to Germany, and some of them have found their way to the United States.
– P.W.G.

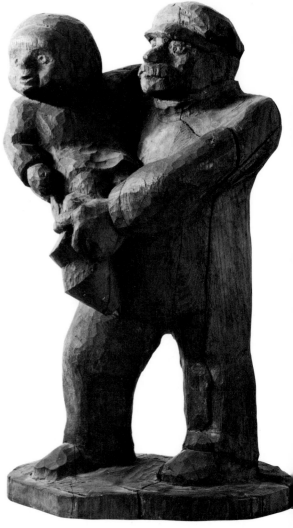

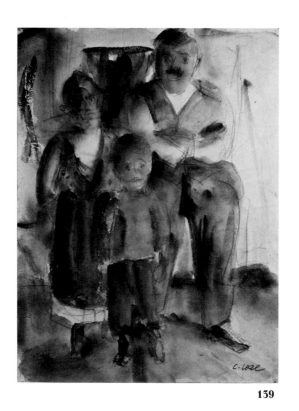

139

140

Fig. 1
Voll in his Dresden studio, 1924.

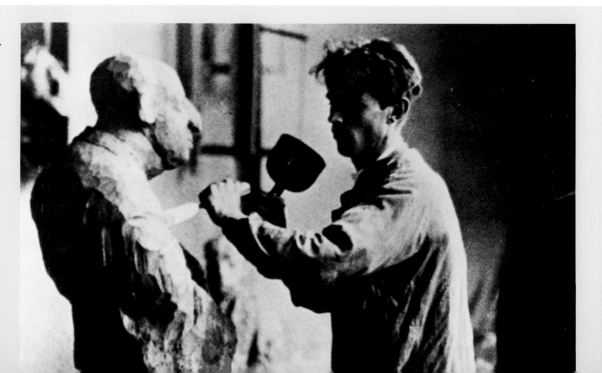

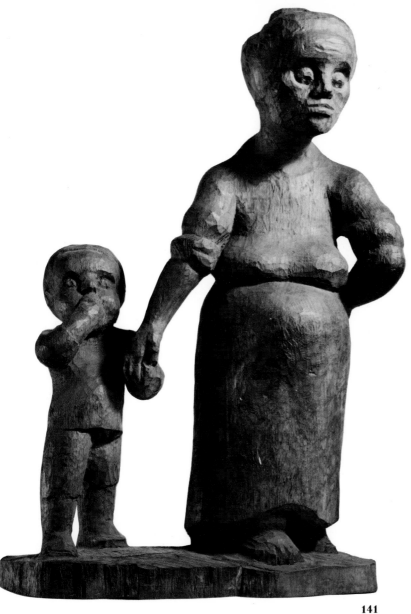

141

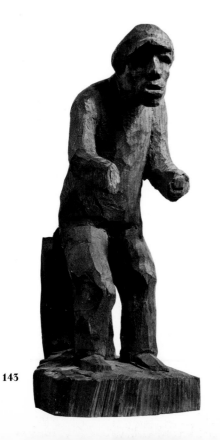

143

142

Cat. no. 139
The Family (Familie), c. 1922
Watercolor on paper
45.2 x 34.5 cm.
(17¾ x 13⅝ in.)
Karen Voll

This watercolor may depict the models for 2 sculptures: *Male Worker with Child* (cat. no. 140) and *Worker's Wife with Child* (cat. no. 141).

Cat. no. 140
*Male Worker with Child
(Arbeiter mit Kind)*, c. 1922
Oak
h: 79 cm. (31⅛ in.)
Janet and Marvin Fishman

Cat. no. 141
*Worker's Wife with Child
(Arbeiterfrau mit Kind)*, 1923
Oak
h: 90 cm. (35⅜ in.)
Janet and Marvin Fishman

Cat. no. 142
Beggar (Bettler), c. 1923
Ink on paper
26 x 21 cm.
(10¼ x 8¼ in.)
Karen Voll

This is one of several preparatory drawings for the sculpture *The Beggar* (cat. no. 143).

Cat. no. 143
The Beggar (Der Bettler), c. 1923
Oak
37 x 15 x 20 cm.
(14⅝ x 6 x 7¾ in.)
Karen Voll

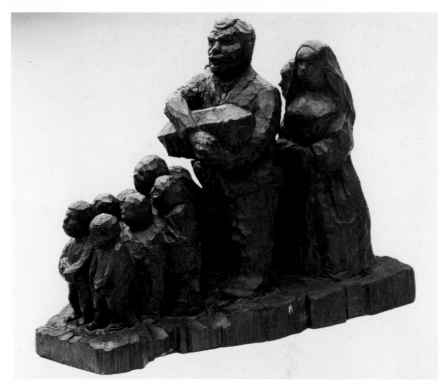

144

Cat. no. 144
Children's Funeral (Kinder-begräbnis), c. 1923
Moor oak
38 x 30 x 51 cm.
(15 x 11¾ x 20 in.)
Städtische Museen Heilbronn
(Cologne only)

This sculpture was exhibited in 1960
at Lenbachhaus, Munich, under the
title *Burial of an Orphan (Begräbnis
eines Waisenkindes).*

Cat. no. 145
*Nude with Drapery (Akt mit
Tuch),* c. 1924
Oak
45 x 18 x 18 cm.
(17¾ x 7⅛ x 7⅛ in.)
Karen Voll

Cat. no. 146
*Nude, Ecce Homo (Akt, Ecce
Homo),* 1924–25
Oak
164.5 x 37.5 x 50 cm.
(64¾ x 14¾ x 19⅝ in.)
The Robert Gore Rifkind Collec-
tion, Beverly Hills, California

Signed *Voll* on base at l.

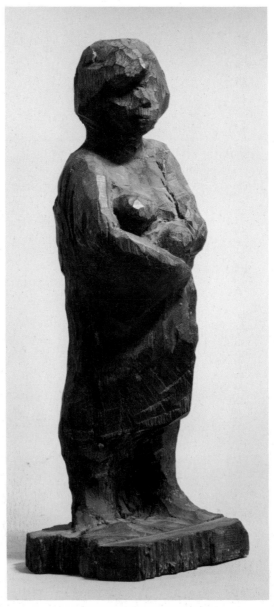

145

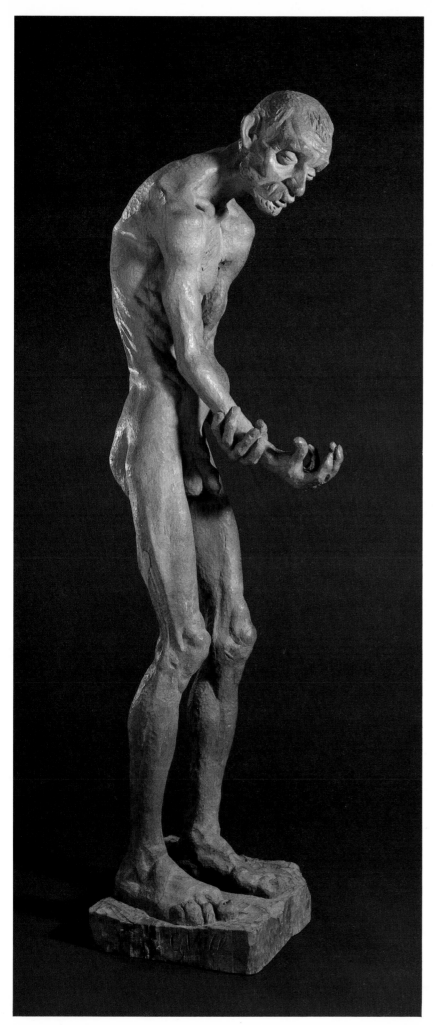

146

146

Wauer

William Wauer

Born 1866 Oberwiesenthal

(Erzgebirge);

died 1962 Berlin.

William Wauer was an exceptional artist of the Expressionist era, a man of versatile talents who worked both independently and in association with the leading cultural groups of his time. His studies at the Dresden, Berlin, and Munich Kunstakademien from 1884 to 1887 were followed by nearly two years of study in the United States, providing the basis for his pursuit of a degree in art history at the University of Leipzig. In 1896, however, rather than taking his examinations, he spent a year in Rome copying works by the Old Masters. Two years later, in 1899, he became the editor of the innovative, but short-lived, Berlin magazine *Quickborn (Fountain of Youth)*. Around 1900, Wauer worked for the popular magazine *Die Woche (The Week)* and later became an advertising consultant for a number of large firms. He then moved to Dresden, continued his advertising activities, founded a weekly magazine, *Dresdner Gesellschaft (Dresden Society)*, and earned his livelihood primarily as a theater critic.

In 1905, Wauer returned to Berlin and worked for a short time for the important theater director Max Reinhardt until joining forces with the Hebbel Theater and finally becoming the director of the Kleines Theater. Then, in 1911, he changed careers again and became active in the young film industry. He gained a reputation as a director and produced all of the films starring the great German actor Albert Bassermann.

While still immersed in the film world, he attended the 1912 Italian Futurist exhibition at Herwarth Walden's Galerie Der Sturm. Wauer, who had always painted as a hobby, was so impressed by the exhibit that he decided to dedicate himself to the visual arts. In March of 1918, he exhibited some of his paintings at the Galerie Der Sturm and in March of 1919 had his only one-man exhibition there. He became a close associate of Walden and published graphic works in the periodical *Der Sturm*, as well as a number of theoretical and combative articles about the "new" art – Expressionism. Walden was so impressed by Wauer's pantomime play, *Die vier Toten von Viametta (The Four Dead from Viametta)*, that he wrote the music for it. The play was performed on October 12, 1920, in Dresden with very limited success and once more in the Überbrettl, a Berlin cabaret. Throughout these years Wauer moved through the "Expressionist scene" with great vitality and inventiveness.

In 1924, however, Expressionism began to suffer from a change in public taste and interest. When the artistic circles surrounding Walden and *Der Sturm* began to dissolve, Wauer tried to stem the dissolution by founding and becoming the president of the Internationale Vereinigung der Expressionisten, Kubisten, Futuristen und Konstruktivisten (International Organization of Expressionists, Cubists, Futurists, and Constructivists), later called Die Abstrakten (The Abstractionists). The group was prohibited in

1933, and it was inevitable that the Nazis would not permit Wauer to continue his work. For a while he seemed willing to accept Nazi aesthetics but soon realized that this went against his better judgment. He survived the Nazi period with the help of friends and his wife, and after the War he began to paint and exhibit again.

Wauer's close friend and associate Lothar Schreyer, who was director of the Sturm Theater, declared that "the rhythmic line (Boccioni) and the rhythmic plane (Archipenko) are united for the first time in the sculptural work of the German William Wauer."[1] Although this was certainly an overstatement, it is striking that, especially in Berlin, Wauer's sculptures have been nearly forgotten. His work is somewhat problematic for art historians, since he frequently used the idioms of other artists, and a work catalogue does not yet exist. Some of his pieces, however, have certainly withstood the test of time, among them the 1919–21 portrait busts of Wauer's friends within the Sturm circle – intriguing attempts to incorporate Cubist planes within three-dimensional Expressionist forms. The bust of Herwarth Walden (cat. no. 147) was the first of this group. The head is set on an elongated neck that curves in a slight diagonal and is surrounded by stylized hair which gives the impression of an Egyptian crown. Walden's deep-set eyes, the prominent planes of his cheeks, his sensitively molded mouth, and strong nose and eyebrows are all clearly recognizable (see fig. 1, p. 207). The likeness to the model is surprising when one takes into account the fact that the sculptor isolated Walden's characteristic features and reassembled them in puzzlelike fashion. Nearly a pendant to this work is the bust of the actor Albert Bassermann (cat. no. 148).

The head of Rudolf Blümner (cat. no. 149) is tilted slightly backward, with closed eyes and sharp lines connecting the nose and open mouth. Such a pose would have been characteristic of Blümner, who was a famous reader of Expressionist poetry and prose within the Sturm circle. A close friend of Nell and Herwarth Walden and of Wauer, Blümner published many theoretical essays on contemporary art.

Wauer's artworks, arranged chronologically, together with manuscripts of his numerous radio programs, his articles on the theater, and his theater designs give a clear impression of the trends within post-World-War-I German Expressionism and await further exploration. – P.W.G.

||
1. Lothar Schreyer, "Die neue Kunst," *Der Sturm*, vol. 10, 1919–20, p. 104.

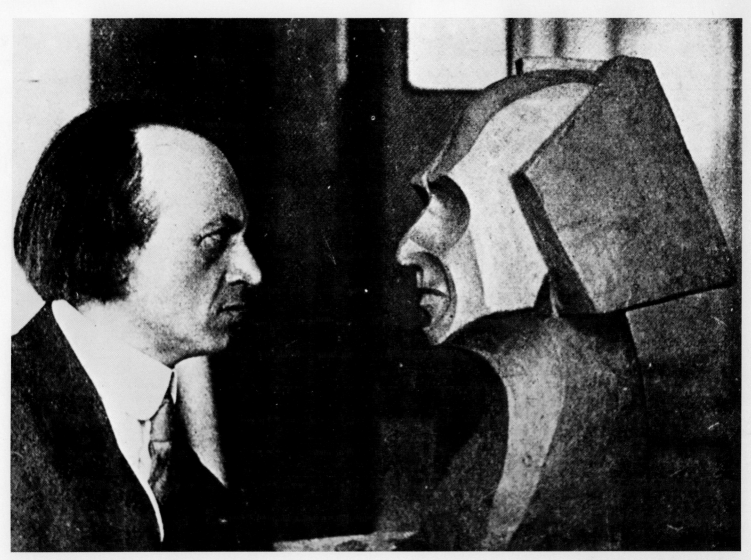

Fig. 1
Herwarth Walden with his portrait by Wauer (cat. no. 147).

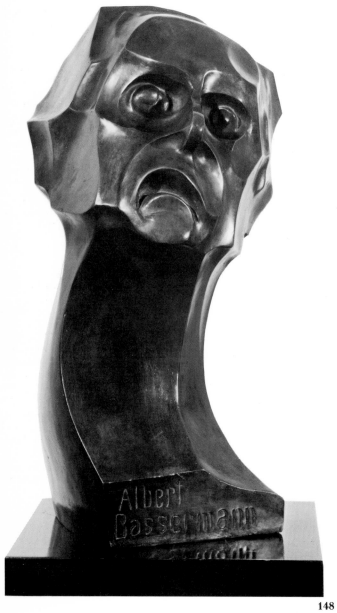

148

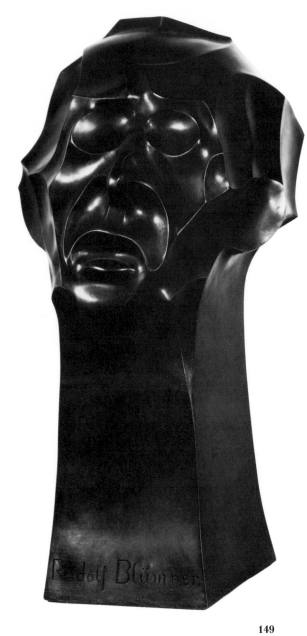

149

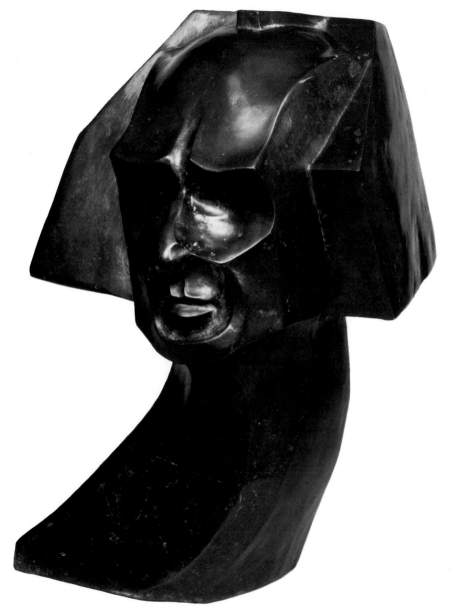

147

Cat. no. 147
Herwarth Walden, 1917/cast after 1945
Bronze
h: 53 cm. (20⅞ in.)
Tabachnick Collection, Toronto

Very few casts of Wauer's sculptures were made between 1917 and 1928. This piece was cast by Füssel, Berlin, after World War II but during Wauer's lifetime. Seven casts inscribed with Roman numerals (and one *hors du commerce*) are known.

Cat. no. 148
Albert Bassermann, 1918/cast between 1945 and 1962
Bronze
51.1 x 18.7 x 19 cm.
(20¼ x 7⅜ x 7½ in.)
The Robert Gore Rifkind Foundation, Beverly Hills, California

Inscribed *Albert Bassermann* on f. of pedestal neck; *HC I–III* on inside of neck; and *W.W.* on r. of pedestal. One of 3 casts with Roman numerals, made for Mrs. Wauer, done by W. Füssel, Berlin, after World War II but during the artist's lifetime. Another edition of 7 examples with Arabic numerals and one stamped additionally *H.C.* exist.

Cat. no. 149
Rudolf Blümner, 1919
Bronze
h: 55 cm. (21⅝ in.)
Berlinische Galerie, Berlin

Inscribed *Rudolf Blümner* on f. of pedestal neck. Seven casts (and one *hors du commerce*) are known.

Zadkine

Ossip Zadkine

Born 1890 Vitebsk, Russia;[1]

died 1967 Paris, France.

Ossip Zadkine is among that group of Russian artists – including Marc Chagall, Wassily Kandinsky, and Archipenko, to name only a few – who, after emigrating to Europe, changed the direction of modern art. In 1910, following a substantial but frequently interrupted period spent studying sculpture in England and France, Zadkine settled in Paris. His considerable oeuvre contains over two hundred works displaying a continually changing approach to the human figure. Influences visible in his sculpture include sources as diverse as Russian icons and African and Oceanic art; contemporary parallels may be found in the works of such artists as Derain, Brancusi, and Picasso. The variety evident in Zadkine's work makes it impossible to classify him under any of the popular rubrics of twentieth-century sculpture.

The artist first made his mark in 1911, when he exhibited at the ninth *Salon d'Automne* in Paris along with his friends Lehmbruck, Raymond Duchamp-Villon, and Archipenko. His early works show a romantic and refined tendency, which was altered by the impact of the First World War, during which he served in the French army. After the War an obvious change took place in his art which might be described as an increased sensitivity to his material, accompanied by a greater receptivity to Cubism. While Zadkine cannot be called an Expressionist, his works executed between 1914 and 1918 reveal the formal concerns of Expressionism, such as elongations and deformations of the human figure and emphatic stylization of the human face. The work included in this exhibition, *The Prophet* (cat. no. 150), retains the form of the original tree; the attenuated figure leans slightly backward. The head with its indistinct crown resembles Zadkine's earlier sculptures in its nearly masklike form. *The Prophet* at first sight gives the impression of an African fetish. It has also been compared to Russian Lechii idols and the Baba sculptures of southern Russia, as well as Gauguin's sculptures, which Zadkine could have seen in Paris. Zadkine himself recognized the importance of the "primitivism" so widespread in Europe at this time. In an article written about a 1919 Paris exhibition of African art organized by Paul Guillaume, Zadkine stated that the African sculptor was "a priest" whose admirable desire was to create "the image, the icon."[2] Regardless of all its possible sources of influence, Zadkine's *Prophet* is one of his outstanding "Expressionist" works, conveying a spirituality rarely found in French sculpture of this period.

Ossip Zadkine was greatly respected and admired during the years between the wars; his many public commissions and his participation in important European and American exhibitions made his works well known. At the great Musée des Beaux Arts exhibition in Brussels in 1933, which occurred at the same time as the incipient Nazi suppression of modern art in Germany, Zadkine exhibited 139 sculptures and 47 gouaches. During the German occupation of France, he found refuge in the United States. He taught at the Art Students' League in New York and exhibited at the Wildenstein Gallery. In 1945, he returned to Paris and taught sculpture at the Académie de la Grande Chaumière, and in 1949, the Museé National d'Art Moderne, Paris, presented a comprehensive exhibition of his works. Among his most famous later sculptures is the large figurative piece *The Destroyed City* (1946–53, bronze), which stands at the harbor of Rotterdam in the Netherlands. – P.W.G.

1. After 1914 Zadkine stated that he had been born in Smolensk, Russia, where his parents had moved later, in fact.

2. Ossip Zadkine, "Un exposition d'art nègre," *Sic*, vol. 4, nos. 45/46, 1919.

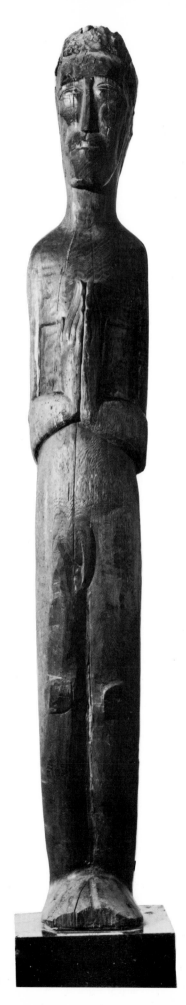

Cat. no. 150
The Prophet (Le Prophète),
1917–18
Oak
219 x 31 x 26 cm.
(86¼ x 12¼ x 10¼ in.)
Musée de Peinture et de Sculp-
ture, Grenoble
Jianou, 14

Inscribed *Zadkine 1914* on base, l. l.
The date of this sculpture is debated.
While the signature on the base
states 1914, de Ridder has dated it
1918; the Jianou oeuvre catalogue
lists it as 1914; and Raynal's mono-
graph lists the date as 1917.

150

Bibliography

General Bibliography

Art Gallery of Ontario, Toronto, *Gauguin to Moore: Primitivism in Modern Sculpture,* exh. cat., 1981.

Schmidt-Rottluff and Kirchner were included in this exhibition.

Sarah Campbell Blaffer Gallery, Houston, *Deutscher Expressionismus: German Expressionism: Toward a New Humanism,* by Peter Guenther, exh. cat., 1977.

Brattskoven, Otto, "Holzbildwerke der Gegenwart," *Kunst der Zeit,* vol. 1, no. 10/11, July–August 1930, pp. 238–45.

Brücke-Museum, Berlin, *Katalog der Gemälde, Glasfenster und Skulpturen,* Berlin: Brücke-Museum, 1971.

Buchheim, Lothar Günther, *Die Künstlergemeinschaft Brücke,* Feldafing: Buchheim Verlag, 1956.

Brief section on sculpture.

Däubler, Theodor, "Gela Forster," *Neue Blätter für Kunst und Dichtung,* vol. 2, June 1919, pp. 51–53. (Reprinted in: Däubler, Theodor, *Dichtungen und Schriften,* Munich: Kösel-Verlag, 1956.)

Included in translation in this catalogue, pp. 30–33.

Dube, Wolf-Dieter, *Expressionism,* London: Thames and Hudson, 1972.

Einstein, Carl, *Negerplastik,* Munich: Kurt Wolff, [1915].

Excerpt (pp. 251–61) included in translation in this catalogue, pp. 34–36.

———, *Werke,* ed. Rolf-Peter Baacke and Jens Kwasny, vol. 1, *1908–1918,* Berlin: Medusa, 1980.

Elsen, Albert E., *Modern European Sculpture 1918–1945: Unknown Beings and Other Realities,* New York: George Braziller, 1979.

———, *Origins of Modern Sculpture: Pioneers and Premises,* New York: George Braziller, 1974.

Discussion of Barlach, Lehmbruck, and several other Expressionists.

Ettlinger, L. D., "German Expressionism and Primitive Art," *Burlington Magazine* (London), vol. 110, no. 781, April 1968, pp. 191–201.

Particular emphasis on the accomplishments of the Brücke artists.

Franzke, Andreas, *Skulpturen und Objekte von Malern des 20. Jahrhunderts,* Cologne: DuMont Buchverlag, 1982.

Discussion of Beckmann, Otto Dix, Kirchner, Schmidt-Rottluff, Kollwitz, and others. Brief bibliographies.

Fuchs, Heinz R., *Plastik der Gegenwart,* Baden-Baden: Holle Verlag, 1970.

Galleria del Levante, Munich, *Dresdener Sezession: 1919–1923,* exh. cat., 1977.

Essays by Fritz Löffler, Emilio Bertonati, and Joachim Heusinger von Waldegg. Excellent reproductions of original documents, illustrations of lost works, and biographies.

Giedion-Welcker, Carola, *Contemporary Sculpture: An Evolution in Volume and Space,* rev. ed., New York: G. Wittenborn, 1961. (Also published in German: *Plastik des XX. Jahrhunderts: Volumen und Raumgestaltung,* Stuttgart: Verlag Gerd Hatje, 1955.)

Goldwater, Robert, *Primitivism in Modern Art,* rev. ed., New York: Vintage Books, 1967.

Originally published in 1938. Includes important chapters on primitivism, Die Brücke, and Der Blaue Reiter.

Grohmann, Will, *Zwischen den beiden Kriegen II: Bildende Kunst und Architektur,* Berlin: Suhrkamp Verlag, 1953.

Discussion of Barlach and Lehmbruck.

Grzimek, Waldemar, *Deutsche Bildhauer des Zwanzigsten Jahrhunderts: Leben, Schulen, Wirkungen,* Munich: Heinz Moos Verlag, 1969.

With chapters on Barlach, Kolbe, Freundlich, Karl Albiker, Lehmbruck, Belling, Marcks, and Karsch.

[Guenther, Peter, see Sarah Campbell Blaffer Gallery.]

Solomon R. Guggenheim Museum, New York, *Expressionism: A German Intuition 1905–1920,* exh. cat., 1980. (Also published in German: *Deutscher Expressionismus 1905–1920,* ed. Paul Vogt, Munich: Prestel Verlag, 1981.)

Essays by Wolf-Dieter Dube, Horst Keller, Eberhard Roters, Martin Urban, and Paul Vogt.

Hamilton, George Heard, *Painting and Sculpture in Europe: 1880–1940,* Harmondsworth, Middlesex: Penguin Books, 1967.

Discussion of Barlach and Lehmbruck.

Haus der deutschen Kunst, Munich, *Entartete "Kunst" Ausstellungsführer,* exh. cat., Berlin: Verlag für Kultur und Wirtschaftswerburg, 1937.

Infamous exhibition mounted by the Nazis in order to condemn modern art as "degenerate." The show, which opened in Munich and traveled to several other German cities, included 730 works of art prominently featured German Expressionists. A sculpture by Freundlich was selected for the cover of the catalogue, which included illustrations of sculptures by Kirchner, Schmidt-Rottluff, Voll, Eugen Hoffman, and Richard Haizmann.

Haus der Kunst, Munich, *Die Dreissiger Jahre: Schauplatz Deutschland,* exh. cat., 1977.

Includes a chapter on sculpture by Günter Aust.

Heise, Carl Georg, "Der Kruzifixus von Gies," *Genius,* vol. 3, no. 2, 1921, pp. 198–202.

Included in translation in this catalogue, pp. 37–40.

———, ed., *Die Kunst des 20. Jahrhunderts,* Munich: R. Piper & Co. Verlag, 1957.

Includes a discussion of sculpture by Hans Platte.

Henning, P. R., *Ton – Ein Aufruf,* Kunsthaus Zürich, 1917. (Reprinted: as the second pamphlet of the Arbeitsrat für Kunst in 1919; in *Mitteilungen des Deutschen Werkbundes,* vol. 5, 1919–20, pp. 141–44; in *Arbeitsrat für Kunst 1918–1921,* exh. cat., Berlin: Akademie der Künste, 1980, pp. 98–99.)

Included in translation in this catalogue, pp. 41–42.

Hentzen, Alfred, *Deutsche Bildhauer der Gegenwart,* Berlin: Rembrandt Verlag, 1934.

Important early discussion by the director of the Hamburger Kunsthalle. Includes many illustrations, although several are of non-Expressionist works.

Hentzen, Alfred, "Kunsthandwerkliche Arbeiten der deutschen Expressionisten und ihrer Nachfolger," in *Festschrift für Erich Meier zum 60. Geburtstag 20.10.1957,* Studien zu Werken in den Sammlungen für Kunst und Gewerbe in Hamburg, Hamburg: Museum für Kunst und Gewerbe, 1959, pp. 311–30.

Extensive article discussing Barlach, Nolde, Kirchner, Schmidt-Rottluff, Heckel, Franz Marc, August Macke, Marcks, and others.

Hofmann, Werner, *Die Plastik des 20. Jahrhunderts,* Frankfurt am Main: Fischer Bücherei, 1958.

Kliemann, Helga, *Die Novembergruppe,* Berlin: Gebr. Mann Verlag, 1969.

Reproductions of original documents, together with biographies and illustrations.

Kuhn, Alfred, *Die neuere Plastik: Achtzehnhundert bis zur Gegenwart,* Munich: Delphin Verlag, 1921.

Cites Garbe, Steger, Herzog, Archipenko, Belling, and Wauer, in addition to Barlach, Lehmbruck, and the Brücke artists.

Kunstmuseum der Sozialistischen Republik, *Deutsche Bildhauer 1900–1933,* exh. cat., Bucharest: Kunstmuseum der Sozialistischen Republik; Wilhelm-Lehmbruck-Museum der Stadt Duisburg, 1976.

Wilhelm-Lehmbruck-Museum der Stadt Duisburg, *Hommage à Lehmbruck: Lehmbruck in seiner Zeit,* exh. cat., 1981.

With articles by Alfred Hentzen, Thomas Strauss, Margarita Lahusen, Karl-Egon Vester, Siegfried Salzmann. Includes discussions of Lehmbruck, Archipenko, Gutfreund, Karl Albiker, Barlach, Hoetger, Kolbe, and Minne.

Münchner Stadtmuseum, *Die zwanziger Jahre in München,* exh. cat., 1979.

Sculpture section of exhibition catalogue written by Gerhard Finckh, Helga Schmoll, and J. A. Schmoll (pseud. Eisenwerth).

The Museum of Modern Art, New York, *German Art of the Twentieth Century,* exh. cat., 1957.

Contributions by Werner Haftmann (painting), Alfred Hentzen (sculpture), and William S. Liebermann (prints). Eleven of the thirty-nine artists in the exhibition were represented by sculpture.

———, New York, *Modern German Painting and Sculpture,* intro. Alfred H. Barr, exh. cat., 1931.

Barr cites the achievements of German sculpture as among the most important in contemporary art. Of the 123 exhibited works, 34 were sculptures.

Myers, Bernard S., *The German Expressionists: A Generation in Revolt,* New York: Praeger, 1957.

Osborn, Max, *Der bunte Spiegel: Erinnerungen aus dem Kunst-, Kultur- und Geistesleben der Jahre 1890 bis 1933,* New York: B. F. Krause, 1945.

Osten, Gert von der, *Plastik des 20. Jahrhunderts in Deutschland, Österreich und der Schweiz,* Königstein im Taunus: H. Köster, 1962.

Raabe, Paul, ed. *Index Expressionismus: Bibliographie der Beiträge in den Zeitschriften und Jahrbüchern des literarischen Expressionismus 1910–1925,* 18 vols., Nendeln, Liechtenstein: Kraus-Thomson, 1972.

Vol. 5 indexes articles and illustrations of sculpture found in 106 German periodicals and yearbooks published between 1910 and 1925.

——— ed., *The Era of German Expressionism,* Woodstock, N.Y.: The Overlook Press, 1974.

Reinhardt, Georg, "Die frühe Brücke," *Brücke-Archiv,* (Berlin: Brücke-Museum), vol. 9/10, 1977/78.

[Rifkind Collection, Robert Gore, see Frederick S. Wight Art Gallery.]

Roh, Franz, *German Art in the 20th Century,* Greenwich, Conn: New York Graphic Society, 1968. (Also published in German: *Deutsche Malerei von 1900 bis heute,* Munich: Verlag F. Bruckmann, 1962.)

Roters, Eberhard, *Berlin 1910–1933,* New York: Rizzoli, 1982.

Includes a chapter on sculpture by Joachim Heusinger von Waldegg.

San Diego State University, University Gallery, *An alle Künstler! War-Revolution-Weimar,* by Ida Katherine Rigby, exh. cat., 1983.

Excellent discussion of German artists active from 1918 to 1925. Prepared as the catalogue for an exhibition of 136 prints, drawings, and posters from The Robert Gore Rifkind Foundation. Includes a bibliography.

Sauerlandt, Max, "Holzbildwerke von Kirchner, Heckel und Schmidt-Rottluff im Hamburgischen Museum für Kunst und Gewerbe," *Museum der Gegenwart: Zeitschrift der Deutschen Museen für Neuere Kunst* (Berlin: Ernst Rathenau Verlag), vol. 1, no. 3, 1930–31, pp. 101–11.

Included in translation in this catalogue, pp. 51–55.

Schleswig-Holsteinisches Landesmuseum and Museum für Kunst und Gewerbe, Hamburg, *Plastik und Kunsthandwerk von Malern des deutschen Expressionismus,* by Martin Urban, exh. cat., 1960.

Exhibition of over three hundred works, with a text by Martin Urban.

Schneckenburger, Manfred, "Bemerkungen zur 'Brücke' und zur 'primitiven' Kunst" in *Weltkulturen und moderne Kunst,* exh. cat., Haus der Kunst, Munich, 1972, pp. 456–74.

An article comparing Brücke and "primitive" sculpture in the catalogue of an extensive exhibition prepared on the occasion of the 1972 Olympic Games.

Selz, Peter, *German Expressionist Painting,* Berkeley and Los Angeles: University of California Press, 1957.

Staatliche Museen zu Berlin, East Berlin, *Revolution und Realismus: Revolutionäre Kunst in Deutschland 1917 bis 1933,* exh. cat., 1979.

Steingraber, Erich, ed., *Deutsche Kunst der 20er und 30er Jahre,* Munich: Verlag F. Bruckmann, 1979.

Joachim Heusinger von Waldegg's chapter on sculpture pays particular attention to the various geographic centers of activity. Many lesser-known artists are discussed.

Trier, Eduard, *Bildhauertheorien im 20. Jahrhundert,* Berlin: Gebr. Mann Verlag, 1971.

[Urban, Martin, see Schleswig-Holsteinisches Landesmuseum and Museum für Kunst und Gewerbe, Hamburg.]

Frederick S. Wight Art Gallery, University of California, Los Angeles, *German Expressionist Art: The Robert Gore Rifkind Collection,* exh. cat., 1977.

Excellent reference for graphics and periodicals of the period.

Walden, Herwarth, ed., *Der Sturm: Eine Einführung,* Berlin: Verlag Der Sturm, [1918].

Westheim, Paul, *Architektonik des Plastischen,* Berlin: Ernst Wasmuth, 1923.

With illustrations of works by Archipenko, Belling, and Jacques Lipchitz.

Willett, John, *Expressionism,* London: Weidenfeld & Nicholson, 1970.

Wolfradt, Willi, *Die neue Plastik,* Tribüne der Kunst und Zeit, ed. Kasimir Edschmid, vol. 11, Berlin: Erich Reiss Verlag, 1920.

Theoretical discussion of contemporary sculpture, its relationship to Rodin and the nineteenth century. Makes reference to many artists represented in this exhibition, among them: Minne, Kolbe, Hoetger, Lehmbruck, Wauer, Herzog, Archipenko, and Barlach.

Alexander Archipenko

Archipenko, Alexander, *Archipenko: Fifty Creative Years 1908–1958,* New York: Tekhne, 1960.

Däubler, Theodor, Ivan Goll, and Blaise Cendrars, *Archipenko-Album,* Potsdam: Gustav Kiepenheuer Verlag, 1921.

Hildebrandt, Hans, *Alexander Archipenko,* Berlin: Ukrainske Slowo, 1923.

Karshan, Donald, *Archipenko,* Tübingen: Ernst Wasmuth Verlag, 1974.

Museum of Modern Art, New York, *Alexander Archipenko: The Parisian Years,* exh. cat., 1970.

Schacht, Roland, *Alexander Archipenko,* Sturm-Bilderbuch, no. 2, Berlin: Verlag Der Sturm, 1915.

UCLA Art Galleries, Los Angeles, *Alexander Archipenko: A Memorial Exhibition,* exh. cat., 1967.

Wiese, Erich, *Alexander Archipenko,* Leipzig: Klinkhardt & Biermann, 1923.

Ernst Barlach

Barlach, Ernst, *Das dichterische Werk in drei Bänden,* ed. Friedrich Dross, vol. 2, *Die Prosa I,* Munich: R. Piper & Co. Verlag, 1958.

——, *Das dichterische Werk in drei Bänden,* ed. Friedrich Dross, vol. 3, *Die Prosa II,* Munich: R. Piper & Co. Verlag, 1959.

——, *Die Briefe,* ed. Friedrich Dross, 2 vols., Munich: R. Piper & Co. Verlag, 1968–69.

——, *Ein selbsterzähltes Leben,* Berlin: Paul Cassirer Verlag, 1928.

——, *Ernst Barlach 1870–1970,* Bonn-Bad Godesberg: Inter Nationes, 1971.

With extracts from Barlach's autobiographical writings, as well as articles by Klaus Günther and Isa Lohmann-Siems. English text.

Groves, Naomi Jackson, *Ernst Barlach: Life in Work: Sculpture, Drawings, and Graphics; Dramas, Prose Works, and Letters in Translation,* Königstein im Taunus: Karl Robert Langewiesche, [1972]. (Also published in German: *Ernst Barlach: Leben im Werk: Plastiken, Zeichnungen und Graphiken, Dramen, Prosawerke und Briefe,* Königstein im Taunus: Karl Robert Langewiesche [1972].)

The translated edition is one of the few comprehensive texts available in English.

Kunsthalle Köln, *Ernst Barlach: Plastik, Zeichnungen, Druckgraphik,* exh. cat., 1975.

Contains an excellent article on Barlach's materials by Dr. Isa Lohmann-Siems, "Zum Problem des Materials bei Barlach."

Schult, Friedrich, *Ernst Barlach Werkverzeichnis,* 3 vols., Hamburg: Dr. Ernst Hauswedell & Co. Verlag, (vol. 1: *Das plastische Werk,* 1960; vol. 2: *Das graphische Werk,* 1958; vol. 3: *Werkkatalog der Zeichnungen,* 1971).

Catalogues raisonnés of Barlach's sculpture, graphics, and drawings.

Staatliche Museen zu Berlin, East Berlin, and Akademie der Künste der DDR, East Berlin, *Ernst Barlach: Werk und Werkentwürfe aus fünf Jahrzehnten,* 3 vols., exh. cat., 1981.

Max Beckmann

Catherine Viviano Gallery, New York, *The Eight Sculptures of Max Beckmann,* exh. cat., 1977.

Göpel, Erhard and Barbara, *Max Beckmann: Katalog der Gemälde,* 2 vols., Bern: Galerie Kornfeld & Co., 1976.

Catalogue raisonné of Beckmann's paintings.

Lackner, Stephan, *Ich erinnere mich gut an Max Beckmann,* Mainz: Florian Kupferberg Verlag, 1967.

——, *Max Beckmann,* New York: Harry N. Abrams, Inc., 1977.

Excellent English-language study of Beckmann.

Rudolf Belling

Belling, Rudolf, "Skulptur und Raum," *Der Futurismus,* vols. 7–8, 1922, pp. 1–3.

Heusinger von Waldegg, Joachim, "Rudolf Belling und die Kunstströmungen in Berlin 1918–1923...," *Pantheon: Internationale Zeitschrift für Kunst,* vol. 41, no. 4, October–December 1983.

A review of Winfried Nerdinger's recent monograph and catalogue raisonné.

Nerdinger, Winfried, *Rudolf Belling und die Kunstströmungen in Berlin 1918–1923: mit einem Katalog der plastischen Werke,* Berlin: Deutscher Verlag für Kunstwissenschaft, 1981.

Contains a catalogue raisonné.

Schacht, Roland, "Archipenko, Belling und Westheim," *Der Sturm,* vol. 14, no. 5, 1923, pp. 76ff.

Schmoll, J. A., [Eisenwerth, pseud.], "Zum Werk Rudolf Bellings," in *Rudolf Belling,* exh. cat., Munich: Galerie Ketterer, 1967.

This includes a catalogue by H. D. Hofmann.

Conrad Felixmüller

Archiv für Bildende Kunst am Germanischen Nationalmuseum, Nuremberg, *Conrad Felixmüller: Werke und Dokumente,* exh. cat., 1982.

Contains considerable archival material, a bibliography, and an exhibition history.

Gleisberg, Dieter, *Conrad Felixmüller,* Dresden: VEB Verlag der Kunst, 1982.

Most recent comprehensive monograph.

Söhn, Gerhart, *Conrad Felixmüller: Von ihm – über ihn,* Düsseldorf: Graphik-Salon Gerhart Söhn, 1977.

——, ed., *Conrad Felixmüller: Das graphische Werk,* Düsseldorf: Graphik-Salon Gerhart Söhn, 1975; addendum 1980.

Catalogue raisonné of Felixmüller's graphic work.

Otto Freundlich

Aust, Günter, *Otto Freundlich 1878–1943,* Cologne: Verlag M. DuMont Schauberg, 1960.

——, *Otto Freundlich 1878–1943: Aus Briefen und Aufsätzen,* Cologne: Verlag Galerie der Spiegel, 1960.

Bohnen, Uli, ed., *Schriften: Ein Wegbereiter der gegenstandlosen Kunst,* Cologne: DuMont Buchverlag, 1982.

Elsen, Albert E., *Modern European Sculpture 1918–1945: Unknown Beings and Other Realities,* New York: George Braziller, 1979, pp. 96ff.

Gindertael, R. V., "Otto Freundlich," *Art d'aujourd'hui,* vol. 3, nos. 7–8, 1952, pp. 59ff.

[Heusinger von Waldegg, Joachim, see under Rheinishes Landesmuseum Bonn]

Rémy, Tristan, "Otto Freundlich," *Maintenant,* vol. 5, 1947, pp. 128ff.

Rheinisches Landesmuseum Bonn, *Otto Freundlich, 1878–1943: Monographie mit Dokumentation und Werkverzeichnis,* exh. cat., 1978.

Contains a catalogue raisonné by Joachim Heusinger von Waldegg.

Roditi, Edouard, "The Fate of Otto Freundlich," *Commentary,* vol. 20, no. 3, 1955, pp. 248ff.

Wenkenpark Riehen, Basel, *Skulptur im 20. Jahrhundert,* exh. cat., 1980.

Herbert Garbe

Biermann, Georg, "Der Bildhauer H. Garbe," *Jahrbuch der jungen Kunst,* Leipzig: Klinkhardt & Biermann, vol. 1, 1920, pp. 233ff.

Galerie Curt Buchholz, Berlin, *Herbert Garbe/Karl Rössing,* exh. cat., 1936.

Grzimek, Waldemar, *Deutsche Bildhauer des zwanzigsten Jahrhunderts,* Wiesbaden: R. Löwit, 1969, pp. 127, 146, 202.

Hentzen, Alfred, "Herbert Garbe," *Die Kunst,* vol. 75, 1937, pp. 18ff.

Oto Gutfreund

Lamač, M., "Oto Gutfreund, der früheste kubistische Bildhauer Europas," *Alte und moderne Kunst,* vol. 3, 1958, pp. 19–21.

Los Angeles County Museum of Art and The Metropolitan Museum of Art, *The Cubist Epoch,* by Douglas Cooper, exh. cat., London: Phaidon, 1970.

Muscik, J., "Oto Gutfreund," *Das Kunstwerk,* vol. 22, no. 9, 1968–69, pp. 63ff.

Museum des 20. Jahrhunderts, Vienna, *Oto Gutfreund,* exh. cat., 1969.

Muzeum Sztuki w Lodzi, *Oto Gutfreund,* exh. cat., 1971.

Strauss, Thomas, "Lehmbruck, Meštrović, Štrusa and Gutfreund," in *Hommage à Lehmbruck,* exh. cat., Wilhelm-Lehmbruck-Museum der Stadt Duisburg, 1981, pp. 186–99.

Erich Heckel

Altonaer Museum in Hamburg, *Erich Heckel, 1883–1970: Gemälde, Aquarelle, Graphik, Jahresblätter, gemalte Postkarten und Briefe aus dem Besitz des Museums,* exh. cat., 1973.

———, *Kunst und Postkarte,* exh. cat., 1970.

Dube, Annemarie and Wolf-Dieter, eds., *Erich Heckel: Das graphische Werk,* New York: Ernst Rathenau, 1964.

Catalogue raisonné of Heckel's graphics.

Vogt, Paul, *Erich Heckel,* Recklinghausen: Verlag Aurel Bongers, 1965.

Monograph containing a catalogue raisonné of Heckel's paintings as well as illustrations of several of his sculptures.

Wietek, Gerhard, "Dr. phil. Rosa Schapire," *Jahrbuch der Hamburger Kunstsammlungen,* vol. 9, 1964, pp. 115–52.

Paul Rudolf Henning

There is no bibliographic information available for this artist.

Oswald Herzog

Casson, Stanley, "Oswald Herzog and the German Artists of the 'Inorganic' School," in *XXth Century Sculptors,* London: Oxford University Press, 1930, pp. 77–87.

Grohmann, Will, ed., *Kunst der Zeit: Sonderheft Zehn Jahre Novembergruppe* (Berlin), vol. 3, no. 1–3, 1928, p. 14.

Herzog, Oswald, *Der Rhythmus in Kunst und Natur: Das Wesen des Rhythmus und die Expression in der Natur und in der Kunst,* Berlin: Selbstverlag des Verfassers, 1914.

Kliemann, Helga, *Die Novembergruppe,* Berlin: Gebr. Mann Verlag, 1969.

Kuhn, Alfred, "Die absolute Plastik Oswald Herzogs," *Der Cicerone,* vol. 13, no. 8, April 21, pp. 245–52.

Bernhard Hoetger

Biermann, Georg, "Hoetgers Denkmal der Arbeit," *Der Cicerone,* vol. 21, 1929.

Böttcherstrasse Bremen and Westfälischer Kunstverein Münster, *Bernhard Hoetger – Gedächtnis-Ausstellung zu seinem 90. Geburtstag,* exh. cat., 1964.

Grosse Kunstschau, Worpswede, *Bernhard Hoetger – Bildhauer, Maler, Baukünstler, Designer,* exh. cat., 1982.

Hoetger, Bernhard, "Der Bildhauer und der Plastiker," *Der Cicerone,* vol. 11, 1919, pp. 165–73.

Roselius, Ludwig, and Suse Drost, *Bernhard Hoetger 1874–1949: Sein Leben und Schaffen,* Bremen: Verlag H. M. Hauschild, 1974.

Schubert, Dietrich, "Hoetger's Waldersee-Denkmal von 1915 in Hannover," *Wallraf-Richartz-Jahrbuch,* vol. 43, 1982.

Werner, Wolfgang, ed., *Bernhard Hoetger: Plastiken aus den Pariser Jahren: 1900–1910,* Bremen: Wolfgang Werner, 1977.

Excellent documentation of these years of Hoetger's life.

Joachim Karsch

Galerie Nierendorf, Berlin, *Joachim Karsch – Gedächtnisaustellung,* exh. cat., 1965.

———, Berlin, *Joachim Karsch zum achtzigsten Geburtstag,* exh. cat., 1977.

Haus der Ostdeutschen Heimat, Berlin, *Joachim Karsch – Plastiken und Zeichnungen aus Gross-Gandern,* exh. cat., 1974.

Historisches Museum der Stadt Heilbronn, *Joachim Karsch: Plastik, Zeichnungen aus der Zeit 1916–1943,* by Andreas Pfeiffer, exh. cat., 1978.

Karsch, Joachim, "Ein Brief," *Das Kunstblatt,* vol. 12, no. 2, February 1928, pp. 161ff.

Osborn, Max, ed., *Vossische Zeitung,* no. 16, April 25, 1920, suppl.

Roditi, Edouard, *Joachim Karsch,* Berlin: Gebr. Mann Verlag, 1967.

Sonntag, Fritz, *Briefe des Bildhauers Joachim Karsch aus den Jahren 1933–1945,* Berlin: Gebr. Mann Verlag, 1948.

Wilhelm-Lehmbruck-Museum der Stadt Duisburg, *Joachim Karsch,* exh. cat., 1968.

Wolfradt, Willi, "Joachim Karsch," *Das Kunstblatt,* vol. 2, no. 12, December 1918, pp. 382–85.

Concerning the Scholarship on Ernst Ludwig Kirchner (bibliography prepared by Dr. Wolfgang Henze)

For the most complete bibliography to date, see Bolliger, Hans, "Bibliographie," in *Ernst Ludwig Kirchner: Zeichnungen und Pastelle,* ed. R. N. Ketterer, Stuttgart: Belser Verlag, 1979, pp. 249–89. This comprehensive work includes Kirchner's published and unpublished writings in sections one and two. Other major sources include:

Dube, Annemarie and Wolf-Dieter, *E. L. Kirchner: Das graphische Werk,* 2 vols., Munich: Prestel Verlag, 1967.

The catalogue raisonné of Kirchner's graphic work.

Gordon, Donald E., *Ernst Ludwig Kirchner,* Cambridge, Mass.: Harvard University Press, 1968.

The catalogue raisonné of Kirchner's paintings.

Grisebach, Lothar, *E. L. Kirchners Davoser Tagebuch: Eine Darstellung des Malers und eine Sammlung seiner Schriften,* Cologne: Verlag M. DuMont Schauberg, [1968].

The following are the most important publications that have appeared since Bolliger's bibliography.

Bündner Kunstmuseum Chur, *E. L. Kirchner und seine Schüler im Bündner Kunstmuseum Chur,* exh. cat., 1980.

Galerie Roman Norbert Ketterer, Campione d'Italia bei Lugano, *Das Werk Ernst Ludwig Kirchners: Malerei, Grafik, Plastik, Zeichnung,* exh. cat., 1980.

Gercken, Günther, *Ernst Ludwig Kirchner: Holzschnittzyklen – Peter Schlemihl, Triumph der Liebe, Absalom,* Stuttgart: Belser Verlag, 1980.

Gordon, Donald E., "Ernst Ludwig Kirchner: By Instinct Possessed," *Art in America,* vol. 68, no. 9, November 1980, pp. 80–95.

Grisebach, Lucius, *Ernst Ludwig Kirchner: Gross-stadtbilder,* Munich: R. Piper & Co. Verlag, 1979.

Henze, Anton, *Ernst Ludwig Kirchner: Leben und Werk,* Stuttgart: Belser Verlag, 1980.

Kornfeld, E. W., *Ernst Ludwig Kirchner: Dresden, Berlin, Davos – Nachzeichnung seines Lebens,* Bern: Galerie Kornfeld & Co., 1979.

Kunstmuseum Basel, *E. L. Kirchner,* exh. cat., 1979.

Museum der Stadt Aschaffenburg, *E. L. Kirchner* and *E. L. Kirchner Zeichnungen,* 2 vols., exh. cat., 1980.

Nationalgalerie, Berlin, *Ernst Ludwig Kirchner 1880–1938,* exh. cat., 1979.

With essays by Erika Billeter, Hans Bolliger, Georg Reinhardt, Wolf-Dieter Dube, Lucius Grisebach, Annette Meyer zu Eissen, Dieter Honisch, Leopold Reidemeister, and Frank Whitford. Extensive catalogue for the centenary exhibition which included fifteen sculptures.

Reidemeister, Leopold, "Ernst Ludwig Kirchners Berliner Strassenszene von 1913: Eine Neuerwerbung des Brücke-Museums," *Brücke-Archiv,* (Berlin: Brücke-Museum), vol. 11, 1979–80, pp. 13–15.

Reinhardt, Georg, "Im Angesicht des Spiegelbildes...Anmerkungen zu Selbstbildniszeichnungen Ernst Ludwig Kirchners," *Brücke-Archiv,* (Berlin: Brücke-Museum), vol. 11, 1979–80, pp. 18–40.

Schiefler, Gustav, *Die Graphik E. L. Kirchners bis 1910,* Berlin: Euphorion Verlag, 1920.

Staatsgalerie Stuttgart, *Ernst Ludwig Kirchner in der graphischen Sammlung der Staatsgalerie Stuttgart,* exh. cat., 1980.

Städelsches Kunstinstitut, Frankfurt, *Ernst Ludwig Kirchner: Aquarelle, Zeichnungen und Druckgraphik aus dem Besitz des Städel, Frankfurt am Main,* exh. cat., 1980.

Wahl, Volker, "Ernst Ludwig Kirchner und Jena," *Forschungen und Berichte,* vols. 20–21, 1980, pp. 473–501.

Concerning the Sculpture of Ernst Ludwig Kirchner (bibliography prepared by Dr. Wolfgang Henze)

Cohn, Alice, "Plastik und Zeit," *Das Kunstblatt,* vol. 5, no. 11, 1921, pp. 347ff.

Gabler, Karlheinz, "E. L. Kirchners Doppelrelief: Tanz zwischen den Frauen-Alpaufzug: Bemerkungen zu einem Hauptwerk expressionistischer Plastik," *Brücke-Archiv,* (Berlin: Brücke-Museum), vol. 11, 1979–80, pp. 3–12.

Contains contemporary photographs by Kirchner of his sculpture, studios, and models.

Göpel, Erhard, "Das wiederhergestellte Kirchner-Haus in Davos" *Werk,* no. 12, 1964, pp. 454–62.

Grohmann, Will, *Das Werk Ernst Ludwig Kirchners,* Munich: Kurt Wolff, 1926.

Kirchner, E. L., *Chronik der K[ünstler] G[emeinschaft] Brücke,* privately printed, 1913. (Reprinted in: Kunsthalle Bern, *Paula Modersohn und die Maler der Brücke,* exh. cat., 1948; and Herschel B. Chipp, *Theories of Modern Art,* Berkeley and Los Angeles: University of California Press, 1968; 2nd ed. 1973.)

E. L. Kirchner [L. de Marsalle, pseud.], "Über die plastischen Arbeiten von E. L. Kirchner," *Der Cicerone,* vol. 17, no. 14, 1925, pp. 695–701. (Reprinted in Grisebach, [1968].)

Included in translation in this catalogue, pp. 43–46.

———, "Über Kirchners Graphik," *Genius,* vol. 2, 1921, pp. 250–63.

Museum of Fine Arts, Boston, *Ernst Ludwig Kirchner,* exh. cat., 1968.

Rosenthal, Donald A., "Two Motifs from Early Africa in Works by E. L. Kirchner," *Abhandlungen und Berichte des Staatlichen Museums für Völkerkunde Dresden,* vol. 35, 1976, pp. 169–71.

Karl Knappe

Grzimek, Waldemar, *Deutsche Bildhauer des zwanzigsten Jahrhunderts,* Wiesbaden: R. Löwit, 1969, pp. 27, 147, 196, 200.

Knappe, Karl, *Das Gesetz heisst Wand der Ausweg: Plastik,* ed. Helmut Beck, Stuttgart: Stuttgarter Verlag, 1950.

Schnell, Hugo, "Karl Knappe," *Das Münster,* vol. 12, 1959, pp. 280ff; vol. 15, 1962, pp. 96ff.

Schwemmer, Gottlieb, "Die Kunst Karl Knappes," *Der Kunstwart,* vol. 3, December 1931, pp. 185–88.

Weiss, Konrad, "Der Bildhauer Karl Knappe," *Jahrbuch der Jungen Kunst,* (Leipzig: Klinkhardt & Biermann), vol. 5, 1924, pp. 249–55.

Georg Kolbe

Andrew Dickson White Museum of Art, Cornell University, Ithaca, *Georg Kolbe: Sculpture from the Collection of B. Gerald Cantor,* exh. cat., 1972.

Casson, Stanley, "The Recent Development of Georg Kolbe," *International Studio,* vol. 96, August 1930, pp. 17–20.

Heller, Reinhold, "Georg Kolbe: A Revaluation," *Apollo,* n.s., vol. 99, no. 143, January 1974, pp. 50–55.

Kolbe, Georg, "Plastik und Zeichnung," *Genius,* vol. 3, no. 1, 1921, pp. 15–16.

Valentiner, Wilhelm R., *Georg Kolbe: Plastik und Zeichnung,* Munich: Karl Wolff, 1922.

Käthe Kollwitz

Klipstein, August, *Käthe Kollwitz: Verzeichnis des graphischen Werkes,* Bern: Klipstein & Co., 1955.

A catalogue raisonné of Kollwitz's graphics.

Kollwitz, Käthe, *Das plastische Werk,* ed. Hans Kollwitz, pref. Leopold Reidemeister, Hamburg: Christian Wagner Verlag, 1967.

———, *The Diaries and Letters of Käthe Kollwitz,* ed. Hans Kollwitz, trans. Richard and Clara Winston, Chicago: H. Regnery Co., 1955.

Meckel, Christoph, Ulrich Weisner, and Hans Kollwitz, *Käthe Kollwitz,* Bonn-Bad Godesberg: Inter Nationes, 1967.

Nagel, Otto, and Werner Timm, *Käthe Kollwitz: Die Handzeichnungen,* Berlin: Henschelverlag Kunst und Gesellschaft, 1972.

Catalogue raisonné of Kollwitz's drawings.

Rauhut, Ilse, "Liebe und Verantwortung der Mütter, ein tragendes Thema im plastischen Werk von Käthe Kollwitz," *Bildende Kunst,* 1966, pp. 250–55.

Roussillon, France, "La sculpture de Käthe Kollwitz," unpub. Ph.D. diss., Sorbonne, June 1983.

University Art Galleries, University of California, Riverside, *Käthe Kollwitz, 1867–1945: Prints, Drawings, Sculpture,* exh. cat., 1978.

Wilhelm Lehmbruck

Badt, Kurt, "Die Plastik W. Lehmbrucks," *Zeitschrift für bildende Kunst,* vol. 31, 1920, pp. 169–82.

Very important early assessment of Lehmbruck.

Heusinger von Waldegg, Joachim, "Die Kunst Lehmbrucks," *Pantheon: Internationale Zeitschrift für Kunst,* vol. 41, no. 3, July–September 1983.

A review of Dietrich Schubert's recent monograph.

National Gallery of Art, Washington, D.C., *The Art of Wilhelm Lehmbruck,* exh. cat., New York: The Macmillan Company, 1972.

Petermann, Erwin, *Die Druckgraphik von Wilhelm Lehmbruck: Verzeichnis,* Stuttgart: Verlag Gerd Hatje, 1964.

An oeuvre catalogue of Lehmbruck's drawings.

Salzmann, Siegfried, *Das Wilhelm-Lehmbruck-Museum,* Recklinghausen: Verlag Aurel Bongers, 1981.

Schubert, Dietrich, *Die Kunst Lehmbrucks,* Stuttgart and Worms: Werner'sche Verlagsgesellschaft, 1981.

Extensive monograph, copiously documented and illustrated.

Städtische Museen Heilbronn, *Wilhelm Lehmbruck,* exh. cat., 1981.

Contains articles by Wilhelm Weber, Andreas Pfeiffer, Dietrich Schubert, Siegfried Salzmann, Waldemar Grzimek, Karlheinz Nowald, Margarita Lahusen, and Paul Pfister.

Westheim, Paul, *Wilhelm Lehmbruck,* Potsdam and Berlin: Gustav Kiepenheuer Verlag, 1919.

Wilhelm-Lehmbruck-Museum der Stadt Duisburg, *Hommage à Lehmbruck,* exh. cat., 1981.

See general bibliography citation.

Gerhard Marcks

Busch, Günter, and Martina Rudloff, eds., *Gerhard Marcks: Das plastische Werk,* Frankfurt am Main: Propyläen Verlag, 1977.

Contains the catalogue raisonné of Marcks' sculpture.

Gerhard Marcks Haus, *Gerhard Marcks Haus: Plastik,* vol. 1, Bremen: Gerhard Marcks Stiftung, 1971.

Germanisches Nationalmuseum, Nuremberg, *Dokumente zu Leben und Werk des Bildhauers und Graphikers Gerhard Marcks,* exh. cat., 1979.

University of California, Los Angeles, *Gerhard Marcks: A Retrospective Exhibition,* exh. cat., 1969.

George Minne

Alhadeff, Albert, "George Minne: Fin de Siècle Drawings and Sculpture," unpub. Ph.D. diss., New York University, 1971.

Haesaerts, Paul, *Laethem-Saint-Martin: Le village élu de l'art flamand,* Brussels: Arcade, 1965.

Langui, Emile, *Expressionism in Belgium,* Brussels: Laconti, 1972.

Puyvelde, Leo van, *George Minne,* Brussels: Editions des "Cahiers de Belgique," [1930].

Contains the catalogue raisonné of Minne's sculpture.

Ridder, André de, *George Minne,* Antwerp: DeSikkel, 1947.

Albert Müller

Bündner Kunstmuseum Chur, *E. L. Kirchner und seine Schüler im Bündner Kunstmuseum Chur,* exh. cat., 1980.

Kunstmuseum Winterthur, *Expressionismus in der Schweiz 1915 – 1930,* exh. cat., 1975.

Stutzer, Beat, *Albert Müller und die Basler Künstlergruppe Rot-Blau,* Munich: Prestel Verlag, 1981.

Contains a catalogue raisonné of Müller's paintings, decorative arts, and sculpture. Extensive bibliography and documentation.

Emil Nolde

Haftmann, Werner, *Emil Nolde,* New York: Harry N. Abrams, 1959. (Also published in German: *Emil Nolde,* Cologne: Verlag M. DuMont Schauberg, 1958.)

Kunsthalle, Bielefeld, *Emil Nolde: Masken und Figuren,* by Martin Urban, exh. cat., 1971.

Museum of Modern Art, New York, *Emil Nolde,* by Peter Selz, exh. cat., 1963.

Nolde, Emil, *Das eigene Leben: Die Zeit der Jugend 1867–1902,* Flensburg: Wolff, 1949.

This forms the first volume of Nolde's autobiography.

Nolde, Emil, *Mein Leben,* Cologne: DuMont Buchverlag, 1976.

Abridged version of the four-volume autobiography.

Reuther, Manfred, "Emil Nolde und Heinrich Sauermann: Die Flensburger Lehrjahre 1884–1888," in *Heinrich Sauermann (1842–1904): Ein Flensburger Möbelfabrikant des Historismus,* exh. cat., Städtisches Museum Flensburg, 1979.

[Selz, Peter, see Museum of Modern Art, New York.]

Urban, Martin, *Emil Nolde: Flowers and Animals: Watercolors and Drawings,* New York: Praeger, 1965. (Also published in German: *Blumen und Tiere: Aquarelle und Zeichnungen,* Cologne: Verlag M. DuMont Schauberg, 1965.)

——, *Emil Nolde: Landscapes: Watercolors and Drawings,* New York: Praeger, 1970. (Also published in German: *Landschaften: Aquarelle und Zeichnungen,* Cologne: Verlag M. DuMont Schauberg, 1969.)

[Urban, Martin, see Kunsthalle, Bielefeld.]

Max Pechstein

Fechter, Paul, *Das graphische Werk Max Pechsteins,* Berlin: Fritz Gurlitt Verlag, 1921.

Text and catalogue raisonné of Pechstein's graphic work; few illustrations. Only five hundred copies published.

Friedeberger, Hans, "Plastiken und neue Zeichnungen von Max Pechstein bei Gurlitt," *Der Cicerone,* vol. 5, 1913, pp. 760–62.

Heymann, Walther, *Max Pechstein,* Munich: R. Piper & Co. Verlag, 1916.

Krüger, Günther, "Die Jahreszeiten: ein Glasfensterzyklus von Max Pechstein," *Zeitschrift des deutschen Vereins für Kunstwissenschaft,* vol. 19, nos. 1–2, 1965, pp. 77–94.

Osborn, Max, *Max Pechstein,* Berlin: Propyläen Verlag, 1922.

Excerpt (pp. 230–36) included in translation in this catalogue, pp. 47–50.

Pechstein, Max, *Erinnerungen,* ed. Leopold Reidemeister, Wiesbaden: Limes Verlag, 1960.

Pfalzgalerie Kaiserslautern, *Max Pechstein,* exh. cat., 1982.

Hermann Scherer

Bündner Kunstmuseum Chur, *E. L. Kirchner und seine Schüler im Bündner Kunstmuseum Chur,* exh. cat., 1980.

Galerie Thomas Borgmann, Cologne, *Hermann Scherer: Holzplastiken 1924–26,* exh. cat., 1981.

Contains a catalogue raisonné and reprints of articles from the 1920s.

Kunstmuseum Winterthur, *Expressionismus in der Schweiz 1915–1930,* exh. cat., 1975.

Stutzer, Beat, *Albert Müller und die Basler Künstlergruppe Rot-Blau,* Munich: Prestel Verlag, 1981.

Extensive bibliography on the Rot-Blau group.

Egon Schiele

Comini, Alessandra, *Egon Schiele's Portraits,* Berkeley and Los Angeles: University of California Press, 1974.

Extensive bibliography.

Kallir, Otto, *Egon Schiele: The Graphic Work,* New York: Crown, 1970.

——, *Egon Schiele: Oeuvre Catalog of the Paintings,* New York: Crown, 1966.

Catalogue raisonné of Schiele's paintings.

Leopold, Rudolf, *Egon Schiele: Paintings, Watercolors, Drawings,* New York: Phaidon, 1973.

Nebehay, C. M., *Egon Schiele 1890–1918: Leben, Briefe, Gedichte,* Salzburg: Residenz Verlag, 1979.

Karl Schmidt-Rottluff

Brücke-Museum, Berlin, *Karl Schmidt-Rottluff: Das nachgelassene Werk seit den zwanziger Jahren: Malerei, Plastik, Kunsthandwerk,* exh. cat., 1977.

With illustrations of several sculptures by Schmidt-Rottluff.

Grohmann, Will, *Karl Schmidt-Rottluff,* Stuttgart: Verlag W. Kohlhammer, 1956.

Catalogue raisonné of Schmidt-Rottluff's paintings with illustrations of thirteen sculptures.

Kestner-Gesellschaft, Hannover, *Schmidt-Rottluff und Negerkunst,* exh. cat., 1920.

The first exhibition comparing sculpture by a Brücke artist to African art.

Leicester Museum and Art Gallery, *Schmidt-Rottluff: Graphic Works and Stone Carvings,* exh. cat., 1953.

Niemeyer, Wilhelm, "Der Maler Karl Schmidt-Rottluff," *Kündung – eine Zeitschrift für Kunst,* o.s., vols. 4–6, 1921, pp. 56–68.

Rathenau, Ernst, ed., *Karl Schmidt-Rottluff: Das graphische Werk seit 1923*, New York: Ernst Rathenau, 1964.

An illustrated catalogue of Schmidt-Rottluff's graphics from the years following 1923. Schapire's publication had catalogued works through that year.

Schapire, Rosa, *Karl Schmidt-Rottluffs graphisches Werk bis 1923*, Berlin: Euphorion Verlag, 1924.

An early catalogue raisonné of Schmidt-Rottluff's graphics; unillustrated.

Sewter, A. C., "A German Sculptor: Schmidt-Rottluff's Carvings at Leicester," *Manchester Guardian*, September 24, 1953.

Wietek, Gerhard, "Dr. phil. Rosa Schapire," *Jahrbuch der Hamburger Kunstsammlungen*, vol. 9, 1964, pp. 115–52.

———, *Schmidt-Rottluff: Graphik*, Munich: Verlag Karl Thiemig, 1971.

Recent catalogue of Schmidt-Rottluff's graphic oeuvre.

Martel Schwichtenberg

Becher, Johannes R., "Heiligsprechung einer Malerin," in *Ewig im Aufruhr*, Berlin: E. Rowohlt, 1920.

Durieux, Tilla, "Martel," in *Omnibus: Almanach für das Jahr 1931*, ed. Martel Schwichtenberg and Curt Valentin, Berlin and Düsseldorf: Galerie Flechtheim, 1931, pp. 187–89.

Klinger, Heinz, *Wege und Nebenwege: Erinnerungen eines Hamburger Arztes*, Hamburg: Hans Christians Druckerei und Verlag, 1976.

Knupp, Christine, "Neuerwerbungen 1971," *Jahrbuch*, ed. Gerhard Wietek, Hamburg: Altonaer Museum, 1972.

Schleswig-Holsteinisches Landesmuseum, *Berichte 1980*, ed. Gerhard Wietek, Schleswig-Holsteinisches Landesmuseum, 1981.

Schleswig-Holsteinisches Landesmuseum, *Schleswig-Holsteinische Künstlerporträts: aus dem Bestand des Schleswig-Holsteinischen Landesmuseums*, exh. cat., 1981.

Wietek, Gerhard, ed., *Deutsche Künstlerkolonien und Künstlerorte*, Munich: Verlag Karl Thiemig, 1976.

See contribution by K. V. Riedel.

Franz Seiwert

Bohnen, Uli, and Dirk Backes, eds., *Der Schritt, der einmal getan wurde, wird nicht zurückgenommen: Schriften – Franz W. Seiwert*, Berlin: Kramer, 1978.

[———, see also Kölnischer Kunstverein.]

Kölnischer Kunstverein, *Franz W. Seiwert, 1894–1933: Leben und Werk*, exh. cat., [1978].

Contains a catalogue raisonné by Uli Bohnen.

Kölnischer Kunstverein, *Vom Dadamax bis zum Grüngürtel: Köln in den zwanziger Jahren*, exh. cat., 1975, pp. 91–114.

Neue Gesellschaft für bildende Kunst, Berlin, *Politische Konstruktivisten: Die "Gruppe Progressiver Künstler" Köln*, exh. cat., 1975.

Renée Sintenis

Crevel, René, *Renée Sintenis*, Berlin and Leipzig: Klinkhardt & Biermann, 1930.

Heise, Carl Georg, "Daphne," *Kunst und Künstler*, vol. 29, 1931, pp. 72–73.

Article by the director of the Museum für Kunst und Kulturgeschichte, Lübeck, who commissioned the *Daphne* sculpture.

Kiel, Hanna, *Renée Sintenis*, Berlin: Rembrandt Verlag, 1956.

Leonard, H. Stewart, "Contemporary German Sculpture by Sintenis, Kolbe, Lehmbruck, and Wimmer," *Bulletin of the City Art Museum of St. Louis*, Summer 1950, pp. 44–47.

Milly Steger

Grautoff, Otto, "Milly Steger," *Die Kunst für alle*, vol. 41, July 1926, pp. 321–28.

Hildebrandt, Hans, "Milly Steger," *Das Kunstblatt*, vol. 12, 1918, pp. 372–77.

Kuhn, Alfred, *Die neuere Plastik: Achtzehnhundert bis zur Gegenwart*, Munich: Delphin Verlag, 1921, pp. 103ff.

———, "Milly Steger," *Deutsche Kunst und Dekoration*, vol. 51, January 1923, pp. 198–204.

Christoph Voll

Galleria del Levante, Munich, *Christoph Voll: Radierungen und Holzschnitte*, by Erhard Frommhold, exh. cat., 1981.

———, *Der Bildhauer Christoph Voll*, by Wilhelm Weber, exh. cat., 1975.

Early photographs of the sculptures by Ugo Mulas, as well as many documentary photographs.

Städtische Kunsthalle Mannheim, *Christoph Voll: 1897–1939*, exh. cat., 1960.

William Wauer

Laszlo, Carl, *William Wauer*, Basel: Editions Paderma, Carl Laszlo, [1979].

Contains many illustrations of sculptures, paintings, and drawings.

Schreyer, Lothar, *Erinnerungen an Sturm und Bauhaus: Was ist des Menschen Bild?*, Munich: Albert Langen, 1956.

Walden, Nell, and Lothar Schreyer, eds., *Der Sturm: Ein Erinnerungsbuch an Herwarth Walden und die Künstler aus dem Sturmkreis*, Baden-Baden: Woldemar Klein, 1954.

Ossip Zadkine

Czwiklitzer, Christophe, *Ossip Zadkine: Le sculpteur-graveur de 1919 à 1967*, Paris: Christophe Czwiklitzer, 1967.

Jianou, Ionel, *Zadkine*, Paris: Arted, 1964; 2nd ed. 1979.

Includes a catalogue raisonné.

Lichtenstein, Christa, *Ossip Zadkine (1890–1967): Der Bildhauer und seine Ikonographie*, Berlin: Gebr. Mann Verlag, 1980.

Extensive documentation and comparative photographs.

Raynal, Maurice, *Ossip Zadkine*, Rome: Editions de "Valori Plastici," 1921.

Ridder, André de, *Zadkine*, Paris: Chroniques du Jour, 1929.

Early catalogue of Zadkine's sculpture.

Photo Credits

Unless otherwise noted, all photographs are courtesy of the lender.

Dr. Karl Albiker, Karlsruhe: fig. 22, p. 22.

Altonaer Museum in Hamburg, Norddeutsches Landesmuseum: figs. 1 & 2, p. 191.

Brücke-Museum, Berlin: fig. 6, p. 95.

©Bündner Kunstmuseum Chur: fig. 25, p. 23; fig. 4, p. 121.

The Busch-Reisinger Museum, *The Busch-Reisinger Museum Harvard University,* New York: Abbeville Press, 1980 (photo: Amy Binder): cat. no. 98, p. 152.

©Erben Otto Dix, Baden: fig. 30, p. 25.

Ursula Edelmann FFM: cat. no. 64, p. 122; cat. no. 138, p. 199.

Egon Schiele Archive, Graphische Sammlung Albertina: portrait photo, p. 180.

Ernst Barlách Haus, Hamburg (photo: Heinz-Peter Cordes): cat. nos. 9 & 10, p. 64; cat. nos. 14 & 16, p. 66; cat. no. 26, p. 70.

Titus Felixmüller: cat. no. 34, p. 80; cat. nos. 35 & 37, p. 81.

Fetzer, Bad Ragaz: cat. no. 41, p. 87.

©Fotoarchiv Ernst Ludwig Kirchner, Hans Bolliger & Roman Norbert Ketterer, Campione d'Italia: figs. 2 & 3, p. 44; fig. 4, p. 45; figs. 6 & 7, p. 46; fig. 4, p. 95; figs. 1, 2, & 3, p. 120; figs. 4, 5, & 6, p. 121; figs. 7 & 8, p. 122; fig. 9, p. 123; fig. 10, p. 125; fig. 11, p. 127; fig. 13, p. 128; fig. 14, p. 129; fig. 2, p. 159; fig. 2, p. 175.

Foto Studio van Santvoort, Wuppertal: cat. no. 30, p. 76.

©Reinhard Friedrich: cat. no. 54, p. 107; cat. no. 56, p. 108; cat. nos. 57 & 58, p. 109; cat. no. 74, p. 134.

H. G. Gessner: cat. no. 1, p. 58.

Erhard and Barbara Göpel, *Max Beckmann: Katalog der Gemälde,* 2 vols., Bern: Galerie Kornfeld & Co., 1976: fig. 1, p. 73.

Graphisches Kabinett, Kunsthandel Wolfgang Werner: fig. 5, p. 106.

Frances Archipenko Gray: fig. 1, p. 58.

The Gutfreund Family, Prague: fig. 1, p. 91.

Paul Rudolf Henning: cat. no. 51 A, p. 99.

Jack Higbee, 1978: cat. no. 85, p. 140.

IFOT, Grenoble: cat. no. 150, p. 211.

Indiana University Art Museum (photo: Ken Strothman & Harvey Osterhoudt): cat. no. 147, p. 209.

Wolfgang Isle: fig. 2, p. 94; fig. 3, p. 95; cat. nos. 46 & 48, p. 96.

Ruth Kaiser, Europhot: cat. no. 21, p. 68.

Karl Ernst Osthaus Museum, Hagen: fig. 2, p. 58.

Florian Karsch, Berlin: figs. 1 & 2, p. 112.

Bernd Kirtz BFF: cat. no. 89, p. 144; cat. nos. 90, 93, & 94, p. 145.

©Prof. Dr. Arne A. Kollwitz, Berlin: fig. 18, p. 20; fig. 1, p. 138.

Koninklijk Museum voor Schone Kunsten, Antwerp: fig. 23, p. 22.

Kunst der Zeit, nos. 1–3, 1928: fig. 1, p. 77; portrait photo, p. 100.

Kunsthalle Mannheim: fig. 1, p. 101.

Kunstmuseum Basel: fig. 5, p. 46.

Stephan Lackner: fig. 2, p. 73.

Landesbildstelle Württemberg, Stuttgart: cat. no. 73, p. 131.

Lehmbruck Estate: cat. nos. 88 & 89, p. 144; cat. nos. 90, 91, 93 & 94, p. 145; cat. no. 92, p. 146; figs. 1, 2, & 3, p. 147; cat. nos. 95 & 96, p. 148; figs. 4, 5, & 6, p. 149.

©Lars Lohrisch: cat. no. 53, p. 107; cat. no. 55, p. 108; cat. nos. 99 & 100, p. 153.

Los Angeles County Museum of Art: fig. 10, p. 18; fig. 37, p. 28; cat. nos. 4 & 5, p. 63; cat. no. 9, p. 64; cat. no. 7, p. 65; cat. no. 18, p. 67; cat. no. 24, p. 70; cat. no. 28, p. 72; cat. no. 29, p. 73; cat. no. 50, p. 96; cat. no. 59, p. 111; cat. no. 67, pp. 124–125; cat. no. 79, p. 135; cat. nos. 81, 83 & 84, p. 139; cat. no. 86, p. 141; cat. no. 102, p. 156; cat. no. 122, p. 181; cat. no. 146, p. 205.

Eric E. Mitchell: cat. no. 60, p. 118.

Ugo Mulas: cat. no. 146 (detail), p. 205.

Museum Folkwang, Essen: fig. 1, p. 199.

Museum für Kunst und Gewerbe, Hamburg: fig. 2, p. 52; fig. 1, p. 94; cat. no. 47, p. 97.

Museum für Kunst und Gewerbe, Hamburg, and Hamburger Kunsthalle: figs. 8 & 9, p. 55.

Museum für Kunst und Kulturgeschichte, Lübeck: fig. 35, p. 27.

Museum of Fine Arts, Boston: fig. 31, p. 25.

National Gallery of Art, Washington, D.C.: figs. 11 & 12, p. 18.

©Nolde-Stiftung Seebüll: fig. 1, p. 164; cat. nos. 110 & 111, p. 165; cat. nos. 107 & 109, p. 166; cat. nos. 105, 106, & 108, p. 167.

Omnibus: Almanach auf das Jahr 1932, Berlin and Düsseldorf: Galerie Flechtheim, 1932: fig. 1, p. 35.

©Max K. Pechstein, Hamburg: fig. 1, p. 47; figs. 2 & 3, p. 48; figs. 4, 5, & 6, p. 49; figs. 7, 8, & 9, p. 50; cat. no. 112, p. 170; fig. 1, p. 170; cat. no. 113, p. 171.

Der Querschnitt, April 1, 1928 (photo: Reiss): fig. 3, p. 77.

Der Querschnitt, nos. 3–4, Fall 1923: portrait photo, p. 196.

Rembrandt Verlag: fig. 1, p. 62.

Renger Foto: cat. no. 101, p. 155.

Rheinisches Bildarchiv, Köln: fig. 2, p. 68; cat. nos. 38 & 39, p. 84; cat. nos. 131 & 132, p. 194; cat. nos. 133 & 134, p. 195.

The Robert Gore Rifkind Foundation, Beverly Hills, California: frontispiece, p. 12; fig. 27, p. 24; fig. 1, p. 31; figs. 2 & 3, p. 32; figs. 4 & 5, p. 33; fig. 1, p. 35; fig. 1, p. 37; fig. 2, p. 38; fig. 3, p. 39; fig. 1, p. 52; figs. 3 & 4, p. 53; figs. 5, 6, & 7, p. 54; cat. no. 11, p. 64; cat. no. 17, p. 67; fig. 3, p. 77; figs. 1 & 2, p. 85; cat. no. 82, p. 141; fig. 1, p. 202.

©Henning Rogge, Berlin: cat. no. 62, p. 118; cat. nos. 127 & 129, p. 186; cat. no. 126, p. 187.

Ernst Scheel: cat. no. 112, p. 170.

Schleswig-Holsteinisches Landesmuseum, Schleswig: fig. 5, p. 95; cat. no. 125, p. 187.

©Dietrich Schubert: figs. 1 & 2, p. 104; figs. 3 & 4, p. 105; figs. 2 & 3, p. 147; figs. 4, 5, & 6, p. 149.

Schweiz Institut für Kunstwissenschaft Zürich: fig. 12, p. 128; figs. 1 & 3, p. 159; cat. no. 103, pp. 160–61; fig. 1, p. 173.

Seattle Art Museum: fig. 28, p. 24.

Sirius Fotodesign und Bildjournalismus: cat. no. 88, p. 144; cat. no. 92, p. 146; cat. nos. 95 & 96, p. 148.

©Staatliche Museen Preussischer Kulturbesitz, Nationalgalerie, Berlin: fig. 1, p. 147.

Staatliche Museen Preussischer Kulturbesitz, Nationalgalerie, Berlin, *Max Liebermann in seiner Zeit,* 1979, exh. cat., p. 110: fig. 1, p. 131.

Staatsgalerie moderner Kunst, Munich: cat. no. 23, p. 68; cat. no. 27, p. 72; fig. 2, p. 77; cat. no. 91, p. 145.

Städelsches Kunstinstitut, Frankfurt: fig. 17, p. 20; cat. no. 33, p. 80.

Hans Wauer, Berlin, and Atelier T. M. Christoph Marlendwalder, Basel: fig. 33, p. 26; fig. 1, p. 207.

Wolfgang Werner, Bremen: fig. 6, p. 106.

Baron Dietrich von Werthern: cat. nos. 139 & 140, p. 202; cat. nos. 141, 142, & 143, p. 203; cat. nos. 144 & 145, p. 204.

Wilhelm-Lehmbruck-Museum der Stadt Duisburg (photo: Sirrus): fig. 13, p. 19.

Liselotte Witzel: fig. 1, p. 157.

Helen Wolff: fig. 1, p. 31; figs. 2 & 3, p. 32; figs. 4 & 5, p. 33; fig. 1, p. 37; fig. 2, p. 38; fig. 3, p. 39.

Index